Palgrave Studies in Business, Arts and Humanities

Series Editors
Samantha Warren
Faculty of Business and Law
University of Portsmouth
Portsmouth, UK

Steven S. Taylor
WPI Foisie School of Business
Worcester, MA, USA

Business has much to learn from the arts and humanities, and vice versa. Research on the links between the arts, humanities and business has been occurring for decades, but it is fragmented across various business topics, including: innovation, entrepreneurship, creative thinking, the creative industries, leadership and marketing.

A variety of different academic streams have explored the links between the arts, humanities and business, including: organizational aesthetics, arts-based methods, creative industries, and arts-based research etc. The field is now a mature one but it remains fragmented. This series is the first of its kind to bring these streams together and provides a "go-to" resource on arts, humanities and business for emerging scholars and established academics alike. This series will include original monographs and edited collections to further our knowledge of topics across the field.

More information about this series at
http://www.palgrave.com/gp/series/15463

Claudia Schnugg

Creating ArtScience Collaboration

Bringing Value to Organizations

palgrave
macmillan

Claudia Schnugg
Wels, Austria

ISSN 2662-1266　　　　　ISSN 2662-1274　(electronic)
Palgrave Studies in Business, Arts and Humanities
ISBN 978-3-030-04548-7　　　ISBN 978-3-030-04549-4　(eBook)
https://doi.org/10.1007/978-3-030-04549-4

Library of Congress Control Number: 2018964911

© The Editor(s) (if applicable) and The Author(s), under exclusive licence to Springer Nature Switzerland AG 2019
This work is subject to copyright. All rights are solely and exclusively licensed by the Publisher, whether the whole or part of the material is concerned, specifically the rights of translation, reprinting, reuse of illustrations, recitation, broadcasting, reproduction on microfilms or in any other physical way, and transmission or information storage and retrieval, electronic adaptation, computer software, or by similar or dissimilar methodology now known or hereafter developed.
The use of general descriptive names, registered names, trademarks, service marks, etc. in this publication does not imply, even in the absence of a specific statement, that such names are exempt from the relevant protective laws and regulations and therefore free for general use.
The publisher, the authors and the editors are safe to assume that the advice and information in this book are believed to be true and accurate at the date of publication. Neither the publisher nor the authors or the editors give a warranty, express or implied, with respect to the material contained herein or for any errors or omissions that may have been made. The publisher remains neutral with regard to jurisdictional claims in published maps and institutional affiliations.

Cover illustration: 'Pneumothorax Machine' by Anna Dumitriu. © Anna Dumitriu

This Palgrave Macmillan imprint is published by the registered company Springer Nature Switzerland AG.
The registered company address is: Gewerbestrasse 11, 6330 Cham, Switzerland

Preface

This is a book about artists and scientists who collaborate and about the organizations in which they and their projects are embedded. In the growing field of artscience, artists and scientists get more and more opportunities to collaborate on projects, interact on a long-term basis, or build up new knowledge and skills during shorter encounters. Artist-in-residence programs where artists are invited to work at scientific organizations for a certain amount of time are becoming quite common; artists are also being increasingly invited for initiatives in the research and development (R&D) departments of corporations. At the same time, scientists are starting to grow interested in the interaction with art and artists to expand their skills and broaden their perspectives. These interactions can give a new twist to scientific work or be the basis for new artworks, but artists and scientists always point to the process of their interaction as the most important part. Organizations from diverse fields—laboratories, research facilities, universities, R&D departments of corporations, cultural organizations like museums, galleries, or festivals—are interested in providing opportunities to artists and scientists to collaborate and present the outcomes or employ the rich artscience collaboration process to help their employees grow their skills and develop new ideas. This process between artists and scientists is an intense one, and it places a huge demand on the involved organizations with regard to time, flexibility, facilitation, and managerial work. By going through this process, much can be learned, new insights can be made, and many other effects can be observed that are important for artists, scientists, and organizations.

Artists and scientists are creative individuals dedicated to pushing the boundaries of knowledge and experience. But the artists create artworks and the scientists create scientific outcomes. Thinking about art, most people

picture paintings, drawings, and sculptures. To some music occurs right away, and a few will think of media art. You might think of those crazy-looking people doing art, leading an eccentric lifestyle, far from a normal person's life, and the very weird art market, where many earn close to nothing and others incredible amounts of money. But you also know that there is a lot of skill, training, and dedication necessary to produce important artworks.

And then, think of science. You probably think of skills and training, although a different training. Maybe you think of some important outcomes like the theory of relativity, or you think about laboratories and people walking around in white laboratory coats, who talk seriously, study their data, do experiments, talk in scientific jargon, present their work at conferences, and are employed by universities or corporations who need and can afford scientific departments. I don't want to push the stereotypes too far, but there are differences in processes, approaches, operative goals, and organizational structures which are relevant when art and science come together.

These differences in the daily realities, routines, and organizations create a different understanding of what is "normal" for artists and scientists. This also shapes their understanding of what they do and how they approach their work and the specific projects they approach and the people they meet. But, at the same time, openness, new experiences, and completely different views can trigger big leaps in projects and lead to breakthrough ideas or paradigm-shifting approaches. And what could create a more exciting new experience than a meeting of artists and scientists?

What is interesting here is to see what is so special about the process and how it came to artworks like these: artists speculating about creating in-vitro meat in a medical laboratory; artists and astronomers reflecting on the complexity of spectacular nebular images; or fashion-tech artists, programmers, sensor developers, and neuroscientists developing a fashionable device to be used in therapies for children suffering with attention deficit hyperactivity disorder (ADHD). These works are artworks based on artscience collaboration. They tackle important topics artists and scientists are engaging with, such as medical issues, social issues, climate change, production and consumption of leather, and descriptions of potentially habitable planets outside of our solar system. Therefore, it is important to keep in mind that any artscience collaboration involving artists from any background, like painters or poets, and scientists from any field, like biology or sociology, can lead to interesting outcomes.

Nevertheless, organizational and funding structures ask for reasons and outcomes to legitimate experiments in new fields or for going off the beaten track. Scientists, for example, have to practice a certain division of labor. They have to think analytically about small questions. Artists, on the other hand,

are much freer in their approach to a topic; they deeply engage with it, but they can draw from many fields to make it experienceable. In collaborations, the mix of this can help to contextualize the work being done and consider its wider implications and connections to other fields. As one scientist said to me: "the collaboration helps me to think about my work differently and I now know that it is valuable to the society outside of the scientific community." These are small steps that are very important for the scientist for understanding the work as meaningful, motivational, and inspirational, or for framing new questions. Moreover, professional requirements and career paths often determine decisions on the selection of projects and priorities given to upcoming opportunities: where would I invest my time in order to have a secured job situation or some contribution to a next show or publication? Can I afford to take the risk to follow a project out of pure personal interest in the experience and out of nothing more than curiosity?

To support a decision toward the interest in experiencing the process and listening to the call of one's curiosity, and to give some arguments at hand that support this decision, within the framework of organizations, funding machineries, and career development, the following chapters will show important aspects of what can happen, and which beneficial effects can occur by focusing on the process. Not all of these effects will occur in each artscience collaboration or artscience project undertaken, but these chapters show the richness of the encounters between artists and scientists. Not every single one of these possible "effects," as they are called, will magically appear in each interaction or collaboration between artists and scientists. And often the changes won't happen immediately. As each encounter and experience in our lives possibly affects us, subtle developments will be triggered, and depending on how much we listen to them and let them get to us, we will know where they are coming from.

Most importantly, the significance of the divergence between understanding of the process among artists and scientists—that makes artscience collaboration so rich in outcomes—and the arguments used widely in blogs, managerial discussions, and funding bodies, as well as the limitations in setting up projects, impelled me to write this book. The selling point of artscience collaboration in many discussions, and basic arguments for funding, is unfortunately often making a shortcut to the outcomes of artscience collaboration as "heightened creativity" or "fostering innovation." Others point to new perspectives, imagination, and inspiration for both artists and scientists: in some arguments the artists become inspired to create great artwork through exposure to the fancy and outerworldly realm of science; sometimes scientists, technicians, or developers are said to be inspired by the fresh look

of artists to create new experiments or even products and get a new perspective on their work. And of course, this can be utilized to produce the kind of innovation, like product innovation, to which such arguments are pointing. In a certain light, this is true: looking at different aspects of social interaction, there are many processes and effects of artscience collaboration that can lead to creativity, but it is important to look closely at the process to understand the dynamics that lead to creativity. Similarly, communication is used as an argument for the funding of artscience projects. Again, shortcuts are often made by talking about using artscience for communicating science to a bigger audience through art. This mistakes visualization for artistic work on the one hand, and on the other hand it neglects all the other much more important aspects concerning communication that are affected by artscience collaboration. A close look at the process between artists and scientists is necessary to understand how communication is affected. Thus, this book examines this process of artscience collaboration to create a better understanding of the broadly claimed effects and create a common ground to discuss them.

Artscience collaboration is a growing field with only little practical experience within the arts, the sciences, and the organizations, and it builds on a growing number of experimental approaches. Therefore, many projects and programs are still set up in a very experimental way, outside of organizational structure and with very limited resources. The participating parties can maximize their gains from the process of artscience collaboration only by giving enough time and space to artists and scientists to collaborate, and by involving the organization at key points. To be able to see this and set up interesting artscience projects, it is important to understand the process of how certain effects emerge from the interaction between artists and scientists. Second, for managerial tasks, there is a lot to be learned from the many projects that have been created throughout the last few years. These insights help to argue for the importance of artscience collaboration in organizations in a more differentiated way.

To show all this and to investigate the artscience collaboration process and its managerial aspects, the lens of organization studies comes in handy. It helps to understand the process because it is concerned with this "normal" that we experience through the organizational structures we live in. It asks, for example, about practices and routines because these shape and create social relations, and this all eventually influences how we understand the world we live in. For that, it borrows theories and tools from fields like sociology, psychology, anthropology, and cultural studies, just like the theoretical perspectives chosen in the book.

Based on the cases presented in the book and the experience of artscience practitioners and experts, theories from the realm of organization studies have

been chosen carefully to illuminate the artscience collaboration process in this book. The material has been researched through qualitative interviews and (participatory) observation. Based on this material, the most important aspects of the artscience collaboration process and the changes interviewees mentioned have been categorized as "effects" and connected to the process. This matrix led to the selection of the theoretical perspectives used in the chapters focusing on the process: interdisciplinary collaboration processes, contextualization, liminality, social networking, sensemaking, aesthetics, communication, and creativity are the leading theories. In close relation to some aspects of cases presented in these chapters, some other theories will be mentioned that focus on the same aspect. For example, meaningful work theory is closely related to ideas presented under the umbrella of contextualization, and identity theory is closely related to ideas presented within the chapter on sensemaking theory.

The process of artscience collaboration is embedded in organizations: scientific organizations, cultural organizations, or corporate organizations. Thus, after focusing on the process of artscience collaboration through different lenses in organization studies, the spotlight will be on the organizational and managerial aspects of artscience collaboration: single projects, programs that enable artscience collaboration, or artist-in-residence programs in scientific and corporate organizations. Based on the experience with many different organizations and qualitative interviews with facilitators and curators of artscience collaboration programs, the following chapters focus on questions of how to bring artscience collaboration to life and those related to (organizational) barriers and enablers of artscience collaboration in artistic, scientific, and corporate environments.

The work on this book started from my own experience in the field and has been expanded by conversations with people I met along the way in artscience projects; extensive research and discussions with leading people working in the field provided additional insight and perspectives. In the end, more than 50 interviews and additional informal conversations; my own experience in creating artscience projects and guiding artists, scientists, and organizations through the process; travels to places of artscience collaboration; and organizational research built the backbone of this book.

I want to say thanks to all these partners in crime for their insights in artscience collaboration: Victoria Vesna, Anouk Wipprecht, Fernando Comerón, Michael Doser, Vanessa Sigurdson, Noah Weinstein, Lucy McRae, Juliane Götz and Sebastian Neitsch, Sonja Schachinger, Anna Dumitriu, Nicola Fawcett, Rob Neely, James Gimzewski, Cvetana Ivanova, Charles Taylor, Bianka Hofmann, Sabrina Haase, Yen Tzu Chang, Domhnaill Hernon,

Sougwen Chung, Larry O'Gorman, Sarah Petkus, Claudia Mignone, Karen O'Flaherty, Christina Agapakis, Natsai Audrey Chieza, Tracy Redhead, Florian Thalmann, Oron Catts, Forest Stearns, Jill Scott, Irène Hediger, Christoph Guger, Annick Bureaud, Olivia Osborne, Chris Salmon, Dr. Cristian Zaelzer, Markus Schmidt, Sarah Craske, Marcos Pellejeros Ibanez, Antonio Mampaso, Casiana Muñoz-Tuñón, Jurij Krpan, Ariane Koek, Amy Karle, Madeline Gannon, Appropriate Audiences, Alexandra Murray-Leslie, Danielle Siembieda, Ian Davis, Ricky Graham, Edwin Park, Johannes Lehner, Andrea Kurz, Bettina Klausberger, and, above all, Roland Aigner, for listening to my ideas and discussing my progress on a nearly daily basis.

Wels, Austria Claudia Schnugg

Praise for *Palgrave Studies in Business, Arts and Humanities*

"Little is known still about the point where art, technology and science collide. Yet large companies are trying to involve themselves heavily in this space. In this book, Claudia Schnugg gives a better view into the world of art and science collaborations through case studies and projects that she either followed or was an integral part of herself. This gives a very deep and thorough insight into what it takes to be involved in this field, or to help it grow. This book is a must-read for anyone interested in the innovations that will shape the future of technology; blending art, tech and science in ways that don't exist yet."

—Anouk Wipprecht, *fashion-tech artist, hi-tech fashion designer, and experienced artist-in-residence working in collaboration with multinational companies, NGOs, and cultural organizations*

"Artists and scientists are increasingly integrating their skills and techniques to produce projects and products that are redefining both disciplines; but until now there has been no analysis of how such collaborations work, what differentiates failures from success, or how institutional contexts mediate success. An essential read for anyone interested in cross- or transdisciplinary ventures more generally, Claudia Schnugg has written *the* book about artist-scientist collaborations that everyone has been waiting for!"

—Bob Root-Bernstein, *Professor of Physiology, Michigan State University, author of* Discovering *and co-author of* Sparks of Genius

"Unlike other books which have focused on 'ArtSci' as the creative practice where artists are inspired by science to create critical artworks, this book focuses instead on collaborative projects between artists and scientists, many of which have resulted in major scientific breakthroughs and discoveries. Schnugg focuses on the values created by work which breaks down knowledge barriers between disparate fields, with new insights and new languages emerging from open and horizontal collaborative environments. Through compelling case studies, she demonstrates the central role of ArtScience in informing both rigorous artistic practice and applied scientific research, with major implications for the study of philosophy, psychology, social studies and educational practice. A must read for anyone interested in creating a bigger societal impact using applied transdisciplinary knowledge."

—Michela Magas, *founder and director of Music Tech Fest, and European Woman Innovator of the Year 2017 for creating an innovation ecosystem which bridges art and science*

"It is a great pleasure to read this book, precisely because of the classic and important theme of the social sciences and of the organizational studies that is discussed here, namely the separation of art and science that has become normal and habitual with modernist thinking. Claudia Schnugg opens a discussion on this that is rooted in empirical research and that allows us to become better aware of how to 'bring the collaboration of artscience to life.'"

—Antonio Strati, *senior professor, RUCOLA, University of Trento, Italy, and i3-CRG, École polytechnique, France, author of* Organizational Aesthetics *and co-author of* Learning and Knowing in Practice-Based Studies

"Timely and timeless, broad and deep, surprising and surprisingly useful … I think these dualities best capture my reading of *Creating ArtScience Collaboration*. And as icing on the cake, it is a genuine pleasure to read. This is a book where the usual becomes refreshingly unusual. Whereas Art and Science stereotypically live in opposite universes, Dr. Schnugg convincingly and provocatively shows us how well they can dance and play together. Highly recommended!"

—Daved Barry, *Reh Family Endowed Chaired Professor, Innovation and Entrepreneurship, Clarkson University, USA*

Contents

1 Building up the Basics: An Introduction to ArtScience Collaboration 1
 1.1 First Things First 3
 1.2 Tracking ArtScience Collaboration 6
 References 11

Part I Perspectives on the ArtScience Collaboration Process 13

2 Interdisciplinary Collaboration 15
 2.1 Interdisciplinary Project Realization and Disciplinary Development 21
 2.2 Raising Questions and Learning Processes 25
 References 30

3 Contextualization 31
 3.1 Narrating and Presenting Invented Futures 37
 3.2 The "Human Side" and Meaningful Work 42
 3.3 Ethics and Critical Discussions of Broader Implications 48
 References 52

4 Spaces In-Between: Liminality — 55
4.1 Exploration, Learning Processes, and Personal Development — 61
4.2 Rituals, Disruption, and Change — 70
References — 71

5 Social Networks — 73
5.1 Creating Bridges: Connecting People, Connecting Fields — 74
5.2 Influences on Putting Opportunities into Action — 82
5.3 Beyond Existing Formal Structures — 89
References — 92

6 Sensemaking — 95
6.1 Enable "New Ways of Understanding" — 98
6.2 A Clash of Identities and Ways of Expression — 102
6.3 The Disruptive Power of ArtScience Collaboration — 108
References — 111

7 Aesthetics — 113
7.1 Experience Aesthetics and Aesthetic Expression — 115
7.2 Organizational Aesthetics, Practices, and Ways of Seeing — 122
7.3 Aesthetics, Professional Expertise, and Education — 128
References — 134

8 Communication — 137
8.1 Enhanced Personal Communication Skills — 138
8.2 Communication Beyond Words — 146
8.3 An Outreach Interplay: A Comprehensive Case on Communication — 150
8.4 Science Communication and Public Engagement — 156
References — 160

9 Creativity — 163
9.1 Factors Influencing Creativity — 164
9.2 Individual and Social Factors of Creativity in ArtScience — 168
9.3 Contextual Factors of Creativity in ArtScience — 176
References — 188

Part II	**Creating and Framing Opportunities for ArtScience Collaboration**	193

10 Exploring the Value-Added: Or Why to Give ArtScience Collaboration a Chance in Organizations — 195
 10.1 The Organization — 198
 10.2 The Artist and the Scientist — 200
 10.3 Cultural and Social Environment — 203
 References — 204

11 Bring ArtScience Collaborations to Life — 205
 11.1 Forms of Collaboration — 206
 11.2 Programs for Collaboration in Organizations — 208
 11.3 Bring Programs and Projects to Action — 211
 11.4 Bridge-Builders — 217
 References — 221

12 Things to Keep in Mind — 223
 12.1 Important Conditions — 223
 12.2 The Role of the Profession — 229
 12.3 Evaluation in the Field and the Attributed Value of ArtScience Collaboration — 231
 References — 234

13 Outlook — 235
 13.1 Education — 237
 13.2 Next Steps — 240
 References — 241

Index — 243

List of Figures

Fig. 2.1 *Tissue Engineered Steak No. 1* 2000, a study for *Disembodied Cuisine* by The Tissue Culture & Art (Oron Catts, Ionat Zurr & Guy Ben-Ary). Prenatal sheep skeletal muscle and degradable polyglycolic acid polymer scaffold. This was the first attempt to use tissue engineering for meat production without the need to slaughter animals. (Image courtesy: TC&A, hosted at SymbioticA, School of Human Sciences, University of Western Australia) 18

Fig. 2.2 *Disembodied Cuisine* installation by The Tissue Culture & Art (Oron Catts, Ionat Zurr & Guy Ben-Ary) 2003, mixed media, photography by Axel Heise. (Image courtesy: TC&A, hosted at SymbioticA, School of Human Sciences, University of Western Australia) 19

Fig. 2.3 *Victimless Leather—a prototype of stitch-less jacket grown in a techno-scientific "body"* by The Tissue Culture & Art (Oron Catts and Ionat Zurr) 2004, biodegradable polymer skin and bone cells from human and mouse. (Image courtesy: TC&A, hosted at SymbioticA, School of Human Sciences, University of Western Australia) 20

Fig. 2.4 Tracy Redhead and Florian Thalmann working on the semantic player and a new composition for the semantic player. (Photography by Andrea Metzger and Florian Thalmann, edited by Jonathan Rutherford) 25

Fig. 2.5 *Theriak*, the peptide synthesized to spell the medieval cure-all within its amino acid sequence. This piece of synthetic biology was made by Sarah Craske in her experiment, 2017. In collaboration with her scientific collaborators Dr. Irene Wüthrich and Dr. Steven

	Schmitt, it has been used with garlic against cholera. The name theriak refers to the medieval belief that garlic is a universal remedy which was also applied as a cure for cholera. (Image credit: Sarah Craske)	28
Fig. 3.1	*Theriak*, a living disease map of Basel in which cholera is fought with a synthetic peptide by Sarah Craske, 2018. This image is a scan from Craske's custom-made petri dish, showing the spread of cholera over a map of Basel. The cholera is in pink, and the peptide is shown where it's starting to go clear. (Image courtesy: Sarah Craske)	34
Fig. 3.2	*The Chemistry of Biology: An Alchemy of DNA Installation View #2* by Anna Dumitriu, 2017. This image shows the presentation of the collaboration between Anna Dumitriu and Dr. Rob Neely in an exhibition setting of their project "The Chemistry of Biology." The project aimed at exploring how new chemical tools in biotechnology will have far-reaching cultural and scientific implications for the future. (Image courtesy: Anna Dumitriu)	36
Fig. 3.3	Logo of *The Institute of Isolation* by Lucy McRae during the shooting of the fictional documentary; scene: Lucy McRae as a member of the institute leaving the organization, at Thermalbad Bad Fischau, 2016. (Photo credit: Claudia Schnugg)	38
Fig. 3.4	Lucy McRae as member of *The Institute of Isolation* training for zero gravity in the Microgravity Trainer. *The Institute of Isolation* with Lucy McRae and Lotje Sodderland, 2016. (Photo by Julian Love, image courtesy: Lucy McRae)	39
Fig. 3.5	*Regenerative Reliquary* by Amy Karle, 2016. A bioprinted scaffold in the shape of a human hand 3D-printed in a biodegradable polyethylene glycol diacrylate hydrogel that disintegrates over time. (Image courtesy: Amy Karle)	42
Fig. 3.6	Artist Sarah Petkus and her robot child *NoodleFeet*, 2017. (Image credit: Mark J. Koch)	47
Fig. 3.7	*Make Do and Mend*, detail, by Anna Dumitriu, 2017. The artwork refers to the saying "make do and mend," stemming from the need to patch clothes during World War II. In collaboration with scientists Anna Dumitriu worked on modern "patching" techniques like CRISPR/Cas9 to exchange bacteria's "damaged" part, which is its antibiotic resistance gene. Infusing handcraft materials with these bacteria and applying traditional patching techniques visualizes this process. (Image courtesy: Anna Dumitriu)	51
Fig. 4.1	Designs, measurements, graphs, and tests of *Agent Unicorn* by Anouk Wipprecht during the development process, 2016. (Image courtesy: Anouk Wipprecht)	58

Fig. 4.2	Screenshot of the teaser video that was released for the online announcement of *Agent Unicorn*. The video was shot by Local Androids, 2016. (Image courtesy: Anouk Wipprecht)	59
Fig. 4.3	The first prototype of the *Agent Unicorn* device, 2016. (Image courtesy by Anouk Wipprecht)	61
Fig. 4.4	*Sleep Symphony* by Chicks on Speed (Alexandra Murray-Leslie and Melissa Logan), installation view from the exhibition *We Are Data*, by Chicks on Speed, 401 Contemporary Berlin. In collaboration with Dr. Sam Ferguson, Varvara Guljajeva, Mar Canet, and Shannon Williamson, kindly supported by SymbioticA, the University of Western Australia, 2015	65
Fig. 4.5	Left: *Computer Enhanced Footwear Prototype 3* by Alexandra Murray-Leslie, worn by dancer Elizabeth Bressler in the music video *We Are Data Remix* (by Chicks on Speed and Cora Nova; music video directed by Alexandra Murray-Leslie, and makeup by Robert Marrast @ MAC Cosmetics). Shot on location at Octolab, Pier 9 Technology Centre, Autodesk, San Francisco, 2016. Right: *Computer Enhanced Footwear*: prototype depicting the final artifact using the process of additive print process of embedding Mylar in every 100 slices of the 3D print. Pier 9 Technology Centre, Autodesk, San Francisco, 2016	66
Fig. 4.6	Alexandra Murray-Leslie performing the Objet Connex 500 3D printer during fabrication of *Computer Enhanced Footwear Prototype 3* by Alexandra Murray-Leslie and Steve Mann. Image depicts a lens-based representation of the performative printing process, where Mylar was inserted into every 100 print filament slices and taped elements were added to the print bed "stage." A cyborg craft collaboration between Steve Mann and Alexandra Murray-Leslie, 2016, Pier 9 Technology Centre, Autodesk, San Francisco	68
Fig. 5.1	The world's first garment pigmented by *Streptomyces* bacteria was designed with a new approach to pattern cutting for in-vitro dyeing. (Credit: Assemblage 001, Ginkgo Bioworks × Natsai Audrey Chieza (Faber Futures) Residency, 2017. Photographer: IMMATTERS Studio. Image courtesy: Natsai Audrey Chieza)	76
Fig. 5.2	*Make Do and Mend: Controlled Commodity* by Anna Dumitriu, 2017, an installation view including other work by Anna Dumitriu. *Controlled Commodity* to be seen in the center of the image. *Controlled Commodity* incorporates an original garment from WWII labeled "Controlled Commodity," which is patched with bacteria-infused material. The recently developed antibiotic resistance is edited out of the bacteria's genome. (Image courtesy: Anna Dumitriu)	79

List of Figures

Fig. 5.3	*Make Do and Mend* by Anna Dumitriu, installation detail, 2017. (Image courtesy: Anna Dumitriu)	80
Fig. 5.4	Michael Doser explaining his work at the antimatter facilities during an introductory visit of artists before their residency at CERN, 2015. (Photo credit: Claudia Schnugg)	84
Fig. 5.5	Left: Victoria Vesna testing interactive elements of *Birdsong Diamond* at the Large Space, University of Tsukuba, 2016. Middle: a still of the *Birdsong Diamond Mimic* presentation at the Ars Electronica Festival 2017. Right: detail of the interactive element of *Birdsong Diamond Mimic*. (Photo credit and image courtesy: Victoria Vesna)	85
Fig. 5.6	Madeline, the Robot Whisperer: Madeline Gannon interacting with *Quipt* at Autodesk, 2015. (Image courtesy: Madeline Gannon/ATONATON [for a video of *Quipt* see https://www.youtube.com/watch?v=e5TofulUhEg, and for the presentation of *Mimus*, the curious robot, see https://www.youtube.com/watch?time_continue=5&v=B9jwNWiEd_M])	88
Fig. 5.7	The meeting of *NoodleFeet* and the ESA rover test robot on the Martian-like landscape at ESA during Sarah Petkus' residency, 2017. (Photo credit: Sarah Petkus)	91
Fig. 6.1	Music_1: Illustration by Marcos Pellejero-Ibanez, PhD, shows the initial approach before the conversations with the music teacher, 2018. (Image courtesy: Marcos Pellejero-Ibanez)	99
Fig. 6.2	Music_2: Illustration by Marcos Pellejero-Ibanez, PhD, shows the changed understanding after the conversations with the music teacher, 2018. (Image courtesy: Marcos Pellejero-Ibanez)	100
Fig. 6.3	Detail *tatoué.* by Appropriate Audiences. The Appropriate Audiences mantras on the industrial robot arm that is modified as a robotic tattoo machine at Autodesk, 2016. The Appropriate Audiences mantras are "Safety first," "To be continued," and "Never to be sorry." (Image courtesy: www.appropriateaudiences.net)	107
Fig. 6.4	*tatoué.* by Appropriate Audiences: Let's go! The first tattoo session using an industrial robot arm on a human's leg at Autodesk, 2016. (Image courtesy: www.appropriateaudiences.net)	108
Fig. 6.5	*How to cut the heel off a high-heeled shoe* (featuring Mary Elizabeth Yarbrough in action) still from music video *We Are Data Remix* and Instructable, by Alexandra Murray-Leslie, 2016. Made at Pier 9, Autodesk Technology Centre, San Francisco (to see the video: https://vimeo.com/207064196/04df14ac93 and https://vimeo.com/278296841/580996ce22)	110
Fig. 6.6	*We Are Data Remix* music video still by Alexandra Murray-Leslie, 2016. Image features a scene showing Elizabeth Bressler dancing with a robot, shot on location at Octolab, Pier 9 Technology Centre,	

	Autodesk, San Francisco. Camera: Blue Bergen; robot choreography: David Thomasson; and makeup: Robert Marrast @ MAC Cosmetics. (Photo copyright: Alexandra Murray-Leslie)	111
Fig. 7.1	Performance of *Omnia per Omnia* by Sougwen Chung, 2018. The artwork reimagines traditional landscape painting as a collaboration between humans, robots, and the dynamic flow of a city. It explores various modes of sensing: human and machine, organic and synthetic, improvisational and computational. (Image courtesy: Sougwen Chung [impressions of the performance https://vimeo.com/268448066])	120
Fig. 7.2	Detail of the collaboration process between Sougwen Chung and the robots during the performance of *Omnia per Omnia* by Sougwen Chung, 2018. (Image courtesy: Sougwen Chung)	121
Fig. 7.3	Artist's view of planetary nebula A14 based on images created during observations of the nebula by Antonio Mampaso and Denise Goncalves, 2018. (Image credit: Roland Aigner)	125
Fig. 7.4	Source images for *Blue Morph* retrieved by imaging the wings of the Blue Morpho butterfly with a scanning electron microscope, colored afterward to represent the color of the Blue Morpho butterfly, 2007. (Image courtesy: Victoria Vesna)	128
Fig. 7.5	Left: installation and performance of *Blue Morph* at the Beall Center for Art + Technology, 2015. Right: detail of the installation; platform illuminated with the wing details of the butterfly. (Image courtesy: Victoria Vesna)	129
Fig. 7.6	Performance *Whose Scalpel* presented by Taiwanese artist Yen Tzu Chang in the scope of Fraunhofer Society's "Science and Art in Dialog" event series in Berlin, 2018. (Photo credit: Fraunhofer ICT Group)	132
Fig. 7.7	Final presentation during the STEAM Imaging workshop with high-school students that took place at Ars Electronica in Linz, 2017. (Photo credit: Martin Hieslmair)	134
Fig. 8.1	*Creatura Micro_Connectomica* by Chris Salmon in collaboration with Alex Bachmayer, Andrea Peña, and Jade Séguéla, 2017. Photography by Dr. Cristian Zaelzer. (Image courtesy: Team of *Creatura Micro_Connectomica* [for more detailed information about the project, including some videos, see http://creaturaconvergence.weebly.com/])	141
Fig. 8.2	*Ex Voto* by Anna Dumitriu, 2017, in collaboration with Nicola Fawcett. This participatory artwork explores the impact of infectious diseases and antibiotics on human lives. The making of "votive offerings" created by the artist, visitors, patients, scientists, and medics happens during story-sharing discussions. These offerings, which are usually found in religious settings, symbolize a wish or thankfulness	

	for its fulfillment. The votives in the artwork are stained or dyed with sterilized bacteria, modified antibiotic-producing *Streptomyces*, and natural antimicrobial substances. (Image courtesy: Anna Dumitriu)	146
Fig. 8.3	Current LA: Water Public Art Biennial at UCLA, project presentation, talks, workshops, and artwork, 2016. (Image courtesy: Olivia Osborne)	149
Fig. 8.4	*Salty Networks* by Olivia Osborne, part of the video *Urbanization of Ecological Networks* by Olivia Osborne and Mick Lorusso, 2016. (Image courtesy: Olivia Osborne [to see the video, https://vimeo.com/191877235])	150
Fig. 8.5	*STONES* from frontal view. Artwork by Quadrature (Jan Bernstein [bis 2016], Juliane Götz, and Sebastian Neitsch), 2016. (Image courtesy: Quadrature)	154
Fig. 8.6	*MASSES* exhibition view: *STONES* can be seen in the background. Artwork by Quadrature (Jan Bernstein [bis 2016], Juliane Götz, and Sebastian Neitsch), 2016. (Image courtesy: Quadrature)	154
Fig. 9.1	Illustration of individual, social, and organizational factors enhancing creative behavior and creative situations fundamental to creative output. (See Woodman et al. 1993: 309)	165
Fig. 9.2	SoundLabsFlow is an adaptation of the PixelFlow library for processing by Delta Sound Labs and Nokia Bell Labs. It visualizes the turbulences in fluids that are sonified by referencing the structure and depth of the information. (Image courtesy: Ricky Graham)	179
Fig. 9.3	*Vorticity* by Ian Davis, Richard Graham, and Edwin Park at Moogfest, 2018. Delta Sound Labs' Stream software and analog synth hardware controlled by a digital motion capture system. (Image courtesy: Ricky Graham)	181
Fig. 9.4	Artistically designed satellite by Forest Stearns, museum exhibit of his artistic work at Planet Labs, 2018. (Image courtesy: Forest Stearns)	182
Fig. 9.5	Forest Stearns' painting representing the Skybox and Dove satellites by Planet Labs on a Minotaur rocket launched from Vandenberg AFB, 2017. (Image courtesy: Forest Stearns)	183
Fig. 9.6	An impression of Anna Dumitriu and John Paul's ongoing collaboration in Modernising Medical Microbiology, art project *Where There Is dust There Is Danger*, 2014. These tiny needle-felted lungs are made from wool and household dust impregnated with the extracted DNA of killed *Mycobacterium tuberculosis* (TB). The organisms have been rendered sterile using a validated process used in whole-genome sequencing of TB. The lungs show various stages of the disease and forms of treatment	187

1

Building up the Basics: An Introduction to ArtScience Collaboration

In a time of rediscovery of art and cultures of antiquity, artists started out to employ scientific principles and philosophy in order to experiment with daily processes of perception. Artists no longer see their roles in the depiction of religious motives, but want to contribute to the exploration of nature or even outplay it with their work. Based in this new self-understanding of art and a process of societal change, a curious scene can be observed: in 1412, the well-known Florentine craftsman Filippo Brunelleschi stands in front of the Florentine Dome looking at the Baptistery through a strange wooden construction, inviting passersby to look through and to see a perspectively correct representation of the Baptistery. In this way, Brunelleschi demonstrates his newly developed method of central perspective to his fellow citizens. He developed this method from his architectural and sketching point of view by investigating geometry and ways of seeing with the goal to create the illusion of depth in paintings. This is the environment where crossing borders between disciplines to create advancement in different fields is rediscovered—and the fruitful environment where the often-cited genius of Leonardo da Vinci is born and where he goes through an apprenticeship as painter, in a world where artists start to cross borders and do not want to be part of this reductionist guild of artisans of high professions. Openness and observation of the world are important for these artists to create their progressive artworks, which drives them to employ methods from natural sciences like mathematics and investigations into the body as basic fundamentals of their artistic production. This led not only to artistic development but also to scientific investigations, or to visionary ideas about flying machines, such as those demonstrated by Leonardo da Vinci.

A yearning for this time seems to be prevalent in our current culture, where the call for "new Leonardos" as figurehead of this fruitful melting pot of art and science is getting louder, as creativity and innovation are major buzzwords that drive economic and social development. Thus, lately, art and science are often named in one sentence: not only as opposite approaches to reality but also as fertile ground for innovation, new perspectives on important questions, deeper understanding of current developments, and exploration of recent technologies to be created. There is an unsatisfied need for this elusive "something new," which is interesting, helps to make the world a better place, helps to redefine societal structures, lowers production costs, or helps to create a more sustainable life. To create this, no new Leonardos as genius individuals are needed; however, opportunities for interdisciplinary exchange that allow for open-ended processes to investigate nature and new technological as well as scientific possibilities are needed. And an exchange that includes artists with their insatiable thirst for investigation, contextualization, and future visions seems to be a productive way to do so. This weird outcome may be ambiguous, like the weird wooden construction by Brunelleschi, but taking it further in scientific, technological, and artistic context can elevate such an outcome to an important innovation that can be understood retrospectively.

Moreover, the artistic or scientific outcome is not always groundbreaking, but the interaction between artists and scientists can be the critical endeavor to change work processes or set the stone for groundbreaking methods. Thus, it is the process of this interdisciplinary investigation that comprises the most interesting aspect, of which the outcome often cannot be foreseen. Individuals who have insights into different areas are often understood as those artists and scientists who are able to create paradigm-shifting ideas: they are either artists or scientists who want to go deep in their field and are able to draw from their extensive experiences in other fields; they understand connections or analogies (Edwards 2008; Root-Bernstein et al. 2017; Kemp 2016).

But it is not only diverse interests that help individuals to create such insights: as art and science are both fields of deep knowledge and imply long learning processes of methodologies and processes, engagement in collaboration can broaden the scope and connect subtle understandings of well-educated individuals from each field. Therefore, it is important to investigate the interdisciplinary process of artscience collaboration to realize the multifaceted implications for the collaborators' knowledge and skills. At the same time, this process can have impressive by-products or lead to enlightening outcomes. This process is thus important, as there is no definite answer as to what the artistic or aesthetic experience does to the recipients, but there are

many processes that can take place and are important to consider for evaluating the impact of the encounters with art and artists (Belfiore and Bennett 2007).

The fragmented understanding of the effects of the engagement with art is based on cognitive, psychological, and sociocultural dynamics. Bringing together a few of them to create a more comprehensive understanding of the artscience collaboration process is the major contribution of this book. First things first though: for starters, a little bit of clarification of terminologies is needed, and, moreover, these recent years are not the first time that these artscience attempts have been made since the Renaissance and on which current collaborations build. Thus, a brief overview of the major developments of the twentieth century will be given in the remainder of this chapter.

1.1 First Things First

Artists and scientists are creative in their work; they produce knowledge and create exciting artworks. They have different workflows, are concerned with different practical issues in their work, and approach bigger problems from their own perspective. However, artists and scientists are often concerned with similar topics: some focus on environmental issues—such as climate change—or societal issues, while others are interested in technologies; secrets of the universe are as fascinating to artists as they are to scientists. Although there is this call for new Leonardos and people who are able to engage across the fields, as we saw in the case of Filippo Brunelleschi, often it is important to take a step outside the own professional field and look into other fields to create something new that is relevant for art, science, and society. In our society, where art and the scientific disciplines create deep knowledge that often relies on previous training in different disciplines or mastering very specific technologies, if an artist or a scientist wants to draw from other disciplines and go beyond superficial knowledge or rough application of methods, the most interesting way to learn and implement new skills is to collaborate.

This is where artscience collaboration starts: basically, it refers to a process where artists and scientists work together on a project or relevant research question. These projects can aim to produce a joint outcome, like an interesting artwork, or to work with a scientific idea. Further reasons why artists or scientists or even their employers are interested in doing so can be manifold: artists have their artistic goals and scientists their scientific goals; organizations even have additional goals like human resource development, project development, or cultural change. Nevertheless, the basic idea is that the artist

and the scientist collaborate and bring together their ideas and skills; thereby, they are tackling bigger problems or research questions they are interested in. The duration can be quite variable: some are short-term projects of a few weeks, other are projects that go on over half a year or up to several years. Such long-term collaborations allow the partners to develop project ideas and realize them. Sometimes, based on the experience of specific projects, artists and scientists develop an ongoing working relationship.

The intensity of the collaboration can differ. For example, some corporate and scientific institutions invite artists to stay at their facilities for a certain amount of time to produce an artwork or to get inspired by the scientific work being done there. This does not necessarily imply that one artist and one scientist or a scientific group will work together intensely on a specific project, but it can mean that the artist invites scientists to discuss and contribute to certain phases of their work. All different types of intensities of collaboration can add value to the work of artists, scientists, and organizations, but they can lead to different kinds of outcomes.[1] Intense collaborations are more likely to bring new insights or personal development processes to all participants, whereas less intense processes, for example, can affect motivation and networking opportunities or lead to smaller learning processes. How the interaction affects artists, scientists, and organizations is much dependent on the situation, personalities, and organizational cultures involved. Nevertheless, knowledge about the aspects of the collaboration process can help to frame the interaction in a more detailed way toward the needs of artists, scientists, and organizations.

Artist-in-residence programs are a more formalized opportunity to realize artscience collaboration within organizational structures. These programs provide artists with the opportunity to work at a scientific organization or to stay at an organization where they can work and collaborate with scientists. The formal structure of the "artist-in-residence" program says nothing about the intensity of the artscience collaboration or about the length of the interaction. Nevertheless, residencies are often longer than two months. Most programs that allow for shorter stays call these "visits" instead of residencies. To qualify as a program, these formats offer regular opportunities for artists. These residencies imply that the artists stay at the scientific organization over a certain amount of time for collaboration. Some programs have a clear focus on the collaboration process or artistic intervention in the scientific process; others offer these

[1] For example, Jack Ox (2014) relates different kinds of outcomes like visualization of scientific work or highly interesting artscience projects for different kinds of intensities of the collaboration process.

residencies to create new art pieces that are based on these new experiences and collaboration processes. Some programs include the opportunity for commissioned artworks based on the experience during the residency.

In contrast to the growing number of artist-in-residence programs offered at scientific organizations or by cultural organizations in collaboration with scientific organizations, there are rarely scientist-in-residence opportunities. There are several reasons for this. For scientists of many STEM[2] disciplines it is difficult to work for a few months in an artistic environment without access to scientific facilities. Moreover, within a scientific career path, it is often difficult to spend a sabbatical outside for personal development and learning processes that do not immediately contribute to scientific outcome which can be published and is important for future funding and positions.

Another term that is more and more often used is "arts-based initiatives," sometimes also called "artistic interventions." These terms more generally point to initiatives that bring art into organizational contexts, mainly to reach an organizational aim. The term arts-based initiative is perceived as more neutral than artistic intervention. Artistic intervention rather implies an active role of art or artists to initiate change in the environment in which they are invited. Intervention is sometimes used to indicate a disruptive character of art in scientific or corporate organizations. These terminologies refer to the difference of the fields and the foreign character of artistic processes and perspectives to scientific or corporate ones. Hence, the words "encounter" and "collision" of art and science are often used.

Additionally, "artscientist" is another term that emerged in the last decade. It was introduced to label those individuals who draw from their own experience in art and science for their own professional work (Edwards 2008). The artscientist refers to the importance of getting experience in diverse scientific and artistic fields to gain new perspectives that help to obtain new insights in the own profession. This is strongly connected to ideas of the importance of including art in education, which were made prominent by John Dewey (1934) in the first half of the twentieth century. Moreover, artistic approaches inspire to walk across disciplinary borders or go beyond traditional approaches, as, for example, Thomas Kuhn shows in *The Structure of Scientific Revolutions* (Taylor 2014; Bijvoet 1997). This is an important argument of the "STEM to STEAM[3] movement" pointing to the importance of art in STEM education. Advocates of STEM to STEAM argue

[2] STEM refers to disciplines from Science, Technology, Engineering, and Mathematics.
[3] STEAM refers to Science, Technology, Engineering, Art, and Mathematics.

that the inclusion of art helps STEM professionals to broaden their knowledge and skill base, create the capability of drawing connections between different fields, improve the perception of complex situations, or gain new perspectives on difficult issues. Similar effects are observed in scientists who start to engage in artscience collaboration.

1.2 Tracking ArtScience Collaboration

The idea to see an equivalence between artists and scientists exploring the edges of knowledge in an interdisciplinary no-man's-land and the power of the creative capacities of artists, inventors, and scientists of the Renaissance is not emerging for the first time now at the beginning of the twenty-first century. The idea to break the boundaries between these two distinct fields of creation and interrogation of reality has been explored several times to date. Most prominently, the creative explorations of artists, engineers, and computer scientists in the mid-twentieth century have already been compared to those of influential artists and inventors like Leonardo da Vinci (Taylor 2014). Ideas of conceptual art and the art and technology movement (Shanken 2002), groups of artists connected to the Fluxus circles or kinetic art, and the origins of computer art as important in the 1950s and 1960s are exemplary for this time. In these exciting years of an artistic, scientific, and technological sense of "get-up-and-go," the time was ripe to explore new ways of working with new technologies and artistic production. Connected to many of these experiments, various interdisciplinary and transdisciplinary scientific fields evolved, such as computer graphics, computer visualization, and diverse streams within media art (Van Dijck 2003).

Although many of these ideas were developed around the same time, exploring possibilities of art, technology, and science was—like today—not a movement with a uniform set of ideas on how and why to create interdisciplinary collaboration (Taylor 2014). Philosophers, practitioners, and theorists at this time started to point to the possible effects of interdisciplinary collaboration in arts and sciences. Starting from the influential writings of Norbert Wiener, Herbert Marshall McLuhan and R. Buckminster Fuller's thoughts on general system theory and cybernetics reached the art world. Especially McLuhan's work *Understanding Media* (1964) was well received by artists who were interested in new technologies (Bijvoet 1997) and inspired art theorists to include system theory and cybernetics in their ideas about art (see a selection of publications collected in Topper and Holloway 1980, 1985). As an important contribution to the discussion, Susan Sontag introduced a

discussion about possible congruencies and differences between art and sciences and technology. In *One Culture and New Sensibility* (1967) and *Against Interpretation* (1967), she explained the artistic experimentation in other fields as a transformation of the function of art through a new cultural and social sensibility. She pointed to the exploration of the boundaries of art as reflection of a change in social life and culture, where fields like art and technology start to move closer and change each other.

In the mid-twentieth century, scientific and technological laboratories started to see opportunities in opening up their ways of working in order to create exchange and explore possibilities with the tools and the ideas they created. For example, after the success of the Radar Laboratory's interdisciplinary research group activities, the first interdisciplinary research laboratory at the Massachusetts Institute of Technology (MIT), the Research Laboratory of Electronics, was founded in 1952. Finally, in 1967, the Center for Advanced Visual Studies (CAVS) was founded at MIT that included artistic perspectives. MIT has remained an important player in this field up until today and strengthened its position with the foundation of the MIT Media Lab in 1985 (Bijvoet 1997), which is today still leading in the field of artscience.

From this fruitful environment sprang many different initiatives, and influential artists and scientists developed ideas that laid the foundation for growing interdisciplinary fields like computer graphics, and ideas were developed which are now reflected in the growing field of artscience. For example, influenced by the ideas of Bauhaus and Constructivism, György Kepes started to integrate visual arts with the visual idioms of the daily environment and to connect the languages of different disciplines and distinct ways of visual communication, like photography, motion pictures, and television, in his book *The Language of Vision* (1944). In the late 1960s, artist and physicist Bern Porter coined the term SciArt, referring to a field that includes artistic and scientific approaches (Porter 1971 as in Sleigh and Craske 2017).

Artists sought new content and media and had a desire to participate in this emerging outside the realm of the arts. Artists exploring the boundaries of traditional media and approaches went in different directions: for example, Jasia Reichardt, who organized the path-breaking exhibition *Cybernetic Serendipity* in 1970[4] in London, an exhibition about works on cybernetics—the control and communication in the animal and machine in order to explore the relationships between technology and creativity; or Jack Burnham, who

[4] *Cybernetic Serendipity. The Computer and the Arts.* (1968) Edited by Jasia Reichardt. London: Institute of Contemporary Art, New York/Washington/London: Praeger Publishers.

created the exhibition *Software* in 1970[5] in New York with a focus on information processes and showing creative possibilities of computer-based art. Individuals on the edge of computer science and graphics explored computer art with a more exploratory approach instead of the ideological and societal goals that the Fluxus circles had in mind in their ways to cross disciplinary boundaries (Taylor 2014). These prevalent ideas of crossing discipinary boundaries and the growing accessibility of computers, technologies, and software in the 1960s allowed a movement to develop where artists started to explore these new media.

Most important for the development of formats for artists, engineers, and scientists to collaborate were the foundation of the Experiments in Art and Technology (E.A.T.) at the AT&T Bell Telephone Laboratories, initiated by Billy Klüver, and the artist-in-residence program at the Los Angeles County Museum of Art, called the Art and Technology Program, initiated by Maurice Tuchman in 1967. Both programs had a major impact on bringing artists into the new environment of scientific, technological, and corporate organizations and explored the potential of collaborations. "The idea was that a one to one collaboration could produce something that neither of the two could individually foresee. And that was the basis for the whole thing, and the system developed from there," as Klüver states about E.A.T. (Candy and Edmonds 2002: 8). The outcomes ranged from artworks based on the most recent technologies, to artistic exploration of the use of such technologies, to reflections of aspects prevalent in the organizations or the organizational sites. Both programs were recognized within the artistic and the scientific community, also because important artists, scientists, and well-known organizations like AT&T Bell Telephone Laboratories and the Los Angeles County Museum of Art were involved. At E.A.T., personalities like Billy Klüver, Fred Waldhauer, Robert Rauschenberg, and Robert Whitman were involved (Patterson 2015). The Art and Technology Program in Los Angeles invited artists like Victor Vasarely, Roy Lichtenstein, and Andy Warhol to be hosted in organizations like IBM, Universal Film Studios, and Hewlett Packard. The program invited Richard Feynman as consultant, who was working at CalTech at this time.

Prominently positioned in the journal *IEEE Spectrum*, Nilo Lindgren contributed two articles on art and technology as a "call for collaboration" (1969a, b). Based on experiences and the work coming out of the newly funded initiatives, he asks about the roles of artists and engineers in the collaboration process and how engineers could profit from such a collaboration.

[5] *Software, Information Technology: Its Meaning for Art.* (1970) Curated by Jack Burnham. New York: Jewish Museum.

He sees potential in changing traditional ways of working in art, technology, and science to create new forms of projects. This is interesting because at that time the artistic profession was not so open for collaboration.

Another initiative that focused more on the changing power of the arts was the Artist Placement Group (APG), founded in London in 1966. Influenced by the ideas of the Fluxus movement, the artists John Latham and Barbara Steveni created an artist-in-residence program in industrial and governmental organizations. These placements of artists in organizational settings aimed at triggering change in workflows and organizational culture, or creating new ideas. Although the idea is close to the initiatives in the USA, the lack of regulation of the collaboration and the often-missing artistic output led to questioning of the program's effectiveness and the funding ceased.

In the 1970s, many of these initiatives started to disappear from a broader discussion, sometimes because of the lack of funding, sometimes because it was still difficult for scientific fields, the artistic community, and corporate organizations to understand and evaluate the outcomes of these collaborations. These experimental settings led to many developments in computer arts, new streams of media art, and new forms of hybrid scientific fields like computer graphics and visualization. Nevertheless, outcomes based on, for example, the exploration of upcoming technologies like plotters, cameras, or audio recordings were difficult to evaluate at the time of their first presentation (Van Dijck 2003; Taylor 2014; Patterson 2015). Only retrospectively in the last few decades have the value and possible utilization of these developments been more broadly understood.

One medium that went on connecting the discussions and developments in the fields of art, science, and technology was the journal *Leonardo*. In 1968, Frank J. Malina founded *Leonardo* with a focus on contemporary art as a platform for communication between artists. From the beginning, Malina, himself a pioneer in light and motion art, thought it was important to display a wide range of topics that might be interesting for artists, and thus the journal would give space for insights from fields like physics and psychology, but also from philosophy, aesthetics, and artistic fields like theater, cinema, and architecture. He was convinced that artists need to communicate about the use of new scientific developments, techniques, and technologies. This created a platform for interdisciplinary fields that otherwise often operated in no-man's-land, where neither artistic nor scientific or technological outcome was difficult to publish and reflect upon in its respective field. In 1981 Roger F. Malina became executive editor and has been an important agent in pushing the field of art and science ever since. He pushed

toward widening the scope of influence with fields like language, performance, music, media, and environmental and conceptual art. Moreover, he wanted to open up the journal to legal, political, and economic aspects. In his later editorials, Malina identifies how media arts could at the time address contemporary needs of society and problems of contemporary scientific practice (Malina 2012). He is arguing for art and science collaboration and interdisciplinary exchange through a shared language, which is important to build a common ground (Malina 2011). The International Society for the Arts, Sciences and Technology (ISAST) was founded with the support of the two founding board members Frank Oppenheimer and Robert Maxwell in 1982 as a network of artists, scientists, and engineers. *Leonardo* became the official publication platform and the journal changed its subtitle, now being called *Leonardo: Journal for the International Society for the Arts, Sciences and Technology.*

The second early founded platform for exchange of ideas that opens the discussion to a wider audience is Ars Electronica, a new media art festival focusing on the nexus of art and technology and including its societal impact. Based in Linz, Austria, the festival was established in 1979. After most of the initial programs had already ceased, this festival provided a place to meet, to present work, and to exchange new ideas.

An important reference point for recent artscience programs in organizations is Xerox PARC's (Palo Alto Research Center) Artist-in-Residence Program (PAIR). The program was initiated by Rich Gold in 1993, supported by John Seely Brown, chief scientist at Xerox and responsible for PARC (Harris 1999). The idea of PAIR was a step in applying the founding idea of the laboratory. The initial idea of the research laboratory Xerox PARC was to connect people from interdisciplinary backgrounds in order to create a conglomerate that is able to build new technologies including hardware and software from the basic idea up to the final product. The open culture of this research laboratory invited future users and possible customers into the lab to collaborate with the employees on questions concerning usability and basic needs, and give feedback to existing products and prototypes. Through PAIR, artists could be included in this community and work collaboratively with scientists, researchers, and engineers on new ideas. The idea behind that was to use this shared knowledge between artists and scientists (on media, methods, or specific questions) as a starting point for collaborative exploration and creation of ideas. In recent years, this program has become a role model for many programs at corporations and scientific organizations because the organization, scientists, and contributing artists saw a lot of value in these collaborations, which were extensively published.

The interest in such initiatives came back in the last decade, and the potential to push borders in art, science, and corporate situations has been rediscovered. Lately, corporate programs, artist-in-residence programs in scientific organizations or within publicly funded scientific projects, and academic opportunities for artists and scientists to cross the borders of their fields have been growing rapidly. The interest in artscience collaboration and its possible effects—like the game-changing experiments at Bell Labs in the 1960s, the development of computer graphics that started out as an exploration in a no-man's-land, or the seminal residencies at Xerox PARC—is growing rapidly. The Swiss Artists-in-Labs program was started in 2003 to bring artists into scientific laboratories. A growing number of scientific and cultural organizations like laboratories, galleries, and departments at universities support artscience centers and provide opportunities for exchange between students from artistic and scientific faculties. Influential role models for these centers are SymbioticA at the University of Western Australia and the Art|Sci Center at the University of California, Los Angeles (UCLA) for universities all over the world. These centers bring together scientists, artists, and students from artistic and scientific faculties. An important outreach and communication role is played by Science Gallery, which started out at Trinity College Dublin. It is now a constantly growing worldwide network of Science Galleries connected to universities. What these centers have in to common is their focus on the process and the idea that right where art and science collide, the lust for exploration and groundbreaking twists in thinking can be ignited.

But what makes the artscience collaboration process so special? And what are the necessary preconditions to create a fertile ground for this extraordinary exchange? As it is important to understand the process first, the next few chapters will focus on artscience collaboration. Based on this knowledge, the last part will discuss practical issues of bringing artscience collaboration to life.

References

Belfiore, E., & Bennett, O. (2007). Determinants of Impact: Towards a Better Understanding of Encounters with the Arts. *Cultural Trends, 16*(3), 225–275.

Bijvoet, M. (1997). *Art as Inquiry. Toward New Collaborations Between Art, Science, and Technology*. New York: Peter Lang.

Candy, L., & Edmonds, E. (2002). *Explorations in Art and Technology*. Berlin: Springer.

Dewey, J. (1934). *Art as Experience*. New York: Minton, Balch & Company.

Edwards, D. (2008). *Artscience: Creativity in the Post-Google Generation*. Cambridge: Harvard University Press.

Harris, C. (1999). *Art and Innovation. The Xerox PARC Artist-in-Residence Program*. Cambridge: MIT Press.

Kemp, M. (2016). *Structural Intuitions. Seeing Shapes in Art and Science*. Charlottesville/London: University of Virginia Press.

Lindgren, N. (1969a). Art and Technology I – Steps Toward a New Synergism. *IEEE Spectrum, 6,* 59–68.

Lindgren, N. (1969b). Art and Technology II – A Call for Collaborations. *IEEE Spectrum, 6,* 46–56.

Malina, R. (2011). Non-Euclidian Translation: Crossing the River Delta from the Arts to the Sciences and Back Again. *Leonardo Reviews Quarterly, 1*(3), 6–8.

Malina, R. (2012). Is Art-Science Hogwash?: A Rebuttal to Jean-Marc Levy Leblond. *Leonardo, 39*(1), 66–67.

Ox, J. (2014). Art-Science Is a Conceptual Blend. *Leonardo, 47*(5), 424.

Patterson, Z. (2015). *Peripheral Vision: Bell Labs, the S-C 4020, and the Origins of Computer Art*. Cambridge, MA: MIT Press.

Root-Bernstein, R., Pathak, A., & Root-Bernstein, M. (2017). Review of Studies Demonstrating the Effectiveness of Integrating Arts, Music, Performing, Crafts and Design into Science, Technology, Engineering, Mathematics and Medical Education. Part 1, Part 2, Part 3. *White Paper*.

Shanken, E. A. (2002). Art in the Information Age: Technology and Conceptual Art. *Leonardo, 35*(4), 433–438.

Sleigh, C., & Craske, S. (2017). Art and Science in the UK: A Brief History and Critical Reflection. *Interdisciplinary Science Reviews, 42*(2), 313–330.

Sontag, S. (1967). *Against Interpretation*. New York: Farrar, Straus, & Giroux.

Taylor, G. D. (2014). *When the Machine Made Art. The Troubled History of Computer Art*. New York: Bloomsbury.

Topper, D. R., & Holloway, J. H. (1980). Interrelationships Between the Visual Arts, Science and Technology: A Bibliography. *Leonardo, 13,* 29–33.

Topper, D. R., & Holloway, J. H. (1985). Interrelationships of the Arts, Sciences and Technology: A Bibliographic Update. *Leonardo, 18*(3), 197–200.

Van Dijck, J. (2003). After the "Two Cultures": Toward a "(Multi)cultural" Practice of Science Communication. *Science Communication, 25*(2), 177–190.

Part I

Perspectives on the ArtScience Collaboration Process

It is important to give space and time to the artscience collaboration process. Only through deep engagement in this extraordinary interdisciplinary process that is demanding for artists, scientists, and organizations can truly groundbreaking ideas follow. These are based on personal development, creation of new knowledge, game-changing experiences, or new connections that are made, connections with other people, or connections between different fields. The theoretical perspectives on artscience collaboration and the cases presented aim at creating awareness of the intensity of the process and the importance of seriously engaging in the process in order to allow all these desired effects to emerge. By understanding the process, it is easier for artists and scientists to get involved in artscience collaboration, and it helps managers and curators to create enough space for the projects to happen and to guide artists and scientists through the process.

The theoretical perspectives presented in the following chapters are as follows: interdisciplinary collaboration and development, contextualization, liminality, social network theory, sensemaking, aesthetics, communication, and creativity theory. The chapter on interdisciplinary collaboration creates a basic understanding of such collaboration, its goals and processes, for example, specific ways to raise questions and trigger learning. The theory of contextualization presents how artscience collaboration helps artists and scientists to gain a broader perspective on their work and relate it to stakeholder groups or the work of other scientific disciplines. This additionally points to two ideas: first, how artscience projects can support ethical reflections and, second, how

they can help the actors to find meaning in their work again. The theory of liminality deals with the idea of artscience collaboration as creating space for exploration, experimentation, and play and enabling changes. Next, with the theory of social networks, the potential of the new connections initiated by artscience projects within organizations and between different fields is explored. Going on to a more cognitive change, the chapter on sensemaking explores how the collision of art and science affects sensemaking processes and potentially leads to new ways of understanding. The chapter on aesthetics is closely connected to this idea: aesthetic knowledge, embodied processes, and sensory perception in the experience of artscience collaboration are explored as potential for new insights and learning processes. The chapter on communication explores how artscience projects can affect communication skills and add new ways of communication, and how artscience projects are intertwined with outreach and public engagement. Finally, creativity theory is explored. This chapter shows how all the other aspects of the artscience collaboration process influence the emergence of creativity and how intense and multilayered the process of fostering creativity is.

2

Interdisciplinary Collaboration

Laying down the theoretical foundations of artscience collaboration, it is first necessary to define collaboration. Most scholars agree that collaboration is a well-defined relationship between two or more parties (organizations or individuals) that is mutually beneficial. The involved parties co-develop structures and strategies, are committed to a common goal, share responsibility, have mutual authority and accountability for success, and thus share outcomes and rewards (Mattessich and Monsey 1992). Interdisciplinary collaboration can be understood as the coordinated relationship between two or more parties who are trained in different disciplines to reach a shared goal. These collaborations can be designed more instrumentally and aim at solving a shared goal by contributing different skills and knowledge sets, but they can be more conceptual and aim at the development of a joint field that involves practices and knowledge from the respective fields of the partners.

Complexity of tasks calls for collaboration to reach goals and to solve problems because obviously the professions and scientific disciplines have reached a certain amount of knowledge and depth that is difficult to understand without extensive education and experience. Interdisciplinary and transdisciplinary collaboration between academics and practitioners has been advocated and researched by social scientists for a few decades (e.g., Klein 1990, 2008). The most prominent examples of problems that need to be tackled collaboratively are sustainability, climate change, changes in society driven by new technologies, and the threat of evolving diseases. Approaching these issues needs expert knowledge from many different fields and experimental approaches to find possible solutions (Falk-Krzesinski et al. 2011; Popescu 2014). The contribution to a specific problem or the development of an

interdisciplinary field can include different kinds of expert knowledge, methods, ways to work (e.g., analytical approaches vs. synthetic approaches), new perspectives on an issue, diverging interpretations of the issue, and awareness of the weak areas of one's field (Amey and Brown 2004).

Although collaborations, especially interdisciplinary collaboration, are intense, take time to establish structures, and thus take time to deliver, they have to be seen as an investment: beyond completion of the set goal, each collaborator can develop new competencies. A reflection of different paradigms in the fields and contradictions can help to understand the blind spot in the own discipline or methods, which helps to focus on these areas to build up new competencies. At the same time this reflection helps to better understand the strengths of the own disciplinary perspectives and to acknowledge the importance of interdisciplinary exchange (Amey and Brown 2004). Interdisciplinary collaborations can be confrontational, as issues appear different seen from diverse disciplinary perspectives. This is important to understand and explore in a common procedure. A successful collaboration can be reached through trust and mutual respect, a shared vision, flexibility, and enough time allocated to the interaction, as well as open, honest, and respectful communication (Mattessich and Monsey 1992).

Such successful collaboration between two or more interdisciplinary collaborating partners who have shared goals or interests can be short term and focus on one project, or it can develop into a long-term relationship of fruitful exchange. In the case of artscience collaboration the professional education is probably farther apart than between different academic disciplines. This makes artscience collaboration difficult to manage because artistic goals and scientific goals are bound to different paradigms: a good artwork that contributes to the artistic realm is not the same as an impactful scientific outcome. Nevertheless, artists and scientists are often interested in the same issues, materials, and media, and thus such collaboration has huge transformative potential: there is great potential for gaining new insights, applying new methods and perspectives, and creating new research and artistic agendas.

The following case shows the possible impact of the collaboration of artists and scientists at the intersection of their interests by employing the same media and methods. In this case, artists can learn from laboratory practices to develop an understanding of the scientific process and, at the same time, they can ask important questions that lead to new interpretations of methods or media. Moreover, artistic interest in the scientific work and media can open up new opportunities for scientists to explore new projects. Sometimes, just as in the following case, the artistic and scientific questions asked can even trigger entrepreneurial interest. It is important to note that the original

artscience collaboration did not have any instrumental character to create an economically valuable outcome, but the openness of the process and the highly important questions asked by artists and scientists inspired entrepreneurial ideas.

Case: The Tissue Culture & Art Experiment—About Art and a Laboratory Fridge Equaling Artificially Grown Meat and Leather
The artists Oron Catts and Ionat Zurr started the "The Tissue Culture & Art Project" (TC&A) in 1996 as an ongoing research and development project on the use of tissue technologies as a medium for artistic expression. The artworks they realized throughout the last few decades revolve around important questions from the ethical exploration of artificially produced meat to misconceptions in the public that the genetic code equals life and that life is information. These big topics that the TC&A raises are connected to a fundamental mechanism of art: art generates questions, poses ideas, and leads to reflections instead of giving answers and reaching solutions (which the task of design is, e.g., industrial design).

Early in his thesis on speculative design within the study of design, Oron Catts realized for himself that he is much more interested in posing these important questions than in finding solutions to given problems—which can never be final solutions. In this way he approached tissue engineering, which was in art as well as in science still an open field to explore, as there were only few artists and scientists working on the topic. After initial research in the field, artists and scientists started to point the duo (Cats and Zurr) to scientists who were already interested in the topic of tissue engineering, and finally, there was an opportunity for funding where they could work collaboratively in the lab. It was important for them to be funded in order to have an equal and justified position in the lab without being dependent on the goodwill of individuals. Finally, in 1999, they were able to receive funding for their artscience research laboratory SymbioticA at the University of Western Australia, which was founded in 2000. In the same year they had the opportunity to move to the Harvard Medical School for a year as research fellows. As research fellows they were full members of the team and were included in all obligatory activities like lab meetings. A scientific colleague of theirs was doing tissue engineering using muscles, growing them from fetal cells, where she looked at satellite cells. Although she needed a limited number of cells, she could not throw away the excess muscle cells, which were filling up all fridges. For the two artists it seemed to be an obvious next step to take these cells and grow meat. Presenting their research in the lab meeting, the head of

the group mentioned, "this is not art, this is business," although the artists' quest was not to find a scientific solution, but to raise questions about the relationship of us as humans with meat, something that we eat, and how it is produced. The artists managed to grow a piece of meat in 2000, but as the lab was a biomedical lab and they shared equipment with other research projects, they were not allowed to eat it. Nevertheless, it triggered questions and ideas about many such instances in the scientific laboratory and reached the wider public through an article in *The Washington Post* in 2000.

In 2000, the artists met Jens Hauser, who was curating a show in France for which he wanted them to grow meat. The artists managed the timing of the show in such a way that they would not be university employees at that time and thus would be able to realize their artistic vision without compromising it due to scientific regulations and ethical board decisions to which they would have been bound in their employment status as "researchers" at the university. Again, touching on the human relation to food, they grew frog meat for the show in France, which was then was cooked, served, and eaten in a performative show. The artwork drew the attention of journalists and generated enough noise in the media to stir the interest of Jason Matheny, who approached the artists and told them their work was so inspiring to him that he started the nonprofit organization New Harvest, which is now leading research on the production of in-vitro meat (Figs. 2.1 and 2.2).

The scientific community in 2005 papers started to cite the work of TC&A at the Harvard Medical School as the first experiment that was successful in

Fig. 2.1 *Tissue Engineered Steak No. 1* 2000, a study for *Disembodied Cuisine* by The Tissue Culture & Art (Oron Catts, Ionat Zurr & Guy Ben-Ary). Prenatal sheep skeletal muscle and degradable polyglycolic acid polymer scaffold. This was the first attempt to use tissue engineering for meat production without the need to slaughter animals. (Image courtesy: TC&A, hosted at SymbioticA, School of Human Sciences, University of Western Australia)

Fig. 2.2 *Disembodied Cuisine* installation by The Tissue Culture & Art (Oron Catts, Ionat Zurr & Guy Ben-Ary) 2003, mixed media, photography by Axel Heise. (Image courtesy: TC&A, hosted at SymbioticA, School of Human Sciences, University of Western Australia)

growing in-vitro meat. Since then, many research initiatives have been started in the field, where scientists try to find their approach to the topic. In the meantime, the artists go on posing new questions, raising ethical issues and questioning processes in the production of in-vitro meat and leather, like in *Victimless Leather* (2004). The artists do not want to take credit for the invention of in-vitro meat or leather, but in collaboration with scientists, by learning scientific techniques and through their exploration of the scientific work, they were able to push scientific and artistic boundaries—using tissue engineering in art and creating awareness of the possibilities in science, raising ethical questions, and even inspiring corporate startup ideas—and they offer this as a starting point for cultural discussion of important topics (Fig. 2.3).

Some argue that artistic processes and scientific processes are fundamentally different. Although artists and scientists are creative in their work, and each scientist and each artist has their individual work process, they do have different audiences in mind and are trained differently in approaching their ideas. Scientists and engineers are trained to efficiently solve a specific problem by first asking a big question, then dividing it into different parts or fields,

Fig. 2.3 *Victimless Leather—a prototype of stitch-less jacket grown in a techno-scientific "body"* by The Tissue Culture & Art (Oron Catts and Ionat Zurr) 2004, biodegradable polymer skin and bone cells from human and mouse. (Image courtesy: TC&A, hosted at SymbioticA, School of Human Sciences, University of Western Australia)

going down to the smallest possible units and attacking them step by step. The exchange they have in mind is either new knowledge that can be shared with peers on professional platforms like journals and conferences, or a functioning device. When the first problem is solved, the next very specific question comes up and has to be solved. As scientists and engineers frequently reported in the interviews for this book, "And when we are down there, we

put our blinkers on and we can't see outside that problem." Between these very detailed questions, scientists and engineers also reported that, unfortunately, it is frequently the case that there is no time to step back and see the bigger picture. Artists, on the other hand, are trained to approach questions in a more synthetic way in order to develop the fundament for their artwork. From a very specific idea, feeling, or situation they start their journey to the bigger picture: it becomes a universe in itself. Only then do they start to realize their artwork. This is what can be seen very clearly in the case shown above. Artists and scientists had different approaches: the scientist was collecting the living cells that were produced in an experiment, staying focused on the project goal. The artists, on the other hand, saw this growing collection and started to think about what they could do with it and how to make an artistic statement. The artistic statement itself did not imply ideas like feeding the world in a new way or any corporate interests. Nevertheless, it raised many scientific questions and hopes that led to further scientific and entrepreneurial exploration. This is close to how the artist Lucy McRae expresses what is fundamental to her work on pushing boundaries of art, science, and technology and understanding the future of humankind: "Art does not give immediate answers, it provides conditions of possibility." Therefore, artscience collaboration can add a whole new dimension to the pressing issues of a time.

2.1 Interdisciplinary Project Realization and Disciplinary Development

In artscience collaboration projects artists are included as experts in their own right: artists are experts in artistic processes and are skillful in their media, like sound, language, or visual expression, whereas scientists have deep knowledge in their field and master their methods. Artscience collaboration can bring together the expertise of artists and scientists to reach a shared goal or develop a project that needs the skills of artists and scientists to be realized. Such collaborative work can be important at the intersection of artistic and scientific disciplines, like in computer music or visualization strategies. Moreover, the contribution of artists to any scientific or development project in organizations has been acknowledged by organizational scholars and practitioners throughout the last few years (a first overview can be found in Barry and Meisiek (2010); since then many more reviews of effects arts in organizations have been published). These reflections of artistic contributions to development teams point to the aesthetic skills of artists that can help to bridge gaps

in conversations by explanations using artistic media (visualization, sculptures, sound, rapid prototyping), discover blind spots in the project team's perspective because artists have a different approach to the topic, or bring in new conceptual and practical knowledge.

Additionally, experiments in art and science or art and upcoming technologies can help to develop new fields at their intersection. Similar to the experiments by artists, scientists, and engineers in the 1960s and 1970s, the outcome of these artistic and technological explorations can help to create new hybrid fields or push the boundaries of existing ones. Examples are the developments made during this time in the fields of computer art, computer graphics, and computer vision (Taylor 2014).

The following case shows a recent example of both, pushing the boundaries of an upcoming artistic field and artscience collaboration to develop a specific technological outcome based on scientific and artistic work.

2.1.1 Tracy Redhead, Florian Thalmann, and the Semantic Player

The composer, musician, researcher, and interactive music producer Tracy Redhead had been invited to join the group of computer scientists and engineers working on the Fusing Audio and Semantic Technologies for Intelligent Music Production and Consumption (FAST) project at Queen Mary University, London. The FAST project is a collaborative project of academic and industrial partners on fusing audio and semantic technologies for intelligent music production and consumption. The collaboration of computer scientists, in various fields like computational perception and mixed reality research, engineers, and developers, aims at creating technologies for music consumption and production that will be used to create music and to consume music. During an invited talk the artist presented her understanding of dynamic music[1] production and, based on her practical artistic experience, the importance of the development of such systems and technical tools for the practice of music production. Prior to her talk, the artist worked on dynamic music production for musicians and on projects on music as participatory art form where the

[1] Dynamic music is a term used to describe music composed for games and interactive art. It refers to a number of techniques and approaches where music is changed by some control input or data mapping. Dynamic music includes many forms and approaches, including nonlinear, fluid forms, adaptive music, generative music, and interactive music. It should be noted that the term "dynamic music" incorporates all of these different approaches. In the collaborative work of Tracy Redhead and Florian Thalmann the term "nonlinear" refers to music in which there is no timeline or fixed structure and arrangement. It is a term used mostly in gaming composition (definition by Tracy Redhead and Florian Thalmann).

audience can interact with the music. Due to the overlaps of the artist's and the scientists' experiences and goals, the team at Queen Mary University decided to invite Tracy Redhead as collaborating partner on the development of one exemplary technological tool: the semantic player.

The initial idea for the semantic player was that the music pieces it played never sounded exactly the same each time. The idea was based in artificial intelligence functionalities and first only focused on autonomously changing music. Over the period of the project, the semantic player should be able to create dynamic music autonomously, but also adaptively and interactively, depending on the parameters the composers use to create their dynamic music. As the semantic player is developed as an app for mobile phones, interactivity thereby means that the listener can influence the music, for example, by moving the mobile phone in the three dimensions of a room as the app reads the sensors of the phone and calculates the changes in the music. Adaptivity means changing the music to contextual factors which the owner of the phone cannot immediately influence, like location (e.g., city, mountain, at sea level), temperature, weather, or time of day, instead of reproducing a fixed and unchangeable recording. Thus, for example, tempo, mood, and other stylistic parameters of the music can change according to the situation, which is measured through the input of sensors of the device on which the application is installed.

The main scientific collaborating partner is computer scientist Florian Thalmann, PhD, with a background in music theory and playing musical instruments focused on the development of the semantic player since its inception. Before the collaboration with Tracy Redhead, Florian Thalmann played the roles of the scientist and the artist by building the system and defining artistic needs for working with the system. But the technical and scientific work limited the time and creativity in the artistic approach to the topic. Florian was able to develop it bit by bit, but based on the collaboration with the artist—later a second composer joined, and even more collaborating partners are planned—the possibilities grew beyond his own perspective. Moreover, the collaboration with musicians is fun and musically inspiring for the computer scientist working on the intersection of music and computer science.

The system of the semantic player is built on music theory and knowledge of a certain set of music, but the art of music is a living kaleidoscope of newly emerging structures and ideas. Thus, a well-defined set of music and music theoretical input never can involve all possible special requirements of such a system. As he is a part-time musician, Florian Thalmann thought about what he would want to do with the semantic player, but biased by his technical work

and with a specific musical perspective, he could not invent all possible musical approaches. In the collaboration with Tracy Redhead, he mentioned, she had had some very specific compositional requirements of the semantic player that led to a restructuring of the underlying system in order to translate her ideas into music. This restructuring process helped to evolve the semantic player, which will be an ongoing process over a few years. Beyond these compositional requirements to the system, the artist helped to push the technical requirements. In a system that integrates not only playing the audio, but also changing the audio at certain demands, sometimes autonomously without predictable measurements, this is a difficult and important aspect of the development. As scientist, Florian Thalmann neither had the time to compose longer samples himself nor had longer samples at hand to test the system. Thus, Tracy Redhead's compositions created awareness and pushed those technical requirements that had not been addressed at that point of time, which include, for example, capacity of storage, memory, and puffer.

The collaboration went beyond its expectations as the artist and the computer scientist started to co-develop the functionality of the semantic player and uncovered issues in the design that tackle specific problems and workflows in the composition of dynamic music. For example, they explored the opportunities for storytelling and melodic ideas in the songwriting of popular music within the field of dynamic music, which has previously been nearly exclusively focused on ambient music. Additionally, they could specify the importance of an interface that helps composers to develop and test dynamic compositions. The collaboration brought practical challenges to the surface when artist and scientist were limited in their workflow to issues like limitations of software updates for compositional applications or user interface design. The collaboration explored the new fields at the intersection of music and computer science, a growing compositional field (dynamic music), while developing a specific outcome (the semantic player and compositions) that is relevant for artists, scientists, engineers, user experience designers, music producers, and many more professional groups (Fig. 2.4).

This case shows beautifully that artscience collaboration can lead to interesting artworks, scientific research, and technological development at the same time. The artist's and the scientist's visions contribute to the development of evolving fields. Additionally, this case points out some of the effects of artistic contribution to development projects which organizational researchers discussed in previous studies: fast prototyping processes, new experimental knowledge, unusual questions raised, and practical issues named that are relevant outside the scientific community by bridging the gap between specific scientific experiments and their application in real-life situations. As

Fig. 2.4 Tracy Redhead and Florian Thalmann working on the semantic player and a new composition for the semantic player. (Photography by Andrea Metzger and Florian Thalmann, edited by Jonathan Rutherford)

we will see in the following chapters, often these artists' quests in corporate or scientific institutions lead to bigger interdisciplinary collaborations that involve people from many fields and departments, who realize during these efforts that they have shared goals, but without such an extraordinary art-science project they would not have had the chance to talk to each other. Specialists are brought out of their silos and pushed to start an exchange which can be very inspiring. Still, art and science can often function as complementary approaches to problems, where the comprehensive artistic thinking and the rigorous scientific process nourish each other.

2.2 Raising Questions and Learning Processes

Trust and respectful communication are fundamental aspects of a successful collaboration. Personal commitment is important, as is the willingness to go a few extra rounds: to reflect on the ongoing process, listen to others, and invest additional time. Active listening and honest and open communication are essential skills. "Members of a collaborative must learn to listen and listen to learn" instead of listening to confirm their beliefs and to take issue with contradicting ideas (Amey and Brown 2004). A respectful collaboration allows for learning processes, an understanding of the importance of open questions,

reflection on new perspectives, newer connections complementing the own belief system, and adaption of new knowledge.

Case: Theriak—Sarah Craske Creating an Antibiotic for Cholera at the ETH Bioprocess Laboratory in Basel

During her residency at the ETH Bioprocess Laboratory in Basel, the artist Sarah Craske brought a lot of confusion and new connections into the lab. For example, she, made the scientists aware of the cultural, historical, and social contexts they were working in, and the strong connection to the local environment. Aside from this essential move, which will be presented in the next chapter, Craske wanted to connect her artistic research and artistic experimentation to the work done in the laboratory. With this, she wanted to collaborate with scientists, address some of their recent questions, and keep the scientists interested in her work, as the project directly overlapped with their interests. The basic idea consisted of the creation of an antibiotic that includes peptides[2] the scientists in the lab were working on. Therefore, one of the questions the artist decided to address was what would happen if part of the BAC7 peptide had some of its 64 amino acids removed, leaving the most optimum part of the peptide remaining and then adding a new sequence within that peptide. Two of the scientists, Dr. Irene Wüthrich and Dr. Steven Schmitt, worked with Craske on this project.

Sarah Craske started her residency at the laboratory conducting an analysis of the historical and social context of antibiotics and diseases in Basel. Going back to historical documents, Craske found out that, through the historic importance of Basel as a merchant's city, there were problems with cholera and treatment against cholera was essential. The historic documents showed that garlic was used in Basel as a natural remedy against cholera. Working with the scientists (who had prepared garlic extracts and had tested them specifically for Craske's experimentation), the artist discovered that garlic had a strong antibiotic potency (but there was potential for it to kill all bacteria—the good and the bad ones). When she and the two scientists used her bespoke peptides and introduced garlic into the assay to weaken the cell walls, the combination ensured that the cholera-producing bacterium was killed.

The artist went on experimenting and refining this methodology so that it had both a successful scientific outcome and a successful aesthetic outcome.

[2] Peptides are short chains of amino acid monomers linked by peptide bonds; they can contain about 50 or fewer amino acids.

She used a Category 2 laboratory that the scientists didn't regularly use, as it was not standard for their experiments. To everybody's surprise, the experiments that the artist proposed worked, but it seemed that they worked differently in nearly all steps than what the scientists expected: cells died when they were not expected to die, developments were seen that were not expected, even the rhythm of the experiment worked differently. And the scientists did not expect that the artist would come up with an antibiotic that worked in the end. Unfortunately, there was too little time to repeat the steps of the experiment and to note every step and outcome down in the detail necessary for scientific rigor. Nevertheless, this raised many questions to the scientists about the experiment, the method, and the fundamentals they applied to predict how the experiment worked. Unfortunately, there was no time in the research of the scientists to experiment with this different idea or the alternative research pathway afterward.

A second situation that raised important questions was when two different scientists trained the artist to do a complicated experiment (for the artist; for the scientists it is a fairly routine method) that was part of her project. When Craske was trained by the second scientist, she got confused as the steps were different than in the first training. She approached the two scientists with this issue, who obviously were not aware of the other's methods. This raised a discussion about why they did it differently, what are the effects in a project, and the possible benefits of changing the procedure. Moreover, the artist was in the position—as she had read the scientists' papers and knew about the projects—to ask questions about methods and backgrounds that the scientists would not think of or would take for granted. So, from time to time, she got the answer, "That's a very good question," followed by an examination of the underlying ideas and mechanisms (Fig. 2.5).

Openness to learning processes, mutual respect, and communication are key to allow exploration of such situations that lead to new insights. If these fundamental aspects of collaboration are taken seriously, the collaboration between artists and scientists can point to disciplinary blindness and raise questions that would not have been asked if there were only individuals from the same background: the scientists would not have tried to use a different method to reach this goal; they would have taken procedures and ideas for granted. Being open in such a situation can lead to a better understanding of the blind spots of a discipline or methodological peculiarities that can affect the outcome. Experimentation with new ideas and approaches can lead to essential developments in personal skills and add new perspectives to disciplinary approaches. Even misunderstandings in the communication between individuals from different disciplines can lead to new insights when they are

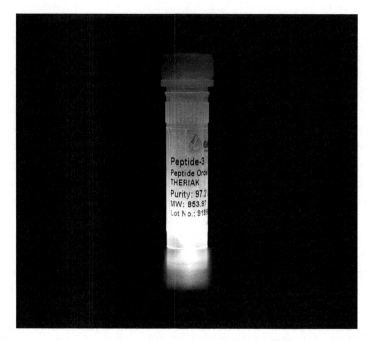

Fig. 2.5 *Theriak*, the peptide synthesized to spell the medieval cure-all within its amino acid sequence. This piece of synthetic biology was made by Sarah Craske in her experiment, 2017. In collaboration with her scientific collaborators Dr. Irene Wüthrich and Dr. Steven Schmitt, it has been used with garlic against cholera. The name theriak refers to the medieval belief that garlic is a universal remedy which was also applied as a cure for cholera. (Image credit: Sarah Craske)

reflected on and discussed. It is important to understand that without openness to learning, mutual respect, and in-depth communication, problems can arise in interdisciplinary collaboration. Otherwise, disciplinary clashes can arise, self-doubt and sabotage can disrupt the process, and instead of a mutual learning process, individuals might jump to conclusions, and change disciplines without reflection, which can lead to biased outcomes, as they may forget to apply basic knowledge of that fundamental in their primary discipline (Amey and Brown 2004).

The case of Sarah Craske at the Bioprocess Laboratory in Basel is not an exception showcasing artists pointing to blind spots or raising important questions. Similarly, the media artists Quadrature, whom I accompanied during their residency at the European Southern Observatory (ESO), were able to raise important questions to the astronomers and engineers about the basic mechanics of one of the instruments at the telescopes in Paranal. Moreover, artists like Anna Dumitriu and Natsai Audrey Chieza, who work with scientists in the field of microbiology, also report that they propose methods that

are diverging from the scientists' preferred methods. Presenting the outcome, scientists are often excited because they did not expect the methods to work. For the effectiveness of such a situation it is not important to have an immediate change in the scientist's daily routines or preferred methods, but the knowledge about different procedures to reach a desired outcome and the accompanying possible differences in the outcome can be essential in a future project or when the preferred procedure does not work out as expected.

This poses important implications for education in the fields of STEM and the professional environment of STEM practitioners. Interaction with artists can help STEM professionals to develop new skills, or the integration of arts in their educational system supports the development of important insights and new methods. For example, the integration of expressive performance courses with theater students in the education of engineers heightened the engineering students' communication and collaboration skills (e.g., Osburn and Stock 2005). Engineers and scientists acquire new methods and start to see the blind spots of their traditional education and are able to expand skills that help them to flourish in their work. For example, medical doctors are found to increase their ability to keep a bigger context of the patient's development in mind when they engage in arts training. A recent meta-study shows that the integration of art in STEM education has been studied in numerous experiments, showing that it leads to the improvement of many skills: observation, imaging, abstracting, patterning, analogizing, modeling and dimensional thinking, empathizing, playacting, bodily thinking, transforming, and synthesizing (Robert Root-Bernstein et al. 2017). But artists can also learn from scientific processes and methods: they experience scientific rigor and the importance of solving one small problem after the other in order to answer bigger questions. Artists who work with scientific materials like new technologies or microbiology gain access to more specialized knowledge and methods that are restricted to scientific laboratories.

Artscience collaboration projects can help artists, scientists, engineers, and students to develop their overall collaboration skills. Artists and scientists who experienced artscience collaboration report that they learned to engage in interdisciplinary projects and developed their collaboration skills even with fellow scientists and fellow artists. The integration of art or courses including artscience collaboration in STEM education can prepare students for interdisciplinary collaboration, as it teaches open communication, reflective interdisciplinary exchange, trust, asking important questions, looking at one's own blind spots, and acknowledging the perspectives of the other discipline. This is important for many disciplines. For example, in health and care studies, it is discussed that students have to be prepared to be proficient in

interdisciplinary collaboration when they leave university and enter professional life because their professional life will be marked by interdisciplinary collaboration (e.g., Selle et al. 2008). Detailed examples of the inclusion of artscience collaboration in academic and high-school education can be found in the following chapters.

References

Amey, M. J., & Brown, D. F. (2004). *Breaking Out of the Box: Interdisciplinary Collaboration and Faculty Work*. Greenwich: Information Age Publishing.

Barry, D., & Meisiek, S. (2010). Seeing More and Seeing Differently: Sensemaking, Mindfulness, and the Workarts. *Organization Studies, 31*(11), 1505–1530.

Falk-Krzesinski, H. J., Contractor, N., Fiore, S. M., et al. (2011). Mapping a Research Agenda for the Science of Team Science. *Research Evaluation, 20*(2), 145–158.

Klein, J. T. (1990). *Interdisciplinarity: History, Theory, and Practice*. Detroit: Wayne State University Press.

Klein, J. T. (2008). Evaluation of Interdisciplinary and Transdisciplinary Research: A Literature Review. *American Journal of Preventive Medicine, 35*(2), 116–123.

Mattessich, P. W., & Monsey, B. R. (1992). *Collaboration: What Makes It Work*. St. Paul: Amherst H. Wilder Foundation.

Osburn, J., & Stock, R. (2005). Playing to the Technical Audience: Evaluating the Impact of Arts-Based Training for Engineers. *Journal of Business Strategy, 26*(5), 33–39.

Popescu, A. D. (2014). A Proposed Methodology for Identifying Multicultural Skills in Heterogeneous Groups. *Procedia – Social and Behavioral Sciences, 124*(2014), 504–513.

Root-Bernstein, R., Pathak, A., & Root-Bernstein, M. (2017). Review of Studies Demonstrating the Effectiveness of Integrating Arts, Music, Performing, Crafts and Design into Science, Technology, Engineering, Mathematics and Medical Education. Part 1, Part 2, Part 3. *White Paper*.

Selle, K. M., Salamon, K., Boarman, R., & Sauer, J. (2008). Providing Interprofessional Learning Through Interdisciplinary Collaboration: The Role of "Modelling." *Journal of Interprofessional Care, 22*(1), 85–92.

Taylor, G. D. (2014). *When the Machine Made Art. The Troubled History of Computer Art*. New York: Bloomsbury.

3

Contextualization

Contextualization refers to the creation of a bigger picture that is fundamental to understanding why things matter. Placing ideas, words, or events in a context helps to see new aspects and how one specific act or thing is interconnected within technological, social, or cultural settings. Basically, interdisciplinary collaboration helps to provide a rich picture about complex issues, as knowledge from different disciplines helps to understand them (Nowotny et al. 2001). It is an important procedure within the humanities and social sciences. In history, for example, contextualization is essential to create an understanding of events in a social and historical setting: what influenced paradigm shift, or which social development was the fundament for a rebellious coup (Hall 2017)? At the same time, knowledge about political and social contexts can help to interpret cultural production, like film production (Orban 2013). In academic management theory, understanding the sociocultural context like historical, cultural, social, and political situations helps to understand the development management theories and best practices (Boyacigiller and Adler 1991).

The relevance of contextualization is also high outside of the humanities and social sciences. In any scientific or technological development, starting from pharmaceutical research to astronomical findings, contextualization of experiments and scientific findings is important for understanding the scientific work and its societal, scientific, and environmental impact. Such a process is important for the scientists themselves to see the importance of their work for stakeholder groups and in a scientific context that goes beyond their own field, and helps stakeholders, entrepreneurs, and fellow scientists to realize ideas to approach pressing issues by relating to other scientific fields. Artscience

collaboration creates opportunities for contextualization of scientific, corporate, and artistic work. Adding context to scientific questions and goals can help to understand broader implications and how these isolated islands of knowledge connect to real life: scientific experiments and technological developments often aim at answering detailed questions that are primarily discussed between scientific peers.

Individuals and groups, even organizations, tend to focus on their specific goals and form certain habits in looking at their work based on their professional background, training, personal motives, and other influential factors. Operating within a professional and often competitive environment, organizations and individuals must focus on those aspects that heighten their chance of creating insight and gaining the funding they have to apply for. Moreover, daily routines and professional priorities overshadow broader approaches to research and the application of scientific outcomes—or even reduce awareness of the work's implications in a broader context. At the same time, scientists and researchers can make the impression to be removed from "normal" people's life. To create rapprochement, artscience collaboration can reintroduce specialized research to its broader context through contextualization of the local, social, and cultural context of a scientific organization or ongoing scientific research.

Case: Sarah Craske at the Bioprocess Laboratory
Biofaction is a research and science communication organization focusing on novel bio-, nano-, and converging technologies, such as synthetic biology, based in Vienna, Austria, founded by Markus Schmidt. The founder's interdisciplinary background in biomedical engineering, biology, and technology assessment represents the organization's core competency, which is broadened by science communication and artscience projects. Talking about the inclusion of artists-in-residence phases in research projects, Markus Schmidt referred to their important role of contextualization of scientific work and the opportunities for artists to engage in new scientific contexts which are inspirational for them. An artist who was able to elevate her contextualization work to a central outcome of her residency was Craske. Biofaction selected Craske to collaborate with the Bioprocess Laboratory, ETH Zürich, in Basel, Switzerland, within the European Union (EU) FP7 project SYNPEPTIDE (Synthetic Biology for the production of functional peptides). The project brought together academic and corporate research groups using methods like synthetic biology to study the role of peptides in fighting the threat of antibiotic resistance. The artist's idea for the residency was to explore the potential of artistic and cultural practices to examine the

research going on in the SYNPEPTIDE project regarding broader visions, societal challenges, and philosophical, aesthetic, and ethical aspects.

Sarah Craske prepared herself for this residency according to her artistic practice. As a starting point for her artistic project development, she wanted to know which context she was entering to understand the world she joined. So she started to explore the social and cultural environment of the work. Craske explored Basel's history, which soon led to the importance of the local history of trade, the silk industry, and dye production. All this started around the same time in the medieval city of Basel, and the local research in biology and pharmaceutics could be traced back to that time. A major connection between pharmaceutical research and trade in medieval Basel was the spread of cholera, which was connected to Basel's history as a city of merchants and exchange of wares, and its geographical location beside a river. This led Craske to explore the nearby pharmaceutical historical museum that researches the history of pharmacies, drugs, laboratory equipment, tools, books, art, and craft on the topic. The museum houses one of the world's biggest and most important collections of pharmaceuticals and pharmaceutical objects throughout history. Naturally, Craske thought this was a perfect fit for the project and the aim of the residency, as the SYNPEPTIDE project is exploring cutting-edge technologies in medicine and drug resistance.

To Craske's surprise there was no previous contact between scientists and the museum staff—a majority didn't even know of each other's existence. When the artist established the contact, more happened than just bringing together two professional groups previously unknown to each other. It provided the basis for exploration of the SYNPEPTIDE project and the laboratory's work within the historical and cultural context of pharmacies and the medical collection of the museum. Specifically, the museum's repository of historical pharmaceuticals and natural medicine throughout the ages could be used by a researcher who worked on finding material in nature fitting for her work on peptides. Craske pointed to the fact that medieval medicine and current pharmaceutical work look for natural products that can help them to fight disease, although the technological and fine-grained specific knowledge nowadays outperforms what historically ever happened. She had long conversations about the inherent meaning of what she was pointing to and how positively this can be understood, as some scientists first understood this as criticism—but from her artistic and cultural perspective it was a positive understanding of a process. This raised important discussions and reflections on the scientific work being done. In these conversations scientists also

pointed to the fact that it is important for them to do more reflective thinking about their work than they have time to do. They are going from one experiment to another without being able to spend time on reflection and contextualization of their work—and thinking of what they are actually doing and how it affects society and nature, which they aim to help and protect. Moreover, the artist's historical research led her to identify a potential ingredient to create antibiotics for cholera called theriak (see the case presented in Chap. 2).

Additionally, Sarah Craske, the Bioprocess Laboratory, the pharmaceutical historical museum, and the University of Basel organized and curated an exhibition shown in October 2018 which aimed at the artist's reflection on the laboratory's work on antibiotics, her experiments on theriak, and a presentation of research in pharmaceuticals throughout the last four centuries. Sarah Craske added "a complementary outside-the-box perspective to synthetic biology, its societal ramifications and cultural aspects" while helping "envision the potential long-term changes synthetic biology might bring to society," as the scientific project partners mention (Fig. 3.1).

Fig. 3.1 *Theriak,* a living disease map of Basel in which cholera is fought with a synthetic peptide by Sarah Craske, 2018. This image is a scan from Craske's custom-made petri dish, showing the spread of cholera over a map of Basel. The cholera is in pink, and the peptide is shown where it's starting to go clear. (Image courtesy: Sarah Craske)

The research group and Biofaction remark that the contextualization through the artist enlightened aspects of their scientific work for the scientists and supported the communication of their work in the social and local context. The artist's work carefully curated the content of their own experience of contextualization of their work, revealed the important connection to local organizations, like the pharmaceutical historical museum, and presented their work to a local audience. Some scientists mentioned that Sarah Craske's work brought them in touch with aspects of their work they were not aware of before—and thus most likely broadened their view on their own scientific work. Inducing new contexts bears the potential to broaden the view or infuse new perspectives, but it can even add values or change personal standards (DeRose 2009). For example, scientists become aware of the importance of their scientific work beyond scientific discussion, or they introduce questions about the social, local, or cultural context to the dissemination of their work.

Of course, the contextualization of their work does not always influence the scientists' motivation or creative endeavors. There are people who are more interested in contextual knowledge and therefore adjust their ideas, whereas others can be less sensitive (less context sensitive; Grindrod et al. 2018). Scientists are immersed in their scientific fields and are interested in pushing the boundaries of knowledge in their fields to identify relevant research questions. Nevertheless, contextualization can be inspirational to and motivate scientists because this demonstrates the relevance of their work for society and the environment to them. Social psychologists show that the more one is exposed to a new culture, the more likely biases are reduced and ideas or complex connections will be better understood, as "[c]ontextualization is an iterative process where content knowledge and learner experience each inform the other [, … it] is the degree to which this process happens in conjunction with a real-world setting, the process that tracks the situatedness of knowledge" (Giamarello 2017: 2).

For science communicational and dissemination issues that are preconditions for generating project funding, contextualization work can be helpful. The contextualization work being done in artscience projects can be an inspiring source for scientists to disseminate their work, and artistic presentation of the outcome can reach out to new audiences. Exhibitions or other projects that provide a context for cutting-edge research provide a platform for the public to access the concepts and implications of the research being done (Dumitriu and Goldberg 2017; Dumitriu 2018).

Additional to the societal and cultural implications, the positioning of the scientific work in a broader scientific context is an important effect of

contextualization. It creates an understanding about connections to other scientific fields and how outcomes of research projects are relevant to societal needs. As Dr. Rob Neely from the School of Chemistry, University of Birmingham, points out, his collaboration with the artist Anna Dumitriu induced a shift of perspective on his own work: "I have a little more confidence that my work matters to the world beyond my peers and that is helping me to build stories into papers and grants that I write." He motivates fellow scientists to collaborate with artists because he thinks their contribution in contextualization is extremely important:

> I've used pictures from the exhibition to promote the work Anna and I have done and to try and encourage other scientists to follow suit. Not as something that I present to help communicate my work (though it is certainly a striking/memorable picture). These are my last two slides in recent presentations. I acknowledge Anna for her contribution to the science and then normally recommend that scientists embrace collaboration with artists as they can change the way that we think about our work. (Fig. 3.2)

Rob Neely said that as he wants to do research that benefits society, but as a scientist who is in this very specific discipline, working with narrow practices and deep knowledge, the connection to the "real world," as he calls it,

Fig. 3.2 *The Chemistry of Biology: An Alchemy of DNA Installation View #2* by Anna Dumitriu, 2017. This image shows the presentation of the collaboration between Anna Dumitriu and Dr. Rob Neely in an exhibition setting of their project "The Chemistry of Biology." The project aimed at exploring how new chemical tools in biotechnology will have far-reaching cultural and scientific implications for the future. (Image courtesy: Anna Dumitriu)

can get lost. So, the questions the artist asks and the stories she creates in presenting their artscience projects are reminders of the importance of his work for society, bring up context, sometimes function as mirror, and help to gain a different perspective on the scientific work.

Many artists and scientists experience similar effects. The artist and artscience pioneer Oron Catts remarks that it is important for scientists and engineers to understand the broader impacts of their work because it is opening up questions within society they don't even recognize from their purely scientific perspective. Artists can come in and point to these issues.

3.1 Narrating and Presenting Invented Futures

Contextualization can help to understand the questions scientific and technological work implies; it can point to both opportunities and downsides. These opportunities and downsides only become tangible when the newest research outcome is applied in real-life situations. Artists can ask these questions and invent scenarios—utopian, dystopian, and neutral ones—based on the information about scientific work and cutting-edge technologies. Thus, contextualization and implications of this work can be discussed before they become reality. Artists can narrate stories that help scientists, engineers, managers, and stakeholders to reflect upon these opportunities. Such stories can be told by artworks in the form of sculptures, interactive works, or more traditional narrative work like film or poetics.

Narrating stories can evoke emotions, create insights, and reach out to people in a more personal way, as they can relate to aspects of the story being told. Social scientists have been discussing narrative fiction as new source of data, a new method of analysis, and a new approach for teaching of social and organizational theories (Philips 1995; Czarniawska 1998). Narrations and stories illustrate ideas and provide connections to a social or cultural context: "Narrative methods introduce ambiguity and avoid unnecessary overspecification [...]. Narrative methods, in showing a theory in action, provide much more complexity and ambiguity into which readers can inject their won concerns and problem" (Philips 1995: 641). Thus, readers of fiction based on scientific theories better understand the theoretical perspective than those lay persons who only read explanations of the theory. Such narrative fiction even has an impact on scientists: a more contextualized portrayal of a situation in a narration can help researchers to better understand the complex issues connected to their work (Patient et al. 2003). Inventing future visions of applications of scientific goals can pose ideas for practical applications. The creation of stories in the form of utopian and dystopian thought experiments can help

to understand which premises in the context can turn outcomes to be judged good or bad. The following two artworks present these two aspects: the first one asks about the implications of a possible future based on scientific developments for humankind; the second one poses questions for applications to deal with important problems by pulling together methods from different disciplines.

Case: Lucy McRae—*The Institute of Isolation*
As part of the EU project "Sparks" the body architect and Sci-Fi artist Lucy McRae created a short art film on the training of the human body in an environment where embryos can be born from mechanical wombs and space travel becomes a matter of course. Following her previous work on bodily augmentation and incremental reconstruction of humans and their bodies through scientific breakthroughs, McRae created the fictional documentary *The Institute of Isolation*. The major question she followed was to understand possibilities to evolve the human body to be able to endure long time spans in isolation, which is necessary, for example, in space travel. For the project McRae worked with 11 scientists from diverse disciplines (i.e., biology, genetics, human medicine, technology, philosophy) to develop the storyline of a fictional documentary (Fig. 3.3). In this fictional documentary, she imagines life 500 years from now and asks, if we are born from scratch in a plastic dish, what does it say about our mind? What does it do to us as humans? Touch is important for our human development, emotions, and

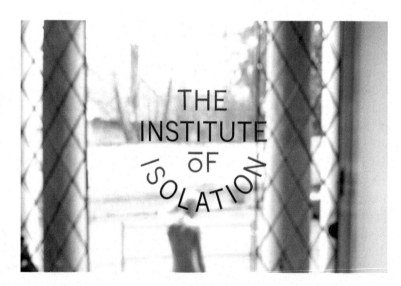

Fig. 3.3 Logo of *The Institute of Isolation* by Lucy McRae during the shooting of the fictional documentary; scene: Lucy McRae as a member of the institute leaving the organization, at Thermalbad Bad Fischau, 2016. (Photo credit: Claudia Schnugg)

feelings; what if we lose it? The project aims to encourage cross-disciplinary debate about augmenting the body, the artist argues.

The fictional documentary follows a young woman who trains her body in this "Institute of Isolation" by the means of isolating herself, depriving the body of diverse sensorial experiences and interaction with others. Thereby, McRae asks if the experience of isolation can prepare the body for the future that humanity is aiming at right now. Could isolation prepare the body for cell treatments to reach eternal youth, in-vitro fertilization even after a parent's death, raising children without the experience of being embraced by a parent, the growth of a fetus in the absence of gravity, or phases of isolation in space travel to reach other planets? The story fictionally explores practices of isolation that incrementally adjust the human body and its genetic material to help humankind to survive structural challenges for resilience and adaptability in future. Based on conversations with researchers in the fields of genetics, microbiology, space science, and other relevant fields, she builds scenarios and artistic research settings, and creates stories that show how humankind can be affected by these visionary developments. She weaves all these little strands of information she finds in her interviews with scientists and imagines a future that involves all these ideas. Thereby, she is always looking at where the humans, the bodies and interpersonal relationships, can be found in this new context (Fig. 3.4).

"Art can drive humanity beyond what we currently know," Lucy McRae argues. So she brings up these questions: where could these scientific breakthroughs lead humankind? And do we—and the scientists searching in this big quest—even understand what everything put together means for

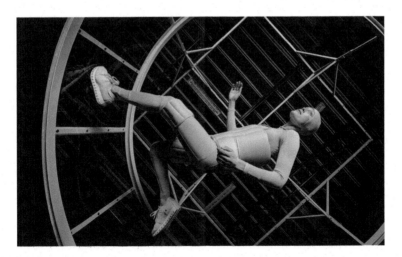

Fig. 3.4 Lucy McRae as member of *The Institute of Isolation* training for zero gravity in the Microgravity Trainer. *The Institute of Isolation* with Lucy McRae and Lotje Sodderland, 2016. (Photo by Julian Love, image courtesy: Lucy McRae)

humankind? In her approach, she raises many questions about knowledge, what kind of knowledge artists and scientists have, and how it is possible to question and integrate it. Her artwork is also confronting: she introduces the uncanny and the absurd to make people realize what they know, what they want, and how it affects them emotionally. In our conversation after first screenings and presentations of *The Institute of Isolation*, she mentioned that everybody seems to interpret it differently, and that people who finished watching the film had more questions than answers. Scientists were inspired to integrate the aspect of isolation in their research, others were reminded of all the scientific questions which are not yet answered, and a broader audience was inspired to investigate research they were not yet familiar with. This is exactly what makes her artwork so powerful.

The transcript of the voiceover Lucy McRae speaks in the short film points to the artistic connections she is making and the questions an artist is asking about the development in science and the existing possibilities of technology. It reads as follows:

> *We can accurately measure the physiology of the body, but the psychological responses to prolonged isolation are largely unpredictable.*
> *How does the brain respond in manipulated conditions below the threshold of hearing?*
> *Does it mimic previous experiences in order to adapt?*
> *The body is not designed to exist beyond the Earth's edge.*
> *Fundamental aspects human of biology will need to change.*
> *10% of people who spend Winters in the Antarctic develop serious psychological problems.*
> *It's difficult to predict who will not cope in extreme environments.*
> *Reproductive technology is editing life, like computational code.*
> *Is this becoming an adventure of control?*
> *Does the body become a mixing board of switches, where we curate life decades after an egg and sperm has left the body.*
> *We are in a different phase of evolution, no longer driven just by nature but human intent.*
> *Technology is embalming the body, pulling death out of time.*
> *Could the design of isolation augment the self, beyond genetic traits?*
> <div align="right">(Lucy McRae 2016, The Institute of Isolation)</div>

Case: Amy Karle—*Regenerative Reliquary*

Art is about visions, about future ideas, and poses possibilities. Art does not have to be tangible or immediately understandable. The outcomes of

artscience collaboration are often far more than representations of a status quo; they can be envisioning futures or questioning ideas, or make completely new statements. The artist Amy Karle explores the meanings of being human and the human condition. She is specifically interested in the ways humans and technology are merging and how to use infotech and biotech to empower humanity and society. Based on her interest in the body and her ongoing artistic reflection on the topic of the display of body parts in reliquaries and based on the technological and scientific possibilities to design an artwork with live cells which have the possibility to grow new structures, she produced the artwork *Regenerative Reliquary*. She aimed at pushing boundaries and going beyond the creation with cold materials by turning to synthetic biology and regenerative medicine. The artwork consists of a three-dimensional (3D) printed scaffold of biological material that can grow. It is displayed as "relic" in a "mechanical womb of scientific equipment" which keeps the tissue alive and growing. The sculpture is installed in a bioreactor, with the intention that human mesenchymal stem cells from an adult donor seeded onto that design will eventually grow into tissue and mineralize into bone along that scaffold.

The artwork is inspired by work in medicine and prosthetics, playing with ideas to help people with medical conditions to create necessary body parts from living material instead of inanimate materials like metal, wood, and fabrics. It refers to scientific work to grow body parts from living tissue and to 3D-print organs, and cites artworks referring to this topic. *Regenerative Reliquary* combines most recent knowledge in regenerative medicine, biotechnology, material science, 3D printing, and computer science and communicates the potential these scientific disciplines bear for a bigger audience. The artwork also raises questions about fighting diseases, opportunities for growing organs or body parts from synthetic materials and tissue gained from a donor instead of abusing animals, helping people with limb differences, and much more. In addressing these complex medical issues by the creation of an artwork in collaboration with scientists and drawing from ongoing scientific projects, the artwork represents an artist's future vision, but does not give immediate answers. It asks questions and encourages next steps in scientific development. In social and cultural contexts, the project is raising discussions on transhumanism, cyborgs, and ethics, and even around spiritual questions (Fig. 3.5).

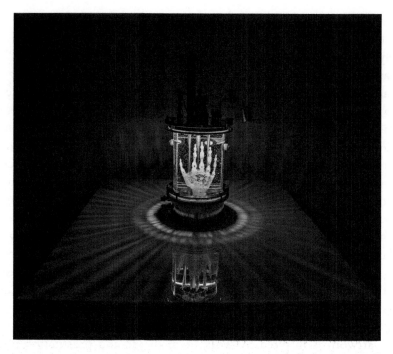

Fig. 3.5 *Regenerative Reliquary* by Amy Karle, 2016. A bioprinted scaffold in the shape of a human hand 3D-printed in a biodegradable polyethylene glycol diacrylate hydrogel that disintegrates over time. (Image courtesy: Amy Karle)

3.2 The "Human Side" and Meaningful Work

No matter where, in the museum or in a laboratory, encountering art and the artist is always a very personal experience. The aesthetic experience is an individual one, and so is the reception of artworks and the ideas they inspire. Depending on personal identity and previous experiences, art evokes emotions, fosters reflection processes, or leads to a better understanding of an idea related to a social or cultural context (Belfiore and Bennett 2007). These reactions to aesthetic experiences further lead to reflections about the own identity, values, goals, and the current period of life. So art can bring its recipients in touch with how they understand themselves as humans and connect to others. This very personal aspect reaches out to specific personal motives and needs. Being confronted with art within the work environment, such reflections tackle interests and dreams, motivations, and visions for desired outcomes. Therefore, it intersects with ideas of motivation at work and meaningful work approaches. These approaches are reflecting on the expectations individuals have to experience their work as something that

matters and fulfills them. Thereby, the understanding of personal development in the field, relationships with others, and the benefit of the work for society or the value of the work for a bigger purpose are relevant for experiencing work as meaningful (Morin 2008). In art, it is possible to bring a shift in the contextual understanding of the work, as this is often stuck in daily routines. Fresh views on tasks, being reminded of dreams, and the personal longing to reach big scientific goals can help to motivate and reclaim (or reflect on) those visions that motivated the decision to strike out a certain professional path. Questions come back to the surface: what am I actually working on? How it is meaningful for us and for society? Seeing the context in which artists put scientific work helps to become aware of these factors. It enables one to see the context of the work outside of routine processes and to-do lists. So this reflection puts oneself in touch with one's fundamental interests—or needs.

3.2.1 Sarah Petkus and *NoodleFeet* Visiting the European Space Agency

As an artist-in-residence at the European Space Agency's (ESA's) technical center the European Space Research and Technology Center (ESTEC), the media artist Sarah Petkus and her robot *NoodleFeet*—Noodle for short—had the opportunity to explore a simulated Martian landscape, to investigate human-robot interaction, and to discuss the ethics of robotics and technology with roboticists, scientists, and engineers at ESA and people within the ESA environment. The residency was a unique experience for the artist to interact at the scientific facilities and with diverse laboratories at ESTEC, and for those ESA scientists, engineers, and roboticists who had the chance to get in touch with the artist and her robot. Petkus, originally coming from a storytelling and illustration perspective, developed the character Noodle as "The Wandering Artist." This is a robot child that develops his basic functions and skills by experiencing his environment and experimenting. In his growth, Noodle also acts as "The Imperfect Probe." Petkus proposed this project to reflect on the robots used in current missions at ESA, by bringing in the character of her robot. Her artistic proposal for the residency postulated that Noodle, who is still a child, "explores another planet in the Solar System and take decisions based on creative and artistic grounds, rather than purely scientific reasoning."

The idea for the robot child originated in one of Petkus' stories about the robot child that is wandering about, exists freely in the world, encounters the world, and starts to define personal expression. As Noodle is still a baby, he has already developed a few functions: he drools, digs, and tries to swallow

stuff, and communicates primarily through a series of beeps and whirrs. These basic functions should develop to more articulate ones with his next upgrade, like a growing child develops new skills—and, not to be forgotten, learns through its behavior. Thus, Noodle is constantly developing, changing his abilities and physical form, and Petkus is keen on studying his development and behavior. The artist brought several rough prototypes of feet which represent these new skills and enable Noodle to investigate space and explore new landscapes. She calls them behavioral appendages that can enact adolescent behavior. For example, by swallowing small objects, the robot investigates the surface of a landscape with one of the appendages; another one enables the robot to taste things. For her residency at ESTEC, Petkus not only brought her robot and the behavioral appendages to seek professional insights or suggestions in the building of the necessary parts, but also sought some feedback beyond her "usual bubble," as she is already working in a long-term collaboration with partner and developer Mark J. Koch. The goal of the project was to encourage reflection of scientists, roboticists, and technologists working at these missions about the purpose and identity of their inventions, the technology, and the missions they are working on.

Noodle was an attention-grabbing and unconventional conversation starter, and functioned as a projection screen for reflections, hopes, ideas, and technological developments. Naturally, robots attract roboticists, and especially an unusual robot such as Noodle raises some questions and eyebrows to begin with. On a technical level, Noodle was interesting for the scientists, as they would ask Petkus why she built it as it is built, and they would talk about what they would approach differently. Beyond that, conversations emerged about other instruments that seem to be necessary to bring on her vision of Noodle's mission in a foreign landscape. Through the artist's personal project with Noodle and her experiences and visions, she led the exchange in a very personal direction for the scientists and engineers she got in contact with. She asked about their emotional connection to their projects and how they coped with the ending of a mission or with missions going wrong. Through the story of her and Noodle and knowing about her personal involvement in such a project, the scientists and engineers seemed to be able to talk about this differently. They talked to her about how, for example, the ending of the Rosetta mission[1] felt somehow like its "death" and affected

[1] Rosetta was a space probe launched by ESA in 2004 and arrived at Comet 67P/Churyumov-Gerasimenko on 6 August 2014, the first mission in history to escort a comet as it orbits the Sun and deploy a lander

everybody who had a part in it. They talked about how these projects felt like "having a puppy," something to care for, watch grow, enjoy the interaction with, but also something that brings responsibility and that becomes an essential part of daily life. Nevertheless, in the ongoing routines and workload that are associated with many of these missions, scientists and engineers do not really celebrate their missions or grieve when a mission ends. Work goes on; there's much to do and contribution to an upcoming mission is taken seriously, and thus sometimes personal involvement and emotions get neglected.

Petkus' questions and visions seemed to remind the scientists and engineers of how they were in the beginning, why they got immersed in this kind of work, and the very personal and human side of their passion. In the course of the interaction about the robots, she continued asking these personal questions about why they started to work in this field or what they would do if they, for example, could go and sit on the spacecraft. Most scientists and engineers had difficulties in answering these questions, as much time had passed since they had last thought about it. Petkus thought one of the best answers she got was, "I would sit and play *No Man's Sky*"[2]—she liked this because they were able to imagine doing something funny on the topic, purely for joy and for relaxation. She described that the conversations in the setting up of the laboratories with their robots at hand and where this personal connection started felt like two kids on a playground talking about what they enjoy. She thinks that her mission was at least partly reached, as she was able to remind the scientists and engineers of who they were once, what they enjoyed once, but had in some cases forgotten, as it was pushed into the background for so many years. After she left, many of her closer collaborators kept in contact with her, continuing their discussions about robots, instruments, and Noodle.

"After almost three weeks immersed in the vast scientific community that cooperates on many fronts to make space exploration possible, I left with a meaningful sense of where the elements of humanity exist within it. I've

called Philae to its surface to study the comet. This first successful landing on a comet was over shadowed by the probe's low battery, which ran out two days later. Communication with the lander was briefly restored in June and July 2016, but shortly afterward Rosetta's communications module with Philae was turned off at the end of July 2016. The mission ended on 30 September 2016. Rosetta was an ESA mission with contributions from its member states and NASA. http://www.esa.int/Our_Activities/Space_Science/Rosetta

[2] *No Man's Sky* is a computer game that allows the player to explore a universe that is generated in the course of the game. The player can investigate planets by walking, fly with a rocket-backpack, or travel to other planets in a single-person spacecraft. Recourses can be collected and traded with intelligent aliens; planets or animals first discovered can be named by the player.

enjoyed to the fullest this opportunity to learn from the people who do the work that inspires me most. My time at ESTEC helped me think critically about humans, machines, and how we relate to the technology we create," says Petkus in an interview for the official ESA blog post on her visit.[3]

The scientists Dr. Karen O'Flaherty[4] and Dr. Claudia Mignone,[5] who acted as facilitators of the residency, commented that it was interesting to see that this interaction with Sarah Petkus and Noodle gave the scientists the chance to connect to the more human level of what they do and to be reminded of the reasons why they decided to work in this field. This gave the scientists the opportunity to talk about their work as something they dreamed of doing—in some cases since childhood—and reminded them of these reasons. This was valuable because, as scientists working on space science missions and in very specific scientific fields, one easily becomes detached from these dreams. Karen and Claudia noted that as a scientist it is important to have these moments where you are reminded of the more human or personal motivation for why you chose to do the job, especially because the human connection means a lot to scientists—they want to share their research goals and the outcomes of their work with others. Being reconnected with this human side of their work helps to reawaken the interest and fun experienced in one's work. Even in situations of success or after the final event of a mission, it is difficult to celebrate fully and to share this important moment with peers. Often routines must go on, new projects must be started, and there is little time for a full celebration or a proper goodbye to a big project (Fig. 3.6).

Other artists and scientists reported similar experiences. For example, Sarah Craske mentioned that the scientists she worked with seemed surprised by her intuitive and emotional approach to the lab experiments she did as artist-in-residence in their laboratory. She was enjoying when an experiment went well, and the scientists often were surprised that the experiment did so, but they wouldn't react to that emotionally. Craske said she felt that due to the linear process and reproducibility of experiments and the scientists' high frustration level in failures of projects, this enthusiasm and emotion gets "trained out of them." Thus, the scientists seemed to be reminded of the enthusiasm they felt about what they were doing when they began their scientific work in collaboration with the artist.

[3] http://blogs.esa.int/artscience/2017/08/03/humans-robots-and-rainbows-how-sarah-petkus-experienced-estec/
[4] Karen O'Flaherty, EJR-Quartz for ESA—European Space Agency.
[5] Claudia Mignone, ATG Europe for ESA—European Space Agency.

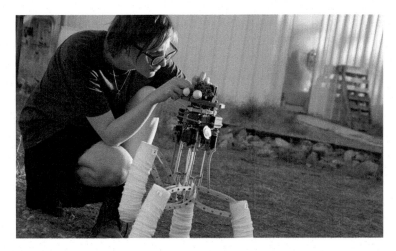

Fig. 3.6 Artist Sarah Petkus and her robot child *NoodleFeet*, 2017. (Image credit: Mark J. Koch)

Getting in touch with personal aspects of one's work, motives, and identity is an important part of interaction with art, even if it is experienced as a short temporal reminder—especially in situations where contexts build up and pictures of forgotten visions are re-evoked, learning processes about how their self and the context influences their work and work experiences. Such a reminder helps to realize how personal feelings and work processes are influenced by external factors. What psychologists call the well-known "personality triad" (Funder 2006) shows that persons, situations, and behavior are interdependent. Contexts can have an influence on the construction of the self—where do I see myself?—and the way individuals construct themselves influences their cognition, emotion, and thus their behavior. In that sense, the self is not a fixed construct, but fluid and adapting to dominant influences. Research shows that depending on the social contexts individuals are embedded in, they see the construction of their selves and thus act accordingly. In the case presented above, there is the self within the professional context of a scientist involved in missions and projects that need to be delivered versus the visionary idealist, one who wanted to reach for the stars. Depending on which one is prevalent, there are different actions, changed decision-making, increased or less cooperative behavior, or changed personal goals (Martin-Murcia and Ferro-Garcia 2016; Liu and Li 2009).

Contextual factors were found to be important in motivation, especially in intrinsic motivation and self-determination theory (e.g., Standage et al. 2003; Cordova and Lepper 1996; Deci and Ryan 1985, 1991). When regulations, rules, or tasks that govern the work process push personal interests into the

background and positive outcomes of projects are not celebrated, motivation can be affected negatively. For example, no celebration of achievements or finalized projects can lead to motivation going down. Even if interest in one's own work is basically high, this perspective can get lost, which is likely to decrease motivation. What Sarah Petkus did at ESA was more than digging down to the human side of technologies that allow humankind to explore space and travel to other planets: it put a spotlight on personal motivation, visions, and allowing emotional attachment to the work. And she triggered another important aspect of motivation: excitement and having fun. Collaborating with the artist on the project was fun, mentioned her facilitators at ESA, and she reminded individuals to enjoy their work again: like two kids on the playground enjoying their robots.

3.3 Ethics and Critical Discussions of Broader Implications

The new contexts in which artists reflect on scientific work can propose applications of scientific work and, at the same time, raise ethical questions. For example, Lucy McRae's story in *The Institute of Isolation* can raise questions as to whether humanity wants to go into such a future, as Sarah Petkus' work will raise questions about whether a machine should be produced as a curious and feeling being and how new worlds are treated that humankind starts to explore. Amy Karle's *Regenerative Reliquary* asks questions about transhumanism, new medical approaches, and the use of living tissue. Especially this field of BioArt and modern bioscience poses unprecedented ethical situations and dilemmas. Ethical discussions of scientific possibilities are not only raised by artworks; art can cause ethical dilemmas in their production. Thereby, they point to irregularities in ethical regulations between different countries, philosophical argumentation, or even between the small-scale possibilities in laboratories and industrial regulations.

Moreover, ethics is a complex issue: from the cultural and philosophical approach to ethical decision-making in scientific and corporate situations, great minds are having deep thoughts about what is right or wrong, what is "good" to do and what one "ought" to do (Björnsson 2017). Through the fast growth in science and technology, developments can be found that are not evaluated in all the possible contexts. The meta-ethical contextual approach considers different contexts on the macro, meso, and micro level, for example,

culture, history, predominant religious beliefs, legislation, or ethnic background, in approaching situations and requirements (Ting-Toomey 2015). Disagreements between different contexts can be displayed and a connection between moral judgment and moral motivation can be examined (Björnsson 2017). By making the ideas of science and technological developments accessible to a broader audience, artscience provides the opportunity to open up ethical discussions in new contexts.

A wonderful experiment digging into BioArt and ethics is the project "Trust Me, I'm an Artist." The project was initiated by the artist Anna Dumitriu and the ethicist Bobbie Farsides in 2011 to explore the ethical differences in laboratories across nations and cultures, especially within bioscience, and expose the novel ethical problems arising from new scientific possibilities (Dumitriu and Farsides 2014). It looked at the different contexts of these laboratories, the cultural traditions, transdisciplinary problems, scientific versus corporate situations, and different levels of society, like communities and nations. More specifically, by exposing artwork at the border of art and bioscience to scientific ethical committees, the possible role of artists in this environment was reflected on. For example, the culture of the country where the lab is situated changes the ethical premises for experiments: whereas in European culture you can donate your body to research, in cultures like in Egypt, it is not possible to "own" your body, which makes human cell research a very complex issue. Therefore, artists who are interested in working in such a laboratory or who plan to exhibit artwork that deals with human cells in such a country can be confronted with ethical issues they probably did not expect beforehand (Dumitriu 2018). Artists who are creating BioArt that goes beyond ethical borders of scientific endeavor created the starting point for these discussions (Dumitriu and Farsides 2014). They were asked to present project plans for works at the border of biology and art which, in a performative act, they have to present to a scientific ethical committee. The project aims at helping artists and scientists, and scientific and cultural institutions, understand which processes are at play when making and exhibiting BioArt that might get censored in its making process or can lead to health and safety issues (Dumitriu 2016). In the "Trust Me, I'm an Artist" project, the artists and scientists were able to point to inconsistencies, widen debates, and share stories, concerns, and new discoveries within the related professional communities and a broader public (Bureaud 2018; Dumitriu et al. 2016).

Nicola Fawcett, one of the scientific partners of Anna Dumitriu who works on the Modernising Medical Microbiology[6] Project at the University of Oxford, mentioned that there are situations that lead to ethical and critical discussions that are less obvious than the direct implications of the scientific work for the human body: when Anna Dumitriu started to work with the technologies used in her laboratory, like CRISPR,[7] to edit the gene of a bacterium used in her art, she asked if she was allowed to exhibit the DNA fragments known as plasmids that are used to cut and paste DNA in a genome. Questions of how to deal with the exhibition of scientific material occurred.[8] Cutting-edge research demands ethical discussion; it has further implications for routines. Artscience collaboration makes them visible because the scientific process gets exposed to a new environment. For example, there is no existing legislation or administrative procedures that guide artists and scientists in questions that have practical relevance. In a scientific experiment nobody has to think about the legal implications of bringing potentially dangerous biological materials outside the laboratory. When the artist starts to contextualize the work, such issues come up and need to be explored. There can be legal questions, questions about emergent routines, and old laboratory rules that were written down in the 1950s and do not apply anymore because practices have changed. It is important that somebody like an artist, with experience in public situations or in interdisciplinary work, asks these questions because their background enables them to bring the work in a new context. It is not within the scope of artscience collaboration to resolve these issues, but to create unknown situations, ask questions, and expose contradictions or lack of knowledge about it.

Dumitriu and Fawcett experienced this when creating their shared work using drug-resistant *E. coli* bacteria from a patient's gut, grown on color-changing cloth and then sterilized. One theoretical concern was whether DNA from these dead bacteria could somehow transform live bacteria into becoming drug-resistant too, yet no clear guidance existed on whether further decontamination steps were required—the science had simply not been done, because no one had tried this before (Fig. 3.7).

[6] Modernising Medical Microbiology is a research group aiming to transform analysis and treatment of infections to improve patient care. http://modmedmicro.nsms.ox.ac.uk/
[7] CRISPR is an abbreviation of clustered regularly interspaced short palindromic repeats; these sequences form the basis of a technology called CRISPR/Cas9 that can be applied to specifically change genes within organisms.
[8] Specifically, the debate here was around the exhibition of wild-type antibiotic-resistant plasmids. Anna Dumitriu still hasn't managed to exhibit this specific type due to legal and organizational issues, but she is working on it. In *Controlled Commodity*, an artwork that builds on this research, Dumitriu was able to show plasmids for CRISPR editing.

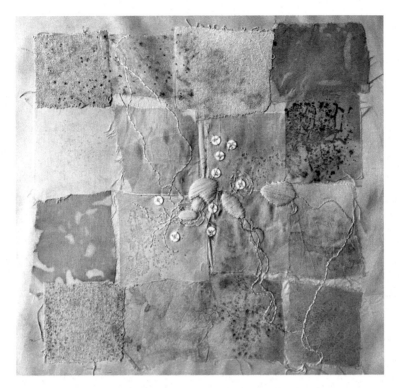

Fig. 3.7 *Make Do and Mend*, detail, by Anna Dumitriu, 2017. The artwork refers to the saying "make do and mend," stemming from the need to patch clothes during World War II. In collaboration with scientists Anna Dumitriu worked on modern "patching" techniques like CRISPR/Cas9 to exchange bacteria's "damaged" part, which is its antibiotic resistance gene. Infusing handcraft materials with these bacteria and applying traditional patching techniques visualizes this process. (Image courtesy: Anna Dumitriu)

Similarly, the neuroscientist Chris Salmon points to these ideas in an interview about his experience with artscience collaborations. He elaborates,

> Art is also perhaps an excellent avenue by which to have critical discussions about science. Criticism of the publishing industry, equitable hiring practices, the replicability crisis, bias in scientific editorial boards, knowledge use by the pharmaceutical industry, the use of animal models, evidence-based policy making, etc. These are discussions that scientists want to and should have, but they are very difficult to have within the traditional confines of the research institute, and very often scientists do not possess the language to have these conversations. Then, if these conversations do happen, they tend to stay inside the academy. Art provides another, probably better space, for having those conversations, I think.

References

Belfiore, E., & Bennett, O. (2007). Determinants of Impact: Towards a Better Understanding of Encounters with the Arts. *Cultural Trends, 16*(3), 225–275.

Björnsson, G. (2017). Contextualism in Ethics. In H. LaFolette (Ed.), *International Encyclopedia of Ethics*. Chichester: Wiley.

Boyacigiller, N. A., & Adler, N. J. (1991). The Parochial Dinosaur: Organizational Science in a Global Context. *Academy of Management Review, 16*(2), 262–290.

Bureaud, A. (2018). What's Art Got to Do with It? Reflecting on BioArt and Ethics from the Experience of the Trust Me, I'm an Artist Project. *Leonardo, 51*(1), 85–86.

Cordova, D. I., & Lepper, M. R. (1996). Intrinsic Motivation and the Process of Learning: Beneficial Effects of Contextualization, Personalization, and Choice. *Journal of Educational Psychology, 88*(4), 715–730.

Czarniawska, B. (1998). *A Narrative Approach to Organization Studies*. Thousand Oaks: Sage.

Deci, E. L., & Ryan, R. M. (1985). *Intrinsic Motivation and Self-determination in Human Behavior*. New York: Plenum.

Deci, E. L., & Ryan, R. M. (1991). A Motivational Approach to Self: Integration in Personality. In R. A. Dienstbier (Ed.), *Nebraska Symposium on Motivation: Perspectives on Motivation* (Vol. 8, pp. 237–288).

DeRose, K. (2009). *The Case for Contextualism*. Oxford: Oxford University Press.

Dumitriu, A. (2016). Art as a Meta-Discipline: Ethically Exploring the Frontiers of Science and Biotechnology. *Technoetic Arts: A Journal of Speculative Research, 14*(1&2), 105–112.

Dumitriu, A. (2018). Trust Me, I'm an Artist: Building Opportunities for Art & Science Collaboration Through an Understanding of Ethics. *Leonardo, 51*(1), 83–84.

Dumitriu, A., & Farsides, B. (2014). *Trust Me, I'm an Artist*. San Francisco/London: Blurb.

Dumitriu, A., & Goldberg, S. (2017). Make Do and Mend: Exploring Gene Regulation and CRISPR Through a FEAT Residency with the MRG-Grammar Project. *Leonardo*. https://doi.org/10.1162/LEON_a_01466.

Dumitriu, A., Bureaud, A., & Farsides, B. (2016). Trust Me, I'm an Artist. *Leonardo, 49*(3), 262–263.

Funder, D. C. (2006). Towards a Resolution of the Personality Triad: Persons, Situations, and Behaviors. *Journal of Research in Personality, 40*(1), 21–34.

Giamarello, M. (2017). Dewey's Yardstick: Contextualization as a Crosscutting Measure of Experience in Education and Learning. *SAGE Open, 7*(1), 1–11.

Grindrod, J., Andow, J., & Hansen, N. (2018). Third-Person Knowledge Ascriptions: A Crucial Experiment for Contextualism. *Mind & Language*. ISSN 1468-0017. https://onlinelibrary.wiley.com/doi/abs/10.1111/mila.12196.

Hall, I. (2017). The History of International Thought and International Relations Theory: From Context to Interpretation. *International Relations, 34*(3), 241–260.

Liu, C.-J., & Li, S. (2009). Contextualized Self: When the Self Runs into Social Dilemmas. *International Journal of Psychology, 44*(6), 451–458.

Martin-Murcia, F., & Ferro-Garcia, R. (2016). Building the Self. A Contextual Approach. *Psychology, Society, & Education, 8*(2), 149–156.

McRae, L. (2016). *The Institute of Isolation*. Fictional Documentary in Collaboration with Lotje Sodderland and Ars Electronica Futurelab, Short Film, Produced by Lucy McRae, Co-production Claudia Schnugg, Funded by the EU H2020 project Sparks.

Morin, E. M. (2008). *The Meaning of Work, Mental Health and Organizational Commitment, Studies and Research* (Report R-585). Montréal: IRSST (Institut de recherche Robert-Sauvé en santé et en sécurité du travail).

Nowotny, H., Scott, P., & Gibbons, M. (2001). *Re-thinking Science: Knowledge and the Public in an Age of Uncertainty*. Cambridge: Polity Press.

Orban, C. (2013). Contextualizing History in Hungarian Films of the New Millennium. *Hungarian Cultural Studies. E-Journal of the American Hungarian Educators Association, 6*(2013). http://ahea.pitt.edu. https://doi.org/10.5195/ahea.2013.111.

Patient, D., Lawrence, T. B., & Maitlis, S. (2003). Understanding Workplace Envy Through Narrative Fiction. *Organization Studies, 24*(7), 1015–1044.

Philips, N. (1995). Telling Organizational Tales: On the Role of Narrative Fiction in the Study of Organizations. *Organization Studies, 16*(4), 625–649.

Standage, M., Duda, J. L., & Ntoumanis, N. (2003). A Model of Contextual Motivation in Physical Education: Using Constructs from Self-Determination and Achievement Goal Theories to Predict Physical Activity Intentions. *Journal of Educational Psychology, 95*(1), 97–110.

Ting-Toomey, S. (2015). Meta-ethics Contextualism Position. In J. M. Bennett (Ed.), *The Sage Encyclopedia of Intercultural Competence* (Vol. 2, pp. 611–615). Los Angeles: Sage.

4

Spaces In-Between: Liminality

Artists and scientists like to refer to artscience collaboration as a space for exploration and experiments that is not bound to other organizational restrictions or where they can talk freely about unique ideas. The formats of artscience collaboration are often not bound to organizational structures; these projects are neither part of routines nor are they standard projects. They break formal structures and open up spaces for learning and idea development without predefined rules, for example, like interaction structures or scientific, corporate, and artistic goals. Such spaces can be used individually for personal development, exploration, creation of experimental work, playful testing of new ideas, and much more, without being bound to former rules, hierarchies, or evaluation by peers. In anthropology these states have first been named as "liminal," spaces on a threshold and in-between (Van Gennep 1909; Turner 1966). Such space is not always constructed and signified by physical room, but by social practice. Liminal spaces are rather cognitive and experiential phases to break out from the "normal" spaces of routine life.

In routine life an individual's space is created by their interests, environment, social contacts, ideas, and practices that govern or frame their behavior, ideas, and actions (Lefebvre 1991). All kinds of spaces can influence and condition ways of thinking and ways of acting, like the social group a person is part of; the social status that restricts and enables certain actions; the organization with its rules, processes, and culture; the profession where habits are created and goals are framed to reach an outcome that is evaluated by peers; or even the family and personal surroundings. Rules, routines, work processes, and structures restrict behavior and influence thinking processes and frame the perspective on problems, questions, and visions. Within these spaces,

people have a hard time imagining that somebody could have a different perspective; they frame their projects and goals according to the group's or spaces' values and restrictions. Thus, it happens that a completely new vision cannot be imagined, or that interesting questions are not asked because peers might laugh about this idea.

The liminal space creates the possibility to step out of this restricting environment, to explore and to create change. The original anthropological concept explains liminal space as space of the "in-between" or a "time between times," a space that is used in rituals of change, where, for example, in the ritual to trespass from childhood to manhood, members of a tribe get separated and are allowed to explore themselves. When they get reintegrated in the tribe, they have experienced themselves and have a different status in the tribe. This "in-between" is understood as a phase for connection, rewiring, or interplay. The original meaning of the word refers to a limited period where such transformation happens and is strongly connected to rituals of change, but recently the concept has been discovered as essential to understand possibilities to initiate learning processes and phases of creative exploration, or even for the development of new visions and strategies,[1] because it is important to remove oneself from restrictions and habits to be able to explore freely and to gain new perspectives.

The concept of liminal space—or "liminality," as Van Gennep originally called such a period—is based on the blurring and merging of distinctions, the simultaneous presence of the familiar and the unfamiliar, and freedom of conventions and regulations, and allows for a sharp symbolic inversion of social attributes. The difference that emerges from liminal spaces allows for sustainable change in processes, or the understanding of new perspectives, because the experience in this space validates this new understanding and attribute of meaning. Somebody who finds themselves in a liminal space is temporarily undefined, which also frees them from structural obligations (Turner 1982)—or pressure and evaluation by peers. This undefined situation heightens reflexivity, as it allows for a meta-perspective on the everyday life (Turner 1987). Additionally, this experience is full of potentials and curiosity, and practices and ideas to discover. Turner (1974), one of the main anthropologists building the theory of liminality, imagines that creating a liminal space can help to foster phases of creativity without necessarily marking a

[1] Cultural change in organizations (see Howard-Grenville et al. 2011), influence of project-based and temporary work on workers (see Czarniawska and Mazza 2003; Eriksson-Zetterquist 2002; Johnsen and Sørensen 2014; Garsten 1999), in times of crisis (Powley 2009), and how to create liminal spaces for effective strategic workshops (Johnsen et al. 2010).

change other than learning and exploration. He calls such a liminal space liminoid to show that such a space can emerge in times when no fundamental cultural change is going to happen. Following this logic, liminal space is relevant for artscience collaboration to provide opportunities for exploration and learning, and in phases of change to support the process.

Case: Anouk Wipprecht and Her Sparks Residency Project *Agent Unicorn*
A project that shows that interdisciplinary collaboration can end up in an utterly interesting exchange between diverse fields because disciplinary restrictions are not applied is *Agent Unicorn*. This project by the Dutch fashion-tech artist Anouk Wipprecht was one out of three residencies within Sparks, an EU Horizon 2020 project that provided the opportunity for artists to develop a vision of technologies in health, medicine, and well-being at the Ars Electronica Futurelab. The goal was to create an artwork that expresses the idea of responsible research and innovation (RRI) by involving different scientific, technological, industrial, patient, and other stakeholder groups. All three art projects were then included in a traveling exhibition that was shown throughout Europe. In this case all contributing artists, scientists, engineers, hardware and software developers, and therapists had to step outside their comfort zone and habits to create something that was experimental for them and, in the end, inspiring to so many peers and stakeholders.

Before *Agent Unicorn*, Anouk Wipprecht experimented with biosignals, a range of body sensors, robotics, microcontrollers, and other technological developments like 3D modeling and 3D printing. Her artwork explores the interaction of body, garment, and environment, and how new technologies can be used to express the wearer's condition. Although she was used to interdisciplinary collaboration she focused on expression of feelings and emotions, and on creating dresses. The inclusion of biosignal sensors that trigger changes in dresses according to the emotional and bodily condition has been her focus and signature work up to her Sparks residency. The starting conversations[2] about the project and the goal of the Sparks exhibition convinced her to step outside of her comfort zone and move into a new field: to work on the development of a device. A device that is not expressive, but measuring and recording, and can be used as an explanatory for emerging

[2] In this project I acted as a project manager and facilitated and mentored the residencies at Ars Electronica Futurelab.

feelings and emotions. This new challenge led her to connect to her previous experience in dealing with biosignals and the understanding of emotional and bodily condition to create a widely discussed artwork and broaden her scope of working.

Anouk Wipprecht came up with a proposal for a "Unicorn" device that helps children on the autism spectrum, their therapists, and their parents to understand this condition on a more individual basis. *Agent Unicorn*, as it was named by then, should be a playful and fashionable high-tech wearable that measures the wearer's attention span and reacts to changes by recording what is seen or blinking. It became a unicorn-shaped, 3D-printed device, mounted as a headset, including cameras and the possibility for other add-ons, like diverse light-emitting diodes (LEDs). "For me, the project is an instrument that could simplify life for a number of people. I concentrate on children but, generally speaking, anyone can wear this device in order to measure his/her brain activity and draw corresponding conclusions from those measurements," as Anouk Wipprecht points out. As soon as the concept was roughly clear, she reached out to her broad network like Intel and her followers on social media and offered them to join the project team or to test the result. Thus, she got feedback from parents of affected children, neuroscientists, and software developers who were interested in contributing to and testing the outcome. There were the first few contributors who started to think outside their usual routines and tasks (Figs. 4.1 and 4.2).

Fig. 4.1 Designs, measurements, graphs, and tests of *Agent Unicorn* by Anouk Wipprecht during the development process, 2016. (Image courtesy: Anouk Wipprecht)

Fig. 4.2 Screenshot of the teaser video that was released for the online announcement of *Agent Unicorn*. The video was shot by Local Androids, 2016. (Image courtesy: Anouk Wipprecht)

Additionally, Ars Electronica brought her in contact with interdisciplinary contributors to the development and implementation of the project idea into a functioning prototype. In-house competencies like a 3D printing specialist and a human-computer interaction developer and professional partners were brought into the team, like a therapist and neuroscientist from the autism competence center at the Barmherzige Brüder Hospital in Linz, and g.tec medical engineering, a company specialized in the development of EEG (electroencephalography—an electrophysical monitoring method to record electrical activity of the brain; typically, non-invasive, with the electrodes placed along the scalp) monitoring, electrode development, and new systems like brain-computer interfaces. At this time g.tec was in the process of finalizing recently developed electrodes, called g.Sahara, that could be used for transmitting brain activity with the Unicorn brain interface without using conductive gel. This was a big plus, as *Agent Unicorn* should be perceived as functioning fashionable high-tech wearable and should not stigmatize the wearer by giving the impression of a clinical medical device.

The collaboration phase was fun and revealing for the participating parties because they saw their work from a new perspective, had to work outside usual routines, and developed something useful that normally would lie outside their practices. The artist explored the terrain of creating a device that is both fashionable and practical for the first time (and went on exploring this);

the therapist and neuroscientist from the hospital in Linz for the first time got in touch with artistic exploration in his field and with details of the technologies presented. One of his remarks was that although neuroscientists can mainly make use of more detailed data, these new technologies could open up ways for different study designs and pre-studies. Moreover, from his experience as a therapist, this is definitely a good way to bring in new helpful assets to the therapeutic work. The scientific and industrial partner g.tec got in contact with artistic exploration of their products and learned about the contributions new perspectives on their work can bring into the field. The company g.tec went on working with the artist, exploring new approaches to their technologies in hackathons at scientific conferences on brain-computer interfaces, such as events at Science Gallery Dublin or other settings like the Ars Electronica Festival in 2017 and 2018.

Moreover, as Anouk Wipprecht wanted this device to be a functioning tool that is not only fashionable but can help affected people and contribute to therapeutic situations and behavioral analysis, she had to enter much deeper discussions with scientific, technological, and psychological specialists than she usually has in her exploratory fashion-tech designs. It was not only her practice that benefited from the liminal space this collaboration provided. The contributing neuroscientist and therapist, who is specialized in working with children on the autism spectrum, pointed out that although he experienced that children in these conditions are often very interested in new technologies and these new technologies can be used as boundary objects in therapies and to start interaction, from his scientific background, he would not have thought of all these additional possibilities emerging technologies can provide to such a therapy. In the collaboration he found himself in a situation where he had to deal with new artistic approaches to his work and with technologies he did not know of before. The experience during the project phase allowed him to do some thought experiments on research designs and setting up situations in therapies where the device can be useful. This created more than new knowledge; it helped him to open up in a new direction and to think of useful contributions through this collaboration to his work. He pointed to the fact that although neuroscientists need very specific and highest-quality data that is possible for their studies, these technologies and new interaction settings could come up with additional information or add to experimental research design. Although eye-tracking is upcoming in neuroscientific research, playful questions and combinations the artist made are new to him, like the use of depth-sensing cameras, videotaping situations directly triggered by heightened attention-level EEG signals, or face-tracking. In the project he started to become interested in researching these technologies

Fig. 4.3 The first prototype of the *Agent Unicorn* device, 2016. (Image courtesy by Anouk Wipprecht)

and bringing his research group in contact with computer scientists working in this field (Fig. 4.3).

Another main collaborating partner for whom this experience was new and outside of any daily business was g.tec. It is not only that the company went on working with the artist in events after the project; it is also that this artistic use of their technology made them aware of the necessary aspects of the hardware they went on refining afterward. Working on this specific device raised new questions. For example, there was already a plan to make the electrodes smaller than the prototype versions, but now *Agent Unicorn* was challenging them to make the electrodes small enough to enable integration in the 3D print without deconstruction of the design. The hackathons help them to explore new fields and new applications outside their work, which is otherwise focused on neurology.

4.1 Exploration, Learning Processes, and Personal Development

Turner (1974: 78) remarks, "Liminality is both more creative and more destructive than the structural norm." Liminality is destructive, first, because it tends to eliminate formal structures and processes individuals are obliged to in social environments, and thus liminal space allows individuals to act beyond routines, social structures, and other day-to-day business activities; and second, because it is functioning as a threshold concept in which new ways, social orders, and rules can be explored. It is creative because it allows

for exploration and new experiences, and after this phase, the change can be incorporated.

The concept of liminality allows individuals to enter an explorative setting where they can bring in their knowledge and explore skills and knowledge, but are not bound to the social rules of their status or profession: it means openness to exploration of tools and new ways, experimenting with new structures and strategies, or experiencing new perspectives. Liminal phases enable a negotiation of the existing, or an inversion, disruption, or new experiences, and have been explored by organization scholars as productive spaces which are associated with creativity (Swan et al. 2016). In such phases, it is permissible to make mistakes and learn from them without being punished or marked negatively. Without such an opportunity, scientists, for example, probably do not apply seemingly crazy methods, but aim at avoiding mistakes and dead-ends by using well-known experiment designs. Like games, cultural events, and festivities, which are usually associated with liminal space, the space artists and scientists enter in artscience collaboration represents the "latent system of potential alternatives" from which novelty can arise (Sutton-Smith 1972). Similarly, Turner (1974) sees this as a phase in which individuals find themselves when, for example, curiosity leads them to play with new opportunities, phases of creativity, and innovation. Liminality constitutes a secure space that frees individuals from peer pressure and formal restrictions to explore. It is restricted in time and is safe because it can be entered and left. This liminal space does not equal routine work, which can be there at the same time in a parallel space.

Getting out of the liminal space, back in the world of science or art, artists and scientists will be evaluated within the rules and ideas of their respective discipline. Through artscience projects artists and scientists can step into a space where they can explore ideas that would not have been possible within the rules and structures of their respective disciplines. Thus, this space allows for the experience of such extraordinary projects and unorthodox approaches, which fosters learning processes that would not have been possible within the boundaries of their organizations or professional groups. Artscience projects are outside of scientific evaluation schemes, but sometimes engaging in such projects is evaluated as an unnecessary choice. Especially scientists, more young scientists than senior ones among those I interviewed, fear that even taking time for such experiments aside from "real" scientific work will be evaluated negatively—"you can always work more and harder in your field"— or have an effect that slows down their scientific career. Senior scientists mention that even if they support their younger scientific colleagues to engage with art and artists because it is an important learning process and triggers personal and idea development, it takes up much time and thus can negatively

affect the quantity of their scientific output in comparison to other young scientists. And this is often a criterion in scientific hiring processes. In terms of quantitative output this might be true in some cases, but what can be learned in these situations can have a much more positive qualitative effect on future scientific work. Openness, awareness of connecting fields or new opportunities, and other learning effects through exploration of their scientific field with different perspectives can add important knowledge and skills to improve their scientific work. Providing and using free space to explore can be central to leaps in personal development.

Case: Residency Phases of Alexandra Murray-Leslie at SymbioticA and at Autodesk Pier 9
The artist Dr. Alexandra Murray-Leslie, who works on the development of new interactive media in music production like *Computer Enhanced Footwear* and is an experimental musician in the group Chicks on Speed she co-founded with Melissa Logan in 1997, likes to push her work in residencies and collaborations. Her artistic practice employs new technologies from a neutral position, being seduced by them to make them strange, defamiliarize them, and celebrate technology in a more awkward and nonvirtuosic way. To use technologies for her artistic expression, she realizes she never finds the outcomes sufficient and thus she constantly wants to extend the technology and makes adjustments. In her artscience practice, Alexandra Murray-Leslie is collaborating with scientists guided by communal exchange based on their expertise and shared interests to go beyond initially planned ideas. This process of experimentation is "followed by gaining new shared insights and then starting again, finding other new paths and overlappings," she states. "Working in these collaborations extended my creativity and went beyond my expectations of each residency, as being exposed to new scientific techniques and processes have the potential to inform new forms of artistic practice and unexpected opportunities."

During her PhD, in which Murray-Leslie (2018) reflects on her previous and ongoing artscience practice, she had to find "daring micro spaces," as she calls them, where it was possible to do her artscience collaborative prototyping. "There was no way to work [on this] inside the university," she recalls; "there's a lot of control of intellect, machinery and spaces, rules about how one should go about generating new knowledge and commercializing (tech transfer) which is connected to how they approach their fabrication spaces and what is made there. One has to go out and find these daring micro spaces where they'll understand and support your ideas and not try and stop you, like SymbioticA (which ironically is one of the few places inside a university)."

These experiences and exchanges at SymbioticA were very important for realizing ambitious and extraordinary work. The artwork *Sleep Symphony* was an unexpected outcome, and another unplanned collaboration led to her ongoing work on shoes.

Sleep Symphony originated from a collaboration with Shannon Williamson, a fellow artist-in-residence at SymbioticA, in the Sleep Department of the University of Western Australia. Based on her previous experience in the laboratory and her ongoing project, including a sleep study,[3] Williamson showed Murray-Leslie the processes involved in capturing sleep data via various EEG sensors. They discussed the different cycles of sleep, the values and parameters and types of data to expect; they went to the clinical space, watching the sleep studies and collecting the data daily. Inspired by the setting of watching somebody sleep, its surveillance aspect, and of course influential artwork like Andy Warhol's "Sleep," they created *Sleep Symphony* by defamiliarizing the research process and the practice of sleep. Murray-Leslie and Melissa Logan (Chicks on Speed) performed a durational sleep piece in costumes; by sleeping in the laboratory they were "performing the sleep department asleep" while Shannon Williamson monitored them and collected the data. "The data was then mapped to FM sound synthesis and visual effect algorithms, representing sleep in all its dimensions, the project just kept growing until it became an installation of a bedroom in a gallery where people could come and watch us asleep and making music and visual art, we were making whilst asleep, we were creating the *Sleep Symphony*," explains Murray-Leslie. "I really didn't expect to do this piece or my other 5 projects at SymbioticA and its the unknown factor that's always a bit scary and exciting when you start an artscience residency working with scientists you don't know, things are out of control and you have to go with it and trust your intuition that you'll end up making new work, but it just won't be in the way you're used to doing it" (Fig. 4.4).

A chain of events and conversations with artists and scientists in this explorative space then led her to the ongoing work on shoes. It is best to let the artist talk about how this came about:

> *It's funny, we had a conversation, Guy Ben Ari and I, about building a bioreactor inside the heel of a high heeled shoe. He said it is not portable, and I said, well, I need it to be portable as it is in a shoe heel and I'm a performer. From this conversation and further understandings of growing cells to generate electrical impulses to be mapped to sound, I realised the BioArt realm was quite restrictive as far as movability of the living cells went and keeping them alive, which didn't work in my context of flying around and performing on stages, what I do is a lot more spontaneous and*

[3] http://swilliamsonstudio.net/symbiotica-artist-residency-august-decem

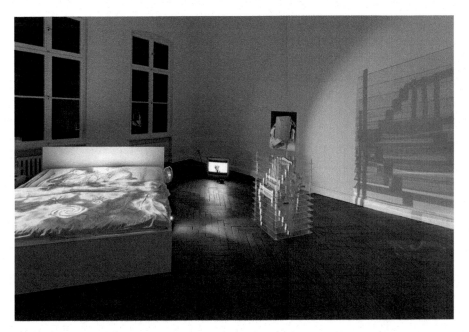

Fig. 4.4 *Sleep Symphony* by Chicks on Speed (Alexandra Murray-Leslie and Melissa Logan), installation view from the exhibition *We Are Data*, by Chicks on Speed, 401 Contemporary Berlin. In collaboration with Dr. Sam Ferguson, Varvara Guljajeva, Mar Canet, and Shannon Williamson, kindly supported by SymbioticA, the University of Western Australia, 2015

body focused. It was an important conversation for us both, Guy went on to build his CellF[4] which he was in the process of doing at the time (which has living cells, is portable, self-contained and actuates sound synthesis). It's a nice example of artists trying to solve problems together by looking at the possibilities from each of other perspectives and the generosity involved. My restraining factor helped me decide not to work with living cells but to focus on the body and this conversation led Oron [Catts] to introduce me to Jonas Rubenson [School of Sport Science, Exercise & Health] who started speaking about body motion and footwear, and his tests on forces of sports shoes on feet and capturing kinesthetic foot models in motion capture labs. As I'd already built a body-centric high heeled shoe guitar and wanted to do a wearable foot instrument this seemed like a good direction to take (to focus on the feet, their motions and get to understand them more from an expert in human movement). This was the start of my practice with on liberation of the feet through computer enhanced footwear in audio visual performance, something I've focused on for the last 6 years and continue with.

[4] http://guybenary.com/work/cellf/

This space to create and experiment did not end in these conversations, but went on in the laboratory and the collaborative work between Alexandra Murray-Leslie and Dr. Jonas Rubens. In the course of this exchange, the scientist could embrace this space the artscience collaboration provided and this led to a free-thinking experimentation: "experiential factors affecting the discovery and making of new types of work," as the artist perceived. "Everything in Jonas' lab became like an artistic opportunity of the feet and his lab was the stage." Based on the development of the first prototype of *Computer Enhanced Footwear*, a second collaboration as artist-in-residence at Nanyang Technological University (NTU) Centre for Contemporary Art in Singapore with trans pole dancers emerged that led to the second prototype. The third prototype was built during the residency at Autodesk Pier 9 in San Francisco (Fig. 4.5).

At the Autodesk Pier 9 residency, the interdisciplinary studio-like space equipped with state-of-the art technology and an open culture for collaboration outside of usual work routines and tasks created an inspiring space. Being exposed to weekly "open-shares" with peer artists-in-residence, including Autodesk employees (engineers, inventors, scientists, cultural producers, and

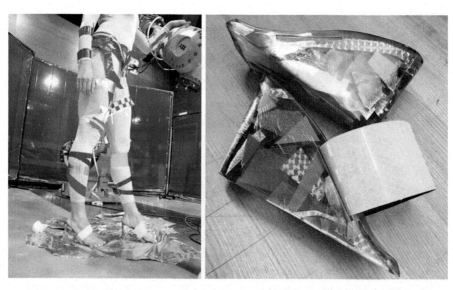

Fig. 4.5 Left: *Computer Enhanced Footwear Prototype 3* by Alexandra Murray-Leslie, worn by dancer Elizabeth Bressler in the music video *We Are Data Remix* (by Chicks on Speed and Cora Nova; music video directed by Alexandra Murray-Leslie, and makeup by Robert Marrast @ MAC Cosmetics). Shot on location at Octolab, Pier 9 Technology Centre, Autodesk, San Francisco, 2016. Right: *Computer Enhanced Footwear*: prototype depicting the final artifact using the process of additive print process of embedding Mylar in every 100 slices of the 3D print. Pier 9 Technology Centre, Autodesk, San Francisco, 2016

curators, and shop staff) enables intense exchange and fast development of ideas. An ethos of pushing things to the limits, deep thinking, and sharing leads to unexpected outcomes and artistic opportunities. At the same time, this culture provided a safe space to experiment and learn unexpected methods without fear or reservation. "If you're around inventors and artists who like to take risks and really go for it, then you'll also take risks, but alone, I think I'd get lazy. [...] the people and energy of the place is so electric, it's contagious, you think way more beyond your own horizon as you learn more about tools and software and how to break them...in a positive way of course," Alexandra Murray-Leslie points out. This is true for artists, scientists, engineers, and other professions.

In the collaborations with experts from different fields for the planned project *Computer Enhanced Footwear Prototype 3*, Alexandra Murray-Leslie ended up exploring methods and materials than she initially intended to. But the process even went beyond her expectations by collaboratively inventing a new material during a 3D printing process by embedding different materials in the print slices that created new multicolored effects. All these additional outcomes and side projects are based on the intense collaboration with people from different backgrounds who wanted to engage in such an extraordinary project.

Such space allows for experimentation with unplanned projects with collaborating partners with other disciplinary backgrounds, which again informs the own practices and enhances project goals. Alexandra Murray-Leslie goes on to explain that "one's ideas, skills of making and prototyping is tested not only in talk at meetings with co-resident artists and technologists, but also through richer bodily, social and playful imagination and experimentation that goes on in the making process," like in her side project during the residency with peer artists-in-residence and engineers. These enhanced the process and helped to spot problems and identify opportunities. The collaborations initiated an additional side project during the residency that involved more than 40 people at Autodesk and friends, a video for the Chicks on Speed song *We Are Data Remix* (Fig. 4.6).

Being trained as a painter, as a molecular biologist, as an economist, or as an astrophysicist and working in the respective professional system does require certain procedures, crafts, and perspectives in problem-solving and idea development. If somebody only lives in this environment and trains again and again these procedures, the necessary knowledge and skills will be perfected—which is even depicted in the growth of neuronal connections visible in the brain. But, at the same time, other strategies and perspectives will be forgotten and impeded. New experiential spaces that allow play aside from

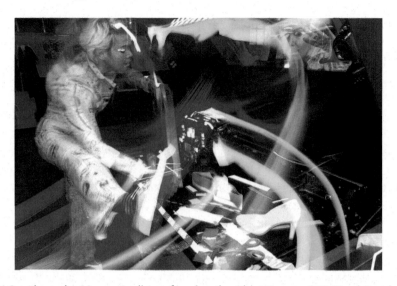

Fig. 4.6 Alexandra Murray-Leslie performing the Objet Connex 500 3D printer during fabrication of *Computer Enhanced Footwear Prototype 3* by Alexandra Murray-Leslie and Steve Mann. Image depicts a lens-based representation of the performative printing process, where Mylar was inserted into every 100 print filament slices and taped elements were added to the print bed "stage." A cyborg craft collaboration between Steve Mann and Alexandra Murray-Leslie, 2016, Pier 9 Technology Centre, Autodesk, San Francisco

professional "monocultures" and foster interdisciplinary experimentation help to open up and support the learning of new skills—and regrow structures and trigger personal development, for example, being more open in the work processes. In a liminal space, learners can work their way to new states of knowing, seeing, and being (Kabo and Baillie 2010). Although they can move from one perspective to another, the experience, and what has been learned in a threshold experience, is unlikely to be unlearned. In the case of artscience collaboration, liminal space helps to grasp difficult concepts that transcend disciplines (Savin-Baden 2016).

Organizational scholars (Wall and Englert 2016) argue that liminal space is important for project teams as fertile ground to develop knowledge and ideas. The case of Anouk Wipprecht's Sparks residency project *Agent Unicorn* shows how the liminal space created in such a project enables contributors to explore new perspectives and integrate new technologies in their work. The contributors brought in their skill and knowledge to develop a functioning version of *Agent Unicorn*, but they could additionally explore their own knowledge and technologies in relation to other fields and learn about new applications. Afterward, they were able to incorporate some ideas from this exploration into the understanding of their own work, as

they experienced these newly explored ideas as value added. They could explore this playfully and test new ideas before they decided on incorporating them.

When Turner (1974) explores the liminal and the liminoid in context with the concept "play," he shows how this phase enables ludic structures in exploration and recombination. Individuals deprived of restrictions and necessities can "lose their ego," can become self-aware, and allow themselves to focus on skills and ideas. Play is fundamental to exploratory processes and innovation, as it questions pre-existing perspectives and allows for experimental recombination of knowledge or practices (Turner 1982). This requires engagement, especially at a level of interaction where values, understandings, and beliefs are at stake. Only by believing in the process and experiences can new knowledge be incorporated. Play can be understood as intuitive, subversive, and unpredictable; it involves interaction, ambiguity, inversion, disruption, and understanding through experience. Through this, liminality fosters deviation and creativity.

Such a fresh view, experiments with new methods which otherwise would not have been used, and new questions about the subject of the scientific research itself can be raised by projects outside of the daily laboratory routine. This is beautifully visible in Sarah Craske's residency at the ETH Bioprocess Laboratory in Basel, as presented in the previous chapters on collaboration processes on complex issues and contextualization. More specifically, in the part of her project where she conducted experiments in the Category 2 laboratory that is not usually used, as the scientists did not think it would provide methods directly related to their scientific goal, the outcome of her experiments contradicted the scientists' assumptions about the cells' behavior: some cells died in a stadium where they were not predicted to and the process was not as linear as it ought to be. This raised important questions about basic assumptions and theoretical ideas that would not have been raised otherwise. It is not that the scientists only thought about that because the artist thought to use it, but the scientists are bound to deadlines and pressure to produce outcomes, and have to publish their results. Therefore, they obviously use those methods that most likely produce an outcome, which are well-tested in the field or best satisfy the necessity of reproducibility in scientific experiments. So they did not take the time to explore this specific method. Often there is neither time nor room outside of such collaborations to apply ideas that are perceived as uncommon or weird within the own scientific community.

Effects of artistic initiatives and such collaborations can be very subtle, are difficult to measure, and not always directly traced back to a specific interaction, but it is an interesting aspect to see how self-reflective practice of a scientist after such a liminal situation leads him to identify the new experience

as at least partly a trigger of this new openness and development in his professional work. The unstructured state of liminality can be seen as the precursor of innovative normative forms and as a source of new culture (Turner 1974), as new ways of doing and thinking can be incorporated after the liminal phase, as the antimatter physicist did.

4.2 Rituals, Disruption, and Change

The concept of liminality emerged as an explanation of the phases during rituals that mark thresholds: first, there is the phase of separation (divestiture), which initiates a ritual, for example, the rite of separation of an individual from the group; second, there is the phase of transition (liminality), which represents the passage itself and is constituted as a phase in-between; and third, there is incorporation (investiture), which represents a rite of reintegration into the group (Van Gennep 1909).

Rituals, stories, and practices that express that the liminal space has been entered help to adjust to this space and act freely. Symbols play an additional role in the rites of separation and incorporation (Turner 1974). Using symbolic and performative action helps artists and scientists who have not experienced artscience collaboration before to enter the liminal space. It helps others to understand that this experience is disconnected from "normal" professional work. Afterward, materials and outcoming artworks can be used as powerful objects for remembering change, or the own learning process, and are symbols of the change as witnesses of the transition (Macho 2004). Boundaries have been crossed, but not all of them will be reinstalled afterward. Rituals and ceremonies dramatize the transition for participants and spectators.

Seen as a disruption and an initiator of change, artscience collaboration is a powerful concept as something outside everyday life and professional routines. It is the dual character of liminality in distinguishing between this space of exploration and the profane daily work that enables play and creativity, but also harnesses anxiety (Turner 1974). Even in long-term collaboration this means that there is value in understanding how the artscience collaboration can enable new perspectives as something outside of professional necessities, where both artists and scientists keep being aware of their own professional goals. If the boundaries get blurred and goals of the project in the liminal space get mixed up with professional goals, anxiety in professional work rises, too, and at the same time, the free spirit of the liminal that is necessary for the experience will be restricted.

Observing the visible signs and phases of incorporation after liminal space, organizational scholars concluded that this is the least developed phase in working situations or project work that is experienced as liminal. Phases of incorporation or signs of leaving the liminal space are often missing (Czarniawska and Mazza 2003; Eriksson-Zetterquist 2002). Also, research on other artistic interventions in organizations found that such projects are likely to be ephemeral if there is no space afterward to reflect and incorporate what has happened during the intervention (Berthoin Antal and Strauß 2016; Schnugg 2011). Artifacts from the artistic intervention, as it is argued in the theory of liminality and rites of passage, help to recall the experience and questioning of routines or mind-sets. This supports the change process and makes it last. Reflection after the liminal experience that allows the incorporation of new ways of seeing and doing in one's own routines is important in artscience collaboration. Taking time to incorporate what was learned in the professional routines can lead to change in practices and approaches to the work, and maybe even to organizational change.

The experience of disruption and how reflection on it can change thinking processes and create new insights will be further discussed in the chapter on sensemaking.

References

Berthoin Antal, A., & Strauß, A. (2016). Multistakeholder Perspectives on Searching for Evidence of Values-Added in Artistic Interventions in Organizations. In U. Skoldberg, J. Woodilla, & A. Berthoin Antal (Eds.), *Artistic Interventions in Organizations: Research, Theory and Practice* (pp. 37–59). London/New York: Routledge.

Czarniawska, B., & Mazza, C. (2003). Consulting as a Liminal Space. *Human Relations, 56*(3), 267–290.

Eriksson-Zetterquist, U. (2002). Gender Construction in Corporations. In B. Czarniawska & H. Hopfl (Eds.), *Casting the Other: Production and Maintenance of Inequality in Organizations* (pp. 89–103). London: Routledge.

Garsten, C. (1999). Betwixt and Between: Temporary Employees as Liminal Subjects in Flexible Organizations. *Organization Studies, 20*(4), 601–617.

Howard-Grenville, J., Golden-Biddle, K., Irwin, J., & Mao, J. (2011). Liminality as Cultural Process for Cultural Change. *Organization Science, 22*(2), 522–539.

Johnsen, C. G., & Sørensen, B. M. (2014). 'It's Capitalism on Coke!': From Temporary to Permanent Liminality in Organization Studies. *Culture and Organization, 21*(4), 321–337.

Johnsen, C. G., Prashantham, S., Floyd, S. W., & Bourque, N. (2010). The Ritualization of Strategy Workshops. *Organization Studies, 31*(12), 1589–1618.

Kabo, J., & Baillie, C. (2010). Engineering and Social Justice: Negotiating the Spectrum of Liminality. In R. Land, J. H. F. Meyer, & C. Baillie (Eds.), *Threshold Concepts and Transformational Learning* (pp. 303–315). Rotterdam: Sense Publishers.

Lefebvre, H. (1991). *The Production of Space*. Oxford: Blackwell Publishing.

Macho, T. (2004). *Das zeremonielle Tier. Rituale – Feste – Zeiten zwischen den Zeiten* [The Ceremonial Animal: Rituals – Feasts – Times Between Times] St. Stefan: Styria.

Murray-Leslie, A. (2018). *Artistic Methods with Computer Enhanced Footwear: Through Iterative Design Processes and Audiovisual Theatrical Performance*. PhD Thesis, University of Technology, Sydney.

Powley, E. H. (2009). Reclaiming Resilience and Safety: Resilience Activation in the Critical Period of Crisis. *Human Relations, 62*(9), 1289–1326.

Savin-Baden, M. (2016). The Impact of Transdisciplinary Threshold Concepts on Student Engagement in Problem-Based Learning: A Conceptual Synthesis. *Interdisciplinary Journal of Problem-Based Learning, 10*(2), 3.

Schnugg, C. A. (2011). *Setting the Stage for Something New*. Proceedings of the 6th International Conference on the Arts in Society, Berlin.

Sutton-Smith, B. (1972, December 1). *Games of Order and Disorder*. Paper Presented to Symposium on "Forms of Symbolic Inversion." American Anthropological Association, Toronto.

Swan, J., Scarbrough, H., & Ziebro, M. (2016). Liminal Roles as a Source of Creative Agency in Management: The Case of Knowledge-Sharing Communities. *Human Relations, 69*(3), 781–811.

Turner, V. (1966). *The Ritual Process: Structure and Anti-structure*. Ithaca: Cornell University Press.

Turner, V. (1974). Liminal to Liminoid, in Play, Flow, and Ritual: An Essay in Comparative Symbology. *The Rice University Studies, 60*(3), 53–92.

Turner, V. (1982). *From Ritual to Theatre: The Human Seriousness at Play*. New York: Performing Arts Journal.

Turner, V. (1987). *The Anthropology of Performance*. New York: Performance Arts Journal Publications.

Van Gennep, A. (1909). *Les rites de passage* [Rites of Passage, 1960]. London: Routledge and Kegan Paul.

Wall, P., & Englert, J. (2016). Business Ethnography: Including Liminality in Pursuit of Innovation. *Journal of Business Anthropology, 2*(2016), 58–76.

5

Social Networks

A very practical occurrence that artists and scientists experience frequently in artscience collaboration is the new and often surprising connections artscience collaboration can create: within the own field, within related fields, and between the disciplines. For example, artist Anna Dumitriu, who experienced residencies in many scientific institutions, referred to her scientific network as valuable for her scientific partners. On the other hand, scientists can establish new connections for artists, and it is interesting for organizations (corporations and laboratories) to explore artscience collaborations for creating new intra organizational connections or potential projects with new organizational partners.

This underlines the basic understanding that artscience collaboration brings together different worlds and groups of people who would under typical circumstances not get in touch with each other: it connects individuals with different backgrounds, creates opportunities for exchange about ideas and topics, and allows a glimpse into new communities one probably would not encounter otherwise. Thus, naming networking as an essential part of artscience collaboration comes quite naturally. Social network theory enables important insights into this process. It focuses on the individual and reflects on organizations and disciplinary fields; it goes beyond individual relationships and allows an understanding of connections in formal and informal structures, how they are used, and how to bridge the gaps between fields. Social network theory helps to understand how people are connected and how these connections, for example, heighten job opportunities, allow individuals to support each other, create insights into new developments, and

enable knowledge sharing and creativity. In this sense, networking per se is something that can push careers or foster innovative projects.

Networks are dominating discussions of our time, as they can be used to describe structures of a set of units and the connection between them: from online social network platforms to terrorist networks, from networks between organizations within a market to technological networks or biological networks. Basically, networks are defined as consisting of "nodes" and "ties." Nodes are the units or actors in the network, which can be individuals, groups, or organizations. Ties are the connection between the units, which can take many forms: from a connection on an online platform to personal relationships which are not technologically mediated. Ties in networks are described as linkages, which can be one- or bi-directional, but multilateral, that is, between at least three nodes. They can come in diverse strengths: strong or weak ties representing close or less close relationships, respectively. Networks are unlike hierarchical structures or free market forms, as ties in networks are based on trust and reciprocity (e.g., Granovetter 1973, 1983).

Due to this abstract view on social connections that implies a neutral reflection of connections between nodes, no matter if scientist, artist, or corporation, social network theory has been proposed as an important approach to reflect on artscience collaboration. It does not ask what art can do for science or what science can do for art (or organizations), but it shows how establishing new connections creates potential (Scott 2010).

5.1 Creating Bridges: Connecting People, Connecting Fields

Networking basically means that individuals get in contact with others and establish a certain kind of relationship. This new relationship can connect insights for valuable exchange, people with different backgrounds, and two distinct network nodes that have many other connections. These other connections can be even more relevant for the new relationship than the new person with whom the contact is established. For example, people who move to a new place, socialize in their new environment, and build up a local social network. By that they actively expand their existing network and create a connection between their old and the new network. These new connections spark ideas by bringing together complementary knowledge, resources, and opportunities. Adding relations to different disciplines like art and science and social groups, network connections enable reflection of visions from distinctive backgrounds. Through social network theory it is possible to grasp

how people interact and connect fields, and to learn about how connections help to understand different modulations of sense and meaning. Malina points out that "[a]lthough scientific knowledge is 'universally applicable,' its cultural context is not neutral" (2006: 287). For example, the outcome of a scientific experiment has different implications in different science-producing fields and stakeholder groups. It is only possible to include the different contexts if knowledge about the different perspective exists, which can be added by interacting with people from the respective groups.

5.1.1 Natsai Audrey Chieza Networking at Ginkgo Bioworks: The First Iteration of Ginkgo Creative Residencies

The artist Natsai Audrey Chieza explained that there were two main dimensions of networking on which she focused during her residency. First of all, she had to build her own local network from scratch on her arrival in Boston. Simply the fact that she started to reach out to people, organizations, and groups who are interesting for her and her work as a designer in the field of biotechnology already led to loads of meetings and opportunities. Second, she wanted to connect her network and Ginkgo Bioworks, start conversations, and create collaboration and exchange opportunities. These possibilities can manifest as new projects or as better mutual understanding of the fields—and the society's understanding of the interaction of art, design, and biotechnology.

As first artist-in-residence at Ginkgo Bioworks invited by Christina Agapakis, Natsai Audrey Chieza wanted to establish structures and an interesting format that supports future artists- and designers-in-residence at the company. At the same time, she wanted to showcase possible contributions of residency programs to the company through her own project during the residency. She created opportunities like meetings and discussions to bring people from her network and the company in touch. Therefore, she used her meetings with interesting people as a networking platform to invite representatives from Ginkgo Bioworks and introduced her network to the corporation. Reflecting on initiating meetings, some of the networking situations probably would have come naturally with her position as an "outsider," as a new network node bringing her own contacts. Especially because she is working at the intersection of design and biotechnology, connection of people with different backgrounds is inevitable. This is where she feels that the most interesting stuff is happening. Natsai Audrey Chieza finds herself as a "bridge between

spaces." In this role she enables communication between design, biology, and technology, understands the different arguments and points of view, and can bring them into a dialogue. This conversation includes society and reflections on how design and biotechnology can make these new developments work in society. This work ended up in the creation of the Ginkgo Bioworks Creative-in-residence program that opened the opportunity for residencies at Ginkgo Bioworks for the next artists or creatives from 2018 onward.

Aside from the interdisciplinary conversations, Natsai Audrey Chieza pursued her own residency project at Ginkgo Bioworks. As artist and designer working with bacteria to dye fabrics, she developed processes and strategies to use the bacteria *S. coelicolor* to create a certain kind of aesthetics. Based on her previous experience and work with this process, the residency project aimed at scaling the processes in an industrial environment. As four steps of her residency she defined: scaling cell count for the production of up to 5 meters of patterned fabric; designing tools and protocol to produce large-scale engineered prints; designing tools and protocol to create coherent print formation on the world's first garment, specifically pattern cut to be dyed by *S. coelicolor*; and making progress on the engineering of *S. coelicolor* to make more pigment by collaborating with two scientists at Ginkgo Bioworks (https://www.ginkgobioworks.com/2018/04/11/creative-in-residence/) (Fig. 5.1).

Naturally, the artist was interested in getting to know people at her new residence, where she would stay for the upcoming few months. So she was exploring

Fig. 5.1 The world's first garment pigmented by *Streptomyces* bacteria was designed with a new approach to pattern cutting for in-vitro dyeing. (Credit: Assemblage 001, Ginkgo Bioworks × Natsai Audrey Chieza (Faber Futures) Residency, 2017. Photographer: IMMATTERS Studio. Image courtesy: Natsai Audrey Chieza)

the local professional field(s) that is connected to her interdisciplinary artistic interest she aimed to push with projects on-site. Even as a newcomer to Boston, she was invited to interesting networking conversations between local agents for her perspective on art and biotechnology, on how design and biological fabrication processes on an industrialized scale can be integrated, as well as how these new developments can be made to work and be communicated in society. From her distinguished perspective to that of Ginkgo Bioworks, she approached new local players and brought them together. It is important to note that her network building was led by her interest and what she thought is important for pushing her own projects, and by her previous experience and knowledge on design practices and her design practice in blurring the boundary between art, design, and biotechnology. Bridging gaps between different fields of science, art and science, or cultures creates advantages through knowledge about nonredundant information, new ideas, and different perspectives, which are associated with heightened openness and creativity (Perry-Smith and Mannucci 2015), and alters possessed cultural metacognitions, changes the awareness of distinct cultures, and supports the tendency to adapt as well as the ability to learn (Chua et al. 2012). Building on this, networking behavior in the field of art and science does more than enabling chances; it leads to personal changes and cognitive development, and supports insights from different perspectives.

Enlarging the network through new connections, especially between fields, locations, and social groups, creates access to nonredundant knowledge or perspectives. The concept of tie strength argues that network actors can be connected strongly, like close friends, close family, or frequent business partners who operate in the same field, or weakly, like acquaintances, people you regularly meet only on a business trip once a year, or loose contacts within an organization with less frequent interaction than with your direct colleagues. Strong ties are characterized by more frequent interaction and higher affection than weak ties; moreover, close contacts tend to know each other and form cliques which tend to have similar information and are more likely to support each other. Weak ties are often associated with bigger network sizes, as they do not need as much maintenance as strong ties. As Granovetter (1974) showed in his famous study on how to get a job, a higher number of weak ties tends to be helpful in gathering a greater diversity of information, which eventually leads to a higher chance of getting to know about a job opening. Aside from the information benefits of strong and weak ties, networks allow access to social capital and the formation of new ties can lead to broadening one's social capital as it connects to a new set of network actors (clique) who previously have not been part of one's network (Burt 1997). Individuals who build bridges between otherwise disconnected individual nodes or cliques are closing "structural holes." Structural holes (Burt 1992) refer to situations in which there is no connection between two people or cliques.

Artists and scientist working on the borders between art and science can serve as bridges between different networks. The artist Natsai Audrey Chieza was building bridges in conversations by talking to people from different fields like art, design, and biotechnology. Through her experience with these diverse fields and people that created insights into work practices, conversational practices, and beliefs held, she can establish further connection, bridge gaps between the fields, and initiate conversations. By bridging structural holes, she has an information benefit about what is going on and which interesting actors in her network exist, and thus she can point collaborators to new sources or other persons who have relevant information and skills.

Artscience collaboration that connects different fields can overcome network actors' tendency to bond ties with similar actors, like the proverb "birds of a feather flock together" suggests. The underlying principle, called the homophily principle, explains that networks are often homogeneous in different respects, like sociodemographic, behavioral, or other intrapersonal characteristics. There is even evidence that individuals connected via strong ties tend to assimilate some characteristics (McPherson et al. 2001). Behavior, interests, and environmental or educational factors can play a role in the formation of a personal network. Especially within professional groups like scientific groups, where networks within the own occupation are very important, it is no surprise that individuals tend to focus on such network connections. Incoming extraordinary connections to other fields bring in more heterogeneous network relations. Sometimes these heterogeneous connections are even represented by scientists that work in neighboring fields, as the following case displays.

Case: Anna Dumitriu—*Make Do and Mend*
One of the most collaborative works of Anna Dumitriu is *Make Do and Mend*, a collaboration with the Synthetic Biology Laboratory for the Decipherment of Genetic Codes, Technion, Israel, with Dr. Sarah Goldberg and Dr. Roee Amit as part of the MRG Grammar research group (Massive Reverse Genomics to Decipher Gene Regulatory Grammar), with additional advice from and in collaboration with Dr. Heather Macklyne, University of Sussex. The project stemmed from Dumitriu's work with Dr. John Paul, Dr. Nicola Fawcett, Dr. James Price, and Kevin Cole as part of Modernising Medical Microbiology and led on to her work with Dr. Rob Neely and the BeyondSeq research group. In this project, Anna Dumitriu uses new scientific methods (CRISPR) to repair a bacterium back to a historic point before the antibiotic age, by removing the antibiotic resistance gene, and patching the break using homologous recombination with a fragment of DNA encoding the WWII slogan *Make Do and Mend*. She uses the British expression "make do and mend," referring to the clothing and commodity restrictions during

WWII, where clothes and other items were rationed and had to be repaired instead of thrown away. Moreover, referring to "Controlled Commodity 1941," she refers to the label given to items of clothing that were considered a good use of resources. In the project, suits and dresses from this time labeled "Controlled Commodity 1941" are patched with fabric infused with the CRISPR-edited bacteria that are no longer antibiotic resistant. At the same time, this date refers to the first use of penicillin in human patients in Oxford by Howard Florey and Ernst Chain, the start of the antibiotic age as we know it (Figs. 5.2 and 5.3).

Fig. 5.2 *Make Do and Mend: Controlled Commodity* by Anna Dumitriu, 2017, an installation view including other work by Anna Dumitriu. *Controlled Commodity* to be seen in the center of the image. *Controlled Commodity* incorporates an original garment from WWII labeled "Controlled Commodity," which is patched with bacteria-infused material. The recently developed antibiotic resistance is edited out of the bacteria's genome. (Image courtesy: Anna Dumitriu)

Fig. 5.3 *Make Do and Mend* by Anna Dumitriu, installation detail, 2017. (Image courtesy: Anna Dumitriu)

Anna Dumitriu's work is driven by her interest in microbes, antibiotic resistance, bacterial diseases, and the sublime, fusing craft, technology, and bioscience. Driven by her interest in exploring the relationship of the microbial world, biomedicine, and technology in her artistic practice, she started to work with laboratories in biology, life, and computer sciences in the early 2000s. In the course of her residencies and collaborations with scientific partners, she made the experience that her collaborating partners introduced her to other laboratories because these were specialized in a technique she wanted to use in her art, or who dealt with her interests in a related scientific field. For example, she was introduced by her partners in the MRG Grammar research group to Rob Neely, who is leading a lab in biophysical chemistry, focusing on the development of new ways to study biological systems using fluorescence spectroscopy and imaging. At the same time this kind of networking, where individuals get connected through a network and start collaborative action, is equally interesting for scientists who work with artists: Rob Neely told me in an interview about the project with Anna Dumitriu that a major benefit for his future development was getting in touch with Dumitriu's network in diverse scientific fields that connect to his research interest. She introduced him to a research group that could be interested in techniques he is developing with his research groups or is approaching similar topics from a different perspective. There he also sees potential for future collaboration or exchange of experience.

Artists can use the new connections and relationships they build up in the new environment of the laboratory to forge new paths in their careers and take next steps. As Irène Hediger tells about her experience with the Swiss Artists-in-Labs program, where she is Co-Head and Curator: "There are artists that come back to me and tell me that new ways opened up for them in their career and that they were able to successfully engage the new contacts they made through their Artists-in-Labs residency for future work."

Depending on the kind of information individuals aim to gather, others will or won't share it with weak ties, there are less direct opportunities that can trigger an exchange, and information that comes from strong ties is often understood to be superior, for example, because strong ties are believed to be trustworthy (Anderson 2008). So if artists like Anna Dumitriu have strong relationships with different scientific laboratories, the scientific partners can gain trust in their conversation to exchange ideas more freely. Additionally, nodes that are well-connected with numerous network ties and who therefore occupy a central network position can be predicted to be more likely to be more active in knowledge sharing and have more opportunities to gather information (Burt 1992). Artists or scientists who are experienced in crossing the borders between fields occupy a central network position. In this position, they can more easily start projects by connecting people from their network and reach out to them with requests that are viewed as interesting because central nodes are seen as credible sources for feedback, information, or links to valuable resources (Tsai 2000; Ashford et al. 2003).

In contrast, individuals in a less centralized network position, like individuals with now relevant connections outside of their field in art or in science, are cut off from some important information flows. Therefore, building up relationships in another field is far more difficult for those in a less centralized network position without strong ties to relevant people in the respective field. Moreover, the reputation of those connecting network nodes and those gaining access to a new clique plays a role: somebody in a central network position with a bad reputation is less likely to establish new collaborations (Shane and Cable 2002). In contrast, if a node's collaborations and interactions with others are well-received and interesting for many, this raises the chance that in the preparation for new projects, direct network partners will be willing to collaborate.

5.2 Influences on Putting Opportunities into Action

The structure of networks, defined by tie strength or network positions, can set the course for opportunities, but existing connections between individuals are not always enough. The network structure creates the possibility to access key forms of social capital like information, but to materialize social capital effects, individuals have to act, wherein agency and motivation play a central role. Social ties can enable communication, mutual support, and identification of opportunities, or offer possibilities for cooperation, but do not force individuals to get in touch. There is evidence that people have varying ability to capture the social capital inherent in their networks, whereas others can more easily work on their network structure and change their position (Reinholt et al. 2011; Burt et al. 1998). Homophily and power structures, for example, might influence this ability (Ibarra 1992). Other factors such as knowledge, the role of personality traits, motivation to gather or share information, and willingness to get in touch with others eventually influence the ability to act and approach network resources. Central personality traits to make use of the opportunities in a network are as follows: need for cognition, openness, and personal interest. Need for cognition is defined as an individual's tendency to engage in and enjoy effortful cognitive activity. People with a strong need for cognition tend to engage in thinking deeply about problems, which others might think of as completely irrelevant. Openness is important to allow new perspectives and be willing to let others contribute. Personal interest in the topics provided is a major boost for motivation in engaging in information exchange and collaborative work. This personal interest is triggered by the need for cognition, future occupational goals, and feelings: the prospect of fun and the possibility to experience something rewarding can be teasing (Reinholt et al. 2011). This perspective shifts the focus from potential opportunities and existing diversity of information to realized opportunities (Adler and Kwon 2002).

Willingness to realize opportunities, interest in new forms of collaboration like artscience collaboration, recognizing the value of an interdisciplinary network for the own work, and traits like openness can be learned through experience of previous collaborations. Successful interdisciplinary projects can lead to shared goals, recognition of opportunities, and eventually to ongoing collaborative projects (Jiang et al. 2015). The experience supports learning and creates fertile ground for each node in the network, which might spark new ideas (Perry-Smith and Mannucci 2015). It initiates understanding of other perspectives, which allows people to open up to input from other points

of view. The collaboration demonstrates to each actor that it is possible to take information and ideas from the interdisciplinary encounter that are relevant for them to pursue their own goals (artistic, corporate, scientific, societal). So the interest in joining further collaborations grows. After all, my interview partners—scientists as artists or intermediaries—tend to point at least once to the fact that the artscience project was fun. It was fun interacting; it was rewarding to see a project developing or the exhibition of the outcome. And this is something that motivates for future activities in the field of art and science.

Experience in artscience projects has been reported to have affected professional lives and the approach to new projects: scientists and artists are more likely to stay active in pushing the boundaries of their field by including new colleagues. For example, the antimatter physicist Dr. Michael Doser is engaged in the arts and educational programs at CERN (like the artist-in-residence program Arts@CERN), the European Organization for Nuclear Research. He mentioned that his interactions helped him become more open and to look beyond his expertise in designing research projects. More specifically, since then, he has observed that research ideas have popped up in his planning phases that require expertise from different fields and real collaboration between these different scientific backgrounds. Thus, he has been looking out for possible project partners in neighboring fields since then. As he explains:

> This happened in a project to apply quantum chemistry to the interaction between antiprotons and specific types of molecules. Another similarly interdisciplinary project, also requiring involvement of chemists as well as plasma physicists, is to investigate the possibility of indirectly cooling antiprotons through two layers, one negatively charged, acting as a buffer, and the second one positively charged, and which can be cooled by lasers. Looking for an appropriate negatively-charged system that could play this role led me into the field of super-halogens, and the question of how such molecules interact with positive ions. Both topics lie far beyond my expertise and, interestingly enough, intrigued those experts that I contacted (Fig. 5.4).

Scientists who are engaged with the Art|Sci Center at UCLA report the opening of their work to other scientific fields that provide valuable perspectives. They like to be included in the artists' other projects or reach out to the collaborating artist's scientific network to broaden the scope of their research. The evolutionary biologist Professor Dr. Charles Taylor, who is a specialist in bird songs and complex systems, is a scientific collaborator of the media artist Victoria Vesna in the artscience project "Bird Song Diamond" along with Takashi Ikegami, PhD, who is a professor in General System Sciences focusing on complex systems and artificial life; Reiji Suzuki, PhD, specialist

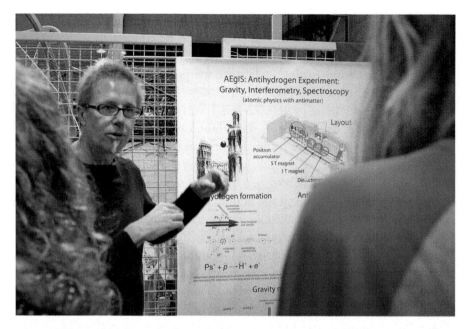

Fig. 5.4 Michael Doser explaining his work at the antimatter facilities during an introductory visit of artists before their residency at CERN, 2015. (Photo credit: Claudia Schnugg)

in analysis of bird songs and evolution of languages; and Itsuki Doi, specialist in sound composition and programming. The artscience project focuses on the evolution of bird song. Based on Taylor's National Science Foundation (NSF)-funded research—"Acoustic Sensor Arrays for Understanding Bird Communication"—this project included the development of devices and algorithms for locative sensing of bird song in the field, the creation of an annotated bird song database, and automated classification and annotation of bird song. The artist was inspired by the scientists mimicking and attracting birds with digital recordings, creating an interspecies communication. This resulted in the more open-ended, habitat-specific installation that allowed participants to grapple with both audition and vocalization of bird song. Audiences are introduced to the complexity of bird song language, which is further complicated with mechanical birds (drones) and human/machine language assessing the level of competency. In past iterations, the system could be used either individually or collaboratively. Through observations and more direct experimentation, the collaborators found that having two participants at a time engaging in a "call and response" is more effective for deeper engagement and understanding of listening to the diversity of bird song. Charles Taylor points out that this project led to new interdisciplinary constellations in projects and fruitful

 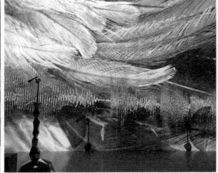

Fig. 5.5 Left: Victoria Vesna testing interactive elements of *Birdsong Diamond* at the Large Space, University of Tsukuba, 2016. Middle: a still of the *Birdsong Diamond Mimic* presentation at the Ars Electronica Festival 2017. Right: detail of the interactive element of *Birdsong Diamond Mimic*. (Photo credit and image courtesy: Victoria Vesna)

interaction between him and scientists from fields and laboratories he had not been collaborating with before. This is also already reflected in a row of publications coming out of this newly formed team.[1] Moreover, he has been included as expert consultant in other projects at the Art|Sci Center, which made connected him to new scientific and artistic teams at UCLA and internationally (Fig. 5.5).

Other scientists at the Art|Sci Center report similar dynamics after their participation in a first project there. Namely, Dr. Olivia Osborne and Dr. James Gimzewski report the multilayered strong and weak ties they build during this kind of work to other laboratories at the university or internationally, and how they start to become involved in new projects or as consultants on specific questions in artscience projects within or even beyond their fields.

Although network structures exist, the strength of ties might change over time: ties can become dormant and communication patterns of individuals alter. These frequent changes cause permanent evolution of the associated social and communication network of individuals. It is enough to have a few ongoing strong ties to have a positive effect on the persistence of a community (Palla et al. 2007). Thus, long-term collaborations or centers for artscience collaboration are important for sustainable work in artscience because they help to form such strong ties that keep up an ongoing exchange between the fields.

[1] http://birdsongdiamond.com/publications/

From a social network perspective, new contacts and collaboration opportunities can be seen as beneficial for the artist, as they are for the organization and other actors like scientists and engineers. At the heart of social network research lies the idea that "actors are embedded in networks of interconnected social relationships that offer opportunities for and constraints on behavior" (Brass et al. 2004: 795). The exchange between fields shows that new perspectives or alien disciplinary contexts can reduce the effectiveness of ideas in a field and can point to completely new opportunities by fostering creativity and inspirational interdisciplinary conversations (Perry-Smith and Mannucci 2015). As Burt (2004: 349) suggested, "people who stand near the [structural] holes in a social structure are at higher risk of having good ideas" because "people connected across groups are more familiar with alternative ways of thinking and behaving, which gives them more options to select from and synthesize." This can overcome a negative effect of homophily found in disciplinary exclusive networks: people who stay within their own group tend to adapt similar behavior and more homogeneous ways of thinking. Therefore, exposure to different knowledge heightens the potential to recombine it to novel ideas and the exposure to new perspectives increases their cognitive flexibility and awareness of opportunities. And, of course, if there is communication across fields—weak or strong ties—information about opportunities can be transferred more effectively (Burt 2004).

Studies found that networks rich in structural holes that cross organizational boundaries are more likely to be creative (Zou and Ingram 2013). Experts from different groups can gather a variety of perspectives and help to select the relevant information and interesting opportunities. People who are regularly exchanging ideas and seek information in other knowledge domains and industries are found to enhance their careers and entrepreneurial success, for example, in the creation of innovative startups, and heightened chances of breakthroughs and impactful ideas (Dyer et al. 2008; Rhoten and Parker 2004). Individuals who constantly cross disciplinary boundaries can build bridges, use the experience from different fields for their own work, foster the exchange of information between them, and initiate valuable experiments or extraordinary projects.

Case: Madeline Gannon, the Robot Tamer
The artist Madeline Gannon positioned herself in-between disciplines. Starting from architecture and media art, her interest in new media, robots, and the longing for developing human-centered interfaces lured her into learning about computer science, writing her first line of code at the age of 25.

Having one foot in media art and one in computer science, she learned to build bridges and mediate conversations along with joint projects between the different disciplines. In her explorative way to build human-computer interfaces for robots, Madeline Gannon first arrived as a research intern at Autodesk Toronto. The following year, she applied again for a research internship at Autodesk Toronto and as an artist-in-residence at Autodesk Pier 9 in San Francisco for Summer/Autumn 2015. As she was awarded both, the teams supported her to work in both positions at the same time and to explore the synergies. Although the interest in both settings was the same (or at least similar), to build a human-centered interface to work with an industrial robot arm, the requirements for the research internship and the artistic residency were completely different: one demanded the production of research output, including academic papers; the other one aimed at producing an artwork that was part of the final show of the summer/autumn artist-in-residence cohort that reached out to a different audience. For her it was exciting to intertwine these two aspects because this gave her the opportunity to build the artistic work on ongoing scientific research: to integrate the artistic ideas as valuable twists into the scientific work and create artwork that challenges state-of-the-art human-computer interaction with industrial robot arms. Discussing insights with the artistic community and the robotics department that looks at far-future developments at Pier 9 and developing the interface in collaboration with the scientists and developers at Autodesk Toronto created a fertile ground to do this.

Hosting Madeline Gannon at these two distinct departments was an opportunity for them to discuss shared interests and exchange information. During this period Madeline Gannon was working on her project *Quipt*. For the realization of *Quipt*, multiple connections had to be established within different departments of the corporation. *Quipt* is an industrial robot arm that interacts with a single person in front of it based on movements and gestures. Based on different sensing and tracking techniques Gannon developed modes of interaction with the robot arm displayed by following, mirroring, or avoidance behavior. This approach circumvents dangers in a direct interaction with industrial robot arms by enabling them to recognize a person through sensors. Such defined behavior of the robot facilitates close interaction with industrial robot arms because it reduces the need for programming reactions of the robot arm in standard interactions. In this artscience project, some latent ideas of the group of engineers and scientists at Autodesk who are working on far-future visions have been materialized and helped them to communicate their ideas to other departments.

Based on this project and the positive international feedback another opportunity emerged in 2016 that included even more collaborating partners. With the support of Autodesk and as a first artist-in-residence in the new Autodesk space in Boston, Madeline Gannon developed *Mimus* for the opening exhibition of the new space of the Design Museum London. In contrast to *Quipt*, *Mimus* is an industrial robot arm that takes the idea of human-robot interaction even further: it interacted with many people at the same time and imitated the behavior of curiosity. This project allowed for the creation of new connections for everybody involved: it gave Gannon the chance to develop her artistic and scientific work and to exhibit it in an important art space, the Design Museum London, and Autodesk could collaborate on this project for the first time (both organizations had thought about collaborations before, but this was the first opportunity) and they went on working together afterward. The industrial robot developer ABB entered into collaboration and this brought the company new insights in practical and safety issues, and the multifaceted interactions between *Mimus* and the audience helped to test a new interaction system that enables more collaborative human-robot interaction (Fig. 5.6).

Bridging network gaps or connecting individuals and departments that are not connected through other formal structures and informal networks within

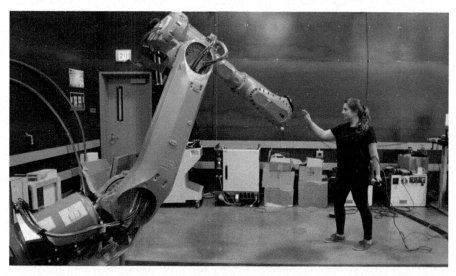

Fig. 5.6 Madeline, the Robot Whisperer: Madeline Gannon interacting with *Quipt* at Autodesk, 2015. (Image courtesy: Madeline Gannon/ATONATON [for a video of *Quipt* see https://www.youtube.com/watch?v=e5TofulUhEg, and for the presentation of *Mimus*, the curious robot, see https://www.youtube.com/watch?time_continue=5&v=B9jwNWiEd_M])

organizations can be an important organizational aspect of artscience collaborations, as shown above. Such newly established relationships within an organization can lead to ongoing interaction and overcome groupthink that might get established within a closed group that exchanges and recycles the same ideas over and over again (Fleming et al. 2007). At the same time, new interactions can point out redundancies in organizations and create opportunities to explore open questions. Therefore, introducing artscience collaborations or artists-in-residence into an organization has the potential to create a balance between using strong ties—and closely formally connected groups and weak ties—and establishing new connections by spanning structural holes.

5.3 Beyond Existing Formal Structures

As the previous case already tackled, artscience collaboration can initiate contacts within organizations that have not been used before or can establish new ones. Organizations contain formal structures like hierarchies and connections between departments or work groups. Within a group, people know each other and talk frequently. Although informal networks can over shadow these formal structures, they are not limited to them. They can, for example, include direct connections between employees from independent departments of an organizations where formally no direct connection exists (Krackhardt and Stern 1988). Within a department, connections to other work groups, laboratories, or the management exist along communication lines and not everybody needs to know each other or talk to each other. Work groups from different departments can have no direct formal connection because they are only connected through a management unit. Without a formal connection it can happen that two work groups have similar interests without fostering exchange. Sometimes there are informal connections because individual actors of the work groups know each other from meetings or events, or because the management established a direct contact. So even when two scientists working in the same organization are interested in the same questions, there is a chance that they do not know each other or of each other's work. Interpersonal relationships are key to inspirational processes, knowledge generation, effectivity, creativity, and, in the end, productivity. Formal structures alone cannot guarantee that all useful interpersonal connections are established within an organization, and even informal networks, which are often bound to frequent exchange or friendships, cannot provide this. Sometimes surprising meetups and extraordinary situations like artscience collaborations provide an additional opportunity to create new connections.

Case: Sarah Petkus and *NoodleFeet* Are Networking at the European Space Agency

In 2016, artist Sarah Petkus from Las Vegas had the opportunity to visit the ESA technical center in the Netherlands, the European Space Research and Technology Center (ESTEC), for three weeks. As an artist, she is building robots that represent characters based on the stories and illustrations she creates. When she applied for the residency at ESA, she wanted to base the residency around the story of her latest project, "The Wandering Artist," focusing on the robot child *NoodleFeet* (Noodle for short). The residency opportunity was originally planned within ESA's Science Directorate, but Sarah Petkus' residency proposal included interactions with roboticists at ESA. As her proposal was convincing, the responsible ESA scientists Karen O'Flaherty, Claudia Mignone, and Mark McCaughrean approached their colleagues from the Human and Robotic Exploration Programmes Directorate and diverse laboratories there in order to facilitate interaction between the artist and roboticists and to permit access to some laboratories, such as the Planetary Robotics Lab, the Orbital Robotics Lab, and the Human Robot Interaction Lab. This first step soon triggered new networking opportunities within the scientific organization, as one of the ESA personnel mentioned that Sarah quickly had a better overview of the existing laboratories at ESTEC than some of the personnel. So she got in touch with scientists with whom there had not been interdirectorate contact before. Sarah acted as a bridge between scientists and roboticists, who normally had no reason to be connected. One outcome of this was that some personnel had opportunities to explore structures of related departments with which they previously had no active contact and they had the possibility to learn about laboratories that they previously did not know of.

The artist's presence allowed for many more networking opportunities. At informal meetups with the artist, interested scientists and engineers were invited to contact her, which created informal meetup situations for likeminded scientists and engineers who didn't know each other. During her residency, Sarah Petkus spent long hours at the laboratories and at meeting spaces, where she talked with diverse scientists and engineers. Often, her robot Noodle served as a conversation starter—in labs, the canteen, and bars, during meetups—and tempted interested people to join ongoing conversations. Again, these informal situations led to conversations between unrelated scientists and engineers who didn't know about their shared interest in related fields of research. Above all, this project was not only an interesting network opportunity for informal networking within the organization, but it also connected the artist to specialized roboticists and engineers, with whom she stayed in contact after the residency. In one case, the conversation evolved to

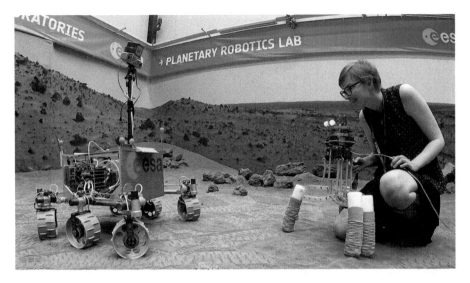

Fig. 5.7 The meeting of *NoodleFeet* and the ESA rover test robot on the Martian-like landscape at ESA during Sarah Petkus' residency, 2017. (Photo credit: Sarah Petkus)

a joint project between the artist and a scientist to build a robot character from a show that both like: a project the artist and the scientist engage in, as they are interested in the story, and at the same time, a project in which the scientist supports the artist in developing specific coding skills (Fig. 5.7).

This case tells most importantly a story about the extraordinary situation of hosting an artist-in-residence that facilitates informal networking beyond formal organizational structures. Not only but especially in large organizations such as ESA, social networking initiatives can be used to enhance communication between departments and outside of established working communities. Organizational structures provide formal ways of communication, knowledge management systems help to keep up the knowledge about existing resources and information within the organization, human resource management tools are required to enable interaction beyond formal structures, and managers need to have an overview to facilitate collaboration and exchange when needed. Sometimes expertise needed does not reside within the research unit or organizational department where it is needed, and blindness toward in-house competences can cause lack of collaborative idea development or simply raise costs. Within scientific organizations, many different expert groups and departments are working on highly specialized projects. Even if there is an open organizational culture that is supporting interpersonal exchange, focus on project development, deadlines, and division into big departments leads to little possibility for exchange and learning about colleagues' ideas and competencies. Physical proximity can help in keeping in contact to foster personal exchange and the growth of

interpersonal networks; creating regular situations for informal meetings is one tool to foster this (Gratton 2005). Artscience collaboration and artists-in-residence can initiate such connections even without the pressure of realizing organizational goals and provide a platform for explorative conversations led by shared interests.

The residency of Sarah Petkus at ESA did this in many ways: first, facilitating the residency led a few members of the organization to learn more about the organizational resources; second, the residency project was framed to initiate as many interesting connections within the organization as possible, which are interesting for the artist and for the scientists. As the artist brought along her self-built robot, Noodle she already brought a conversation starter. Third, the process of developing the robot into a next stage and her stories around the robot, the wandering artist on Mars, created context that allowed many scientists and engineers to connect their own interests and research to her project. Fourth, the fact that it was a weird, fun, unconventional situation lured many scientists to talk to her, in formal and informal meetings throughout her stay at the laboratories. This created networking situations for her and the scientists. It provided potential for exchange between scientists who work in different units, on different missions, and in different departments. How much these newly formed informal connections will be used in future is still to be seen, but broadening the understanding of what is going on within the organization is fundamental for expanding exchange opportunities beyond formal organizational structures and can positively affect performance (Reagans and Zuckerman 2001). Going past formal organizational structures extends beyond networking within the organization itself. External or interorganizational networking can help to create competitive advantages, is a part of outsourcing activities, and can help to establish access to new fields (Brass et al. 2004). Actors (nodes) who are better connected within a network than others are high in network centrality (Ibarra 1993), and studies show that those actors have more opportunity to share their knowledge or form interdisciplinary connections to develop ideas with others than those who are low in network centrality (Reinholt et al. 2011).

References

Adler, P. S., & Kwon, S.-W. (2002). Social Capital: Prospects for a New Concept. *Academy of Management Review, 27*(1), 17–40.

Anderson, M. H. (2008). Social Networks and the Cognitive Motivation to Realize Network Opportunities: A Study of Managers' Information Gathering Behaviors. *Journal of Organizational Behavior, 29*, 51–78.

Ashford, S. J., Blatt, R., & Vande-Walle, D. (2003). Reflections on the Looking Glass: A Review of Research on Feedback-Seeking Behavior in Organizations. *Journal of Management, 29*(6), 773–799.

Brass, D. J., Galaskiewicz, J., Greve, H. R., & Tsai, W. (2004). Taking Stock of Networks and Organizations: A Multilevel Perspective. *Academy of Management Journal, 47*(6), 795–817.

Burt, R. S. (1992). *Structural Holes: The Social Structure of Competition.* Cambridge, MA: Harvard University Press.

Burt, R. S. (1997). The Contingent Value of Social Capital. *Administrative Science Quarterly, 42*(2), 339–365.

Burt, R. S. (2004). Structural Holes and Good Ideas. *American Journal of Sociology, 110*, 349–399.

Burt, R. S., Jannotta, J. E., & Mahoney, J. T. (1998). Personality Correlates of Structural Holes. *Social Networks, 20*, 63–87.

Chua, R. Y. J., Morris, M. W., & Mor, S. (2012). Collaborating Across Cultures: Cultural Metacognition and Affect-Based Trust in Creative Collaboration. *Organizational Behavior and Human Decision Processes, 118*, 116–131.

Dyer, J. H., Gregersen, H. B., & Christensen, C. (2008). Entrepreneur Behaviors, Opportunity Recognition, and the Origins of Innovative Ventures. *Strategic Entrepreneurship Journal, 2*, 317–388.

Fleming, L., Mingo, S., & Chen, D. (2007). Collaborative Brokerage, Generative Creativity, and Creative Success. *Administrative Science Quarterly, 52*(3), 443–475.

Granovetter, M. S. (1973). The Strengths of Weak Ties. *American Journal of Sociology, 78*, 1360–1380.

Granovetter, M. S. (1974). *Getting a Job: A Study of Contacts and Careers.* Cambridge, MA: Harvard University Press.

Granovetter, M. S. (1983). The Strength of Weak Ties: A Network Theory Revisited. *Sociological Theory, 1*, 201–233.

Gratton, L. (2005). Managing Integration Through Cooperation. *Human Resource Management, 44*(2), 151–158.

Ibarra, H. (1992). Homophily and Differential Returns: Sex Differences in Network Structure and Access in an Advertising Firm. *Administrative Science Quarterly, 37*, 422–447.

Ibarra, H. (1993). Network Centrality, Power, and Innovation Involvement: Determinants of Technical and Administrative Roles. *Academy of Management Journal, 36*, 471–501.

Jiang, L., Clark, B., & Turban, D. B. (2015). Creating Breakthroughs: The Role of Interdisciplinary Idea Networking and Organizational Contexts. *Academy of Management Annual Meeting Proceedings, 2015*(1), 18645.

Krackhardt, D., & Stern, R. (1988). Informal Networks and Organizational Crises – An Experimental Simulation. *Social Psychology Quarterly, 51*, 123–140.

Malina, R. (2006). Network Theory: Art, Science and Technology in the Cultural Context. *Leonardo, 39*(4), 287–288.

McPherson, M., Smith-Lovin, L., & Cook, J. M. (2001). Birds of a Feather: Homophily in Social Networks. *Annual Review of Sociology, 27*, 415–444.

Palla, G., Barabási, A.-L., & Vicsek, T. (2007). Quantifying Social Group Evolution. *Nature, 446*(7136), 664–667.

Perry-Smith, J. E., & Mannucci, P. V. (2015). Social Networks, Creativity, and Entrepreneurship. In C. E. Shalley, M. A. Hitt, & J. Zhou (Eds.), *The Oxford Handbook of Creativity, Innovation, and Entrepreneurship*. New York: Oxford University Press.

Reagans, R., & Zuckerman, E. W. (2001). Networks, Diversity, and Productivity: The Social Capital of Corporate R&D Teams. *Organization Science, 12*(4), 502–517.

Reinholt, M., Pedersen, T., & Foss, N. J. (2011). Why a Central Network Position Isn't Enough: The Role of Motivation and Ability for Knowledge Sharing in Employee Networks. *Academy of Management Journal, 54*(6), 1277–1297.

Rhoten, D., & Parker, A. (2004). Risks and Rewards of an Interdisciplinary Research Path. *Science, 306*(5704), 2046.

Scott, J. (Ed.). (2010). *Artists-in-Labs. Networking in the Margins*. Vienna/New York: Springer.

Shane, S., & Cable, D. (2002). Network Ties, Reputation, and the Financing of New Ventures. *Management Science, 48*(3), 364–381.

Tsai, W. (2000). Social Capital, Social Relatedness and the Formation of Intraorganizational Linkages. *Strategic Management Journal, 21*(9), 925–939.

Zou, X., & Ingram, P. (2013). Bonds and Boundaries: Network Structure, Organizational Boundaries, and Job Performance. *Organizational Behavior and Human Decision Processes, 120*(1), 98–109.

6

Sensemaking

Artscience collaborations can enrich underlying assumptions and perspectives on the own work processes, theories, data, projects, and the questions that are asked. The experience of unknown situations, new contextual embedding of the work, diverse information, and resources contribute essentially to this development. But artists and scientists are trained in working with their data and know how to look in order to see, to handle their tools and materials, and to approach questions to reduce the complexity of situations. They make sense of these situations and the information at hand. What if somebody contributes a new perspective? Is it trustworthy? Does it fit into the known understanding of the world? Does it make sense? A collision of worlds like art and science, a collision of identities like artists and scientists, induces ambiguity, dissonance, and uncertainty. This collides with previous understanding of situations, and engagement with this situation triggers a sensemaking process to analyze the experience. This process enriches the previous understanding or even leads it to shift.

The theory of sensemaking describes the process by which people give meaning to their collective experiences. This process of making sense of the world constitutes the meaning of the decisions that are enacted in the ways people behave and understand the world around them. "Sensemaking is what it says it is, namely, making something sensible. Sensemaking is to be understood literally, not metaphorically" (Weick 1995: 15). The theory is rooted in social psychology, which focuses on the explanation of behavior and experiences that are based on interpersonal interactions and relationships. Thereby, it focuses on the behavior of groups and on individuals' experiences and behavior in social situations. Emerging from this fundament, sensemaking asks how

people make sense of what they experienced in a certain situation. For example, information that reaches individuals in extreme situations like crises or catastrophes is difficult to understand and makes no sense to these individuals who experience this. So a process of reflection—an inner dialogue—starts, questioning what the information is about, challenging existing thinking patterns, previous experiences, and fundamental assumptions about how the world around oneself is understood.

Weick (1995) defines seven aspects of sensemaking to make it distinguishable from interpretations or classifying situations. First, sensemaking is part of the construction of identity. When a sensemaking process starts, an individuum has to renegotiate the position of their own identity in relation to the environment. Second, it is retrospective, as it is initiated by a new experience that calls for understanding of what happened and how the own perception of the experience can be validated by what happened afterward. Third, it is integrated in a reacting environment. There is a mutual influence between environment and behavior, as the environment influences the behavior, but a changing environment again influences the behavior of the individuum. Fourth, sensemaking is social because experiences or observations of the environment are always reflected in relation to the social environment and its behavior. Fifth, it is an ongoing process, as there is never a final conclusion, but every following stimulus leads to a proceeding sensemaking process. At a certain point, sensemaking can be very distinct in only small steps as a social environment starts to behave predictably, but a new extraordinary situation can lead to a change in the sensemaking process. Sixth, due to bounded rationality, sensemaking is focused on central references or details. As attention is limited by previous knowledge to what was recognized as important or different, these details and reference points of observations are sorted as missing or different in unexpected events. Only after the sensemaking process is over are surprising and irritating details understood or will be reflected in the observation of a similar situation. Seventh, sensemaking is driven by plausibility rather than by accuracy. In sensemaking, it is most important for the individuum to create a plausible understanding of what has happened instead of accurately reproducing an event.

Based on these key aspects, sensemaking is defined as a social process, meaning it is continually negotiated between people, is contested, and is mutually co-constructed. The environment, (social) situations, or events are interpreted in and through interactions with each other to comprehend their sociomaterial environment and to act collectively. In organizational research, this idea is applied and shown to happen within organizations and teams. People who work together, who spend time in the same environment, or work

with a specific production process learn to understand the events and different states of their (organizational) environment, and to act accordingly. This understanding is constantly negotiated and adapted to new developments and new situations, based on past experiences and shared interpretations of these to understand possible futures. This process of sensemaking based on past experiences can be triggered especially when expectations of how a situation should develop or how the environment should behave in a certain constellation of events are violated. This is true for situations or for outcomes of standard procedures. When such a moment is irritating, confusing, surprising, or even alarming, a sensemaking process will be triggered. Referring to the views, ideas, and processes that constitute the "world" that employees share—the main context that is focused on in their views—or scientists and artists of a certain background "live in," sensemaking is also understood as a process to create intersubjective meaning and a process to "produce, negotiate, and sustain a shared sense of meaning" (Maitlis and Christianson 2014: 66).

Connected to the sensemaking theory, two other processes are studied: sensegiving and sensebreaking. Sensegiving can be understood as the process of learning how sensemaking works in a specific organizational (or professional or cultural) environment, what the clues are, what images and symbols mean, and how meaning is constructed within this specific environment. It is not a strict top-down process like a learning process of fixed interpretations. New meaning can be added by active sensegiving actions, but individuals can resist these actions (Gioia and Chittipeddi 1991). Sensebreaking on the other hand is defined as the opposite, as destruction of meaning. This process can be important to motivate individuals to revise ideas about their environment and to rethink the sense they have already made.

Scientists, like artists, develop their own ways of working and of making sense of the topics they work with and the environment they work in. Each scientific field, scientific organization, and even laboratory group has its own culture and codices: young scientists learn to understand the data, to read the papers for the relevant information, to interpret the scientific jargon used within their very specific field, to set up experiments in a standard procedure, and to be alarmed by things that do not work as expected. As soon as graduate students start in their field, there is little exchange with outside perspectives, and the methods and numbers they see start to make sense to them in the way these things make sense to their experienced colleagues. They learn to make sense of the information they get to continually take part in the collective sensemaking process of the very specialized field, working on specific questions and pushing the boundaries of knowledge as it is understood within their professional environment.

Artists are trained differently in their methods, procedures, and contexts to draw from based on the necessities in the art world. They use different media, ways of expression, and methods to express their ideas. The more artists, curators, or aficionados are experienced in this environment, the more they are able to make sense of what they see in a very specific way, see ideas and connections to other works, or interpret an artwork in a completely new way. So artists make sense of their environment, learn to approach their environment in a specific way, take the information that is most interesting from their point of view, and interpret material objects by referring to certain (aesthetic) criteria. Combining artistic and scientific approaches, in collaborations, this clash of perspectives can trigger sensemaking processes that lead to a new understanding of the work being done and the theories and methods used, or a shift in constructing meaning.

6.1 Enable "New Ways of Understanding"

Many scientists and engineers reflected on the changes they experienced after artscience collaboration like this: "I ended up understanding my work differently." "I learned to understand my work differently." "It helped me to look at my work differently." "It helped me to understand my work differently and its meaning for people outside of the scientific community." "It helped me to look at my work in new ways, ways I do not have time to explore when I am only discussing it in scientific environment, nor would I have time for it, because after one project is finished, I have to engage in the next experiments and papers." "Normally, we do not have time to think about it in new ways or experiment with nonstandard procedures if the standard one is working." "This is not something that led me to a publication but helped me get a deeper understanding of the field." Similarly, managers and curators who facilitate artscience collaborations, like Ariane Koek previously at CERN, Iréne Hediger at the Swiss Artists-in-Labs program, or Domhnaill Hernon at the new E.A.T. program at Nokia Bell Labs, refer to scientists claiming that these interactions provided them with new ways of doing their work or new perspectives on their work. Such different perspectives on one's work could mean many things: they point to data, work processes, or links between content and theories that are understood in new ways; the integration of new procedures for analysis; or contextual embedding that adds to the scientific interpretation. These changes are the fundament for new research, methods, and work processes, and, in the end, for more reflective output.

Case: Marcos Pellejero-Ibanez, Music, and a New Perspective on the Universe

Marcos Pellejero-Ibanez, PhD, is a researcher in Elementary Particle Physics, Cosmology, and Theoretical Physics. During his PhD project in cosmology at the Department of Astrophysics Research, Instituto de Astrofísica de Canarias, he continued his musical practice, developing his skills in electric guitar with regular lessons. Talking to him about his experience in music and cosmology, one of the first sentences he said stood out: "I found out that I can look at the universe in a completely different way." A little later in our discussion he went on to say: "It changed how I look at my work. I understood what I do better because I have different perspectives to look at what I'm doing. … It can be a seed to a different outcome. I've got the feeling that now the understanding of my work is deeper. … As the conversations with my music teacher made me rethink it." He shows the change in the two images he prepared for this book. What is displayed in the two images accompanying this case is how Marcos Pellejero-Ibanez understood data of his PhD project before the discussions and interactions with his music teacher and afterward. Both images show a correlation function and power spectrum that are statistical quantities related to the universe, and therefore both are trying to capture the same kind of information, that is, how galaxies are positioned with respect to each other within the cosmic web (Figs. 6.1 and 6.2).

The sensemaking initiated by the discussions with the music teacher can be best seen in Pellejero-Ibanez's own descriptions of the process:

> The correlation function measures the increase in probability one would measure when answering the question of how probable is it to, living in a galaxy, have another galaxy at a distance "r". Thus, the left part of Music_1 would tell us that at low distances, there is high probability of finding another galaxy. Very

Fig. 6.1 Music_1: Illustration by Marcos Pellejero-Ibanez, PhD, shows the initial approach before the conversations with the music teacher, 2018. (Image courtesy: Marcos Pellejero-Ibanez)

Fig. 6.2 Music_2: Illustration by Marcos Pellejero-Ibanez, PhD, shows the changed understanding after the conversations with the music teacher, 2018. (Image courtesy: Marcos Pellejero-Ibanez)

natural, isn't it? As gravity is attractive, one would expect to find galaxies close together and not highly scattered. Anyway, as I am speaking about distances, this is clearly a statistical quantity living in the real space (the usual one, the one in which we measure distances in meters and times in seconds).

On the other hand, the power spectrum (right part of Music_1) contains the same kind of information, but it lives in what we call the Fourier space. I don't want to get into very much detail but let's just state that it is the space that naturally describes the behaviour of waves. In Fourier space, instead of working with seconds or meters, you work with times per second and times per meter (how many times a structure is repeated every second or meter). In this sense in Fourier space you work with frequencies.

Ok, let's move on. Even if they describe the same phenomena, scientists use them differently as different physical phenomena become more apparent in each one. At the very beginning of my PhD I got used to handle the correlation function, and for me, power spectrum was just a mathematical transformation of this function. Now I realize that I really didn't understand it. I understood the maths behind, but I had no idea of what was physically going on. As you can guess, this is of great importance in physics. This is what I tried to show with the plot Music_1. For me, the power spectrum was simply the Fourier transform of the correlation function, that is, a mathematical function that came from a mathematical transformation of something that I understand.

This is where everything gets a bit messy because I am going to start including what my music knowledge helped me with. I'll try to be clear.

About two years ago I started a new project where I had to use the power spectrum from the very beginning—I really needed to understand how spatial waves evolved in the Universe. This is where my music teacher comes into play. We were discussing how each music key works. He explained to me how each instrument potentiates different harmonics of the key you are playing, and that a key is not "pure," but it is a mixture of many other keys ordered in a specific manner. Basically, he was telling me that an instrument is a device that takes noise (which is everywhere) and transforms it into what we call music keys. This gave me the clue to start understanding what I was working with.

I understood that the evolution of the power spectrum worked like an orchestra tuning at the beginning of a concert. At first there is only noise (primordial power spectrum), then instruments start tuning. By the end all of them are playing the same key with many different harmonics (today's power spectrum). This is what I am trying to show with the plot Music_2. At that moment I got the idea of how the random spatial waves (green line) could get structured to what we see nowadays (the blue line). This is an idea of the evolution of structure predicted by the Big Bang theory that has been thoroughly tested.

The universe started as noise, and gravity, which worked like the music instrument, potentiated some keys over other ones to end up with a symphony where different harmonies get mixed, each coming from a specific physical process.

May be the word "understand" [is] not the right word, may be getting the feeling of what is going on is more accurate. In any case, I acquired an intuition over the topic. Developing intuition over a topic you are working on is very important in all of science, as it allows you to move forward.

Now I understand power spectra in very different ways, more physical, but this is the first idea I got about the topic and it obviously helped me and defined how I understand it now.

This reflection, generously provided by Marcos Pellejero-Ibanez about his experience in discussing his work with his music teacher, shows how such a sensemaking process can be triggered and developed into something valuable for a scientist. Here the literal meaning of sensemaking, making things sensible, becomes obvious. New ways of understanding in the form of "getting a new feeling for something" can be supported by new aesthetic approaches to the data. This describes the process of acquiring a new layer of knowledge or a deeper understanding, as Pellejero-Ibanez calls it. Of course, time is necessary and so is engagement with the topic, but using new approaches or aesthetic experience supports the creation of relevant insights. In artscience collaboration or through artistic expression, surprising insights can be made, or irritating situations occur. These moments trigger sensemaking processes—or can serve as sensegiving or sensebreaking events. Most important is to engage in this process and take action. Action precedes cognition and focuses cognition,

and through action important ingredients for sensemaking are created: clues and stimuli for sensemaking are experienced and connections to what is encountered can be made (Weick 1988).

A sensemaking process is evidently important in many stories that illustrate the importance of artscience collaboration and art in STEAM education (Edwards 2008; Root-Bernstein et al. 2012). For example, Buckminsterfullerenes[1] were discovered as the chemist Dr. Harold Kroto looked for opportunities to understand the structure of the C60 molecules. The experience of the architectural structures[2] by Buckminster Fuller made him realize that he didn't see the correct structure in the microscopic images because his analysis was influenced by previous knowledge of how molecules are structured. Through inspecting the architectural structures, he found the key to rebuild the correct structure of a C60 molecule (Kemp 2016). A similar story can be found about Feynman and the wobbling plate, where this process becomes evident when Feynman talks about his interaction with the circus artist when he wanted to understand how to balance the plates on the sticks, which suddenly made him realize that this was actually the problem he was trying so hard to solve for more than a year (Feynman 1997). In recent artscience collaboration and throughout history many more stories like these can be found and art historians gathered many of these cases (e.g., Kemp 2016).

6.2 A Clash of Identities and Ways of Expression

Prevalent in the process of sensemaking in artscience collaboration are the clash of identities and aspects of sociomateriality. At the core of sensemaking is what is called the "necessity to restore identity" (Weick et al. 2005) and "cognitive order" (Sandberg and Tsoukas 2015: 15) to understand novel, unexpected, irritating, or confusing events. In interpersonal, collaborative settings with a shared (organizational) identity, a common reflection easily converges into one univocal meaning. This can be observed within groups of scientists who work together frequently: they develop their identity based on characteristics and shared knowledge of their group that leads to interpretation of data that follows an exemplary routine, feedback comes from a certain perspective, and proposed methods resemble each other. Similarly, artists have

[1] Molecules named after Buckminster Fuller with the formula C60 in a cage-like fused-ring structure.
[2] In particular, Buckminster Fuller's geodesic dome structures.

a certain identity based on their profession and develop a specific way to look at topics and make sense of the appearance of artistic objects.

Expertise in handling and interpreting the environment is connected to a specific image of the self, identity, habitus, and style show (Bourdieu 1999). Identities are reflected in the design (as a representation of style) of material objects and of practices, including discursive practices and conversational style (Weick 1995). Pre-conceptions refer to ideas or stereotypes of other professional groups in contrast to the own identity and are fundamental to expectations of processes, sequences of events, or outcomes of experiments. In organizations, such different styles and identities surface especially when experts and novices are working together (Baron and Ensley 2006) or in heterogeneous teams (Shelly and Shelly 2009) with members coming from very different domains of expertise or which have been socialized in different cultures. Nevertheless, an expectation to see things the same way is unjustified when experts with different individual identities collaborate. Contradictions emerge that require new sensemaking processes: for example, a database administrator interprets a physicist's requirement in a way which preserves her identity; her interpretation will hardly adhere to the meaning given by the physicist. Even people from different backgrounds in the organizations, with different status, or from different departments can see the same event in diverging ways. Adding an alien identity, like an artist, to a scientific collaboration, the differences in approaches and interpretations can be more substantial, based on the very different knowledge of objects, embodied processes, and selection of important aspects. Collaboration involving different identities "threatens" the identity, disturbs the collaborating individuals' cognitive order, and thus calls for sensemaking to restore identity and cognitive order. At the intersection of diverse identities (based on professional background, language, mission), this core element of sensemaking processes leads to a possibly contradictory consequence: interpersonal sensemaking results in diverging interpretations of issues, thus potentially threatening subsequent cooperation, or new identities emerge on the individual or higher levels, which contradicts the notion of stable identities and cognitive orders (Sandberg and Tsoukas 2015).

The challenge of artscience collaborations is to find a balance between these two extremes. It is important to learn from the diverging interpretations and compare the processes, which ultimately leads to knowledge production and acquisition of new perspectives and methods instead of neglecting possible approaches. On the other hand, it is important to reflect and contrast the ideas with the own style and identity to be able to integrate unexpected insights, which leads to changes in style and bears the potential of growth of

the own professional identity. A radical shift in identity or isolating the own identity from this new experience (e.g., "I am an artist and what a scientist sees in my work is basically not relevant to me") will reduce the potential personal development in an artscience collaboration to a minimum. A successful collaboration that led to big leaps in personal development and development of the own professional field is illustrated in the case about *tatoué*. below. There, collision of ideas between the safety department and the artists enabled discussions, revealing experiences, which eventually created relevant insights for the future of the safety department.

Experienced individuals can mediate the process between partners in communicative relationships to explore skills and tactics for adaptive and mediated sensemaking (Strike and Rerup 2016). This is important for inexperienced collaborating partners to find a balance between radical shifts and neglecting others' methods. A third-person presence in the sensemaking process can translate ideas, introduce the points of views that are challenging to the collaborating partners, guide the process, and thus guide the sensemaking process. In artscience collaboration processes, especially in bigger artists-in-residence programs, such a mediating role is essential. It is important for artists and scientists to be able to concentrate on their process, to have an additional communicator instead of mediating ideas, and it is important for the organization, as this person informs about the essential aspects of the project. Very experienced artists and scientists, who are used to interdisciplinary work, are open to engaging in these confrontations of identities and are more used to managing such situations without a mediator. Nevertheless, it puts a higher workload on them, and in the absence of a designated mediating role, under strong time pressure, and in contexts of high complexity, contradictions between identities ("outside" vs. "inside": the scientist does not know about art; the artist does not know about science) might not be resolved.

Additionally, objects and materials play a central role in mediating sensemaking. Basically, resolution can be achieved at least partly by the introduction of material objects and artifacts, like images, software code, physical prototypes, or a boundary infrastructure (e.g., templates for presentations, for simulation, conventions), or through a collaborative design process of these objects. These materials and objects have been shown to facilitate and to anchor sensemaking and to enable collaborative work in complex tasks (Stiglani and Ravasi 2012). Such tools, prototypes, or models can act as "boundary objects," facilitate the exploration of different interpretations, and enable the identification of a common ground for further development (Okhuysen and Bechky 2009). Material practices and artifacts serve as interactive tools to enable the transition from individual to collective sensemaking by resolving representational gaps among team members, and prototypes help to mediate

between individuals with different backgrounds by the means of materialization and visualization.

Particularly the defamiliarizing experiences of artscience collaborations or contrasting different ways to express one and the same idea are understood as extremely valuable for distinction-making and to push experts or somebody familiar to understand their own object of inquiry differently. Art and artistic expression are understood as valuable means to express something unnoticed or overlooked (Tsoukas and Chia 2002). Creating experiences with boundary objects in the form of the realization of artwork or going through the process of scientific experiments creates insights and shared experiences that support the mutual learning and reflection process. The importance of this experience and the materialization of the proposed ideas together form the second aspect of the sensemaking process, which is demonstrated by the following case of *tatoué*.

Case: *tatoué*.—Appropriate Audiences Experimenting with an Industrial Robotic Arm and the Autodesk Safety Department

The artist group Appropriate Audiences (appropriateaudiences.net), consisting of Johan da Silveira, Sebastian Morales, and Pierre Emm, started to experiment with 3D printers in 2013 and soon wanted to find new applications to use the device. Instead of producing small objects made of plastic, they experimented with possibilities of other applications, and eventually exchanged the filament and extruder of the 3D printer with a tattoo pen. In their experiments in tattooing with a 3D printer as a robotic tattoo machine, they aimed at making use of upcoming technologies to create new tools for tattoo artists. In 2014, *tatoué.*, a 3D printer built into a robotic tattoo machine, was presented to a public audience for the first time. When Appropriate Audiences applied for the residency at Autodesk Pier 9, they wanted to continue the work on the robotic tattoo machine based on the 3D printer. They originally worked with the 3D printer, using their knowledge to specialize and create a more and more accessible tool, but they also had other technologies in mind that could be used in this scenario.

Parallel to the invention of *tatoué.*, the team at Autodesk Pier 9 that is responsible for working on far-future visions of applications of technologies and software and their effect on work and society worked on ideas to create interactions with industrial robot arms. Currently, there are only smaller robot arms with which one can work more closely, but industrial robot arms are these impressive machines one only interacts with behind a fence. Above that, an important topic to work on in future is to make these robot arms accessible for those creative people who are working with them. Now, the workflow

is rather bumpy, often using a complex code, where the creative person first has to talk to the engineer, who then implements the ideas in the system of the industrial robot arm. But it was not only usability for creative people the team at Autodesk Pier 9 were concerned with, but also possible intuitive forms of interaction between a person and the machine. And bringing the interaction as close as it gets between a machine and a person, the team fantasized about using the robot arm for tattooing. There are loads of issues around this topic, and doing a little bit of research, they found out that artists (such as Appropriate Audiences) are already experimenting with new technologies and tattooing machines. They put the idea aside because of many issues the idea involved—as David Thomasson, engineer and scientist of this group, told me—and started working on other interaction ideas. There were numerous safety issues and restrictions, and the idea seemed far-fetched for their audience. Then the phone rang, and the managers of the Pier 9 residency program called David Thomasson to tell him that there were these guys coming to the residency program who are developing a robotic tattoo machine based on the hardware of a 3D printer.

When the two teams met, they only had about one more month to realize their idea for a final tattooing performance, which was scheduled only a few hours before the artists left for their flight back to Europe. The two teams, the artists and the scientists and engineers, were able to complement their expertise: the team of scientists and engineers had the knowledge to handle the robot arm in challenging situations; the artists had the expertise in using the tattoo pen, relevant knowledge about the skin, experience with their robotic tattoo machine on how to find a balance between the determined behavior of a machine and the creation of a desired visual outcome, and the emotional situation of the person being tattooed by such a machine.

As if the project itself was not complex enough, it was risky too, and therefore involved, to a great extent, the safety department. Safety regulations are often understood as rather conservative and restrictive when it comes to creative explorations and new technologies. These regulations are oriented at previous knowledge, proofs, and experiences, and must be restrictive to guarantee humans' safety. So imagining the huge robot arm that can become destructive if there is a mistake or malfunction in direct interaction seems to be extremely risky. Imagining this robot arm—no matter how precise it must be in industrial applications—manipulating the body of a person with something intrusive like a tattooing needle seems outrageous. Why even think about it? Through a lot of interactions between the different departments, discussions about the topic, and test runs of the robot in this situation, it was possible to create an exceptional situation with many new safety regulations to make the project possible. What is even more remarkable was that not

necessarily the rather theoretical discussion that in future such robots and humans have to interact directly created a push toward creating new regulations and patterns in operating industrial robots, but that the will and intention of the artists, combined with the support of the technical team, helped to communicate this discussion broadly, and showed how important it is to think about this topic when it comes to future scenarios.

This experience convinced the head of the safety team about the importance of this topic and inspired her to become an expert at the forefront of this issue. She is now exploring the topic from many angles, visiting conferences, giving talks as a leading person in the field, and developing new approaches with her team. Although this team was merely connected to the project as a controlling body, through a formal connection within the organization that did not demand intense exchange between the safety department and the ideas of the future visions department, the project with the artists enabled intense exchange and created a firsthand experience that triggered the new focus on safety issues. At first glance, neither the artists nor the scientists reported a big change or input for their own work, the far-future visions team could realize their idea, and Appropriate Audiences made huge steps in developing the tattoo robot they were envisioning, but a third party in this collaboration who had to take part in the realization of the project was urged to act against their initial ideas and to strike a new path after the collaboration (Figs. 6.3 and 6.4).

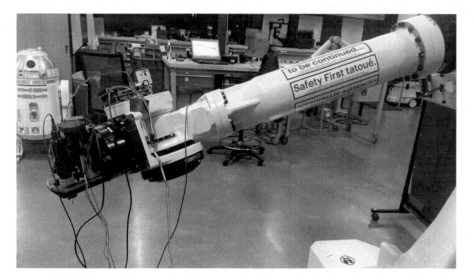

Fig. 6.3 Detail *tatoué.* by Appropriate Audiences. The Appropriate Audiences mantras on the industrial robot arm that is modified as a robotic tattoo machine at Autodesk, 2016. The Appropriate Audiences mantras are "Safety first," "To be continued," and "Never to be sorry." (Image courtesy: www.appropriateaudiences.net)

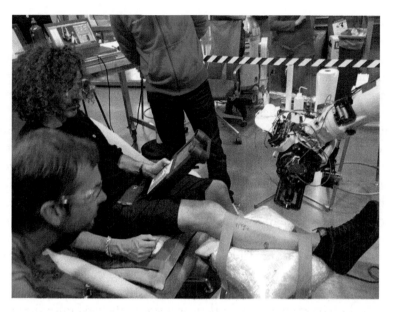

Fig. 6.4 *tatoué.* by Appropriate Audiences: Let's go! The first tattoo session using an industrial robot arm on a human's leg at Autodesk, 2016. (Image courtesy: www.appropriateaudiences.net)

6.3 The Disruptive Power of ArtScience Collaboration

Last, but not least, the element of disruption, irritating or surprising experiences, and rare events is an important trigger for sensemaking processes leading to or supporting change processes (Maitlis and Sonenshein 2010; Weber et al. 2015). Sensemaking helps to explain divergent and convergent actions of individuals to make sense of the behavior of others, for example, the divergent actions of organizational stakeholders in change processes or the actions of actors coming into the organization who are not used to the organizational conventions like processes, practices, and strategies. Artists coming into a scientific setting is a rare event, and even in an artist-in-residence program, each residency is very specific and lies outside common procedures. Moreover, the new interpretations and the alien conception of ideas can be surprising, confusing, or even irritating to scientists and other members of the organization. (And actually, the same is true for artists: the scientists' way of thinking can be irritating and thus opens up opportunities for new interpretations or even a new focus in their work.) When artists collaborate with scientists, this can be disruptive to the scientific, artistic, and organizational process.

The power of artscience projects goes even beyond their disruptive power; they are perceived as something special in corporations and scientific organizations. This gives them visibility. Those engaging in the artscience project are thus able to give more attention to the differences and surprising aspects. This is utterly important because it is not the rare event itself or the diverging interpretation of ideas that triggers sensemaking only; these events need to be recognized, and the diverging interpretation of ideas needs to be seen and taken seriously (Griffith 1999). Threshold situations or situations with surprising outcomes can help to take the situation seriously. Interruptions and careful examination, working with such rare events, can trigger sensemaking and important learning processes. Therefore, "the issue is not so much what organizations learn 'from' rare events but what they learn 'through' rare events" (Christianson et al. 2009: 846). Thus, the collaboration process between the artist and the scientist and the embedding of the process in the organization are much more important than the actual outcome. It is not claimed here that the concrete collaboration process ends up in an overwhelmingly new scientific insight, but the collaboration process is important for learning processes and a reflection of the own knowledge and identity which can lead to new research questions or new interpretations of the ongoing work.

Additionally, understanding artscience collaboration as a valuable contribution to the organization and individual work heightens the impact of this experience on sensemaking processes. As status and social position influence sensemaking (Lockett et al. 2014), an open environment and supportive actions through top-level management or influencers in the organization help to take these interdisciplinary collaborations seriously and enable reflection on the value of their contribution.

In our conversation, Noah Weinstein, inventor and founder of the Autodesk Pier 9 artist-in-residence program, pointed to one important aspect he observed on many occasions during residencies and as part of the whole program within the organization itself: the power of disruption, irritating ideas, and divergent thinking. The management communicates the importance of the program, and a common understanding of the possibilities the residency programs bear has been developed at Pier 9. Divergent thinking and engaging in ideas of a cohort of over 14 artists and creatives are regularly acknowledged as sources for learning, reflection, and knowledge creation by the organization and employees. These interactions are powerful opportunities to grow and explore projects, from intense collaborations between teams or individuals to a whirlwind project that involves a huge number of people for a short and intense period. The artists' ideas pushed the boundaries of the organization's and the employees' domain and

offered other perspectives for the future the organization aims to build. All of this was created in such a different way that was welcomed, and with such passion that it was contagious to everybody. Surprising questions, unforeseen disruption of work practices, divergent use of tools, and previously unexperienced situations will trigger sensemaking and eventually new insights (about the current work project or about the own identity, not necessarily about the artscience project).

Such a surprising whirlwind project that shortly involved many staff members and residency artists was the video production by Dr. Alexandra Murray-Leslie for the song *We Are Data Remix* by Chicks on Speeds. This project started with over 40 employees at Autodesk Pier 9 and artists-in-residence, along with other women in the "maker scene" from the Bay Area and Los Angeles. Almost everybody played a role in the video, its production, and creating make-up and costumes, and the video features Pier 9, its workshop, and its electronics and robotics labs. These short but intense interactions involved many actors in surprising ways, creating artistic expressions and enabling fun with the actors' favorite work processes and (heavy) machinery. The project probably did not make sense for everybody at first glance, but reflecting on the experience, it will be valuable for the contributors, as it can add to the understanding of personal ideas and approaches to the own work (Figs. 6.5 and 6.6).

Fig. 6.5 *How to cut the heel off a high-heeled shoe* (featuring Mary Elizabeth Yarbrough in action) still from music video *We Are Data Remix* and Instructable, by Alexandra Murray-Leslie, 2016. Made at Pier 9, Autodesk Technology Centre, San Francisco (to see the video: https://vimeo.com/207064196/04df14ac93 and https://vimeo.com/278296841/580996ce22)

Fig. 6.6 *We Are Data Remix* music video still by Alexandra Murray-Leslie, 2016. Image features a scene showing Elizabeth Bressler dancing with a robot, shot on location at Octolab, Pier 9 Technology Centre, Autodesk, San Francisco. Camera: Blue Bergen; robot choreography: David Thomasson; and makeup: Robert Marrast @ MAC Cosmetics. (Photo copyright: Alexandra Murray-Leslie)

References

Baron, R. A., & Ensley, M. D. (2006). Opportunity Recognition as the Detection of Meaningful Patterns: Evidence from Comparisons of Novice and Experienced Entrepreneurs. *Management Science, 52*(9), 1331–1344.
Bourdieu, P. (1999). *Die Regeln der Kunst. Genese und Struktur des literarischen Feldes (Rules of Art)*. Frankfurt am Main: Suhrkamp.
Christianson, M. K., Farkas, M. T., Sutcliffe, K. M., & Weick, K. E. (2009). Learning Through Rare Events: Significant Interruptions at the Baltimore & Ohio Railroad Museum. *Organization Science, 20*(5), 846–860.
Edwards, D. (2008). *Artscience: Creativity in the Post-Google Generation*. Cambridge: Harvard University Press.
Feynman, R. (1997). *Surely, You Are Joking, Mr. Feynman*. New York: Norton.
Gioia, D. A., & Chittipeddi, K. (1991). Sensemaking and Sensegiving in Strategic Change Initiation. *Strategic Management Journal, 12*, 433–448.
Griffith, T. L. (1999). Technology Features as Triggers for Sensemaking. *Academy of Management Review, 24*(3), 472–488.
Kemp, M. (2016). *Structural Intuitions. Seeing Shapes in Art and Science*. Charlottesville/London: University of Virginia Press.

Lockett, A., Currie, G., Finn, R., et al. (2014). The Influence of Social Position on Sensemaking About Organizational Change. *Academy of Management Journal, 57*(4), 1102–1129.

Maitlis, S., & Christianson, M. (2014). Sensemaking in Organizations: Taking Stock and Moving Forward. *The Academy of Management Annals, 8*(1), 57–125.

Maitlis, S., & Sonenshein, S. (2010). Sensemaking in Crisis and Change: Inspiration and Insights from Weick (1988). *Journal of Management Studies, 47*(3), 551–580.

Okhuysen, G. A., & Bechky, B. A. (2009). Coordination in Organizations: An Integrative Perspective. *The Academy of Management Annals, 3*(1), 463–502.

Root-Bernstein, R., Lamore, R., Lawton, J., et al. (2012). Arts, Crafts, and STEM Innovation: A Network Approach to Understanding the Creative Knowledge Economy. In M. Rush (Ed.), *Creative Knowledge Economy* (pp. 97–117). Washington, DC: NEA.

Sandberg, J., & Tsoukas, H. (2015). Making Sense of the Sensemaking Perspective: Its Constituents, Limitations, and Opportunities for Further Development. *Journal of Organizational Behavior, 36*(1), 6–32.

Shelly, R. K., & Shelly, A. C. (2009). Speech Content and the Emergence of Inequality in Task Groups. *Journal of Social Issues, 65*(2), 307–333.

Stiglani, I., & Ravasi, D. (2012). Organizing Thoughts and Connecting Brains: Material Practices and the Transition from Individual to Group-Level Prospective Sensemaking. *Academy of Management Journal, 55*(5), 1232–1259.

Strike, V. M., & Rerup, C. (2016). Mediated Sensemaking. *Academy of Management Journal, 59*(3), 880–905.

Tsoukas, H., & Chia, R. (2002). On Organizational Becoming: Rethinking Organizational Change. *Organization Science, 13*(5), 567–582.

Weber, M. S., Thomas, G. F., & Stephens, K. J. (2015). Organizational Disruptions and Triggers for Divergent Sensemaking. *International Journal of Business Communication, 52*(1), 68–96.

Weick, K. E. (1988). Enacted Sensemaking in Crisis Situation. *Journal of Management Studies, 25*, 305–317.

Weick, K. E. (1995). *Sensemaking in Organizations*. Sage: Thousand Oaks.

Weick, K. E., Sutcliffe, K. M., & Obstfeld, D. (2005). Organizing and the Process of Sensemaking. *Organization Science, 16*(4), 409–421.

7

Aesthetics

Individuals who populate the realms of art, science, and organizations perceive them in a certain way. Through their senses, they start to get a feeling for the realms, to build up an understanding, create knowledge, and develop certainty in processes or classification of the sensory input. Thus, although it doesn't seem obvious at first glance, aesthetics links these three areas as a central perspective: primarily, art is associated with aesthetics; many interpretations and discussions emerged throughout the history of art and the philosophy of art about the relation between art and aesthetics. Nevertheless, aesthetics is more than that. In science, aesthetics can play a major role in the perception of data, as an established way of representations or illustration, and the knowledge of reading these illustrations impacts processes and practices of scientists, and eventually influences the knowledge they develop and how they communicate it. The same is true for every other profession and cultural group. Lately, organization studies discovered aesthetics as an important perspective on organizing work, organizational workflow, and organizations themselves. Organizational aesthetics thereby does not refer to the corporate design or design of advertisements, but to processes, practices, and workflows in organizations, or how the physical environment of an organization is related to these activities.

Aesthetics is central in art. In its history, theories of aesthetics have been developed alongside philosophical approaches to art, and aesthetics represents a separate philosophical realm next to rationality and ethics. Since the works of Hegel, aesthetics has sometimes been equaled with philosophy of art. The work-centered art theory became the dominant view on aesthetics, dominating the field for over 150 years, from philosophers like Immanuel Kant to

Martin Heidegger. These perspectives reflected on the attributes of the artwork and aesthetic judgment as based on aesthetic qualities—something that lies within the artwork. Moreover, the aesthetic can be inherent in artworks, artifacts, atmospheres of spaces, or buildings (Böhme 2003), and thus the environment influences an individual's reaction to it by creating a sense of beauty or, for example, ugliness. But the investigation into aesthetics does not stop there. Contrary to this idea, David Hume, for example, argued that aesthetics is nothing that lies only in the work, but lies in the consciousness of the beholder. Here in the tradition of the word's Greek origin, meaning sensibility and response to the stimulation of the senses, the experience and the involvement of the bodily senses are essential.

As such, aesthetic experience has been discussed by Alexander Gottlieb Baumgarten (1750/1758) as "sensual knowledge" and by Maurice Merleau-Ponty (1966) as "embodied phenomenology." Focusing on sensual perception as basis for the development of knowledge, the concept of Baumgarten goes thus far to sketch a program that aims at perfection of sensory cognition. It suggests a process in which the individual continually refines perception as a program of philosophical self-perfection in the art of living (Shusterman 1999). Baumgarten writes, "The end of aesthetics is the perfection of sensory cognition as such, this implying beauty" (Baumgarten 1750/1758: §14). Sensual or embodied knowledge, also sensible knowledge, is based on the visual, auditory, olfactory, gustatory, and touchable attributes of an object, person, or situation; it "concerns what is perceived through the senses, judged through the senses, and produced and reproduced through the senses" (Strati 2007: 62). Individuals build up a competence to "feel" something is right or works within a framework and thus is beautiful. Moreover, this kind of knowledge is a continuous interaction between the sensing subject and the other. Michael Polanyi (1962) relates the concept of tacit knowledge to the realm of sensible knowledge as based in experience and acting and manifesting as such: as something that is not possible to translate into words.

Notions of tacit knowledge and embodied knowing have become of major importance in management studies, organization studies, and science and technology studies. In the latter especially since Bruno Latour's seminal work on laboratory settings: *Laboratory Life: Social Construction of Scientific Facts* (Latour and Woolgar 1979). The argument is that even the outcomes of scientific experiments are influenced by social conventions and adopted perspectives on patterns or embodied knowledge of handling the objects and experiment equipment. In management and organization studies, organizational aesthetics and embodied knowledge help to understand practices,

processes, interpersonal interaction, production of knowledge, and learning (Strati 1992, 1999; Gagliardi 1996).

This stream of thought is fundamental to the upcoming research called "empirical aesthetics," which uses scientific approaches like neurological or psychological approaches to study the sensory experience of art as embodied process (Tschacher and Tröndle 2011). It aims at understanding what happens when the recipient of an artwork sees beauty in a painting, listens to music, or experiences a play or a film from a more quantitative and natural sciences approach: is there something trained? How does the nervous system react to these stimuli? Measuring the bodily reactions to art experience often contrasts biofeedback with intellectual discussions and qualitative interviews about the art experience to gain a comprehensive understanding of the effects of an art experience (Tröndle and Tschacher 2012). Recent outcomes of the studies support the notion of aesthetics as something that is not a purely intellectual sequence or culturally emerged convention, but includes an experience with the senses and that the experience of beauty triggers bodily reactions. The interplay of cognitive and sensory perception in aesthetic experiences and its role in the development of knowledge, emotions, and the contextual understanding of phenomena is currently the subject of interdisciplinary investigation (Ivanova 2017).

Bluntly speaking, aesthetics is a lot: attributes of the artwork or artifacts are important, intellectual reflection and cultural conventions influence the perception, and, at the same time, there is biofeedback that can be measured and senses can be trained. Obviously, aesthetics is essential in art, but the importance of aesthetics in any profession like science and in organizations should not be underestimated. Artscience collaboration can bring peculiarities in artworks produced, science practiced, and organizational life to the surface.

7.1 Experience Aesthetics and Aesthetic Expression

Research into the aesthetics of artworks, artifacts, media, and technology, as well as into the aesthetics of emotions and ideas, is important for understanding the world and communication is essential. Artistic practices are focusing on the creation of a deeper understanding of this and explore modes of aesthetic expression. At the same time, scientists are researching a better understanding of the universe and engineers build new media and tools for expression—an

expression that again is characterized by aesthetics. So exploration of the aesthetics through senses and tools is central in art and science, and at the same time, the ways of expression of the findings need to be refined to enable their accurate and comprehensive communication.

The German philosopher Ernst Cassirer (1944) takes up these ideas of aesthetics and sensible knowledge and argues that art and science are different modes of perception, which are trained, but also which create a different kind of perspective on one and the same thing, and this can again result in different interpretations and different kinds of knowledge: "The depth of human experience in the same sense depends on the fact that we are able to vary our modes of seeing, that we can alternate our views of reality" (Cassirer 1944: 170). Cassirer classified symbol-giving forms and individual logics for the realm of science, technology, art, myth, history, and religion, whereby these symbols used, abstractions made, and practices can cloak the reality in a certain way and guide the methods of investigation and interpretation. He shows that, through training, a certain depth can be reached in the respective knowledge, but that focusing on only one kind of knowledge, like art or science, can lead to "habitual blindness," as the dominant way of thinking can leave out other important perspectives or cover the sight of aspects that lie outside the field of view. Therefore, Cassirer argues that a "two-eyed" vision is important to create a more comprehensive picture of the things, objects, or environments an individual is investigating. By pointing to these different perspectives on subjects that are investigated, Cassirer challenges his readers to overcome the dual perception of what is true and untrue as adding new perspectives and new layers of knowledge can contribute something different. His idea is that art and science represent two sides of one coin, two perspectives on the truth, and to be able to grasp the richness of the world, both have to be taken into account. He argues to be open to both, the knowledge created by scientific processes like classification and analysis of specific aspects through reduction, and the knowledge created by art, which adds information about meaning, relationships, interactions, and how the world is shaped. This "two-eyed" vision would therefore intensify experiences instead of reducing them and categorizing them.

In the same vein, Susanne Langer (1957) argued that not only is art a different kind of knowledge, but the aesthetic practice of artists represents the ability to create forms that are able to evoke or represent the feeling of human experience. Therefore, art adds to the hard facts found by science and can create a bigger picture and construct a representation of the relationship between the human experience and the subject investigated. Investigation in to the aesthetics of human experience, artifacts, and the environment creates potential for new forms of expression.

Case: *Omnia per Omnia* by Sougwen Chung at the New E.A.T. Program at Nokia Bell Labs

The new E.A.T. program is a revival of the former E.A.T. program that took place at the AT&T Bell Telephone Laboratories in the 1960s and 1970s. The new E.A.T. program at Nokia Bell Labs offers residencies for 12 months as an ongoing interaction between artists and the research groups. The program takes place in collaboration with diverse partners. The residency of artist Sougwen Chung took place in collaboration with The New Museum and its incubator NEW INC. It enables an exchange between the differing practices of both parties, combining the aesthetic approaches, work processes (e.g., sensual knowledge), and human-centric judgment of the artists and the research inquiries of engineers. After the residency phase, the program offers the possibility to propose a new artwork based on the experience and exchanges during the residency, which can then be commissioned by Nokia Bell Labs. The vision of the program aligns with the laboratory's goals to create new forms of communication aided by future technologies. The Bell Labs vision seeks to address issues of today's society—issues which include digital loneliness and tensions between the digital and the physical. The vision questions the current landscape of human society, which could be described as quite technologically dominated and perhaps reductionist. As Domhnaill Hernon, PhD, MBA, head of the new E.A.T. program puts it, the Bell Labs ethos is "to create a new language to share emotion."

Thereby, the ethos necessitates the exploration of new avenues for communication beyond written or spoken language, and beyond current methodologies of interpreting images. Another important aspect of this vision is to create an understanding across cultures: how can experiential investigations unearth broader and more expressive approaches to interpretation? Or as the artist Sougwen Chung puts it, "Nokia Bell Labs tries to make the invisible visible." Their research is often in the pre-visual, theoretical territory, similar to artists, but artists have a visual fluency which oscillates between that which can be experienced and that which remains highly conceptual. Artists can help make the theoretical and the conceptual observable, expressive, and communal. Artists are experts in aesthetic expression—in creating a specific sensible experience. The practice of an artist enables a different repertoire to explore questions and create dialogue. On the other hand, Nokia Bell Labs' research is grounded in technology. Scientists have an alternate approach, one grounded in objectivity and rationality, even when the aim is to build a certain environment that enables communication.

The new E.A.T. program and the residency projects are of major interest within this chapter. Sensing emotional states in human interaction and how

that can be used to create new forms of aesthetic experience and expression is at the core of what the artists, scientists, and engineers are after as part of this program. Thereby, they are investigating aesthetics in all its manifestations as presented above: the aesthetics inherent in objects, atmospheres, sensual knowledge, perfection of perception, and understanding the interconnectedness of bodily experience, intellectual experience, and emotional reactions of aesthetic expression. At Nokia Bell Labs, the primary aim of scientists and engineers is building the communication network. By doing so, they often deal with things that are invisible or complicated to express beyond their professional jargon. In this case, the artists' work and experience in aesthetic communication with said networks is a natural complement, especially in collaboration with the scientists and engineers involved in building the infrastructure. Developments in technology and science lead to new media for art-making and experiencing. These collaborations between artists and scientists and engineers are leading the way, charting the space to explore new forms of communication and experience.

The artist Sougwen Chung had been working on the topic of human-robot interaction for a few iterations of artworks and within different residency programs before she arrived as artist-in-residence at Nokia Bell Labs. As an interesting example *Omnia per Omnia*, the collaboration between Chung and Nokia Bell Labs, brings to the surface the importance of this ongoing process by openly engaging in new ways of perception and exploration of the aesthetic possibilities of art and technology. In this sense, Chung's projects reflect the core intentions of the ethos of the new E.A.T. program and vice versa. Her projects create opportunities for aesthetic exploration for the artist and the scientist alike. Absorbing the perspectives and ideas being developed at Nokia Bell Labs, Chung was inspired to embark on the next chapter in her artistic practice. For the artist this exchange offered experience and new insights regarding Bell Labs' research and approach to technology and software development. For the scientists and engineers at Nokia Bell Labs, Chung's work presented a "special aesthetic, a beautiful line," as Domhnaill Hernon, head of the new E.A.T. program, expresses, uncommon to machine-generated visual outcomes because her drawings rest upon a fine, hand-drawn quality. To some they are reminiscent of elaborate calligraphy; to others they demonstrate a fragile quality.

This was not the only new aesthetic aspect the artistic practice revealed to be different. Before her residency at Nokia Bell Labs, Chung had already been artistically investigating the notion of human-robot interaction and the

ways of collaboration between humans and machine. She explored human-machine interaction through the creative process of collaborative drawing. Her exploration of this concept began in 2014, when the experimental *Drawing Operations* project began. The interaction between her and her robot arm became the center of this artistic research. Gestures, memory, and style analysis are the foundation of Chung's investigation of how humans and robots interact, mimic, learn, and collaborate. An artifact of this process is the drawings themselves, functioning both as an archive of research and as artistic works for speculation.

The interaction and the algorithm are grounded in the core principle of collaboration and shaped by the artist's aesthetic sensibilities. The subjective dimension of artistic inquiry guides this unusual research. The co-creation of images speaks to an evolving artistic style as well as to the machine's scope of perception and understanding through algorithmic approaches. Thereby, each collaborative drawing session has the potential to "free itself from any aesthetic restrictions," as the artist mentions. Aesthetic exploration through human-robot interaction and collaboration renders the process visible and experiential. As an artist, Sougwen Chung frames the technology itself as a collaborator and researches the often-overlooked data nested at the interstitial between human and machine. By doing so, Chung examines how machines could perceive, how this can be modified, and which connections can be made within the frame of artistic collaboration. Moreover, the intuitive, expressive gesture of Chung's hand-drawn lines contrasts the complex rationality of the process of scientific research. The value of experiments in art and technology goes beyond the aesthetic or conceptual, however.

One interdisciplinary dialogue that emerged during Chung's residency is her collaboration with Larry O'Gorman. Larry O'Gorman, PhD, who sees himself in both roles as scientist and engineer, leads a computer vision group at Bell. He was one of the main collaborators through the development of the second iteration of the residency which focused on mutual exploration of ideas and concepts; later the artist and the scientist went on to collaborate for the commissioned artwork *Omnia per Omnia* by Sougwen Chung. *Omnia per Omnia* is a performative piece in which the artist interacts with a custom multirobot system and is linked to the "biometrics" of a city. This multirobot interaction pushes the borders of her previous research in collaborative painting processes with a single robot. For the performance, Chung integrated the motion vector analysis algorithm originally developed by Larry O'Gorman for surveillance cameras to create "kinder cameras" (O'Gorman 2013). Instead

of demarcating the individual in a video feed via blob tracking or facial recognition, the algorithm understands surveillance footage differently by extracting collective information about crowds and the visual data flow. Chung responded to the poetic implication she perceived of this technological way of seeing, likening it to an impressionist painting (Figs. 7.1 and 7.2).

Her decision to use O'Gorman's work goes along with his implicit critique of current trends in technological surveillance, which in its use of facial recognition and single-subject detection can infringe an individual's right to privacy. By favoring the optical flow algorithm that regards the collective instead of the individual, Chung offers a subtle endorsement of O'Gorman's "kinder" approach to computer vision. The data extracted from the algorithm is adapted for the multirobot system that collaboratively paints with Sougwen Chung. The data is the basis for the videos and impressions of the city that reflect the "biometric" of the city in this body of work.

The Bell Labs motion engine designed by O'Gorman enables the artist to observe "biometrics" of place, even though, as an engineer, O'Gorman sees the output quite differently. The collaboration with Chung provides O'Gorman another lens to his work, offering a look into an approach to data that is at once gestural, conceptual, and ambiguous in nature. The

Fig. 7.1 Performance of *Omnia per Omnia* by Sougwen Chung, 2018. The artwork reimagines traditional landscape painting as a collaboration between humans, robots, and the dynamic flow of a city. It explores various modes of sensing: human and machine, organic and synthetic, improvisational and computational. (Image courtesy: Sougwen Chung [impressions of the performance https://vimeo.com/268448066])

collaboration with Chung and other artists even led him to explore the addition of other sensing techniques because the artists could create experiences that expressed the beneficial additions different sensors can bring.

Although artists, scientists, and engineers differ in lexicon and process, through shared values and opportunities to work on focused projects, they can establish connections between their fields, philosophies, and approaches. Collaborative practices, processes, and perspectives emerge through shared research, and the co-creation of ground breaking projects incubates new dialogues among them. Therefore, aesthetics in all its manifestations is at the heart of these collaborations. Artistic, scientific, and engineering work are based on different practices that can be made visible at their intersection created in collaborations. Exploration of these different practices helps to experience new ideas and incorporate them in their own practice. Moreover, artists, scientists, and engineers—as in the example of Nokia Bell Labs—are concerned with aesthetics, communication beyond language, and the use of different media and technologies to sense the environment and communicate ideas, emotions, and feelings. The different aesthetic approaches that are based in artistic, scientific, and engineering practice complement each other and push the shared research interests further.

Fig. 7.2 Detail of the collaboration process between Sougwen Chung and the robots during the performance of *Omnia per Omnia* by Sougwen Chung, 2018. (Image courtesy: Sougwen Chung)

7.2 Organizational Aesthetics, Practices, and Ways of Seeing

Aesthetic experience and aesthetic expression are connected to the senses, the capability of using the senses—or the refinement of the perception—and the aesthetic knowledge or sensibility that is built through the exposure to art, artifacts, the experience of movements, or the refinement of practices. Gottlieb Baumgarten refers to aesthetics as the perfection of perception. In the process of becoming a specialist in a field—in art, craft, science, engineering—or any other practice in an organization, sensible knowledge is created. Such practical knowledge can be classified beyond theoretical knowledge that explains things, as it is tightly connected to practices and processes individuals get used to and that influence behavior and production of an outcome in conscious and often unconscious ways. Approaches like embodied knowledge and its influence on interpretations of situations and tacit knowledge are closely connected to this process (Latour and Woolgar 1979; Polanyi 1962). In organization studies, a comprehensive view on how individuals train their different senses in order to learn the practices and important aspects of their profession is discussed as aesthetic approach or as organizational aesthetics (Strati 1992, 1999; Gagliardi 1996). It points to processes of knowledge creation in a profession, information and interpretation of artifacts in use in organizations, or the handling of materials essential to the professional practices or which constitute refined outcomes, and interrogates the organizational aesthetic environments like rhythms, architecture, paths throughout a facility, smells, and noises that constitute practical knowledge.

This approach relies on the idea that the interaction between individuals, between individuals and their material, as well as between individuals and the organization as such is based on the perceptive-sensory faculties and on the sensitive-aesthetic judgment. The aesthetic experience or pleasure that can be aroused is here less than the awe in perceiving a beautiful artwork—the performance or outcome of work practices can be impressive or perceived as beautiful and elegant though—but based in this "knowing how to do it," pleasure can arise from the practice and dealing with the materials or artifacts. This aesthetic knowledge in organizations emerges from practice and experience (Strati 2007). How individuals in an organization react and feel about certain artifacts or about how their current working process develops is based in their knowledge about previous working processes, and the meaning that is attributed to the certain artifacts and their aesthetic appearance within their professional or organizational environment. Studies have shown that work itself

"includes an essential aesthetic element; ... aesthetics pervades the everyday life of organizations" (Ottensmeyer 1996: 192–193) and created a more sensual approach to organizational life which is also represented in the growing importance of artifacts and materiality (Elsbach and Pratt 2008) and visual studies (Warren 2008) in organization research. Researchers in the field describe aesthetic ways of knowing as passionate knowing, negotiated and "explored through the materiality and connections amongst work, workplace and work objects" (Gherardi et al. 2007: 316).

In science, for example, notations and visualizations of scientific data and ideas follow a specific form. Thus, in the development of the conventions of a field, aesthetics evolve that are a common base for scientists in the field to understand, for example, data visualizations and reading the notations of their peers (e.g., Jones and Galison 1998; Galison 1997; Wechsler 1988). Moreover, this shared knowledge enables judgment of outcomes and arguments based on the aesthetic material: something looks right, feels correct, or convincingly straightforward or elegant; some refer to the experience of scientists, mainly mathematicians, where they see beauty or elegance in some proofs or forms, and where they find a strong correlation between the elegance or beauty and truth or correct outcomes, which is again strongly correlated with simplicity (Schmidhuber 1997). It is not only simplicity or a simple form that allows anyone to see beauty in a mathematical form because this experience is also connected to the trained eye of the mathematician, to previous experience in their field, and to knowledge about other notations and other mathematical proofs. This is similar to how physicists or astronomers understand the visualizations of their data, or others perceive highly skilled work in their field.

Artists and scientists from different fields are not only trained in different workflows with a diverging knowledge base, but as a result of their practice and education in their own field, they are trained in a certain way of seeing, pattern recognition, or aesthetic judgment of the material representations of their work, the artifacts they work with. This, of course, relates to preferred methods of analysis and senses used (e.g., specific visualization techniques for scientific data), which build up a diverging body of sensual knowledge within artists and scientists. Even if artists may not be able to contribute something substantially new to the theory or subject of investigation a scientist is working with, their new approach to seeing things differently can help to frame new questions or to see previously unrecognized patterns in data. This can happen by analyzing the images and data the scientists use (as experienced by Antonio Mampaso below) or by translating the data into a new aesthetic form (as can be seen in the case of *Blue Morph*). An aesthetic investigation of an

artist into scientific visualization techniques can be important to give new insights into things that seem to be rigid systems of symbols or formal restrictions that are no longer questioned—sometimes for decades or even longer. Thus, artists can bring in their expertise to make the invisible visible, to express experiences or knowledge in new, unexpected ways that address different senses than a scientist is used to in their work. A confrontation with the practices and new aesthetic techniques can be important for scientists to see new aspects in their work, using new aesthetic approaches or to get around questions they have been stuck with using their traditional scientific tools (Root-Bernstein and Root-Bernstein 2013).

Dr. Antonio Mampaso, astrophysicist and former director of the Museum of Science and Cosmos in San Cristobal de La Laguna in Tenerife, in the chapter on communication, also refers to the importance of allowing different kinds of knowledge, and how artists may provide different visions on objects, data, processes, and connections between ideas and data. In the discussion, he is very much referring to an aesthetic approach, a different and complementary approach to understanding the cosmos based on aesthetics, and how artists can approach knowledge differently. Referring to the nebula shown below, he mentioned a conversation with an artist where she was asked to express what she would think about it, her first impression. The artist referred to it as "an organic structure, an evolving shape reflecting the evolving nature of the central star." As for astrophysics, although there are general ideas about how these structures could be originated (e.g., symmetry is thought to be caused by a binary central star), there is not really an accepted and detailed model explaining them. The morphology of these kinds of nebulae is very complex, showing a strong bilateral symmetry, and it brings traditional interpretations and approaches into question. What if an astronomer could take this idea, of this as an evolving organic structure, as a notion that leads to a new exploration of this complexity (Fig. 7.3)?

In the ongoing conversation, Mampaso pointed to further images, like two galaxies that are interacting, where an artist mentioned it looks like they were dancing tied one to the other. And in a sense, they are.

Such an additional layer of knowledge, another approach that is not purely rational or derived from traditional accepted process, can deliver important inputs for questions and new scientific approaches. Experience of these new perspectives can lead to fruitful conversations about techniques, tools, and the modes of analysis (or modes of seeing) applied to the data—things that are refined within a group of peers—and thus overcome "habitual blindness" (Cassirer 1944). To break this "habitual blindness," it is important to get new insights and learn about other ways of seeing. Although highly qualitative

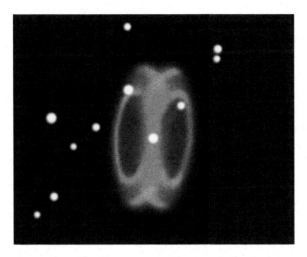

Fig. 7.3 Artist's view of planetary nebula A14 based on images created during observations of the nebula by Antonio Mampaso and Denise Goncalves, 2018. (Image credit: Roland Aigner)

work is based on well-established and trained practices and a high level of specific knowledge, breaking routines and experimentation with new modes of doing and seeing can help to take next steps in a professional development or in a (artistic or scientific) project. Breaking such routines helps to be open to new practices and can trigger sensemaking processes, as presented in the previous chapter. Thus, an interaction between artists and scientists can be a trigger for change and new developments, or lead to finding a new "hook" for asking new questions and starting new projects. In the case of Antonio Mampaso, questions about forms of complexity and morphologies that were central to the discussions with artists laid the fundament for succeeding scientific research projects.

The more interaction there is, the more the collaborating artists and scientists have the opportunity to experience the other's perspective and to get more deeply involved in new methods or even to acquire new techniques and perspectives. Thereby, learning to interpret sensitive knowledge and create more comprehensive knowledge in interpreting aesthetic expression is crucial to evolving personal competencies. The creation of a comprehensive artscience project tackles artistic and scientific aesthetic knowledge and practices.

Case: Victoria Vesna and James Gimzewski—The Creation of *Blue Morph* It all started with a media artist and a nanoscientist working together, testing experimental approaches: Victoria Vesna, PhD, media artist and professor for media arts at UCLA, met the nanoscientist Dr. James Gimzewski, as she was interested in the structures named after Buckminster Fuller: Bucky Balls. At

that time, James Gimzewski arrived as professor of chemistry at UCLA after a successful career in Switzerland, knowing how to manipulate Bucky Balls, although he didn't know about the architect Buckminster Fuller and the story of why these structures are named after him. When they met to talk about these Bucky Balls they went on to do a first collaborative artscience project on these structures called Zero@wavefunction which was presented in 2002. The artscience partnership developed from that point on into a fruitful ongoing exchange.

At that time in 2002, James Gimzewski was researching on yeast cells, experimenting with looking at them with unusual tools like the atomic force microscope (AFM). Assisted by Andrew Pelling, his PhD student at the Pico Lab at the UCLA Chemistry department, Gimzewski found out that the yeast cells were oscillating at the nanoscale—which wasn't expected—which they depicted in graphs as per their usual practice. "Let's send this to Victoria. Maybe she has an idea to do something with it" was the proposal; but these graphs didn't feel like enough data to send to her. What should she do with these lines, these waves? Although there is a convention to depict the results of research on the nanoscale in visualizations, there is no rule that this is the only possible way to interpret them—and to reproduce the data. As Andrew Pelling has a background in music, they decided to convert it to sound, amplified the oscillation, and sent the resulting sound that was within the human audible range to Victoria Vesna. This is an important turn, as the AFM does not use optical imaging to investigate the sample like other microscopes; it rather "feels" the sample by touching it with a small tip. These interesting results still did not trigger another artscience project, but resulted in the cutting-edge research field "sonocytology," an investigation into the potential of cellular oscillations. Although these results received mixed response from the professional community, a paper (Pelling et al. 2004) was published and much speculation and investigation into why cells oscillate, when they do this, and what it means were triggered. "This work and this paper just came out because of him trying to impress a media artist," says Victoria Vesna jokingly.

This work created interest from many different fields: from different scientific fields, from different artistic perspectives like media art and music, and even from spiritualists and the New Age Movement. Anne Niemetz—Victoria Vesna's graduate student in Design | Media Arts—and Andrew Pelling used

these outcomes to work on a collaborative project called "The Dark Side of the Cell" for the *NANO* exhibition project at LACMA (the Los Angeles County Museum of Art—where already in the 1960s one of the first exhibitions in art and technology took place), which was led by Victoria Vesna and James Gimzewski.

During this frenzy about the "singing cells," what the results have colloquially been called, a woman, the wife of a collector of butterflies, called at James Gimzewski's laboratory and asked if they ever looked at the chrysalis of butterflies during the metamorphosis. They had not considered something like that before, but the woman was quite insistent, so they approved, and she sent a collection of chrysalises. The first batch of butterflies hatched before the scientists did any experiments and the lab was full of butterflies. But the woman was persistent enough and again sent another batch of chrysalises to look at the transformation process of the caterpillar to a butterfly. Developing a specific construction to measure possible vibrations, as the chrysalis was too big for the microscope, the team around James Gimzewski discovered that there were eight pumps or "pumping hearts" that beat throughout the metamorphosis. They discovered that these sounds of the metamorphosis are not a continuous flow or appear to be gradual, but in sudden bursts, interrupted by stillness and silence. These eight "pumping hearts" create a rhythm that remains constant throughout the changes. As the artist and the scientist describe it: "The amplified sounds reveal the process both to be halting and violent, contradicting our imagination of a gradual peaceful metamorphosis." This surprising insight and the impressive sound from the amplified data were suddenly proposing themselves as a fundament for an artwork.

The intriguing color and structure of the Blue Morpho butterfly's wings should find a space in the artwork. The sensorial environment of the artwork is inspired by the wings' structure and subtle movements of its parts and layers; it displays images of the butterfly's wings in different scales of magnification based on recordings from the scanning microscope, as well as the sounds of the metamorphosis. The movements of the participant on the main platform interact with the imagery and sound to influence the atmosphere in the sphere of the artwork (Fig. 7.4).

The artwork *Blue Morph* is a site-specific interactive installation that uses the images and the sounds derived from the scientific investigations into the metamorphosis and the wings of the butterfly. It is also referring to silence or apparent silence, making the inaudible audible. Thereby, it was never meant to be a visual and audible representation of the process, but aims at immersing

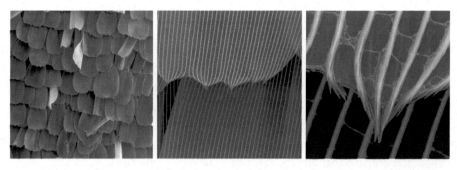

Fig. 7.4 Source images for *Blue Morph* retrieved by imaging the wings of the Blue Morpho butterfly with a scanning electron microscope, colored afterward to represent the color of the Blue Morpho butterfly, 2007. (Image courtesy: Victoria Vesna)

the audience into this process. The installation is designed so that one person from the audience enters the center for the experience within the images and the sounds generated from the scientific research. Through this kind of ritual, getting into the center, mounting the central piece on the head, this person becomes the performer, creating a powerful momentum for the whole audience. No matter what this person does, stays still, starts to meditate or to dance, this person, in connection with the music, visuals, absorbed in the blue color of the Blue Morpho butterfly, is always creating an atmosphere that absorbs the audience and reaches into the small or huge spaces to which the work is adapted. The artist and the scientist wondered, as often nobody even asks what it is about, it just works, proposing that people want to experience something in there, creating a ritual for themselves, creating a change for themselves (Fig. 7.5).

7.3 Aesthetics, Professional Expertise, and Education

Aesthetics, human senses, materiality, embodied knowledge, and routine practices play an important role in work processes and professional expertise. Over time, aesthetic experience can build comprehensive professional expertise, and this expertise can be expanded by new aesthetic experiences. A more comprehensive knowledge can be reached through aesthetic experience that combines artistic and scientific experience: as John Dewey (1934) points out, where science states meaning, art expresses it. Without going into the depth of Dewey's argument why science and even life itself can be considered

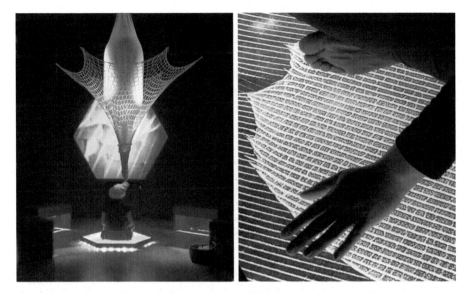

Fig. 7.5 Left: installation and performance of *Blue Morph* at the Beall Center for Art + Technology, 2015. Right: detail of the installation; platform illuminated with the wing details of the butterfly. (Image courtesy: Victoria Vesna)

as art, mastery of anything someone does needs experience. These comprehensive aesthetic experiences and the inclusion of artscience in education are fundamental for an understanding of the connectedness and interdependence of disciplines.

New aesthetic experience can alter and expand professional knowledge and practices as artists and scientists often refer to: after their own work had been expressed in the other's aesthetic language they started to "see" or "understand" why others perceive their work differently. Others expressed their feelings in phrases like "I understood it differently," "learned to express it with different media," and "experience it with my senses triggered a better understanding of what I actually was doing in my scientific project." The more comprehensive the practices and methods used in the own professional work are, the higher the potential of new insights and effective projects. Robert Root-Bernstein and Michele Root-Bernstein (e.g., 2013) show in their comprehensive research on art, science, and creativity that most successful scientists are often polymaths or claim that the training of their sensible/aesthetic abilities through art or music helped them to come up with new ideas in their scientific fields.

Adding interdisciplinary methods and new aesthetic approaches to traditional education systems helps to develop more comprehensive skills and knowledge about the subjects in question. For example, refined observation skills, improved visual thinking techniques, or improved pattern recognition and tactile, that is, manipulation, abilities can be trained through exposure to art (music, dance, painting, etc.). Thus, even an engineering career or interest in science will not be possible without sensible knowledge and refinement of perception that can be supported through engagement in art. It helps to gain new competencies to expand the own work practices and skills of expression. In artistic education, logical argumentation, analytical thinking, and precise investigation methods can be crucial for artistic development and work. Concerning the development of deeper knowledge, Dewey (1934) explains that creation of art and exploration of sensory perception allows for further discovery of sensory aspects that go beyond the fundamentally necessary aspects needed for the recognition of objects. The more one knows, the more one can see. And if there is a necessity to reproduce sounds of a machine or paint a horse, one needs to know more about the objects than what you need to know to recognize them at first glance. Although there are certain things that are specifically relevant to master a specific profession or craft (or science), there is experience necessary in many fields to get a comprehensive understanding of a practice or subjects investigated.

Lastly, professions, disciplines, and scientific and artistic fields cannot be seen in isolation. Within the last few decades, many new interdisciplinary fields evolved: media art is based on computer science and engineering, and scientific disciplines employ visualization techniques and create aesthetic languages. Implementing the idea of crossing disciplines early in education is essential for future professional development. Artist-in-residence projects at scientific organizations can provide a platform for interdisciplinary collaboration and courses that bring together students from different disciplines to experiences the process for the first time (Thomas 2013). The inclusion in the educational system at an earlier point in time can be even more effective to create an understanding of how highly specialized professional work draws from knowledge and methods from different disciplines.

Case: Yen Tzu Chang at Fraunhofer MEVIS—STEAM Imaging Residency, Including Interdisciplinary Workshops for High School Students

The fundamental forces that led Bianka Hofmann and her team to develop the project and artist-in-residence opportunity called "STEAM Imaging" lay within ideas for pioneering projects of science communication and the

willingness to create novel educational opportunities within the paradigm of the STEAM movement—the idea to integrate art into the STEM education. The more specific idea was to add to the learning experience of pupils by creating a deeper understanding about the latest developments in science and medical technology through a workshop that includes artistic perspectives. The workshop should close the gap between what happens in science and technology organizations and what the young generation knows about the inherent workflows and the technological advances made in these research projects. The integration of artistic elements and a media artist's practices and perspective on the topic should narrow the gap between pupils who are either artistically or scientifically interested, and show them the importance of aesthetics in science and the role of scientific methods or technological tools in art. This aims at overcoming stereotypical behavior pupils are often socialized to: those who are good at mathematics with technological interests, and those good at languages or visual expression who wouldn't be too good if they did anything more "sciency." Integrating scientists in this project aimed at creating new opportunities for them to communicate their work and to raise the value of science communication activities for everybody involved (Hofmann et al. 2017).

So far, the driving force of the project was high aims, a complex idea difficult to address within one project. Thus, the formal structure of the project was twofold: in the beginning of 2017, the artist Yen Tzu Chang spent two weeks for a residency at Fraunhofer MEVIS, where she worked on her artist-in-residency project in collaboration with scientists. Referring to the main ideas of her artworks, using her artistic tools, and the software platform for medical imaging development (MeVisLab), the artist and the mathematician Sabrina Haase, who is experienced in giving STEM workshops, collaboratively prepared two workshops for pupils aged 12–15 years. To finish the ambitious artwork, Chang spent the second part of her residency at Ars Electronica Futurelab. The artwork *Whose Scalpel* deals with important topics of the future of digital transformation in medicine and general topics Fraunhofer MEVIS is confronted with, such as new team-building of physicians and computer and new roles for physicians and computer. Chang raises these issues to bring them to a broader public, to enable open discussions, and to reduce fear that is based in lack of information. The experience of the artwork raises questions and aims at the ethical discussions led at Fraunhofer MEVIS among the scientists. One module of the residency included ethical discussions by the artist with pupils and scientists. Within the organization, this created a new opportu-

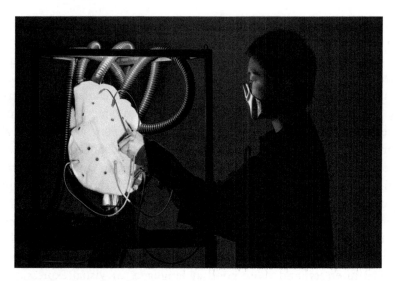

Fig. 7.6 Performance *Whose Scalpel* presented by Taiwanese artist Yen Tzu Chang in the scope of Fraunhofer Society's "Science and Art in Dialog" event series in Berlin, 2018. (Photo credit: Fraunhofer ICT Group)

nity to get together, discuss these questions, and start working on an ongoing format to do so. Additionally, the dominant sense the invited media artist is addressing in her work is the auditory sense. Her experimentation in sound in the context of the visualizations done by the scientists has been named by her collaborators as something they experienced as an important additional aspect that can support their work (Fig. 7.6).

In collaboration with the artist Yen Tzu Chang, the mathematician and experienced STEM workshop lecturer Sabrina Haase and Bianka Hofmann prepared the STEAM Imaging workshop for 12–15-year-old pupils. The workshop connected mathematical and software skills to learn about the student version of the tool MeVisLab as well as some interaction and information about medical technologies, with artistic processes, programming, and hardware skills to produce and record sounds and videos. It is not only the high level of the STEM interaction and meeting scientists that is so important for the pupils to acquire new knowledge that enables them to work more enthusiastically and to deeply engage in the topic. In the questionnaire given to these pupils, they provided information about the STEM skills they learnt and if there was too much formal content, too little time, or things they already knew; the responses were mixed. There

were mixed reactions to questions about how explicitly they realized the importance of technological tools for art, how aesthetic approaches are used in science, and about how much they think they learnt new hard facts and theories (Schnugg 2017). It is for the pupils to single out and express some new experiences and learning developments that are completely new immediately after the workshop experience itself. The important aspect is, though, that the pupils engaged deeply in the software and hardware learning requirements with the goal of the production of an artistic output. They started to learn how to utilize these scientific and technological tools to create an aesthetic output, and some even easily developed the skill of using a new programming language or building the hardware components which were needed for the sound recordings. For those pupils in the second group who did not find easy access to these techniques because they did not have any previous interest in computer science, the goal to create an artwork was so important that they wanted to spend more time training and learning to use the required techniques. They experienced the interdisciplinary nature of any work and the importance or otherwise as "dry" or "boring" classified school subjects in any exciting professional environment, ranging from engineering to science and from medicine to art. Moreover, during the workshop with these pupils, such ethical discussions and deep questions concerning the possibilities of these technologies arose on a level of depth and engagement that does not usually happen in STEM workshops with pupils of this age, as Bianka Hofmann and Sabrina Haase remark. This experience, this first contact with the practices and the (aesthetic) experiences as well as perspectives that are prevalent in the different fields, plants important seeds for the future development of these pupils in any professional field.

Based on shared experience and exploration of artscience methods in the two workshops, the scientist and the artist thoroughly developed their interdisciplinary teaching methods, which had an enormous impact on the engagement of the pupils in the workshop. Since then, follow-up workshops have been designed at Fraunhofer MEVIS with different groups of students, people in the "maker scene," and semi-professionals in more interdisciplinary artscience settings, and future STEAM Imaging workshops are planned. At the same time, the STEM workshop material included an arts teacher's perspective, and an increased understanding of connections to artistic practices in the original STEM workshops by Fraunhofer MEVIS has developed (Fig. 7.7).

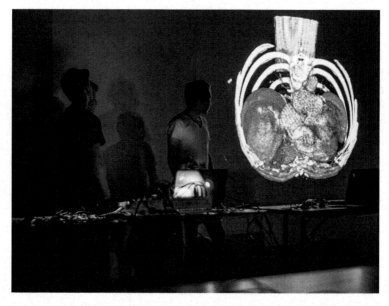

Fig. 7.7 Final presentation during the STEAM Imaging workshop with high-school students that took place at Ars Electronica in Linz, 2017. (Photo credit: Martin Hieslmair)

References

Baumgarten, A. G. (1758). *Theoretische Aesthetik – Die grundlegenden Abschnitte aus der "Aesthetica"* (1750/58) [Theoretical Aesthetics – The basic sections of the "Aesthetica" (1750/58)]. Hamburg: Felix Meiner.

Böhme, G. (2003). Atmosphere as the Subject Matter of Architecture. In P. Ursprung (Ed.), *Exh. Cat. Herzog & de Meuron. Archaeology of the Mind*. Montreal: Canadian Centre for Architecture, 23 October 2002–6 April 2003.

Cassirer, E. (1944). *An Essay on Man*. New Haven: Yale University Press.

Dewey, J. (1934). *Art as Experience*. New York: Minton, Balch and Company.

Elsbach, K. D., & Pratt, M. G. (2008). The Physical Environment in Organizations. *The Academy of Management Annals, 1*(1), 181–224.

Gagliardi, P. (1996). Exploring the Aesthetic Side of Organizational Life. In S. R. Glegg, C. Hardy, & W. R. Nord (Eds.), *Handbook of Organization Studies* (pp. 565–580). London: Sage.

Galison, P. (1997). *Image and Logic. Material Culture of Microphysics*. Chicago: The University of Chicago Press.

Gherardi, S., Nicolini, D., & Strati, A. (2007). The Passion for Knowing. *Organization, 14*(3), 315–329.

Hofmann, B., Haase, S., & Black, D. (2017). STEAM Imaging: A Pupils' Workshop Experiment in Computer Science, Physics, and Sound Art. *Sciart Magazine*, 8/2017. http://www.sciartmagazine.com/steam-imaging-a-pupilsrsquo-workshop-experiment-in-computer-science-physics-and-sound-art.html

Ivanova, C. (2017). *Neuroestetics of Emotion and Contemporary Art Forms*. Doctoral Dissertation at the National Academy of Art Sofia, Bulgaria. Australian National Centre for the Public Awareness of Science.

Jones, C. A., & Galison, P. (1998). *Picturing Science Producing Art*. New York: Routledge.

Langer, S. K. (1957). *Problems of Art: Ten Philosophical Lectures*. New York: Scribner.

Latour, B., & Woolgar, S. (1979). *Laboratory Life: The Social Construction of Scientific Facts*. Los Angeles: Sage.

Merleau-Ponty, M. (1966). *Phänomenologie der Wahrnehmung (Phenomenology of perception)*. (frz. 1945). Berlin: de Gruyter.

O'Gorman, L. (2013). Putting a Kinder Face on Public Cameras. *IEEE Computer Society, 0018-9162/13*, 84–86.

Ottensmeyer, E. (1996). Too Strong to Stop, Too Sweet to Lose: Aesthetics as a Way to Know Organizations. *Organization, 3*(2), 189–194.

Pelling, A. E., Sehati, S., Gralla, E. B., et al. (2004). Local Nanomechanical Motion of the Cell Wall of *Saccaromyces cerevisiae*. *Science, 305*(5687), 1147.

Polanyi, M. (1962). Personal Knowledge. In *Towards a Post-Critical Philosophy*. London: Routledge.

Root-Bernstein, R., & Root-Bernstein, M. (2013). The Art and Craft of Science. *Creativity Now!, 70*(5), 16–21.

Schmidhuber, J. (1997). Low-Complexity Art. *Leonardo, 30*(2), 97–103.

Schnugg, C. A. (2017). *STEAM Imaging: Art Meets Medical Research*. Workshop Evaluation. Report for Fraunhofer MEVIS, Germany. Retrieved from https://www.researchgate.net/publication/318572754_STEAM_Imaging_Art_Meets_Medical_Research_Evaluation_Summary

Shusterman, R. (1999). Somaesthetics: A Disciplinary Proposal. *The Journal of Aesthetics and Art Criticism, 57*(3), 299–313.

Strati, A. (1992). Aesthetic Understanding of Organizational Life. *Academy of Management Review, 17*(3), 568–581.

Strati, A. (1999). *Organization and Aesthetics*. London: Sage.

Strati, A. (2007). Sensible Knowledge and Practice-Based Learning. *Management Learning, 38*(1), 61–77.

Thomas, L. (2013). *Inter-virtual Total Recall* (p. 309). Linz: Ars Electronica Festival Catalogue.

Tröndle, M., & Tschacher, W. (2012). The Physiology of Phenomenology: The Effects of Artworks. *Empirical Studies of the Arts, 30*(1), 75–113.

Tschacher, W., & Tröndle, M. (2011). Embodiment and the Arts. In W. Tschacher & C. Bergomi (Eds.), *The Implications of Embodiment: Cognition and Communication* (pp. 253–263). Exeter: Imprint Academic.

Warren, S. (2008). Empirical Challenges in Organizational Aesthetics Research: Towards a Sensual Methodology. *Organization Studies, 29*(4), 559–580.

Wechsler, J. (1988). *On Aesthetics in Science*. Boston-Basel: Birkhäuser.

8

Communication

Many things can be understood as communication, and people who reflect on artscience collaboration and communication refer to a kaleidoscope of experiences of changed communication: communication in the sense of outreach or communication of content from one group to another group of people has been a major argument for artscience collaboration for a long time. Already in the 1980s inclusion of art in the communication of science and scientific outreach processes was proposed and supported by official funding bodies (Sleigh and Craske 2017). Exploring artworks for communication to a broader public has been adopted by science museums (Gates-Stuart 2014) and, lately, it has become a part of public engagement processes (Bureaud 2018). Others talk about inclusion of art to foster communication through experience or different senses. At the same time, artists, scientists, and managers report an increase in their communication skills through developing new conversational techniques to talk to a broader public and different stakeholder groups and learn to create a visual framework for presenting their idea and use nonverbal expression.

Communication is defined as an exchange of information between individuals that can take place using language, a common system of symbols that are not limited to words or letters, signs, or behavior. Personal ability to convey content can be trained and built through experience and reflection. Additionally, communication in an organizational context involves outreach activities or the communication of information based in the organization to a different group or broader public. This includes activities to inform the public about the existence or activities of an organization and thereby reach out to

specific groups or to a yet unknown audience to initiate contact. Science communication specifically aims at making new insights and theories available to the public or a specific group of stakeholders. The term science outreach includes those activities by scientific organizations, museums, and other institutions to promote a public awareness and understanding of science, and is connected to the science organizations' educational activities and can include public engagement projects.

Broadly speaking, in communicating, the five axioms of communication (Watzlawick et al. 1967) are central in framing and developing communication skills. These are as follows:

1. One cannot not communicate.
2. Every communication has a content and a relationship aspect such that the latter classifies the former and is therefore a meta-communication.
3. The nature of a relationship is dependent on the punctuation of the partners' communication procedures.
4. Human communication involves both digital and analogic modalities.
5. Inter-human communication procedures are either symmetric or complementary, depending on whether the relationship of the partners is based on differences or parity.

Modalities of communication range from a spoken word to movements, pictures, and music. Moreover, modes of communication are not only influenced by the type of medium that is used, but also by the relationship between the individuals who are communicating (Ruesch and Bateson 1951).

Communication is a broad field that tackles many disciplines. All of them cannot be covered in this overview, so the presentation of artscience collaboration tackling communication will revolve around these basic ideas: developing communication skills, employing different modalities and media, the interconnectedness of communication aspects and organizational communication in the form of outreach, and more specifically science communication and public engagement processes.

8.1 Enhanced Personal Communication Skills

One of the first things humans learn is to communicate: to convey information or feelings and to process received information. Socialization in cultures, societal groups, or professions renders the ways of communication more precisely. Artists learn to express their ideas within their communities, just as scientists learn to talk effectively and efficiently about their work to their

peers. For example, over centuries—and in some cases over the last few decades—scientific language evolved into the formal carrier of unambiguous information by adopting rules and standards that allow for clear communication of outcomes, methods, and theories. As scientific language must be precise and unambiguous in transmitting information, to a large extent symbols, metaphors, imagines, irony, paradoxes, and ornamental telling of stories got lost. There is no room for ambiguities or things that can lead to misunderstandings (Picardi et al. 2016). Thereby, specific meaning gets attached to terms that are used in a broader sense outside of the scientific field. This can lead to insecurities or misunderstandings in communication across fields. As scientific jargon becomes normal for those using it daily, it becomes part of general conversations without being translated in to a more common language. The same is true for disciplinary visual communication (Jones and Galison 1998). Thus, conveying ideas to a new audience can become more difficult. Creating awareness of disciplinary language and communication conventions is the first step to improving broader communication skills. Training artists and scientists in interdisciplinary collaboration helps to overcome challenges and enhance personal communication skills.

Referring to the five axioms of communication, this means first: one cannot not communicate. Even saying nothing implies meaning, which is not necessarily the same meaning for individuals with different professional backgrounds. Second, communication is not only about what information is transferred from one person to another; it is influenced by their relationship and builds relationship. So communication can develop based on shared experiences and knowledge about the relationship. Third, people with different backgrounds can develop different ways to express themselves or use non-verbal communication differently, so reflection on meta-communication aspects helps to communicate more clearly. Fourth, the words and expressions used can either be very concrete and defined elements or evoke analogies, used as metaphors; but even defined elements can mean something different in different areas, meaning that digital and analogic modalities of communication can be used. Fifth, people who communicate do not necessarily have the same education or pre-information; there can be symmetric or complementary information transfer.

Evolving personal communication skills is important for anyone from any professional or cultural background in intercultural and interdisciplinary exchange. The following examples focus on scientists' experience of this learning process; additionally it is necessary for artists to express their ideas toward a broader public or learn to sell their work to individuals and organizations, as it is for organizations to find the right ways to communicate their visions and goals.

Case: *Creatura Micro_Connectomica*—A Convergence Initiative Collaboration Project

The artwork *Creatura Micro_Connectomica* was developed by the neuroscientist Chris Salmon and artists Alex Bachmayer, Andrea Peña, and Jade Séguéla within the framework of the Convergence Initiative at McGill and Concordia Universities in Montreal. In this interdisciplinary program, interested neuroscientists (mainly doctoral and postdoctoral researchers) working at McGill University entered into collaborations with artists at the Concordia Faculty of Fine Arts. During the first phase of the program, the artists and the scientists were introduced to the idea of artscience collaboration, presented their previous work to each other, and personally explained their visions for their artworks and their scientific research. The three artists and the neuroscientist decided to collaboratively create a kinetic artwork inspired by Chris Salmon's research into neural network development.[1] Salmon found that the collaboration helped him to interact with his research from new perspectives, to think more laterally, and to tackle critical issues about the scientific process. He reflected extensively on communication throughout the collaboration and found that both this reflection and the act of communicating with his collaborators helped him develop communication skills that are relevant in interdisciplinary collaborations within the scientific realm. He pointed out the difficulties that both the scientists and the artists in the program experienced in explaining their work and ideas for the first time to nonspecialists: terms must be used that everybody understands and that connect to a common knowledge base. Both artists and scientists are used to very technical jargon pertaining to their specific discipline that includes attribution of meaning to certain expressions and assumptions about shared vocabulary. This leads to a certain kind of communication about their work. Both groups are accustomed to talking to peers about their work, where there is no need to translate this jargon. However, when artists and scientists exchange ideas, a shared language must be found. Otherwise, issues arise in their collaboration due to different sets of assumptions, the vocabulary used, and diverging interpretations of terms and expressions (Fig. 8.1).

Salmon describes the first meetings with his artistic collaborators as exciting, and he was committed to getting the important aspects of his work across to the artists. This made him aware of the idiosyncrasies of discipline-specific

[1] The brain is like an unimaginably complex circuit board, where information gets passed around between nerve cells to allow for locomotion, perception, thought, memory, and so on. To obtain that complexity, during development, the brain needs to go from a blob of tens of billions of unconnected nerve cells to a circuit containing more than a hundred trillion connections between those same cells. Chris Salmon's research looks at how the circuitry in the hippocampus, a brain region essential for learning, memory, and spatial navigation, gets built.

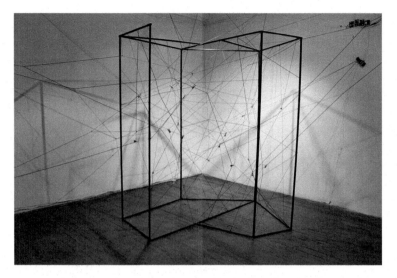

Fig. 8.1 *Creatura Micro_Connectomica* by Chris Salmon in collaboration with Alex Bachmayer, Andrea Peña, and Jade Séguéla, 2017. Photography by Dr. Cristian Zaelzer. (Image courtesy: Team of *Creatura Micro_Connectomica* [for more detailed information about the project, including some videos, see http://creaturaconvergence.weebly.com/])

expressions, and how the same words can be connected to completely different meanings and how assumptions about words diverge based on differences in education and routines. In that sense, the collaboration helped him to explore language and communication skills that are necessary to talk accurately to other disciplines and to avoid pitfalls. He explains that these reflections allowed him to be patient in the conversation with others. He referred to another interdisciplinary collaboration with computer scientists in which the skills gained in his artscience collaboration were useful. He was already aware of the hidden problems in interdisciplinary communication, and so when a reference to complex topographies meant something completely different to him as a neuroscientist than to his colleagues specializing in computer vision, his awareness and practice in circumventing such problems enabled him to translate his scientific jargon into broader terms and revealed that his collaborators were thinking of a completely different problem. Having experienced this first in the artscience collaboration, he was trained to be more patient and tolerant in interdisciplinary communication, and indeed to be lenient enough with his and others' terminology to ultimately find a common understanding. This raised the confidence and efficacy in such interdisciplinary communication processes.

In the same vein, Dr. Rob Neely from the School of Chemistry, University of Birmingham, mentioned that the conversations with the artist Anna Dumitriu create awareness on how scientific communication skills are limited to exchange with peers. Ongoing conversations between the artist and the scientists are beneficial for them: for example, when the artist follows the scientists through the lab and asks questions about the processes and the theories, this challenges especially younger scientists and PhD students to talk to a nonexpert in an elaborate way about the science without getting superficial because Anna Dumitriu knows enough not to accept superficial answers and wants to know more than laypersons. This helps to think deeply about the scientific jargon and the science behind it because it is necessary to grasp the basic ideas and connect different theories to be able to talk clearly.

This development is recognized not only by the scientists, but also by artists, who suddenly are in the position to talk in a different language, and many of the mentors, curators, and facilitators of artscience collaboration projects. Julia Buntaine from SciArt Center's The Bridge residency observed this in the residents she mentored, and Irène Hediger and Jill Scott from the Swiss Artists-in-Labs program pointed to this aspect. The curator, mentor, and facilitator of the Swiss Artists-in-Labs program, Irène Hediger, points to relationship building and the creation of a common ground as something extremely important that she sees happening over and over again in the residency processes she guides. From my own experience, in the beginning, it often takes translation and mediation work to communicate artistic ideas to scientists or to make them aware that they should not reduce the conversation to superficial aspects of their work. Later in the collaboration process, the communication develops a lot through finding a common language.

8.1.1 Metaphors, Creating Contexts, and Stories Conveying Ideas

Artscience collaboration helps to find stories and metaphors to communicate scientific work and artistic visions. Stories help to create a relation between those who communicate. Additionally, stories add layers of meaning to abstract information and make the information easier to memorize (Negrete and Lartigue 2010). Previous cases already showed how the creation of art inspired by science tells stories about scientific ideas and visions, and creates a bigger picture by contextualization. Stories tackle emotions and can trigger imagination to get a feeling of what theoretical ideas and scientific visions

mean. Through this, stories can support communication processes. Repeated confrontation with storytelling and the inclusion of a bigger context to scientific communication can help scientists to gain access to such a skill. The interaction between artists and scientists leads to the development of a relation between them that, in the ongoing process, allows artists to understand how scientists communicate and what is important in the mode of communication, as well as allowing scientists to obtain access to the new mode of communication.

The biophysical chemist Dr. Rob Neely referred to this experience based on artscience collaboration with the artist Anna Dumitriu. He maintained that his communication of his work in talks has changed through experiencing the ways in which the artist talks about the research. His way to narrate the story of his work evolved and he even exchanged terminology to reach out to a broader scientific community:

> As for stories, I have a manuscript that is under revision at a good journal at the moment. We started writing it around the time the collaboration with Anna began so it has been over a year in the making. Its original title was "Direct labeling strategies for DNA mapping." I had some idea of a story I wanted to tell with the paper, but it wasn't clear when I started writing. (My approach to scientific writing is usually quite methodical; start by gathering results and then build a story around the evidence we have.) The (final) version of the manuscript is called "A general strategy for direct, enzyme-catalyzed conjugation of functional compounds to DNA." The first title is short and sweet but uses lab jargon (terms used in my lab commonly but not beyond, i.e., "direct labelling") and focusses on one application for our chemistry (DNA mapping). I don't think this version would have been accepted by the journal. We added new results over the past 12 months, but the premise of the paper is still the same. What I have come to realise, though, is that there is a bigger picture and the second title captures that. It sets up a story that appeals to a much wider audience. This is me developing as a scientist, but I think the collaboration with Anna has contributed to that development.

8.1.2 Engagement Through Relationships: Spark Questions, Create Experiences

Quite a few scientists mentioned that there is something quite obvious to learn about aesthetics and how to create better communication by making it more appealing. To get a new feeling for structures and aesthetics, exploring

ways to create experiences and singling out the most important messages for communication help to build up a relationship and draw interest in the ideas. Design, telling stories, and ways of presentation play a big part in this. Establishing relationships instead of asymmetric information transfer allows conversations to emerge and creates reference points for open discussions. This triggers interest and open exchange between the groups instead of pure information transfer, which most probably is not understood in every detail and thus gets questioned in its essentials, or does not even stir the slightest interest. As a scientist reflects on their experience:

> Another purely utilitarian reason for collaborating with artists is that it gives scientists a chance to learn a bit about aesthetics and design. Although this probably doesn't strictly help with one's understanding of their science, it undoubtedly can be of help to one's scientific career. Being able to represent your data in a more clear and beautiful way will help you and your work be more visible, more memorable, etc.

Case: *Ex Voto*—The Collaboration of Nicola Fawcett and Anna Dumitriu
Nicola Fawcett is Medical Research Council (MRC) Clinical Research Fellow with Modernising Medical Microbiology at the Nuffield Department of Medicine, University of Oxford, studying the effect of antibiotics on the gut microbiota using next-generation sequencing. She is one of the long-term scientific partners of the artist Anna Dumitriu. Nicola Fawcett experienced many learning processes and new experiences around communication in this artscience collaboration process. These range from experiences in public communication to communication with focus groups in research or reflective processes, to public engagement, to outreach, but she was able to articulate clearly that a lot has to do with a personal skill development in communication that took place through the interaction with Anna Dumitriu. She pointed to structural and stylistic aspects of her communication that changed: the ways to approach people and to stir their interest and curiosity. The collaboration with the artist demonstrated to Nicola Fawcett how important these communication processes are in any kind of communication. And this is true for communication not only with any kind of public or focus group, but also with colleagues. Through artistic strategies, curiosity, conversations, and new professional partnerships emerged.

Scientists find the idea of an artist in a lab rather unusual and a little surprising, as they (often incorrectly) assume the artist has little or no experience. A first step to learn about the potentials and communication practices of the artist is in interactions and conversations when the artist proves previous

knowledge, skill, or very specific understanding of the research that is going on in the lab. Conversations start to open up and help both artists and scientists to learn about new perspectives and ways of doing things. Artists start to ask questions about processes in an experiment, for example, which a trained scientist would not ask. They need expertise, creativity, and the ability to ask questions, which together put an interesting conversation forward that can stir reflection in the scientist or a search for new answers. It takes time to understand an artist's argument, but it is important to take this time to push ideas and boundaries. This is part of the practice to talk to people with different backgrounds and learn to understand them.

What Nicola Fawcett experienced as central to artistic approaches in the communication that she for herself learnt to integrate was that it is important to create an open environment, no matter where you are and with whom you communicate, so this leads to much better answers. For example, when she as a specialist leads a focus group on a medical issue she is working on, participants know that she is the expert and are hesitant with their answers, as they want to give the "correct" answers to the scientist. And nobody wants to say something silly. She, like other researchers, experienced difficulties in getting these people to open up or to explain to them how important anything they say is: there is no wrong or right. Including Anna Dumitriu in these sessions helped her to get better data, as they received more responses. These audience responses can be stories of personal experiences, things that occurred to them as strange or interesting, rather than things they thought were the "right" answer. During her work with Anna Dumitriu the scientist developed an understanding about the difference between the artist's way to engage with audiences and hers as a scientist. Once, of course, there is the beauty of simple practices, beautiful artwork can even come out of bacteria retrieved from diluted feces,[2] or the design in the material that is used for communication. Nicola Fawcett found an astonishing development of how she created PowerPoint presentations for public talks. But there is more to it. It is important to ask questions and engage people in discussions, so singling out the right messages that can stir curiosity is more important than conveying a simplified version of all information about a topic available. Actively asking questions and finding out what people know and how they feel about it help to address the important topics in engagement activities. So, spark interest, spark curiosity, and then find out what people want to know and answer these questions (Fig. 8.2).

[2] The artist had to have a typhoid vaccination prior to starting the work.

Fig. 8.2 *Ex Voto* by Anna Dumitriu, 2017, in collaboration with Nicola Fawcett. This participatory artwork explores the impact of infectious diseases and antibiotics on human lives. The making of "votive offerings" created by the artist, visitors, patients, scientists, and medics happens during story-sharing discussions. These offerings, which are usually found in religious settings, symbolize a wish or thankfulness for its fulfillment. The votives in the artwork are stained or dyed with sterilized bacteria, modified antibiotic-producing *Streptomyces*, and natural antimicrobial substances. (Image courtesy: Anna Dumitriu)

8.2 Communication Beyond Words

Seeing something one hasn't seen before and experiencing something one hasn't experienced before can be much more effective than reading an explanation of something one hasn't seen or experienced before. Art has the power to communicate beyond words, as in to employ different media and senses in the communication process. For example, rapid prototyping helps to bring a

heterogeneous group to the same understanding of the presented ideas by using visualization, sculptures, or sonification to translate ideas into something more tangible (Barry 2005). These tangible representations, for example objects, support the communication between individuals stemming from different disciplinary backgrounds. Such objects, also called boundary objects (Star 2010), support cross-disciplinary communication by involving different senses to convey ideas. Such objects represent ideas and meaning instead of relying only on verbal and written expression which is biased by disciplinary jargon and expressions. Thereby, they invoke a deeper understanding for specialists and create access to ideas for a broader public. Already early studies on communication show that the chosen words contribute only a small part of information transferred as compared to nonverbal information (Mehrabian 1971). Artists can contribute to communication between experts or between scientists and a broader public by their expertise in nonverbal communication, creating experiences, and expressing through new media.

At the same time, artscience collaboration can grow scientists' abilities to employ different media and to reflect about their communication beyond words. Within a narrow field, scientists develop a specific way to illustrate and present their work, whereby visual aspects used imply typical meanings (Jones and Galison 1998). Becoming aware of this particular style of communication and learning to use nonverbal expressions beyond scientific visualizations improve communication with fellow scientists and a broader audience.

Case: Olivia Osborne's Experience After Collaborating with Artists
Dr. Olivia Osborne is a scientist in the fields of human health and the environment. Her expertise lies in screening platforms to nanoparticles/chemical compounds and complex mixtures by investigating and assessing the interactions of molecules with organisms using toxicology, developmental biology, and physiology. During her work at UCLA and her previous interest in art she came in contact with the Art|Sci Center+Lab at UCLA, where she participated in a range of artscience collaborations and proceeded to work on her own artscience projects afterward. Her experience in these collaborations points very much to the development of communication skills and learning processes of communication with other disciplines and a public community. One of her projects at UCLA revolved around the risk assessment of nanoparticles in the environment—how these human-made nanoparticles may affect the ecosystem, how these are spread, and how they affect the growth and physiological aspects of living organisms. Olivia Osborne got involved in a few artscience projects that broach the issue of climate change, how (human) actions affect the ecological system, and how changes in the ecological system can be linked to actions or other developments. The manner in which this

kind of communication through artworks reaches out to people was an eye-opening experience for her. In the Current LA: Water project with the Art|Sci Collective she saw how people in the time of the Californian draught for the first time understood what draught really means as they experienced it through these artistic-scientific experiments the group enabled them to do. The Current LA: Water project used different techniques to involve the public to express what draught and dry season means and raise water awareness. In the exchange with the public it was striking that many people didn't think the draught was as excessive as it was because they still had water in their water pipes at home and arguments seemed to be too abstract or people were cautious because arguments can be politically influenced. Only when the attending people were instructed to do small experiments with water and saw for themselves how jars of water they filled dried up over only a few days in the open could they create a new understanding of the situation during draught. This raised emotions, created tangible understanding of the situation, and included different senses to experience and analogies to transfer the essential scientific information. Additionally, in this collaborative workshop that included these creative tasks, Olivia Osborne presented her research on how silver nanoparticles in consumer products potentially end up in water bodies like rivers and there affect the aquatic environment (Osborne et al. 2015). Seeing how such a different kind of communication reaches out to the public, raises interest that makes them engage, and reaches them even emotionally was very rewarding for the scientist; this led to repeated participation by the scientist in such artscience projects that communicate differently to a public as compared to rational science communication, and which have been awarded and exhibited in artistic environments (Fig. 8.3).

But artscience collaborations and their artistic outcome are not only enabling communication between the scientific community and a broader public, as they include a different sensory experience, a storyline, and emotions or new feelings, but can even lift the communication between scientists onto a new level. Olivia Osborne explains how artistic approaches and the work in her collaborative film project, called *Urbanization of Ecological Networks*, in which she again worked with the artist Mick Lorusso, supported her communication with scientific collaborating partners from related fields. In detail, in her work with her colleagues on adsorption, distribution, metabolism, and excretion (ADME) of materials (Osborne et al. 2017) and angiogenesis (Zhao et al. 2016), the video linking networks, arteries, roads, and fluid systems was helpful to explain the theoretical aspects of resemblance, connections of systems, and growth. In scientific collaborations beyond one scientific field, theories have to be simplified and reduced in depth without degrading the

Fig. 8.3 Current LA: Water Public Art Biennial at UCLA, project presentation, talks, workshops, and artwork, 2016. (Image courtesy: Olivia Osborne)

science. In such a situation, details can get lost or it is difficult to transfer all the important aspects for a comprehensive understanding. By using the artistic material and experience from the collaboration, the conversation with scientific colleagues can be supported, as this material expresses the underlying theory or mechanism not in words, but visually, acoustically, or through an interactive experience. This in turn helps to understand not only the rationale of a theory, but through the senses, and this is even for scientists who are experienced in related fields of importance to understand the most important aspects. The theoretical details can be read and reflected on afterward in a much more target-oriented way (Fig. 8.4).

Theories and scientific discoveries get translated into experiential artworks, a language that tackles different senses. For laypersons, a very detailed description and a highly technical theoretical language are not the most important aspects to understand basic ideas, and specialists from other fields can come to new interpretation of the words, which can have a different meaning attached in their scientific jargon. The chosen media and artistic presentation succeed to invite exploration and creation of an own understanding of the information and to encounter the phenomenon which is communicated. Based on this experience, the audience—specialist or laypersons—get a feeling for the theory and this enables them to better grasp facts and figures in detailed (verbal) communication afterward (Weinberg 2010).

Fig. 8.4 *Salty Networks* by Olivia Osborne, part of the video *Urbanization of Ecological Networks* by Olivia Osborne and Mick Lorusso, 2016. (Image courtesy: Olivia Osborne [to see the video, https://vimeo.com/191877235])

8.3 An Outreach Interplay: A Comprehensive Case on Communication

Before going on with scientific communication and public engagement, the following case will comprehensively show that even artscience collaboration projects that are intended to heighten organizational outreach go beyond this goal and affect communication on many levels.

Case: Quadrature at the European Southern Observatory, Creating *MASSES* and *STONES*
The artist trio Quadrature won the second residency at the ESO that has been enabled by the Digital European Art and Science network, a project co-funded by the Creative Europe Programme under the lead of Ars Electronica. The idea of the project was to enable residencies for artists in diverse scientific institutions, allowing them to interact with scientists and researchers and to create media artworks and projects inspired by this interaction. ESO got involved in the project as scientific partner, with a focus on their obviously outstanding scientific facilities: the telescopes in Chile, namely at Cerro Paranal and La Silla, as well as their collaborations on Chajnantor with

ALMA, the Atacama Large (Sub)Millimeter Array, and APEX, the Atacama Pathfinder Experiment. As a starting point for the "expeditions" to the telescope sites in the Atacama Desert, Chile, an obligatory visit to the ESO offices in Santiago, Chile, was intended as a welcome to the artists, but also to get first impressions and to discuss the first direction of the planned project.

Right from the beginning during the planning process of the whole Digital Art and Science Network residency opportunities, the ESO representative in Chile, Fernando Comerón, has been very supportive of the project. He had already experienced a few interactions with artists and curators and found this a unique opportunity to start to engage with artists and other interest groups. This way, it was a good fit to include the two artist-in-residence opportunities that emerged through the collaboration with the European Digital Art and Science Network in the outreach activities of ESO, first in 2015 and the second one in 2016. It was a one-time opportunity to start such a program that provides artists access to the outstanding facilities of ESO while working with a group of experienced galleries and museums in that field, and at the same time reaching out to a new audience and a wider public. Both the participation of ESO in such a network and the artworks created by the artists based on their experience at ESO support the communication of the mission and work of ESO in their own way: through interviews and presentation of the organization in a new environment on the one hand, and through the artistic expression on the other.

When Quadrature won the residency at ESO, their informed background about astronomy, cosmonautics, and astrophysics, combined with their previous artwork based on this scientific field and amateur astronomy, was already a good predictor that there will be more interaction with the scientists and engineers on site than an informative access to the facilities. Based on the artists' interests, Paranal was chosen as the main residency site, with an additional one-day visit to APEX and another one-day visit to ALMA. Already at the first meeting at the ESO offices in Santiago, Chile, Fernando Comerón and I decided to organize an introductory discussion between the artists and the staff astronomers available to start interaction and facilitate some future collaboration or at least information flow during the residency at Paranal. Most of the staff astronomers at this discussion were junior scientists and postdocs, who were first hesitant in talking to Quadrature about the details of their work, but soon opened up to go into more depth. Due to scientific jargon and the level of technical detail in conversation about astronomical work, it was difficult for the young scientists to imagine which technical detail they could use in the communication with the artists and to translate the scientific vocabulary to a more commonly understandable lan-

guage without becoming superficial. Building a relationship and reflections on the language used developed a common ground and established a conversation. Two of the staff scientists were present at Paranal during the residency time, invited them to their observations in the control room, and with them and others Quadrature stayed in contact via email for more interaction.

Although there was no opportunity for a long-term collaboration with a single scientist or scientific group outside these two staff scientists and the ongoing interaction with Fernando Comerón as astronomer, Quadrature had an opportunity to engage with many different aspects of the work at ESO and the technical details of the telescopes. In their interest, they focused on recurring topics of the ongoing research and technical details of the instruments. Therefore, they spent a lot of time with scientists at the control room during the day, and approached senior scientists and engineers with questions that were so specific that they pushed them in rethinking the borders of their knowledge. This deep interest and the acknowledged technical competencies of the artists led to a further invitation to the ESO headquarters and the laboratories in Garching, Munich. Based on their experience and interactions the artists singled out binary systems as a common feature among celestial bodies and the popular topic of the search for planets in the habitable zone as fundament for the two artworks they produced. However, the interaction with the scientists did not stop there. During the production of the two artworks, Quadrature stayed in touch with the respective staff astronomers and Fernando Comerón about scientific details and triggered thought experiments for solving some theoretical problems they approached during the production of the artworks. In the naming of the two artworks the artists played with the obsession for acronyms in scientific projects, to which some scientists in the course of their residency referred in a positive but also self-deprecating way. Such acronyms are representative for the project within a specific scientific community, but as soon as these acronyms become part of the communication with new interest groups or the public, they are problematic to read and understand.

The first artwork that came out of this residency communicates about the growing field of *STONES*. *STONES* stands for Storage Technology for Observed Nearby Extraterrestrial Shelters. The artwork consists of two granite tablets, of which the first one serves as a legend to decipher the content depicted on the second one. The measurements of the stones are artificial, so that a civilization after the current one would be able to understand them as a human-created board with information engraved. The second tablet shows the locations of, at this point of time, known exoplanets in a habitable zone

around a sun—those exoplanets on which liquid water could exist, possibly leading to the development of life. The location of the planets is transcribed into binary code, additionally including their sizes, the duration of a year, and other fundamental characteristics; all information given on the planets is given in proportion to its corresponding value on earth. The scientists were surprised about the accuracy of the artists' encoding of the information and that they redesigned the stone plate with the information as a row of new planets found, announced shortly before the date of the production of the engraving. Moreover, the interaction was challenging for the scientists and provoked thought experiments, which only came up because of the deeper thinking about how these planets are embedded in the galaxy and how such information can be communicated and contextualized for anyone now or in future. Beyond that, the artwork contextualizes basic ideas of the scientific astronomical research and how the findings could reach far beyond the context of our own and current culture. It aims at communicating the findings as purely and as simply as possible, in a language—numbers, reference systems, and binary code—that should be decipherable and understood beyond the current civilization on earth. In the experience of the artwork, not only is the pure information about the planets important, but also the context of the science, contemplation of the cultural and communicational fundaments of our culture, and experiencing imagined far-reaching developments in a possible future. This contemplation of cultural context and beliefs is prevalent in the artwork, as it refers to religious beliefs and visions to a safe humanity by finding a new habitable earth and implying critical reflections on understanding scientific findings as religious visions (Fig. 8.5).

The second artwork, *MASSES*, is named as an acronym too: it stands for Motors And Stones Searching Equilibrium State. Consisting of two stones that have to balance a steel plate by finding their appropriate positions, it represents how systems—celestial systems and others—stabilize themselves by the permanent endeavors of their parts to balance each other. Looking at the artwork, it represents this fragile constant situation that can be disturbed easily. Furthermore, it refers to the complex but fragile machinery of modern research instruments that are highly vulnerable and require constant calibration, with the degree of precision that is demanded by state-of-the-art science. This ongoing process and all these aspects become prevalent by looking at the installation, its movements, and the ongoing struggle between balance and imbalance (Fig. 8.6).

Fig. 8.5 *STONES* from frontal view. Artwork by Quadrature (Jan Bernstein [bis 2016], Juliane Götz, and Sebastian Neitsch), 2016. (Image courtesy: Quadrature)

Fig. 8.6 *MASSES* exhibition view: *STONES* can be seen in the background. Artwork by Quadrature (Jan Bernstein [bis 2016], Juliane Götz, and Sebastian Neitsch), 2016. (Image courtesy: Quadrature)

Both artworks represent common features and important topics in astronomy, and the artworks are able to create interpretations and get a feeling for the topic. Nevertheless, without a long explanation next to the artwork a person completely new to the topic may not understand all the necessary scientific details and ideas the artists put into these two works. Deep thoughts

contributed by scientists in the conversations with the artists inspired these works. Looking at the artworks is more than providing facts and figures (which pure science communication already does); the artworks make processes and ideas experienceable (especially *MASSES*). Art can induce a "different" kind of understanding of the scientific questions and outcome; it creates a story, and the aesthetic experience supports the process of making sense of facts and figures presented by science communication. It is important to note that this communication beyond words also goes beyond a design process that makes scientific sketches more pleasing or visualizes scientific theories. Based on an ongoing exchange and learning process between artists and scientists, the artwork makes ideas experiential.

Many scientists and engineers stated the value of such an experience in their warm welcome and their positive comments about this second iteration of the residency project. They welcomed this situation and interaction with the artists as fun, interesting, and challenging—just as they were curious about the outcome. The communicational aspect is very visible in the two artworks developed and presented above. The artists wanted to stay as true to the science as possible and reached this by creating two pieces that very visibly and experientially communicate the two topics of binary systems and planets found outside our solar system that lie in the habitable zone. The thought experiments triggered by the conversations on the development of the language used in *STONES*, especially finding an appropriate notation system and a reference system for stars that should be possible to decipher in a few thousand or even hundreds of thousands of years from now, led to new calculations and thinking about the construction of a referential system. Understanding this both as part of the contextualization the artists pushed with their work and as questions raised through the interdisciplinary collaboration is valid. Getting back to language and scientific jargon, the scientists and the artists learned to talk to each other; they experienced that communication across disciplines is challenging: jargon (like acronyms) has to be explained and a common ground has to be found without losing the depth of the conversation.

The outreach of the scientific organization and scientific content to a wider public through partaking in a network of cultural institutions that promote the art and science projects through exhibitions, festivals, events, and other platforms is valuable for the organization and researchers. Through this, contact with new communities and interest groups can be established. This is something that is important for artists, scientists, and the involved organizations or corporations. Through a residency at a scientific organization or the communication of their work through the corporate communication of the organization, artists will automatically reach out to new audiences, and the artistic audience will (at least partly) be new to the

outreach of the scientific organization or the scientists. Although this might be the easiest one to argue in managerial terms and is of high importance for organizations, there are some challenges in the interaction with these new audiences, and the individual development processes of those involved, artists, scientists, facilitators, communicators, and the audience, are of high relevance. Through new network connections and presentation within a new field, a scientific organization gained a wider field to communicate with. And the same is true for the cultural institutions, galleries, museums, and science communication organizations that took part in the initial iteration of the European Digital Art and Science Network: they, probably for the first time, were connected to the participating scientific institutions and could reach out and present themselves and their ideas on art and science to this new audience.

8.4 Science Communication and Public Engagement

Outreach and organizational communication are an opportunity to reach out to a broader public and transfer basic ideas, visions, and goals. Science communication and public engagement processes in scientific projects go beyond this basic outreach process. Science communication aims at spreading scientific knowledge and recent scientific insights, making it possible for the public to access this knowledge and pursue educational goals. Promoting public awareness of the most recent research and scientific results and creating an understanding of general scientific knowledge are central to science communication. Science museums and galleries pursue this goal and sometimes add artwork based on scientific principles to their exhibitions. In this context, art or artworks can be understood as a medium or vehicle of communication, more specifically as a vehicle of communication of scientific knowledge. Artworks can make scientific principles experiential and create a feeling for scientific ideas. The Science Museum in La Laguna in Tenerife (Museo de La Ciencia y el Cosmos), which is connected to the local astrophysical institute, has a long tradition in working with artists from any background to create artwork that is included in the science communication program: performances, music, interactive pieces, sculptures, and visual artworks on scientific topics that have been produced in collaboration with scientists are included in the exhibitions and event program. Playful interactive installations help the audience to discover knowledge by themselves and create a deeper understanding of the science behind it. Studies on educational effects of science communication through traditional material versus the integration

of interactive artistic installation show that participating in the creation of an art installation and interactivity enhance the probability of storing the information in the long-term memory. Moreover, the "evidence gathered in this research suggests that while information presented with a list of scientific facts loses accuracy and homogeneity over time, the information presented via art installation gains accuracy as well as homogeneity" (Negrete and Rios 2013: 17). Such results uphold the belief that art installations support the understanding and retention of scientific information.

The residency program at Planet Labs, for example, acknowledges that the program helps to communicate their scientific work and mission because they think that when traditional art and science meet, ideas become much more illuminated, interesting, and accessible. The Science Gallery network goes even further and provides a platform for artscience exchange with a broader public in events and by including artworks, presentation of scientific projects, and artscience projects in exhibitions, communicating them with the help of mediators. Including high-school students and university students in their main audience helps to grow a comprehensive understanding of issues at stake and the interplay of experiences and disciplinary knowledge.

New forms of science communication including art are often part of educational settings, as studies show on the inclusion of art projects in science education at schools (e.g., O'Connor and Stevens 2015). These projects show that a heightened awareness of new topics and a curiosity to learn something new are fostered by workshops and educational settings that include artistic and scientific approaches and tangible, crafty project work, designed and supervised by both artists and scientists. An example of a successful workshop including art and science is STEAM Imaging by Fraunhofer MEVIS (to be found in Chap. 7).

Instead of educating a local audience and providing a platform for knowledge exchange as these museums do, artscience collaboration can support scientists in the communication of their scientific work to a broader audience, in the sense of higher outreach and communication of scientific ideas at the same time. Dr. Charles Taylor, ecologist, evolutionary biologist, and a long-term collaborating partner of the media artist Victoria Vesna, mentioned that presenting the artwork Bird Song Diamond worldwide triggered outstanding conversations with different communities, which help to create a better understanding of the research in public and to reach out to scientists from other fields. Similarly, Chris Salmon pointed out that

> there are plenty of reasons for scientists to enter art-sci collaborations without requiring it to contribute to their career or their science. It takes your scientific topic to a wider audience who are simply interested – that audience doesn't have

to be made up of "knowledge users" to make it worthwhile, it is ok for them to just be interested, even if they don't fully or even partially grasp the science behind the art. It may simply serve as a focal point for a conversation about space, mental health, the arctic, technology, whatever. This does not have to lead to a net gain in the number of people who think space exploration is something the government should fund to be a worthwhile conversation.

Nicola Fawcett mentioned about her group's collaboration with Anna Dumitriu: an artwork traveling to many exhibitions worldwide enables worldwide outreach to people who otherwise would not even know that this research is going on. The outcome of the artscience collaboration is not only represented in scientific communication, but goes beyond this specific audience and reaches out to audiences within the art realm like at art festivals, galleries, and art museums. There, the result is discussed and awareness of the ongoing research is created.

Creating a shared understanding of new disciplines in artscience collaborations further supports communication about upcoming fields. For startups and organizations in these upcoming fields outreach and creation of knowledge about their work is as essential as it is for the scientists and artists who are engaging in these fields. In the conversation with Christina Agapakis, PhD, she pointed to the importance of creating awareness and understanding about the vision and work at Ginkgo Bioworks. Collaborative projects between artists, designers, and scientists that create access to the organization's ideas help to educate about the topic and reach out to a bigger audience. Such projects are an important part of the communication strategies due to the newness and extraordinary approach of their scientific and corporate field to communicate to stakeholders and possible audiences in an interesting, experiential, and understandable way to avoid potential misunderstandings or misinterpretations of this new field and subsequently to avoid disinterest, disappointment, or blind refusal.

Artworks have the potential of reaching out worldwide to a broad and huge audience. This implies careful communication and contextualization in the presentation of artscience projects. Artworks based on artscience collaboration are not bound to accurately transferring knowledge: they are raising questions, presenting far-future visions, can have ethical implications, create unforeseen connections, and trigger feelings and emotional reactions. Nevertheless, it is art, and art has the freedom to explore possible futures, to dream a "what if." Artists like Oron Catts do not get tired of pointing out that art is a creator of fictions and not bound to scientific proof. Similarly, the artist Anna Dumitriu says about artscience collaboration, "[A]rt can raise questions, but art does not have to provide answers." The science fiction artist Lucy McRae also refers to this by saying, "[A]rt doesn't give immediate

answers, but gives conditions for possibilities." Artscience projects are not the design versions of scientific communication. Artists in their profession are creators of visions and ideas. Artistic decisions are part of the artwork. Especially in a world where "fake facts," "fake news," and a rising mistrust in scientific knowledge, misinterpretations of artscience projects and fearful reception of daring projects, or exaggerated interpretations of visions as facts have to be considered as possible reactions. It is important to develop strategies to deal with such feedback and keep in mind that not every setting is appropriate to include artscience collaboration in the communication process. The inclusion of art in science communication is valuable, but science communication is an important field that cannot be replaced by art.

Thinking back to a few other artworks that emerged from artscience collaborations, this can be seen clearly in many works: *The Institute of Isolation* by Lucy McRae shows something different than a determined future, and the *Victimless Leather* project and other experiments by Oron Catts and Ionat Zurr do not represent a golden future where meat and leather are grown artificially without any organic input. In his argumentation for the integrity of the profession, Catts points to the fact that it is an important aspect that artists are not bound to the reproduction of verifiable facts, but they are producers of fiction who are allowed to go beyond current knowledge and imagine stories beyond technological possibilities. This enables them to create new visions, but it would not be an easy task to integrate certain artscience projects in, for example, scientific or corporate communication.

Awareness of basic principles of communication and enhanced communication skills can help to overcome situations of possible misinterpretations and insecurities. First, keeping in mind that one cannot not communicate shows the importance of being clear in what the artwork or the communication is about: is it about ideas, visions, or scientific knowledge? Second, understand the relationship between the communicator and the audience. What does the audience expect to find out or to do? Third, scientific jargon can lead to misunderstandings, but aesthetic language can do so too. Reflect on meta-aspects of the communication to understand what the audience's background is. This is the knowledge base and framework relative to the information given on which the content is received, evaluated, and subsequently understood. Fourth, are the stories understood literally or as metaphors? Fifth, is it a discussion among peers, an open discussion between stakeholders, or an educational setting that makes additional information necessary? Sixth, the outcome of a scientific project or scientific research does not state a final answer—it has to be seen in the context of a bigger picture and ongoing scientific research. Scientists who communicate about major breakthroughs and insights are able to understand this context, but the audience does not

necessarily know this and can understand the outcome as final truth. Later insights that twist the understanding of previous scientific outcome can then be received as contradictory. Art can help to add knowledge of this complexity and the ongoing interplay of scientific outcome and questions.

Exchange with the public does not end at science communication. Some scientific research relies on a community to engage and give insights, and RRI aims at including stakeholder perspectives, their ideas as specialists on their conditions, and needs early in the research process. Artists, curators, and scientists see a huge potential in the integration of artscience collaboration in public engagement processes (e.g., Dumitriu 2018; Bureaud 2018). The inclusion of artists in these processes means more than giving an artist the task to create a nice poster or presentation that tells a new audience about scientific outcomes; it is about encouraging stakeholders to get involved and to create a curious and interested public that wants to contribute in debates and research processes, learn through stories about what the science actually means, and understand the ethical and legal aspects. Engagement activities are not just pro-forma activities that are put at the end of a project; they can add valuable information and new perspectives in the course of a scientific project and help to frame questions and goals. Such activities provide a platform where all stakeholder groups can get in touch, add insights, and learn from each other.

Based on its role in society, art is thereby not only a vehicle for knowledge, but for discussion. Artists are allowed to break boundaries, be provocative, exhibit contradictions, and confront individuals and society with contradictions. This implies a lot of responsibility for all actors in this discourse to communicate openly and accurately. Nevertheless, there are no final answers in science just as there are many interpretations of the art that displays it. Art might help a broader audience to get a feeling for this scientific quest of never-finally-answered questions and these ongoing processes of discovery of new details that influence the understanding of a bigger picture. Including artists in this process is important to open up discussions: through an ongoing interaction everybody—artists, scientists, and the public—can learn and develop a new understanding of issues at stake.

References

Barry, D. (2005). The Play of the Mediate. In M. Brellochs & H. Schrat (Eds.), *Product and Vision* (pp. 57–77). Berlin: Kadmos.

Bureaud, A. (2018). What's Art Got to Do with It? Reflecting on BioArt and Ethics from the Experience of the Trust Me, I'm an Artist Project. *Leonardo, 51*(1), 85–86.

Dumitriu, A. (2018). Trust Me, I'm an Artist: Building Opportunities for Art & Science Collaboration Through an Understanding of Ethics. *Leonardo, 51*(1), 83–84.

Gates-Stuart, E. (2014). *Communicating Science: Explorations through Science and Art.* Doctoral Dissertation, Australian National Centre for the Public Awareness of Science.

Jones, C. A., & Galison, P. (1998). *Picturing Science Producing Art.* London/New York: Routledge.

Mehrabian, A. (1971). *Silent Messages.* Belmont: Wadsworth.

Negrete, A., & Lartigue, C. (2010). The Science of Telling Stories: Evaluating Science Communication via Narratives (RIRC Method). *Journal Media and Communication Studies, 2*(4), 98–110.

Negrete, A., & Rios, P. (2013). The Object of Art in Science: Science Communication via Art Installation. *Journal of Science Communication, 12*(3), A04.

O'Connor, G., & Stevens, C. (2015). Combined Art and Science as a Communication Pathway in a Primary School Setting: Paper and Ice. *Journal of Science Communication, 14*(4), A04.

Osborne, O. J., Lin, S., Chang, C. H., et al. (2015). Organ-Specific and Size-Dependent Ag Nanoparticle Toxicity in Gills and Intestines of Adult Zebrafish. *ACS Nano, 9*(10), 9573–9584.

Osborne, O. J., Lin, S., Jiang, W., et al. (2017). Differential Effect of Micron-Versus Nanoscale III–V Particulates and Ionic Species on the Zebrafish Gut. *Environmental Science: Nano, 4*(6), 1350–1364.

Picardi, I., Balzano, E., Camurri, A., et al. (2016). *Art for Science in Society: Theory, Practices and Technologies in Design Artistic-Scientific Works.* Napoli: La scuola di Pitagora editrice.

Ruesch, J., & Bateson, G. (1951). *Communication: The Social Matrix of Psychiatry.* New York: W.W. Norton & Company.

Sleigh, C., & Craske, S. (2017). Art and Science in the UK: A Brief History and Critical Reflection. *Interdisciplinary Science Reviews, 42*(2), 313–330.

Star, S. L. (2010). This Is Not a Boundary Object: Reflections on the Origin of a Concept. *Science, Technology & Human Values, 35*(5), 601–617.

Watzlawick, P., Beavin, J. H., & Jackson, D. D. (1967). *Pragmatics of Human Communication: A Study of Interactional Patterns, Pathologies, and Paradoxes.* New York: W.W. Norton & Company.

Weinberg, D. H. (2010). From the Big Bang to *Island Universe*: Anatomy of a Collaboration. *Narrative.* Retrieved from http://www.astronomy.ohio-state.edu/~dhw/McElheny/narrative.pdf

Zhao, H., Osborne, O. J., Lin, S., et al. (2016). Lanthanide Hydroxide Nanoparticles Induce Angiogenesis via ROS-Sensitive Signaling. *Material Views, Small, 12,* 32.

9

Creativity

Creativity is the stuff contemporary legends are made of. Creativity and innovation are hot topics, as they legitimate funding activities and attributing them validates projects by locating them in a fruitful, future-oriented environment. The scholarly discourse on organizational creativity has defined creativity as the first stage of an innovation process and therefore substantial to it (Oldham and Cummings 1996; Woodman et al. 1993). This directly links creativity to innovation, the holy grail of success. Thus, the idea is to push things that make people creative to make progress or reach innovation. In recent years, creativity has been advocated as critical to job performance and career trajectories as well as for entrepreneurship, organizations, and scientific and technological fields (Barrett et al. 2014). Therefore, the modern world is in high demand for creativity, arguing for any methods that enhance creativity as useful.

Creativity is an important argument for support of artscience collaboration, as it is a buzzword within economic development, technical progress, and thus official funding schemes. To make a case for artscience collaboration (and funding), this is a valid way to go. Artists, scientists, and engineers are all creative in their work processes, and by bringing them together, there is a huge potential to enhance each other's creativity or reach a completely new and unforeseen outcome. Referring to creativity as a reason to fund artscience collaboration bears potential pitfalls through misunderstandings or wrong expectations caused by shortcuts made in the argument. First, is it the person, the process, the product, or the press, meaning that the organizational structure can provide creative environments (Rhodes 1961), that should become creative? Second, the rise in creativity in any of these four dimensions is

mainly based in effects generated by engaging in the ongoing interdisciplinary exchange between artists and scientists, an (organizational) environment that is open to incorporate the process and the ideas that spring from this, time and interest in the process, and the changes it entails. Artscience collaborations do not produce creativity out of nothing; creativity does not magically appear, but an open-minded interaction between artists and scientists brings together perspectives and knowledge, and enables individual, social, and organizational development, which is the basis for creativity. It is a complex phenomenon pointing to aspects of human development, interactivity, and culture, linking the individual and the environment, touching on complexity, connectivity, and chaos (Siler 2012). The previous chapters presented a kaleidoscope of effects of artscience collaboration that are fundamental for heightened creativity. Even individuals and departments not directly connected to the artscience collaboration can be inspired by the process and changes in organizational structures and culture based on artscience programs.

This chapter elaborates on effects of artscience collaboration in the context of creativity and innovation in more detail, and summarizes the individual, social, and organizational development triggered that creates this fertile ground that evokes, fosters, or supports creativity. Thereby, the focus stays on creativity research within the organization studies perspective, instead of going into details of how different media or visual imagery affects the creative process (e.g., Miller 1996) or how different creative processes within the professions of artists and scientists look. Instead, questions are how an individual is affected by social settings, how workflows are changed through experiences, how an environment influences the personal process, and how organizational structures give space to creativity. The influence of artscience collaboration on the main individual, social, and contextual factors will be investigated.

9.1 Factors Influencing Creativity

Creativity is a complex topic that is approached by many scientific fields, like psychology, organizational theory, sociology, and cognitive sciences. It can be understood as the generation of ideas that are both novel and useful (Mumford and Gustafson 1988) and it can be found in any professional environment from art to science and from craftsmanship to management. The romantic perception of the genius is as someone who creates important artistic and scientific work out of higher inspiration; but in recent research, creativity is widely understood as embedded in a social environment, and in creativity research the exchange

of information and novel resources is seen as a driver of novel ideas. Amabile (1983, 1996) and Woodman et al. (1993), to mention two of the most influential sources, categorized the major factors that contribute to creativity into individual, job, group, and organizational factors. They argued that individual creativity is also influenced by social and contextual factors. Since Woodman et al.'s (1993) conceptualization of the conditions and contextual factors for creativity, a lot of research has been done in its details. Nevertheless, a basic understanding of the individual, group, and organizational characteristics, which lead to a transformation, which can be understood as a creative process or creative situation, which again leads to an output, preferably a creative product or a new creative process, has been acknowledged as important.

Figure 9.1 is one of many exemplary models that gives an overview of individual, social, and organizational factors that enhance a creative situation and trigger creative behavior, which ultimately leads to a creative outcome. An individual can be creative due to certain factors: the organizational culture welcomes certain ideas, or interest in the topic inspires ideas. Additionally, the

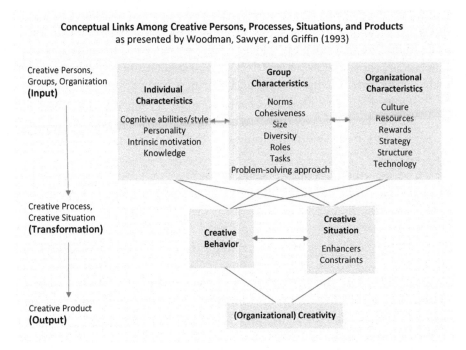

Fig. 9.1 Illustration of individual, social, and organizational factors enhancing creative behavior and creative situations fundamental to creative output. (See Woodman et al. 1993: 309)

group environment and direct contacts in the team influence creative behavior: is there space in the team for a creative idea, or does the dominant work process restrict creative behavior? These interdependencies create or limit creative behavior and situations that allow for creative processes or the enhancement of standard processes by creative methods. In the end, there can be a creative output. Thus, these interrelated factors constitute the possibility of a creative process and are allocated to three different levels of a social setting.

First, on the individual level, there are personal preconditions and factors that can be fostered or suppressed by interaction. Fundamental is the individual's personality: for example, is this person an introvert or an extrovert, and what kind of social interaction is supportive to the work and creative process of this person? How open is this person? Everybody has a history that influences visions, behavior, and processes: education is laying the foundation of knowledge and practice; previous experiences in the field, in the organization, or in collaborations influence the behavior, too. Experiences and trainings shape the thinking styles and improve the cognitive ability. For example, artists and scientists are trained in different work processes. Thinking styles such as synthetic or analytical approaches can get engraved in the personality, and in certain situations a reminder is needed to think differently. Interests, visions, and emotions influence behavior and intrinsic motivation. Motivation plays a major role in the work an individual gets done, in openness to new perspectives, and in suggestions to push ideas even further. High intrinsic motivation and openness to cross borders of the own discipline to reach a goal have been attributed to Nobel laureates, successful or paradigm-changing scientists, engineers, and artists, as they are inspired to merge ideas from many disciplines in their work (e.g., Root-Bernstein 2001, 2004).

Second, a person does not work in a social vacuum. People who are defined through their profession are influenced by the norms, standards, tasks, and ways of working that are common within this specific group. So individuals who are managers have different approaches to their work than scientists or artists. Moreover, these individuals get in touch with certain social groups and are influenced by them. In a team or a social group, members of different professional backgrounds have to interact and collaborate. Thus, heterogeneity and homogeneity of the group members influence work and problem-solving processes. Heterogeneity can influence the creative process of a group because it brings together different perspectives, knowledge, and methods. Nevertheless, group structure, cohesiveness, openness for new perspectives, roles, tasks, and responsibilities influence how much this heterogeneity can support a creative process; new ideas and role models in the group can be

inspiring, and restrictions in time and arguments lead to a loss of motivation to contribute.

Third, individuals and teams, and the artscience collaboration projects we've been looking at, are embedded in organizations. Such organizations can be corporations, NGOs, scientific organizations, cultural organizations, or art organizations like art festivals or art museums. Organizational structures, culture, and expectations shape the foundations of creative processes; they can nurture the individual preconditions and social settings that should lead to creative processes, but they can also hinder them. Opportunities given, technologies and space available, specific expectations, or regulations can be fruitful, supportive, or limiting to creativity. Reward structures and acknowledgment of individual contribution can be motivating. Contextual factors can go beyond an organization, as professional contexts like artistic and scientific responsibilities or cultural contexts like an interaction of Asian and African societies add additional layers that influence collaboration and possible creative interaction.

These three levels of preconditions, individual, social, and contextual factors of creativity, are strongly interrelated, which can be seen in the case of artscience collaboration. Experiences can change thinking patterns and add to individual skills. Allowing artscience collaboration to be fun can have a positive effect on the motivation, but this collaborative engagement and motivation can also have a positive effect on the team working on the project. On top of that, providing such a space for experimentation in organizational structures and professional environment can introduce new formats and processes to the organization and affect its culture (e.g., by understanding the importance of time in the qualitative development and contextualization of projects).

Additional to this understanding of factors that influence creativity—a creative setting, a creative behavior, a creative group, a creative individual, or a creative outcome—a multilevel phenomenon with a static outcome, creativity itself can be understood as a process (Weick 1979; Getzels and Csikszentmihalyi 1979; Drazin et al. 1999; Hargadon and Bechky 2006). Such a creative process is, for example, the engagement in creative acts, or playful experimentation in the state of "flow," a feeling of getting immersed in the process. Influencers and factors as defined in the model above can provide a fertile ground for such a creative process. Studies in artistic and scientific creative processes try to unveil differences in the process and identify stages of these processes and enablers that are specific for artistic and scientific work (e.g., depth and breadth of knowledge, or exploration of visual styles and painting techniques). These processes can be very individual though, depending on personality, experience, and discipline. These differences add to the creative potential of artscience collaboration but cannot be explored in detail here.

9.2 Individual and Social Factors of Creativity in ArtScience

The individual and their social environment interact and are influenced by each other. Perspectives are explained, processes are learned, and thinking styles or practices can be trained. Knowledge is built on experiences and reflection on situations. Looking at social situations like artscience collaboration, the interdependence of the factors and effects is tightly knitted. The following reflections on the empirical material and claims by artists, scientists, and managers about their experience in artscience processes will provide an overview of individual and social factors, displaying the complexly interwoven connections of individual and social preconditions for creativity. This investigation in artscience collaboration as an influence on individual and social factors of creativity illuminates the power of the artscience process.

9.2.1 Fun and the Power of Intrinsic Motivation

Fundamental to being creative and inspired is to be relaxed, enjoy the work, and time to spend in recreation and free exploration. Intrinsic motivation is essential for a creative process. Studies have shown that intrinsic motivation is strongly linked to creativity (Amabile 1985; Amabile et al. 1986). The idea is that individuals who enjoy their tasks, have positive feelings about them, and who want to play around with ideas that came up within this task are persistent enough to overcome challenges. On the other hand, individuals who are interested in their work but feel more pressure to come up to established formal requirements may become less intrinsically motivated and lose the motivation to be creative, following existing norms that should enable success instead (Faulkner and Anderson 1987; Cattani and Ferriani 2008).

Artscience collaboration contributes a lot to motivation by triggering such moments: the most frequent answer in interviews about artscience collaboration and the obvious aspect in observing the progress of artscience projects was that they are fun. Artists and scientists, intermediaries and managers, facilitators, curators, and other contributors ended their story by referring to the fun and joy the artscience collaboration brought to them. Lastly, and perhaps I am showing my naïveté here, it can simply come down to deriving some kind of satisfaction from creating something outside of science and adding to, or maybe starting, a completely different and potentially new conversation in doing so. Never underestimate fun and love of the work, as it bears motivation, inspiration, and the drive to go on working, and this influences

the quality of the outcome. Intrinsic motivation is a driving force to invest as much as possible, to look at the details, in pursuing new ideas, strange proposals, hard questions, and comprehensive research.

Some of the collaborations started out on a bumpy road because there was not enough time or resources to engage in the process, or there were difficulties in the initial communication. But anyone engaging in these projects refers at a certain moment of delightful experiences, the joy it adds to experimentation and exploration in the own professional field, and the fun, which is also inspiring. Some of the scientists, managers, and artists are even hesitant to mention this in a qualitative interview because they think it is just a very personal experience, a superficial add-on that is not worth mentioning: in serious work there is no place for pleasure. Only some see and value "having fun" as an important effect. Having fun does not steal valuable work time, but it revives interest in the own work process, has an inspiring character—"I want to do more of this; I do have an idea that I want to realize"—and supports intrinsic motivation.

Work is always embedded in structures and organizations, so there are regulations and norms that constitute the working environment, which can become routine and outperform intrinsic motivation. Without fun and enjoying the process, organizational or academic goals can become the utter landmark instead of the content of the work and why people do their work. Motivation gets lost and projects get narrowed down to purposeful to-do lists. So, in some cases, as shown in the chapter on contextualization, artscience collaboration can remind one of the value of the work for oneself and for others, contextualize it in the society, and create meaning, which is motivating by getting in touch again with personal interests and higher aims.

Not only did scientists report a high in motivation and unusual project ideas after artscience collaboration, but artists also talked about the inspiration and motivation the conversations, interactions, and conversations with scientists had for their artistic work. They claimed they felt motivated to approach other works again where they felt stuck before, or that they worked harder and longer with better outcomes during the phase of the collaboration. Many artists reported inspiration for one or many future artworks and experiments, as well as that the collaboration motivated them to work to explore these ideas and topics further long after the collaboration took place. Importantly, these claims are uttered highly enthusiastically and thus point to the motivational aspect, and not just to evaluation of the work they actually realized afterward.

Intrinsic motivation is a driving force that enables artists and scientists who work together enthusiastically to enjoy the interaction and want to engage

more deeply with the topic. It is more than something allocated to the very personal realm. Organizations, whatever kind of organization it is—scientific, cultural, or corporate—must be aware that this kind of motivation is fundamental for creativity and thus a precondition for possible innovation.

9.2.2 Personal Development: Growing Skill and Knowledge Base

The feedback of artists and scientists suggests that these projects can add new insights, add methods, affect the breadth and depth of knowledge, and lead to openness. An interaction of artists and scientists is often perceived as broadening and deepening knowledge because it enables experiences, reflection, and insights; brings in diverging perspectives; creates connections to other fields; challenges established practices; and adds methods. Apart from intellectual effects, artists and scientists refer to a broadened skill base by adding different practices, breaking routines, or sensory input that alters processes, or receiving sensory input that alters processes or the understanding of situations. All these are important individual and social factors in fostering creativity.

The breadth of knowledge enables lateral thinking processes and establishes relevant connection between fields of knowledge or new perspectives and approaches to a (research) subject. On the other hand, the depth of knowledge is important to see relevant aspects or outstanding developments, or understand what is missing or what the problematic situations are. For example, being able to contextualize work within a scientific field and a social environment builds the basis for designing research projects and applications. Openness to new contexts, visions, and new aesthetic representations can inspire new questions and projects (Styhre and Eriksson 2008). It is argued that depending on an individual's stage in the career, a deepening and broadening of the knowledge base can be beneficial to creativity. Especially in the early stages of a professional career, knowledge depth is more beneficial for creativity because it allows more precise questions to be asked and creates a feeling for relevant questions, whereas knowledge breadth can be an important aspect in the later career stages to break up knowledge structures that became increasingly rigid (Mannucci and Yong 2018). Knowledge breadth and knowledge depth can have positive effects on scholars and artists and on their projects in any stage of their career.

Artscience collaboration can trigger sensemaking processes that add knowledge, change routines and perception, or bring new insights. Reflections on the processing of sensory data, like ways of looking at images to analyze data

or hearing a machine getting stuck, can be affected consciously or unconsciously by artscience collaboration. Such new aesthetic knowledge enriches working processes and methods (George 2007; Root-Bernstein and Root-Bernstein 2004). Both aesthetics (like visual imagery, sonification, "getting a new feeling" for handling a tool) and sensemaking are crucial for personal development, learning processes, and insights.

Most important for such personal development based on artscience collaboration is being open and engaging in the process. Openness toward the potential of artscience collaboration and interdisciplinary exchange can grow based on positive and surprising experiences in previous projects. Scientists, engineers, artists, and managers report that they encountered reservations concerning the idea of artscience collaboration, but after the experience of the intense process, many of these reservations could be overcome—in collaborating with partners and observers. This openness facilitates the learning process and is a central factor in enabling creativity.

9.2.3 Cognitive Abilities and Problem-Solving Strategies

Artists and scientists are understood as creative personalities and have to be creative in problem-solving: artists create innovative artwork, whereas scientists create innovative research output. To reach this goal both professions have to be inventive and find unprecedented ways to reach goals beyond the existing ones. Both are creative and still the artistic and the scientific process are not the same. Studies show that there are predominant models in artistic and scientific working processes that lead to different cycles of creativity influenced by working conditions and needs (Barrett et al. 2014; Mace and Ward 2002). Meta-studies show that artists and scientists who are creative display similar personality traits (Feist 1998) and thinking patterns. For example, paradigm-changing artists and scientists often display the cognitive ability of lateral thinking. Thus, for every (creative) person, there is a mix of conscious and unconscious thinking processes, based on knowledge, experience, and embodied processes, which can finally lead to creative processes and creative outcomes (George 2007). Moreover, artists and scientists develop their own working style—some start with an explorative approach and others with an analytical phase, for example.

Nevertheless, there are dominant work processes and thinking styles that are based in their disciplinary education and environment. Scientists and artists are trained differently to approach topics and research problems. Whereas scientists—engineers in an even straighter way—are trained to identify a

problem, break it down to the smallest possible pieces, and approach it analytically, artists often display a more comprehensive and synthetic approach early in their process. Juxtaposing these different processes and experiencing the other's way of working contributes rich information and context. Artscience collaboration is a space to experience these different ways of working and learn from diverging mindsets and strategies to tackle problems. These situations allow disciplinary norms to be overcome that otherwise restrict approaches and working processes. Interlinking fundamentally different approaches generates creative processes, and application of these diverging strategies in a group process can produce complementary insights.

A recurring topic in the conversations with scientists and engineers was that artscience collaboration helped them to initiate or train lateral thinking processes. Lateral thinking can be understood as the cognitive ability of individuals that influences creativity. It has been discussed extensively as being important for individual creativity and a major contribution to groups in creative processes (Gibson 1993). It describes the ability to make connections between ideas and seemingly unrelated knowledge. This enables, for example, problem-solving in unconventional ways or project ideas that combine not-obviously-related topics. Artscience collaboration can inspire to leave routine tracks and to make unusual connections, and it gives space to do so.

Case: *Creatura Micro_Connectomica*—Trigger of Lateral Thinking Processes

"I think I was able to derive value for myself in all the ways I have listed above through my collaboration on *Creatura Micro_Connectomica*." This is the final statement the neuroscientist Chris Salmon makes when reflecting on his experience in the creation of *Creatura Micro_Connectomica*, the artwork he produced in collaboration with artists Alex Bachmayer, Andrea Peña, and Jade Séguéla within the framework of the Convergence Initiative. There is not only one way to look at the artscience collaboration processes in how they can be of use to the artist or the scientist to evolve their own work. Thus, Salmon was eager to point out that, although he thinks the project helped him to reach expected outcomes—"I enhanced my communication skills; I was able to get my scientific research and message to a wider audience including artists and the public; I ended up with an artistic interpretation of my work that could be used for educational and promotional purposes in the future"—this was not the most important outcome: "However, for me, although useful, those benefits were not the most important. (I would also note here that to reduce such collaborations to such simplistic outcomes denigrates the art, and probably doesn't serve the continuation of such projects very well.)"

Nevertheless, this "luxury," as Chris Salmon calls it, to work with his scientific ideas in a different context, bring it into a new context, and ponder about how it could affect other fields is something a scientist can rarely afford to do, especially a young scientist who has the pressure to experiment and publish extensively in order to advance in his career. In this project, Salmon was able to explore new ideas and topics connected to his work: "For instance we talked a lot about circuit dynamics and emergence during the creation of *Creatura Micro_Connectomica*, and so I read into those topics much more deeply than I had before. I can think of numerous ways in which this may be of benefit to me in the future." Such interaction allows scientists to generate new perspectives on scientific work and triggers lateral thinking processes, which are important in scientific discovery. This supports new approaches to their own work or to forming new collaborations with related scientific groups (e.g., Root-Bernstein 2001; Root-Bernstein et al. 1993; Edwards 2008). Although this short-term collaboration has yet to initiate any new projects based on lateral thinking processes, it created new awarenesses through the reflection engendered by the process. Later on Salmon observed that this initial experience in lateral thinking processes fostered a new avenue for searching for ideas and creating connections between topics: "There is something essential to being adrift on occasion to spur the creativity that science requires. For instance, when I have down time over the holidays and I get to read fiction and avoid thinking explicitly about my research, I tend to end up making more notes about random thoughts about my research than at any other time."

9.2.4 Group Creativity and Interdisciplinary Collaboration

Creativity through interdisciplinary collaboration and inclusion of new contextual factors, like artists in organizational groups, cannot be taken for granted. Diversity in cognitive styles, personality, functional roles within a group, and demographic diversity are rated as important influences on the creative process in models like the one by Woodman et al. (1993) shown above, but there is more to it than just adding new people and perspectives to a group to make them creative. It is important to be aware of the social process in a team as another precondition for creativity: the interaction process, interplay of personalities, communication between team or group members, and trust (Reiter-Palmon et al. 2012).

Sometimes long-term collaboration is experienced as overtly effective and a rich artscience process. Giving enough time to collaborations is important for

the success because there is time to invest in the relationship between artist and scientist, to build trust, mutual understanding, clear communication (including an established common language between artist and scientist and ways to resolve conflicts), recognition, and observation of different perspectives, which create a fruitful encounter. This also creates a feeling of safety in such an experimental situation. Rushing into a superficial interaction does not allow for such extensive and substantial exchange. Personality traits like openness and curiosity or an open organizational culture can support the collaboration of artists and scientists even in short-term projects, and help to integrate processes and ideas.

Additionally, previous experience in interdisciplinary or artscience collaboration creates an open approach to such projects and establishes a framework that allows all collaborating partners to contribute and access new approaches. Group creativity is influenced by the work processes, creative strategies, and goal-setting techniques of the group or team members, and their capacity in engaging in a collaboration that values and reflects these differences (Reiter-Palmon et al. 2012). Combining different idea generation processes or creative problem-solving processes can lead to more creative or innovative outcomes. Workplace design and organizational culture can influence individual and group creativity by supporting such processes (Amabile et al. 1986; Shalley and Gilson 2004). In the setting of an open mindset and structures that are open to changes, the introduction of new members into existing teams might contribute to improvements in organizational creativity by enhancing communication about the topic or by bringing in new perspectives (e.g., Perry-Smith and Shalley 2003; Amabile 1996; Woodman et al. 1993; Kanter 1988). Studies show how the exposure of individuals to different environments might make them more creative, as employees gain new experiences and are exposed to different and unusual ideas (Ancona and Caldwell 1992).

Art and science are both understood as creative professions. Thus, their processes and ways of approaching a topic are not only different, but inherently creative. One very influential factor in fostering creativity seems to be the contact with role models and other creative people (e.g., Perry-Smith and Shalley 2003; Kanter 1988; Simonton 1984; Zuckerman 1977). Their work processes can be copied, their approaches to a topic can inspire lateral thinking processes, and much more, as presented above. Nevertheless, there is no simple "overflow" of creativity from one person to another; it is not contagious like a virus, spreading without direct interaction, nor is creativity a commodity that can be bought. Mutual interaction and engagement in a process are necessary for stimulation of each other's creative process

(Raviola and Schnugg 2015). Artists and scientists can benefit and learn from each other, inspire and experience processes, but time, willingness to engage in the collaboration process, and a structural framework to do so are essential.

9.2.5 Play and Liminal Situations

Artscience projects are often associated with situations that allow for experimentation and playful engagement with ideas, objects of investigation, and technologies. Artists and scientists report that it gives them the possibility to experiment outside peer pressure or their organizational obligations. Artist Lucy McRae argues that she experienced in her work with scientists and researchers that art allows for spaces of chaos and serendipity, for a combination of things and ideas that otherwise would not get connected within strict routines and organizational practices—just like a liminal phase gives this safety to explore beyond rules and societal (or organizational) structures. In organizations and at work such spaces are important as generative "dwelling places" in addition to transition spaces in times of becoming (Shortt 2015). Such spaces create meaningful spaces for workers to explore the sense of the space, materiality, and work they are confronted with in their work routines and professional aims. Retreating into dwelling spaces offers a fertile ground to better understand lived experiences at work.

Such a space is an important precondition to allow play and playful experimentation. As Turner (1982) points out, this helps to enter situations of "flow" as elaborated by Csikszentmihalyi (1996), which is strongly connected to creativity. Play is seen as refreshing and emotional, as enabling a link between ideas and action, and as fostering linear and nonlinear strategy-building to reach the goal set in the play (Styhre 2008; Anderson 1994). As work has real-life consequences, whereas play does not, a pure work environment and work situations can never be pure play (Huizinga 1950). The situation of play requires safety, to be safe from consequences at work if the play does not work out in a desired manner. Play does not go on forever, but it is limited in space and time, as individuals need to know the boundaries of play to be able to consciously enter it. As play is also referred to as enabler of creativity, such dynamics within artscience collaboration can lead to creativity. Thereby, play is nothing completely decoupled from the artistic and scientific work and previously accumulated knowledge; it, as Caillois (1961) states, "implies rule-following while simultaneously moving beyond these rules" (Caillois 1961: 27, as cited in Styhre 2008: 139). Although this situation

liberates from organizational pressures and structures, it does not free from knowledge and previous experience, like the one a scientist or an artist builds up in their own field. Thus, such a playful situation can be an important stepping-stone for an interesting recombination of existing knowledge or creative idea development.

9.3 Contextual Factors of Creativity in ArtScience

Contextual factors are set by the organization and its environment, which can be influenced by goals in the scientific, artistic, or economic field, and by cultural values. They are the ones that bring people in contact or give the space for exploration that eventually allows for creativity or innovative outcomes.

9.3.1 Organizational Culture, Space for Creative Action, and Structures Allowing Exploration

The introduction of artscience collaboration and formats like artist-in-residency programs influences the organization. Depending on the organization's possibilities and willingness to open up to these new formats and projects outside their routine goals and processes, artscience programs can influence the organization, create a fertile creative ground even for those employees who are not participating in artscience projects, and provide an open-minded context for creative ideas and processes. This interdependence between a successful artscience project, engaging individuals, and organizational development toward providing an environment that is supportive to creativity is crucial. For example, resources like time, materials, budget, access to facilities, and platforms to exchange ideas about the project with a bigger audience or colleagues provide necessary contextual factors to motivate the participating collaborating partners, express organizational support to the project, and legitimate the project within the organization. Legitimization is essential for others (who are probably not convinced about the idea) to accept the project and justifies providing resources, access to facilities and technologies for experiments, and possible rewards. Over time, artscience programs can be incorporated in the organizational structure and get more space and resources. Some of the corporate artist-in-residence programs became an important part in the organization, as they reflect the organization's vision

and strategy, which supports the status of the program in the organization even more.

This creates a situation within the organization that allows employees to enter liminal spaces within the organization. Such spaces create freedom to explore, to become free of peer pressure or routine structures and processes. Routine practices and rigid organizational structures and processes affect the way of working, get engraved in an employee's ways of thinking, and thus limit creative behavior and processes. Working in playfully designed office spaces or open offices that are designed to create a bigger chance for interpersonal exchange and collaboration does not always allow to break these structures and routines. Creating extraordinary situations and projects outside routine work processes, like artscience projects, that are legitimated within the organization can be effective to evoke liminal spaces. Creating such an opportunity brings employees in a liminal space which they are officially allowed to use. Artists and scientists talk about this new situation—or as, for example, the report about the FEAT projects (Art in Future Emerging Technologies, a Horizon 2020 STARTS project funded by the European Commission; STARTS stands for Science Technology Arts; Anna Dumitriu's project *Make Do and Mend* was one of the artscience collaborations funded within FEAT) refers to liberation—stating that scientists who were part of the artscience collaboration "reported how the interaction with artists liberated scientists and engineers from their daily lab routine, permitted a fresh look at their own work, and allowed to devote explicit time for less goal-focused deliberation that is usually difficult to achieve given project deadlines" (Prem 2017: 8).

This liminal space is a safe space without immediate evaluation through peers or managers. Feeling safe in experimentation and exploration is an important contextual factor supporting creativity (George 2007). A safe space is characterized by trust on both sides, of the employee in the organization and vice versa. As these projects can be disruptive or cause some collateral damage, for example, that weeks of work might not pay off or that somebody discovers a new call for a different vocation, thus the organization has to trust that there is no misuse or that some of these incidents can happen. Nevertheless, it is also important to allow unwanted outcomes, discuss them openly, and create a culture that can deal with changes.

Case: *Vorticity* by Ian Davis, Ricky Graham, and Edwin Park
The creation of an artscience program can influence the organizational culture and become an integral part of the organizational vision. The open mindset that is communicated through the incorporation of such a program engages employees to think outside the box and feel safe in situations of experimentation with unusual ideas. The integration of the new E.A.T. program in the

vision and work ethics of Nokia Bell Labs is an amazing example that shows how the integration of such programs and the space it creates within an organization demonstrate to employees an open culture that allows for experimentation. As noted by Domhnaill Hernon, head of the E.A.T. program at Nokia Bell Labs, after a short period of time, there was a large culture shift in the organization following the introduction and expansion of the art and technology collaborations. Engineers were examining the use of their core technology in more creative ways and seeking out collaborations with the artists involved in the E.A.T. program.

Once such example of this is that of a research scientist, Ian Davis, at Nokia Bell Labs in Dublin, Ireland, which is not directly connected to the E.A.T. program (the program is centered at Murray Hill, NJ, but it reaches out globally), who was inspired by the program and its embedding in the organization's vision to include an artistic approach to his scientific project. The knowledge that the organization supports such projects created a supportive culture, which communicates to employees that it is appreciated to experiment with ideas because this enriches the research process and bears huge potential.

Ian Davis was researching the effect of turbulence in fluids, which is a complex issue that takes a lot of experimentation time and processing power to analyze the data. The researcher was inspired by the artscience program and its series of works under the theme of "Making Visible the Invisible" and knew it was okay to do something different and to test new creative approaches. So Davis decided to sonify the turbulences instead of using traditional data analysis approaches to gain additional insights into the complex underlying structures that are invisible to human perception. With the algorithm he developed, it is possible to immediately understand the structure of the complex turbulent flow by using the processing power of our brain, which is well-trained in understanding patterns in music. With his background in acoustics, Davis applied a basic approach to translate the massive data sets to sound. This approach to understanding turbulence is interesting in that the conversion of the fluid patterns in the turbulence, which are normally invisible to humans, become visible, or audible in this case. Visualizations are usually used in scientific publications to support the argument and the case visually, but they can be difficult to understand for somebody who is not used to them. This different kind of understanding, sonification, is very powerful to experience the data in a different way and add meaning to the visualizations. Additionally, this opens up new data analysis techniques using principles of pattern recognition in sound, which in turn opens up new knowledge of this long-studied field of inquiry.

When Ian Davis met Ricky Graham, an artist with a background in music and music technology, he learned that the process of sonification can be much more complex through a series of different parameter- or model-based approaches. With his interest in the richness of sounds, Graham started to experiment with the data sets to create a more detailed impression, to hear the structures and depth of sound, with a focus more on timbre than on pitch-based mappings. As it was his first experience working with such heavy data sets, he invited his colleague Edwin Park at his newly founded Delta Sound Labs to bring in his programming skills. Step by step a sonification of the turbulences developed which tied in with projects at Delta Sound Labs and provided a rich experience and a field of learning for Ian Davis at Nokia Bell Labs. The collaboration produced a successful artistic installation that presented the visualization and sonification of the turbulences in fluids in the anechoic chamber at Nokia Bell Labs. All three of them mentioned how the collaboration provided them with insights into the other's fields and helped them recognize the relevance for their own work and explore new methods in their respective practices (Fig. 9.2).

Ricky Graham and Edwin Park's work with motion-tracking systems for spatial audio resulted in an invitation to create an exhibition piece for

Fig. 9.2 SoundLabsFlow is an adaptation of the PixelFlow library for processing by Delta Sound Labs and Nokia Bell Labs. It visualizes the turbulences in fluids that are sonified by referencing the structure and depth of the information. (Image courtesy: Ricky Graham)

Moogfest in Durham, NC, in May 2018. They wanted to extend the initial collaboration with Davis by including an interactive component to track the body of audience members in order to create a more embodied experience with a clear visual tied to sound structure. In this setting, the movements of the audience informed the flow of the fluid simulation on the screen, which then influenced the audio produced by the Delta Sound Labs hardware and software (Fig. 9.3).

It was not only that the artwork *Vorticity* was well-received at the festival, but future opportunities and ideas came up there too. A group of professional dancers improvised with the installation at the experimental music festival, Memphis Concrete, in Memphis, TN, later that summer. The idea was mentioned to use it in future events with dancers. Ian Davis added, "[O]ne useful thing somebody at Moogfest said, something I hadn't thought of myself, a few people there had said to me that a system like that could be a mode of communication. You know, a gesture-based communication instead of language based, where through your gestures there are audio and visual elements influenced that get the ideas across. How actually do this, I have not yet thought about, but it would be interesting to do so."

As Edwin Park elaborates about the experience, "Every time you do this kind of creative collaboration you wind up with way more ideas at the end of it than you had at the beginning. That is certainly the case here. We're still having brainstorming for next year, sorting out all these ideas. It's gonna be fun."

This is not surprising. Research shows that employees who know that their managers and leaders support creative work in an organizational culture that allows for creative approaches and experimental work feel more capable of creative work and are more likely to explore new ideas (Tierney and Farmer 2004; Tierney 2008). Such work environments are characterized by welcoming creative approaches without evaluation of the outcome (a rewarding system and acknowledgment of an interesting outcome are supportive though). Nevertheless, it is crucial that these organizational cultures do not force creativity or display a strong requirement for being creative at a certain point of time, because employees who experience an increasing demand for creativity often also experience a decreased sense of efficaciousness for creative work (Tierney and Farmer 2011).

Case: Forest Stearns at Planet Labs
Such far-reaching effects on the organizational culture and an open exchange between departments, scientists, engineers, and managers have been observed by Forest Stearns, Principal Space Artist, founder, and first alumni of the artist-in-residence program at Planet Labs in San Francisco, CA. Planet

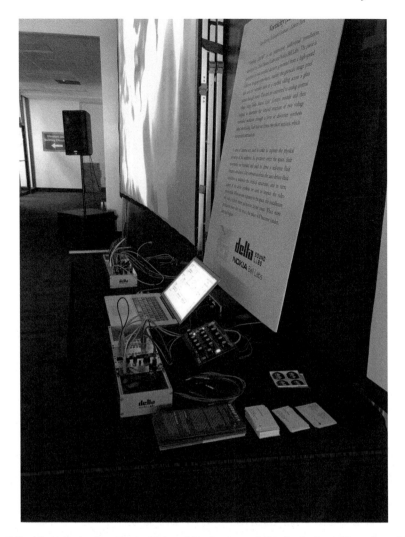

Fig. 9.3 *Vorticity* by Ian Davis, Richard Graham, and Edwin Park at Moogfest, 2018. Delta Sound Labs' Stream software and analog synth hardware controlled by a digital motion capture system. (Image courtesy: Ricky Graham)

Labs is a company that builds space crafts to monitor the environment to make global change visible, accessible, and actionable. There is always an artist-in-residence on site, at least a few days a week. Each artist-in-residence stays only for three months and is free to develop ideas and interact with those departments they find interesting. This open mindset and realization of wild ideas encourage employees to think beyond usual borders and to bring in their own wild ideas. Scientists and engineers regularly express the positive effect of this encouraging organizational culture on their own work, motivation,

Fig. 9.4 Artistically designed satellite by Forest Stearns, museum exhibit of his artistic work at Planet Labs, 2018. (Image courtesy: Forest Stearns)

and work processes, which is symbolized by the artist-in-residence (Figs. 9.4 and 9.5).

Based on the feedback in the organization and five years of experience leading the program, Forest Stearns sums up three aspects he found in which the artist-in-residence influences the organizational culture:

> One, humanize the mission, especially if the hardware or software goals are sterile or inaccessible. Humans are marked making species and if the program allows the artists to work directly with the employees and make creative pieces based on the common conversation, then everyone feels like they are part of the

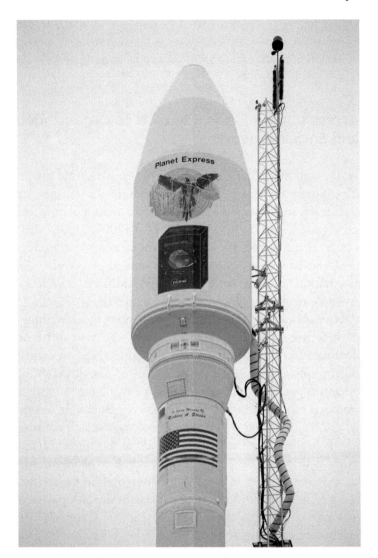

Fig. 9.5 Forest Stearns' painting representing the Skybox and Dove satellites by Planet Labs on a Minotaur rocket launched from Vandenberg AFB, 2017. (Image courtesy: Forest Stearns)

exchange even if the audience or onlooker is more of a tourist and less directly involved. Secondly, an artist in residency program helps build the structure of a balanced and diverse culture. Being a cause for inclusion and a vehicle for fresh perspectives. Thirdly it allows the topics at hand to be approached in a more open manner. Art acts as a gateway or entry point for the audience and the employees to see the product or topics at hand in a different manner, many

times the intense subject matter of science and engineering is very opaque to the outsider. When art is used to beautify or add a story, there is a much more robust and inviting platform for the outsider to be inspired by and permission for them to investigate further.

9.3.2 Access to New Fields, Contacts to Organization, and Social Networks

Social networks and network structures support creativity and the production of innovative outcomes. In the chapter on social network theory, strong network character of artscience collaborations and their potential effect have already been tackled. For example, Ronald Burt (2004) argued that bridging structural holes is connected to the generation of new ideas. Fundamentally, loose connections or connections to new clusters of people are said to bring up new information, different perspectives, and additional resources. Through access to a whole new set of knowledge and materials, actors in a social network can act creatively or come up with new ideas by combining the new input with their preceding knowledge. Moreover, the more different collaborating individuals are, the more diverse is the input they can contribute to a problem-solving process or to the development of new ideas. Weak ties are understood as a trigger for creativity; that is, people tend to form strong ties with like-minded others and thus, over time, a conglomerate of similar ideas within this cluster of strong ties evolves. Weak ties can thus bring in fresh ideas and new contexts for the work being done. Studies on scientists and researchers show that they use strong and weak ties to share knowledge, and that weak ties make it easier to transfer instrumental information effectively without being bound to additional conventions in the group or practices, or hindered through dominating theoretical perspectives (Bouty 2000).

Based on this line of thought, much research has been conducted to explore the connection of creativity, the development of breakthrough ideas, and social networks (Perry-Smith and Mannucci 2015). Research in the fields of social psychology, sociology, cognition science, organizational creativity, and innovation supports the idea that social networks enable creativity by triggering motivation, mutual support, openness for new ideas, and limited negative social influence like peer pressure or fear of negative feedback from peers. The field expands to literature that reflects on successful implementation of a new idea, development of patents, and entrepreneurial success. It is important to understand that much of this later literature does refer to the implementation of creative ideas and processes into an existing system, organization, or environment. The social network can become supportive or hindering in the

realization, publication, and outreach of the outcomes of a creative process: this is true for individuals and groups within organizations, and important to note in an organizational network.

Network ties, connection to peers or people with similar interests, help to reduce other psychological mechanisms that can hold someone back from being creative: they can reduce the perception of risk or produce affirmative and positive feedback (Hoang and Antoncic 2003). Both strong and weak ties can have a positive effect on creativity, which is supported by a substantial body of research. In contrast to Burt's (2004) argument of the strength of weak ties, which lies in the diversity of information and resources weak ties create access to, strong ties can have other beneficial effects, as closeness and trust are built up, which facilitates the ability to share new or critical information and leads to solidarity and socialization between like-minded people who support each other (Coleman 1988; Gilson and Shalley 2004).

In organizations, artscience projects can bridge intraorganizational network gaps, as, for example, shown in the cases of Sarah Petkus and Madeline Gannon in the chapter on social networks. Newly established contacts within an organization can enhance intraorganizational exchange and thus overcome the possibility of groupthink, which can become established within a closed group that exchanges ideas regularly. Moreover, other cases show how artscience collaboration brings together different organizations or individuals from different disciplinary backgrounds who are interested in the same ideas or connects laboratories that work with similar material or on complementary projects. The scientific partners of the artist Anna Dumitriu, for example, who focuses a big part of her artistic work on microbiology and computer science, pointed to a lot of networking effects they experienced that led to interesting ideas for new projects, collaboration with laboratories from neighboring disciplines, or exploration of new methods. Dumitriu's scientific partner Rob Neely referred to new research ideas and possible future collaborations, which involve a laboratory from a different field that has been introduced to him by Anna Dumitriu. Rob Neely's report shows how artscience collaboration brings up opportunities and connects resources and ideas that would not have come up or be seen as interesting by the scientific group in the first place. But especially these opportunities raise the chances to create interesting new projects that can be creative or innovative because, through a connection, both scientific groups can complement and contextualize their highly specialized and deep knowledge and provide a rich environment that supports creativity. Such collaborative ties between organizations in closely linked fields can increase the transfer of complex knowledge and create a performance benefit (Powell et al. 1996). Compared to other groups, they have the advantage

of an outside perspective, access to different facilities and materials, and application of their work in a new environment.

Dr. John Paul, lead public health microbiologist, is Anna Dumitriu's longest scientific collaborator. They started their collaboration in the early 2000s. He supported her learning and training in performing microbiological experiments in his laboratory. The relationship between them grew into eye-to-eye conversations between an experienced scientist and an artist working in the field of microbiology, and they started to develop ideas collaboratively. In 2010 he proposed that Anna Dumitriu become artist-in-residence with Modernising Medical Microbiology at the University of Oxford. In the course of their professional interaction, they developed ideas on the brink of art and science that sometimes leaned more toward art projects and sometimes contributed to scientific projects in the laboratory. These ideas can be new ways to do experiments or other experiments with specific bacteria they would not have used from their scientific way of approaching their media, up to co-developing an innovative project proposal about research on bacteria in space. Anna Dumitriu's big network helped to develop the idea, as she had been in contact with somebody about the International Space Station. Asking about who contributed what to the idea development, the scientist found it difficult to answer, as he pointed out, "[T]here was an equal amount of input by us." Also in writing the grant application, "she became a part of the team" for this project. John Paul went on describing the conversations and ideas the artist and the scientist have been pondering for a while, and Dumitriu's experiences at other laboratories finally led to the development of this specific project proposal. There is no single cause that can be named as a specific trigger of this idea, and there is no single person responsible for it; it was a joint idea that was influenced by the weak network ties the artist brought into the research laboratory, for example, connections to a person working in the surroundings of NASA. It is the "most unusual experiment he can think about," says John Paul and is based on their previous work, and all the other input during their past collaboration led up to this (Fig. 9.6).

9.3.3 Time and Expectations

Time as important resource and expectations as personal, organizational, and disciplinary evaluation systems are essential factors to provide a supportive environment for creativity. Time pressure in general has been found to impose a recombination of already known solutions or problem-solving approaches rather than to trigger creativity. Similarly, expectations and pressure through supervisors, which involves close monitoring, can lead

Fig. 9.6 An impression of Anna Dumitriu and John Paul's ongoing collaboration in Modernising Medical Microbiology, art project *Where There Is dust There Is Danger*, 2014. These tiny needle-felted lungs are made from wool and household dust impregnated with the extracted DNA of killed *Mycobacterium tuberculosis* (TB). The organisms have been rendered sterile using a validated process used in whole-genome sequencing of TB. The lungs show various stages of the disease and forms of treatment

to less creativity (George 2007). Time and a supportive environment to allocate time to artscience collaboration are essential for personal engagement. In artscience collaboration projects, especially as they are outside of usual organizational duties, responsibilities, and routines, it is important to provide time and trust to the employees to engage in the process. Pushing artscience collaboration into leisure time and after-hours will probably not end up in creativity. Of course, there is only a certain amount of time available for extraordinary experimentation, but at least a realistic amount of time to interact and learn has to be provided. Artists and scientists who are part of such a collaboration or experience a residency program need time to dive into the projects and ideas presented; they need time to get involved and to learn. Only then can a fruitful and creative collaboration emerge.

Additionally, unrealistic specific expectations of artscience projects can be counterproductive or specific goals like producing an artwork within a certain amount of time or squeezing an art project in a predetermined schedule of a scientific project can limit the outcome and thus the creative process. It is

difficult to be "creative on demand" for a predefined outcome. Allowing more time or providing phases for reflection between the actual collaboration can support the creative process by creating a welcoming atmosphere instead of undermining it by too-specific requirements (Tierney and Farmer 2011).

A part of the environment provided by the context concerns organizational expectations from the employees, disciplinary evaluation systems, and a reward system that is connected to the fulfillment of expectations. For example, expectations to publish a certain number of papers or invest a certain amount of time in project applications which will be rewarded in the career trajectory or in an organizational bonus system can be hindering to the engagement in artscience collaboration because it is more valuable to invest time in other tasks and thus limits its creative potential. Including general openness to cross-disciplinary borders in an organizational or disciplinary culture and rewarding daring projects at the boundaries of a discipline additionally support engagement and foster the creative potential of artscience collaboration.

References

Amabile, T. M. (1983). *The Social Psychology of Creativity*. New York: Springer.
Amabile, T. M. (1985). Motivation and Creativity: Effects of Scientific Productivity. *American Sociological Review, 55*, 469–478.
Amabile, T. M. (1996). *Creativity in Context*. Boulder: Westview Press.
Amabile, T. M., Hennessey, B. A., & Grossman, B. S. (1986). Social Influences on Creativity: The Effects of Contracted-for Reward. *Journal of Personality and Social Psychology, 50*(1), 14–23.
Ancona, D., & Caldwell, D. (1992). Demography and Design: Predictors of New Product Team Performance. *Organization Science, 3*, 321–341.
Anderson, J. V. (1994). Creativity and Play: A Systematic Approach to Managing Innovation. *Business Horizons, 37*, 80–85.
Barrett, J. D., Vessey, W. B., Griffith, J. A., et al. (2014). Predicting Scientific Creativity: The Role of Adversity, Collaborations, and Work Strategies. *Creativity Research Journal, 26*(1), 39–52.
Bouty, I. (2000). Interpersonal and Interaction Influences on Informal Resource Exchanges Between R&D Researchers Across Organizational Boundaries. *Academy of Management Journal, 43*, 50–65.
Burt, R. S. (2004). Structural Holes and Good Ideas. *American Journal of Sociology, 110*, 349–399.
Caillois, R. (1961). *Man, Play and Games*. Trans. by M. Barash. Chicago: University of Illinois Press.

Cattani, G., & Ferriani, S. (2008). A Core/Periphery Perspective on Individual Creative Performance: Social Networks and Cinematic Achievement in the Hollywood Film Industry. *Organization Science, 19*, 824–844.

Coleman, J. S. (1988). Social Capital in the Creation of Human Capital. *American Journal of Sociology, 94*, 95–120.

Csikszentmihalyi, M. (1996). *Creativity*. New York: Harper.

Drazin, R., Glynn, M.-A., & Kazanjian, R. K. (1999). Multilevel Theorizing About Creativity in Organizations: A Sensemaking Perspective. *Academy of Management Review, 24*, 286–307.

Edwards, D. (2008). *Artscience: Creativity in the Post-Google Generation*. Cambridge, MA: Harvard University Press.

Faulkner, R. R., & Anderson, A. B. (1987). Short-Term Projects and Emergent Careers: Evidence from Hollywood. *American Journal of Sociology, 92*, 879–909.

Feist, G. J. (1998). A Meta-Analysis of Personality in Scientific and Artistic Creativity. *Personality and Social Psychology Review, 2*(4), 290–309.

George, J. M. (2007). Creativity in Organizations. *Academy of Management Annals, 1*, 439–477.

Getzels, J. B., & Csikszentmihalyi, M. (1979). *The Creative Vision: A Longitudinal Study of Problem Finding in Art*. New York: Wiley.

Gilson, L. L., & Shalley, C. E. (2004). A Little Creativity Goes a Long Way: An Examination of Teams' Engagement in Creative Processes. *Journal of Management, 30*, 453–470.

Hargadon, A. B., & Bechky, B. A. (2006). When Collections of Creatives Become Creative Collectives: A Field Study of Problem Solving at Work. *Organization Science, 17*, 484–500.

Hoang, H., & Antoncic, B. (2003). Network-Based Research in Entrepreneurship: A Critical Review. *Journal of Business Venturing, 18*, 165–187.

Huizinga, J. (1950). *Homo Ludens*. Boston: Deacon Press.

Kanter, R. M. (1988). When a Thousand Flowers Bloom: Structural, Collective, and Social Conditions for Innovation in Organizations. In B. M. Staw & L. L. Cummings (Eds.), *Research in Organizational Behavior* (Vol. 10, pp. 169–211). Greenwich: JAI Press.

Mace, M.-A., & Ward, T. (2002). Modeling the Creative Process: A Grounded Theory Analysis of Creativity in the Domain of Art Making. *Creativity Research Journal, 14*(2), 179–192.

Mannucci, P. V., & Yong, K. (2018). The Differential Impact of Knowledge Depth and Knowledge Breadth on Creativity Over Individual Careers. *The Academy of Management Journal, 61*(5), 1741–1763.

Miller, A. I. (1996). *Insights of Genius. Imagery and Creativity in Science and Art*. New York: Copernicus.

Mumford, M. D., & Gustafson, S. B. (1988). Creativity Syndrome: Integration, Application, and Innovation. *Psychological Bulletin, 103*, 27–43.

Oldham, G. R., & Cummings, A. (1996). Employee Creativity: Personal and Contextual Factors at Work. *Academy of Management Journal, 39*, 607–634.

Perry-Smith, J. E., & Mannucci, P. V. (2015). Social Networks, Creativity, and Entrepreneurship. In C. E. Shalley, M. A. Hitt, & J. Zhou (Eds.), *The Oxford Handbook of Creativity, Innovation, and Entrepreneurship*. New York: Oxford University Press.

Perry-Smith, J. E., & Shalley, C. E. (2003). The Social Side of Creativity: A Static and Dynamic Social Network Perspective. *Academy of Management Review, 28*(1), 89–106.

Powell, W. W., Koput, K. W., & Smith-Doerr, L. (1996). Interorganizational Collaboration and the Locus of Innovation: Networks of Learning in Biotechnology. *Administrative Science Quarterly, 41*, 116–145.

Prem, E. (2017, June 18–21). Innovation Opportunities Emerging from Leading-Edge Art/Science/Technology Interaction. *The XXVIII ISPIM Innovation Conference – Composing the Innovation Symphony*, Vienna.

Raviola, E., & Schnugg, C. A. (2015). Fostering Creativity Through Artistic Interventions: Two Stories of Failed Attempts to Commodify Creativity. In U. Johannson, J. Woodilla, & A. Berthoin Antal (Eds.), *Artistic Interventions in Organizations. Research, Theory and Practice* (pp. 90–108). New York: Routledge.

Reiter-Palmon, R., Wigert, B., & de Vreede, T. (2012). Team Creativity and Innovation: The Effect of Group Composition, Social Processes, and Cognition. In M. D. Mumford (Ed.), *Handbook of Organizational Creativity* (pp. 295–326). Amsterdam: Elsevier.

Rhodes, M. (1961). An Analysis of Creativity. *Phi Delta Kappa, 42*(1961), 305–310.

Root-Bernstein, R. (2001). Music, Creativity, and Scientific Thinking. *Leonardo, 34*(1), 63–68.

Root-Bernstein, R., & Root-Bernstein, M. (2004). Artistic Scientists and Scientific Artists: The Link Between Polymathy and Creativity. In R. J. Sternberg, E. L. Grigorenko, & J. L. Singer (Eds.), *Creativity: From Potential to Realization* (pp. 127–151). Washington, DC: American Psychological Association.

Root-Bernstein, R., Root-Bernstein, M., & Garnier, H. (1993). Identification of Scientists Making Long-Term High-Impact Contributions, with Notes on Their Methods of Working. *Creativity Research Journal, 6*, 329–343.

Shalley, C. E., & Gilson, L. L. (2004). What Leaders Need to Know: A Review of Social and Contextual Factors That Can Foster or Hinder Creativity. *The Leadership Quarterly, 15*, 33–53.

Shortt, H. (2015). Liminality, Space and the Importance of 'Transitory Dwelling Spaces' at Work. *Human Relations, 68*(4), 633–658.

Siler, T. (2012). Neuro-Impressions: Interpreting the Nature of Human Creativity. *Frontiers in Human Neuroscience, 6*, 282.

Simonton, D. K. (1984). Artistic Creativity and Interpersonal Relationships Across and Within Generations. *Journal of Personality and Social Psychology, 46*, 1273–1286.

Styhre, A. (2008). The Element of Play in Innovation Work: The Case of New Drug Development. *Creativity and Innovation Management, 17*(2), 136–146.

Styhre, A., & Eriksson, M. (2008). Bring the Arts and Get the Creativity for Free: A Study of the Artists in Residence Project. *Creativity and Innovation Management, 17*(1), 47–57.

Tierney, P. (2008). Leadership and Employee Creativity. In J. Zhou & E. E. Shalley (Eds.), *Handbook of Organizational Creativity* (pp. 125–147). New York: Erlbaum.

Tierney, P., & Farmer, S. M. (2004). The Pygmalion Process and Employee Creativity. *Journal of Management, 30*, 413–432.

Tierney, P., & Farmer, S. M. (2011). Creative Self-Efficacy Development and Creative Performance Over Time. *Journal of Applied Psychology, 96*(2), 277–293.

Turner, V. (1982). *From Ritual to Theatre: The Human Seriousness at Play*. New York: Performing Arts Journal.

Weick, K. E. (1979). *The Social Psychology of Organizing* (2nd ed.). Reading: Addison-Wesley.

Woodman, R. W., Sawyer, J. E., & Griffin, R. W. (1993). Toward a Theory of Organizational Creativity. *Academy of Management Review, 18*(2), 293–321.

Zuckerman, H. (1977). *Scientific elite: Nobel laureates in the U.S.* New York: Free Press.

Part II

Creating and Framing Opportunities for ArtScience Collaboration

After creating a general understanding of what artscience collaboration is and a deep reflection of the mechanisms artscience processes trigger that affect artists and scientists, one question remains: how is it possible to support artscience collaboration and create an environment that helps artists and scientists to go through this process? To answer this question managerial aspects have to be explored, organizational restrictions have to be overcome, and institutional dynamics within the fields of art, science, and the corporate environment have to be considered. Every artscience collaboration and each artist-in-residency program lives in its own environment. The organization, whether it be a corporate, scientific, or cultural organization, constitutes a part of this environment; there are strategic goals and operative goals, artistic and scientific environments, individuals and groups. There is no simple one-way solution to grow an amazing artscience program, but there is always the potential to do so. And being aware of the following topics supports the development of an engaging initiative.

This section of the book systematically presents the necessary information to explore the creation of artscience programs, which can take the form of collaborative projects, educational programs, or artist-in-residence programs. First, based on the previous investigation of the artscience collaboration process, the value-added for artists, scientists, and organizations will be presented. Without a clear understanding of these values-added, artists, scientists, and organizations have problems in supporting their interdisciplinary ideas before funding bodies or even their peers. The second chapter is concerned with the practical issues of bringing artscience collaboration to life. It defines different forms of collaboration; presents frameworks for projects in artistic, scientific, corporate, and educational environments; gives managerial advice; and makes an argument for the importance of those actors who pave the way for artscience

collaboration in organizations: the bridge-builders, the curators, the facilitators, and the managers. The third chapter reminds us of barriers that still exist for artscience collaboration within the fields of art, science, and the corporate environment. There are important pre-conditions, evaluation criteria within the respective fields, and the role of the profession that have to be kept in mind for setting up new opportunities. An outlook on and a discussion of looming developments will comprise the final chapter. The chapter is concerned with aspects that ease the way for artscience collaboration and gives some insights on opportunities in the education of artists, scientists, managers, and curators.

Finally, I want to add that awareness of these above-mentioned issues is the first step to resolve them and ease the way for artscience collaboration. With my elaboration on the following topics, I hope to contribute to the ongoing discussions and help to obliterate some of the obstacles artists, scientists, and organizations currently face.

10

Exploring the Value-Added: Or Why to Give ArtScience Collaboration a Chance in Organizations

Each artscience collaboration has the potential to add value to projects, develop fields (in art, science, and engineering), and contribute to organizational change or creative endeavors. Some outcomes like artworks or artscience projects are creative output, but the creative process did not develop on demand; it grew organically. The most interesting and sustainable effects of artscience collaboration are those that are not obvious to an outsider and grow silently. Sometimes even artists and scientists do not immediately see a change or a creative outcome of their interaction, but the experience incrementally grew their competencies and provided a more comprehensive understanding of the ideas, methods, and fields they are working in. This ongoing process of learning and reflection provides the fundament for open exchange, feeds creativity, and eventually leads to innovation and substantial contributions. This cannot be planned or forced but enabled by taking one step at a time and by surprising experiences. Understanding the process of artscience collaboration and its entanglement with its environment is a first step to see the essential contribution of experiences and interdisciplinary exchange to enable individuals to enhance their own potential and the contribution of incidences, connections, and spaces for playful engagement with ideas. The possibilities do not stop here.

The chapter on interdisciplinary collaboration showed how artists and scientists can contribute to the development of projects and even new disciplines, raise questions, initiate mutual learning processes, and support reflective practices and spinning of ideas.

The chapter on contextualization showed the importance of creating a bigger picture, understanding effects of the own work (and how it is useful for society), the motivational factor of getting in touch with the own interests and finding meaning in work, projecting ideas into the future, or reflecting on the ethical implications of recent work. It showed that contextualization enables one to look beyond boundaries for creation of connections, and to reflect on cultures as well as disciplinary assumptions.

The chapter on liminality showed how important transitory spaces are, spaces that enable change and allow for experimentation and play without peer pressure or restrictions by specific goals. Liminality enables interdisciplinary exchange and engagement in coincidences that can lead to interesting outcomes. At the same time, it is open to failure, creates space to learn from mistakes, accepts discussions about misunderstandings, and bears no pressure to produce relevant outcomes that can lead to unexpected discoveries.

The chapter on social networks showed the importance of bridging the gaps between tightly knit social groups. These connections can be inspirational through new information as well as through access to resources and span dormant or nonexisting formal structures. They can support organizational change by bringing in a different mindset and create access to stakeholders and previously unknown audiences.

The chapter on sensemaking showed how unforeseen events and uncomfortable situations trigger sensemaking processes. Routine behavior and interpretation of routine situations can be altered and insights added to a comprehensive understanding of phenomena. This can help to overcome blind spots and triggers reflections on implications of the own identity for knowledge creation and behavior.

The chapter on aesthetics showed the importance of aesthetics in human life, interaction, and work. It showed the influence of sensual perception, intellectual and cultural interpretation of aesthetic expression, and how aesthetic experience affects insights and knowledge. Aesthetic experiences and confrontation with aesthetic possibilities help to gain new insights and foster reflection processes. The chapter also points to the essential contribution of aesthetic experiences and interdisciplinary experiences to learning processes and professional development.

The chapter on communication showed the influence of artscience collaboration on different levels of communication: outreach, science communication, public engagement processes, as well as the development of communication skills. New ways of communication include aesthetic expression, communication that includes senses and experiences, reflection on the (disci-

plinary or cultural) use of words, and the importance of stories, metaphors, and relationships in communication.

The chapter on creativity showed how artscience collaboration can contribute step by step to influence factors of creativity: individual, social, and organizational ones. Artists and scientists are creative in their work, and their creative process can be very individual. The exchange between them, learning, and new perspectives can inspire them and support their creative process, just as a supportive context is an essential factor for creativity. Mutual trust, engagement, time, and expectations play a major role in facilitating creativity. Thus, the incoming artist will probably not be the most creative person in the organization, but their work can be inspiring to scientists or engineers, just as the scientific work is inspiring to the artists. Moreover, the inclusion of artists in the organization is also a sign of permission for its employees to be creative and positively influences the culture as a factor of creativity.

Going through this process, being creative, and reaching to the point of innovation and substantial changes is not easy. This is rooted in engagement, interests, challenges, and uncomfortable situations, in approaching and overcoming the unknown. Such situations are uncanny for organizations and individuals. It is daring to engage with something unknown, with an unknown outcome, that is not yet completely understood and that has the potential to create a mess. Thereby, the unknown is the challenge of experiencing new ideas, learning from seemingly contradictory perspectives, and building new relationships. In this process of living through such new experiences, artists and scientists need to overcome organizational and personal challenges. What is learned in this process is not always obvious: sensemaking, gradually building new aesthetic competencies, or combining additional resources and information in a collaborative act can lead to interesting research, changes in methods, or outcomes long after the artscience collaboration process took place. The collaboration, obviously, affects the collaborating individuals; it reaches out to the colleagues, who interrogate the extraordinary project and the organization by influencing the organizational culture.

Artscience collaboration thus has effects on many levels. The individual development is beneficial for the organization, of course, and the invitation of artists-in-residence or ongoing artscience collaborations in an organization have an influence on its culture. The influence of artscience collaboration goes even beyond this. It has a social and cultural impact too, addressing and interacting with the audience and building bridges between cultures, social groups, and professional disciplines.

10.1 The Organization

Artscience collaboration and the incorporation of an artist-in-residency program have major impacts on how an organization is perceived—internally and externally. Engaging in this field impacts the organizational culture. In the chapter on sensemaking, the term culture of an organization or a laboratory has already been mentioned. There it was mainly referred to as routines, processes, and historically developed thought and belief systems. The disruptive element of artscience collaboration and the uncomfortable—and sometimes even unpredictable—situation created through such encounters have an impact on this very specific notion of culture: routines, beliefs, and well-established structures can be disturbed and adjusted through new insights in this process, for example, through sensemaking processes or the realization that some routines are superfluous and have never been questioned before.

Organizational culture evolves through artscience programs: values, behavioral systems, perceptions of ideas or the organization's mission, restrictions, expectations, and relationships can be changed. It is frequently reported that such projects can create a more general feeling of openness in the organization toward new ideas or unusual approaches. An explicit example is found at Nokia Bell Labs in Ireland, where the research scientist Ian Davis was inspired by the revived E.A.T. program and understood through this program that divergent thinking and experimental approaches are allowed within their company. This led to a successful project within the E.A.T. program and further collaborations. Others report that the residency program created an affirmative culture toward unconventional ideas, like at Autodesk and Planet Labs. Seeing these wild and uncategorizable projects brings fun, motivates, reminds employees about their personal vision, and creates meaning of their work in a bigger context and themselves. This further creates certain motivational effects and can even lead to "flow" experiences in the work, or "a certain drive" in their work, as some say. Allowing such unconventional projects within an organization creates an organizational culture that is open to disruptions and visionary experimentation; to messy situations within the process of project development, in order to learn from mistakes; to becoming aware of misinterpretations at an early stage of ideas; and to the often nonlinear process that is necessary for the realization of impactful projects.

Forest Stearns, founder of the Planet Labs' artist-in-residence program, experienced effects on three aspects of organizational culture: effects on hiring, inclusion, and employee retention. First, good scientists and engineers—even for a successful startup in the Silicon Valley—have a choice where to apply for a position. There is not a small number of scientists and engineers who explicitly pointed to the fact of the company having an artist-in-residence

program as something appealing to them and an important component of decision-making when applying to a position there because they think this is a company where they can be themselves, as they want to follow big ideas and realize projects also in ways they create them. Second, referring to be who you are in the company, artscience projects can be a catalyst for cultural inclusion. It is not only an official notion that each gender, race, anybody in the corporation is the same. Treating people the same and welcoming any artist for their abilities to create art and including them in the community is a role model for anyone in the company for an inclusive culture, Forest Stearns states. Third, employee retention is closely connected to these two aspects and an open and motivating organizational culture. Even employees who see this not as essential or are not interested in collaborating with artists can go to lunch, see the artwork in the company, are delighted by it or feel a certain relaxation, and then go back to work without thinking of it anymore.

Experiencing art in the organization created by the ongoing artscience interactions or the artwork that is displayed or regularly experienced at events in the organization influences the atmosphere of the organization. This can support well-being (Von Brandenburg 2009) or an open organizational culture. Artscience collaboration can go even further and help to define and establish an organizational vision by integrating the employees and stakeholders in the process.

In such an environment, fresh ideas are more often expressed and artscience collaborations often bring in new possibilities and completely new ideas. Sometimes the artscience projects allow employees (scientists or engineers) to express their ideas more explicitly than they would have done without the motivation and drive created by such an initiative. As shown in the chapter on networks, new connections within the organization are built or artscience collaborations are an opportunity to start new collaborations with external partners. Both new internal and external connections mean new access to social capital and new intellectual or practical resources. This has been identified as a key advantage for organizations (e.g., Tsai 2000). Sometimes a program can start a conversation between two scientific organizations, an art school and a scientific school, and on some occasions, the artscience project is the first time two disconnected (scientific or corporate) organizations work together and then start off a longer working relationship.

Communication and outreach aspects are important for any kind of organization: corporate and scientific organizations. Organizations can reach out to a broader audience or a completely new audience through the establishment of an artist-in-residence program or by including the presentation of the artscience collaboration in their outreach program. Through the connection of different groups that are interested in the topic, the artistic or the scientific

work, organizations can reach out to new communities. The stories told in the residencies or artscience projects can include new approaches to bringing the organization's vision to a broader public. Referring to the Ginkgo Creative Residencies, this corporation deals with a topic that appears exotic to many stakeholder groups. The stories told by the artscience collaboration focus on the goals and projects of the corporation and thus communicate more context and more intensely (but to a smaller group) than a typical outreach campaign could do. The residencies at ESO helped to reach out to a broader audience and communicate to them what ESO is. This happens through communication about the residency processes and presentations of the outcoming artworks in different contexts.

Artscience collaboration can support communication about scientific outcomes and public engagement projects. Nevertheless, in this point, it is important to find the balance between employing the artwork to communicate scientific ideas, referring to important contexts of the scientific work, and the implications of understanding an artwork literally. Artworks can go beyond communication of proven fact. Art can state, art can propose ideas, art creates fictional stories, but art does not deliver answers and is not bound to communicating the smallest aspects of scientific or technological possibility.

10.2 The Artist and the Scientist

Much of the beneficial effects of artscience collaboration on artists and scientists have been stated through the previous exploration of the collaboration process. The importance for STEM students and scholars of exposure to art to become successful in their future careers (e.g., likelihood of founding successful companies, important innovations in their field) has been shown in studies (LaMore et al. 2013).

The process of artscience collaboration and its effects are as valuable for artists as for scientists, as they build on their own intellectual, skill, and personal development to push the boundaries of their own work. Artists and scientists cannot rely on a certain skill set and knowledge base they acquired once; they expand it with each project and experience they have. All this they relate to their most recent projects and fundamental questions they approach. They continuously refine their knowledge and skills, and they work in high concentration on their goals. Nevertheless, this can lead to certain habitual blindness or blind spots in their perspectives or lets them rely on routine procedures instead of experimenting with less routine methods. Sometimes

these routines and basic knowledge applied become so normal that scientists do not question anymore or even reflect upon how such methods could be refined and what they actually do in the process. In such situations, disruption can be helpful—disruption and a little bit of a mess in a positive way. Scientists at ESA experienced it this way as Karen O'Flaherty reports: it helped them to engage with the fresh ideas that came up in the conversations, revolved around the artists' work, or even came up in the conversations started between scientists after the artist had left. As she says: "There is somebody throwing in extra ideas and new context" that contribute new aspects to think about or even question more traditional approaches. Danielle Siembieda from Leonardo experienced this as a positive way of being uncomfortable and challenged. People want to be challenged to be motivated and deeply engage in a topic, as she says, which is true for artists and scientists. Scientists, engineers, and the facilitators and inventors of the artist-in-residence program at Autodesk describe similar experiences, a place where artists are challenged, too, by learning to use new hardware and software as a first step in getting acquainted with the place, people, and corporation.

Overcoming these challenging situations can bring new insights and build knowledge and new methods, but is also fun and motivating. It helps artists and scientists to become more flexible in their thinking because they have been confronted with many ways of solving a problem. The theoretical physicist James Wells reports to have experienced this flexibility in thinking and experimenting with new approaches aside from crunching numbers all the time (Koek 2017). A confrontation with outside perspectives can help artists and scientists to gain this flexibility themselves, but in a first interaction, artists and scientists can comment and contribute valuable insights to the work of the other, like the artist can find new ways to use new technologies or to approach a question. On the other hand, the scientist can give valuable input to the artist's work on a specific topic, as they have very specialized knowledge, or give them access to new techniques (Prem 2017).

Detailed questions about projects, visions, contexts, methods applied, or fundamentals constituting the scientific approach can disrupt work processes and initiate reflection or recalling of the knowledge base. People engaged in daily work tend to focus on specific aspects of their work, want to acquire new knowledge, and rely on other aspects as given. Artists in scientific contexts are often reported to ask a lot of questions, questions fellow scientists would not ask: some because they take it as basic knowledge, others because they are afraid to ask too banal questions. Such conversations are helpful to clarify the understanding of fundamental ideas, contrast the effects of different methods used for experiments, or just practice the ability to talk about these things in

such terms that people who are not from the field understand what it is about. This again helps to deepen the own understanding. This consumes time, but it helps to reflect on the work, can be very beneficial for young and experienced scientists, and is a pleasant distraction, as the scientist John Paul reflects on his ongoing long-term collaboration with the artist Anna Dumitriu—especially because an artist's questions seldom stay at the surface and they want to go deep into the topic, as it is essential for their work process and they want to be able to do the experiments themselves.

Access to facilities, inspiring contexts, and new social groups is essential for artists to evolve their work. Especially artists working in very specific fields like BioArt inspired by bacteria or antibiotic resistance or artists working with robots or interested in the universe seldom have access to high-quality facilities and deep scientific conversations, as during residencies in laboratories or a corporate R&D department. Similarly, for artists without previous experience in scientific topics, artscience collaboration is inspiring and valuable for their artistic practice. This can even go further and help artists to articulate their ideas on specific topics more clearly or to build future work on studying related topics.

As Forest Stearns observed at Planet Labs and Sarah Craske in her residency at the Bioprocess Laboratory, for the artist, it is more than access to facilities. They have the opportunity to work in a highly specialized environment with a diverse group of people they would normally not be able to interact with. They come into this place and experience its extraordinariness, which is inspiring and exciting to them. At the same time, this is a sterile and most routine place for the engineers and scientists working there. This excitement helps the employees to again get in touch with the uniqueness of the place and become inspired by what the artists see in the place, materials, and routines they find at the laboratory.

The values-added for artists and scientists depend on the kind of organization in which the collaboration or project is embedded. Corporations can act faster and can provide a different format for artscience collaboration than scientific organizations like universities can do. Artistic organizations and scientific organizations can attract different stakeholders in public engagement events or help to reach out to completely new audiences. Communication to a broader audience and public engagement are essential topics for artists and scientists. Artists can reach out to new communities and present their work to a group of interested people they possibly would not reach through traditional artistic channels like museums, art festivals, or events. The collaboration with cutting-edge scientific organizations or upcoming scientific fields can increase the visibility of artists in the field—and their work will be recognized by highly established art institutions. For scientists, presentation

of their artscience collaboration on artistic platforms helps them to reach out to new audiences and engage with stakeholders. Through public engagement co-facilitated by artists and scientists, new ways of communicating their work to a bigger audience and audience participation get enabled.

10.3 Cultural and Social Environment

A major dimension affected by artscience collaboration that has not been in the focus of the previous analysis of the individual artscience process or its intersection with the organization in which the collaboration process takes place is the broader social and cultural environment. Each artscience collaboration is embedded in a number of cultural and social spheres. The first, of course, is the organization itself. Interactions, values, and routines in an organization are influenced by the organization's vision. The organization itself is embedded in a field and a social environment that influences its vision, mission, and culture by requirements, mindsets, and goals. Organizations within different branches of economy have different goals and cope with different structures than organizations in the sector of education, the art market, the cultural sector, or an NGO. Comparably to how these mindsets influence goals and cultures of an organization are individuals socialized within the cultural and social rules of their profession. When artists and scientists collaborate, and managers facilitate the artscience program, this leads to a clash of cultures. Through the ongoing exchange between these cultures, for example, an understanding of the social mechanisms and cultural rules of the other field, sector, or discipline can be created; in the end, even new shared values may evolve.

Having dominant sectors or philosophical approaches in countries or regions can shift the interest in artscience collaboration to only one of its aspects. In some regions characterized by startups and economic growth, the interest in artscience collaboration can be focused on the process of making an innovative tool or in buying the extraordinary artistic outcome; in other regions a more philosophical and theoretical approach to what artscience can do gains importance. Then there are others who are more interested in greater spiritual or playful investigations and still others in a more technological component. Nevertheless, establishing a collaborative project can go beyond cultural expectations. Bringing artscience collaboration in different cultural contexts can trespass the limits of what is expected and its cultural interpretations. Looking at the embedding of artistic programs in scientific organizations, which are influenced by the mindset of their scientific profession and scientific

culture, can help individuals in this scientific environment and the organization itself to open up and to relate their work to a broader social and cultural context. For example, a crucial factor for Ariane Koek to create Arts@CERN was to initiate such exchange and cultural development at CERN.

Last but not least, the cultural heritage of a social group is marked by their local traditions and ideas, and their shared history, language, and stories. This influences how individuals and organizations relate to art and science, and interpret artscience collaboration within this cultural context. Bringing different cultures together in artscience collaboration can even go beyond that. As the brief reference to Anna Dumitiru's experience about ethics in Egypt showed, moving beyond the Western understanding of art and science and their embedding in the local culture and tradition reveals a lot about the ways of thinking, processes, and interpretations. Thinking about artscience collaboration in contexts of the Arab world, or African, Asian, or Latin American cultures, can have many other implications, which are not tackled in this book. Crossing borders and using a space like artscience collaboration to learn from and about each other can be a huge opportunity for intercultural exchange.

References

Koek, A. (2017). In/Visible: The Inside Story of the Making of Arts at CERN. *Interdisciplinary Science Reviews, 42*(4), 345–358.

LaMore, R., Root-Bernstein, R., Root-Bernstein, M., et al. (2013). Arts and Crafts: Critical to Economic Innovation. *Economic Development Quarterly, 27*(3), 221–229.

Prem, E. (2017). Truth Emerging from Leading-Edge Art/Science/Technology Interaction. *Leonardo*. https://doi.org/10.1162/LEON_a_01470.

Tsai, W. (2000). Social Capital, Social Relatedness and the Formation of Intraorganizational Linkages. *Strategic Management Journal, 21*(9), 925–939.

Von Brandenburg, C. (2009). Art, Health Promotion and Well-Being at Work. *Synnyt, taidekasvatuksen tiedonala, 1/2009*, 25–31.

11

Bring ArtScience Collaborations to Life

"Artist-in-residence programs reflect a lot the organization and the people and goals in the organization who develop the residency programs," as the artist Sougwen Chung mentions in our interview about her experience with many different programs. She has been artist-in-residence for artscience projects in corporations, R&D facilities of corporations, scientific organizations, media art settings, and museums. Her experience not only reflects the diversity of settings of the artist-in-residence programs, but points to specific goals the organization has, the (personal and funding) capacities that can be used for the program, their goals and understanding of residency programs, and cultural differences.

In the course of my experience managing a residency program that dealt with diverse artistic and scientific aims in different organizational settings, I saw that it is important to think about the goals and the organizational setting first before designing a program. I have often been approached to talk about best practices and instructions on how to organize a residency, how to approach artists, and how to create interesting programs that attract artists and foster interdisciplinary collaboration. There is no single format that fits all, but understanding the process between artists and scientists; the factors that allow creative exploration; the organizational restrictions, goals, and culture (and thus the organizational needs); and the culture in which the exchange is embedded is the first step to create an impactful program. Asking the two questions first—"Who are we?" and "Where do we want to go?"—is the fundament for successful programs and projects at corporations, scientific organizations, or cultural organizations like those presented in this book.

© The Author(s) 2019
C. Schnugg, *Creating ArtScience Collaboration*, Palgrave Studies in Business, Arts and Humanities, https://doi.org/10.1007/978-3-030-04549-4_11

The second step is to become aware of the more managerial part of the issue: the different forms of artscience collaboration and their impact, how programs can be structured, and upcoming difficulties in managing interdisciplinary collaboration. The following overview builds a first knowledge base, creates awareness of possible pitfalls, and helps to implement an artscience program.

11.1 Forms of Collaboration

Artscience collaborations can take many forms: from mutual inspiration and short-term interaction to long-term collaborations that imply mutual learning and an ongoing development of new projects. This can take place in many different forms or formats. It can be embedded in a residency program where an artist is invited to become a member of a certain team or organization for a limited amount of time (artist-in-residence). These residencies can take the form of one-to-one collaboration between an artist and a scientist, or an artist becomes a member of a scientific group or department, where they work on their projects involving different scientists, regularly engaging with the scientific team or sharing processes and the scientific group's facilities. In these situations, some closer and some loose collaboration relationships develop—similarly to the inclusion of a new member in the scientific team. Artists can become residents in a scientific organization, scientific corporation, or the R&D department of a corporation and then start to find their way around, exchange with different groups and experts, and start collaborations and exchange depending on their projects.

Originally the term "artist-in-residence" does not only refer to artists-in-residence in scientific organizations or to foster artscience collaboration, so there are different possible interpretations of this term. The term artist-in-residence originally referred to a visiting artist at any place (organization, cultural heritage site, national park, church) who is provided with accommodation and living expenses to work on art, but it does not imply collaboration. In the context of artscience, though, collaboration processes and interdisciplinary exchange are essential to the value of residencies.

To organizations the position of an artist-in-residence can create certain insecurities, as this job title or position does not exist in their management structure. Thus, sometimes these artists are employed for the time they are part of the laboratory or scientific department in another visiting position (e.g., visiting researcher, expert) or other short-term contract positions. The position of the artist in the organizational structure has effects on access and on the interpersonal exchange because job titles create hierarchies.

Depending on the funding situation, artists are required to spend a certain number of days or hours in the lab or at the corporation's facilities during their residency time. Artists are mostly self-employed and thus they are used to dealing with different projects at a time and to visiting new places for inspiration and creation of new artwork. Artist-in-residence programs are dominating the field because of this possibility to invite self-employed artists, who are more flexible in their working situation. The outcome or future artwork based on this experience can contribute to their portfolio or give them access to new insights or even new connections to cultural institutions.

Scientist-in-residence programs in cultural or artistic environments are still quite rare. There are a few reasons for this. Although a change of environment can help a scientist to experience new perspectives and develop ideas, scientists are often bound to facilities or laboratory structures, as these are essential for their work. Being able to keep a connection with the laboratory is often a necessary precondition to enable such an experience. Additionally, spending a few months or half a year at a cultural institution can—especially for younger scientists—have a severe impact on the next steps in a scientist's career or in funding opportunities of the next few scientific projects. Scientists often take visiting positions at scientific organizations, but these opportunities during sabbaticals are clearly linked to their career trajectory, whereas it is currently still difficult to argue phases outside a scientific environment. It is definitely a positive trend that there is interest in scientist-in-residence programs at cultural organizations and in artistic environments, but there is still a long way to go concerning the acceptance of these opportunities as a valuable contribution to a scientific career (at least in terms of disciplinary evaluation, which is often bound to the quantity of publications and realized projects).

At some organizations artists do get the opportunity to become a fellow of the organization or scientific group. This terminology often refers to a more long-term connection between the artist and the organization or group and provides more flexibility in the collaboration or exchange process. Often artists become fellows of an institution after a residency that continues their access to facilities and scientific staff. Such formal connections help artists and scientists to proceed with ongoing exchange on a long-term basis. Some artists get the opportunity to stay connected to a scientific organization as (research) associate. Using terms such as associated artists, fellow artist, or artist-in-residence is still often difficult within organizational structures.

Artistic intervention in organizations, or arts-based initiatives, is a broader term that includes any activities by artists in organizations, often referring to activities that include art in organizations intervening with daily routines, team structures, goals, or culturally engrained processes. These more strategically

commissioned initiatives can include a short term of artists and scientists and long-term programs, for example, to trigger mutual learning processes.

11.2 Programs for Collaboration in Organizations

The artscience projects presented as case studies in this book took place in various programs and formats provided to the collaborating partners. The value-added of the process for artist and scientist and for the organization can be optimized by the decision for a specific format. The residencies in collaboration with the Ars Electronica Residency Network (with ESO, ESA, or the Sparks residencies) have been adjusted to the needs of the project and the possibilities at the sites. For example, at ESO there are restrictions on time spent at the scientific facilities and the location of the scientists and engineers. Moreover, all these residencies had some additional time for production and collaboration at the Ars Electronica Futurelab as well as free reflection and development phases in between the residency phases. Similarly, the residencies in collaboration with Biofaction like the SYNPEPTIDE Residency in Basel had a rather short residency time funded, but the artist, scientists, and the museum went on collaborating in order to push a project. Projects presented by Anna Dumitriu and Oron Catts and Ionat Zurr were single projects with diverse funding, where artists had the opportunity to join a laboratory without a program as visiting researchers or research fellows over a longer period of time (e.g., an academic year, duration of a scientific project). Numerous important artscience programs can be found worldwide. As these programs provided the framework for the projects presented in this book and are mentored by interview partners who have a voice in this book, the selection for this inspirational overview is restricted to them.

11.2.1 Programs at a Corporation

The *new E.A.T. Program* at Nokia Bell Labs is based on the tradition and heritage of the former E.A.T. Program, headed by Domhnaill Hernon. It focuses on exchange between art and science by inviting artists for 12 months to the Bell Labs facilities in New Jersey (about three days/week). After this intense process, there is an opportunity for artists to propose a collaborative artscience project that can be commissioned and this prolongs the time span of the collaboration for another few months.

The *Pier 9 Artist-in-Residence Program* at Autodesk created by Noah Weinstein and facilitated by Vanessa Sigurdson has been designed to host artists-in-residence and other creatives in cohorts for four months. As the residency is at a certain department of Autodesk, the artists (and other creatives) engage in an intense workshop training at the beginning of the residency and are supported in handling the technologies at Pier 9. By experimenting with the corporation's products in the development of their artwork, they find new ways to apply or defamiliarize them. At the end of each cohort's time, there is a collective presentation of the outcomes. Since the inception of this program, many more formats have been developed at Autodesk and other locations.

The *Ginkgo Creative Residency* started to take form during the residency of Natsai Audrey Chieza in collaboration with Christina Agapakis. This residency offers a three-month program at the intersection of design and biology. It is a fully funded residency acknowledging the incoming creative person at the same level as the scientists, to address the shared goals of the corporation and the incoming creative person/artist.

The *Artist-in-Residence Program* at Planet Labs created by Forest Stearns offers three-month residencies for incoming artists. There is the opportunity for year-round application, and for each round (quarter of the corporate year), one artist will be selected according to the current state of the art (projects, ideas, next steps) at the organization. Artists are included in weekly updates and corporate meetings.

11.2.2 Programs at a University or Scientific Organization

The *Arts@CERN Program* created by Ariane Koek and now led by Monica Bello is divided into three opportunities: the residency program Collide@CERN, which involves at least an introductory visit for a few days, a two-month residency, and a scientific inspiration partner for the artist to find their way around (collaborations are not limited to this person); Accelerate@CERN, which is a short-term, less intense residency for about one month; and the Visiting Artist program, to give artists the opportunity to get a glimpse into the world of CERN.

The *Swiss Artists-in-Labs Program* created by Jill Scott and facilitated by Irène Hediger provides consulting, facilitation, a platform, and a network for artists and interested scientific organizations to host residencies. Residencies in Switzerland take about seven to nine months, and at collaborating institutions three months. The projects and the process of the residencies are regularly published in an edited book about the program.

The *FEAT Residencies* have been funded by the STARTS program to include artists-in-residence as experts for a few months in ongoing Horizon 2020-funded scientific projects. The design of this program is based on the comprehensive residency experience of Anna Dumitriu. It integrates artists in the research teams as experts and supports the production of their artistic work.

SymbioticA at the University of Western Australia, created by Oron Catts and Ionat Zurr, is an artistic research laboratory at the School of Human Sciences that invites artists-in-residence as visiting researchers (compared to a PhD-level invitation) for at least three months. SymbioticA has its own level 2 biological lab and provides connections and access to other research laboratories at the university, gives courses, and runs educational programs at the intersection of art and science.

Biofaction Residencies created by Markus Schmidt are a regular opportunity for artists to spend three weeks at a scientific collaborating partner of Biofaction to enable interdisciplinary exchange, experimentation, and experiences by recontextualization. As it is often connected to a collaborative research project, the funding for artistic contribution and collaboration involves a four- to six-week stay at scientific institutions. As artists find the laboratories inspiring partners, most aim to produce artworks and stay in contact with the scientific organization.

11.2.3 Programs that Include an Educational Aspect

The *Art|Sci Center + Lab* at UCLA created by Victoria Vesna is connected to the UCLA School of the Arts and Architecture's Design | Media Arts Department and the California NanoSystems Institute (CNSI) in order to bring collaboration and provide joint education of arts and science students, and to foster exchange between faculty and staff of the different departments at UCLA. It hosts residencies and provides opportunities for art and science students to collaborate on artscience projects.

Convergence, Perceptions of Neuroscience is an independent initiative created by Dr. Cristian Zaelzer, PhD, in partnership between the Brain Repair and Integrative Neuroscience Program of the Research Institute of the McGill University Health Centre, the Faculty of Fine Arts of Concordia University, and the Canadian Association for Neuroscience. The program is supported by the McGill University Integrated Program in Neuroscience, The Montreal General Hospital Foundation, The Research Institute of the McGill University

Health Centre, and the Visual Voice Gallery. The program involves graduate students (master's and PhD) in the area of neuroscience and those in the last terms of their Bachelor of Fine Arts. The process is designed to bring interested scientists and artists together and to start an interdisciplinary exchange. Based on interests and information about personal projects and work, interdisciplinary teams start to work together on an interdisciplinary project (mainly artwork) that will be presented to a bigger audience at the end of the term. Basically, the program designs an outline for the courses, organizes artscience mixer events, brings the collaboration into a guided teamwork, and creates a platform for presentation and reflection.

The *STEAM Imaging* project at Fraunhofer MEVIS has been created by Bianka Hofmann as an experiment for possible future interaction between in-house scientists, science communication, and artists. Important were the experimental STEAM workshops with a mathematician and the artist that reach out to high-school students. From the first visit to Fraunhofer MEVIS (two weeks), the execution of the two workshops and the residency period for the production of the artwork at Ars Electronica spanned over about half a year.

11.2.4 Other Programs

The Bridge residency by SciArt Center created by Julia Buntaine is a virtual-opportunity residency over the time of four months where artists and scientists can explore a collaboration and ongoing interdisciplinary exchange that is regularly facilitated. They get a virtual space for collaboration and use the blog space to reflect upon their process.

The *Djerassi Artist Residence Program "Scientific Delirium Madness"* by the Djerassi Foundation and Leonardo provides an opportunity for artists and scientists to explore collaborations and start to work together in the course of a retreat, providing uninterrupted time for work, reflection, and collegial interaction in a scenic and isolated space.

11.3 Bring Programs and Projects to Action

The collaboration processes—in bigger programs and in single projects—involve many managerial steps and interdisciplinary competencies to make them work. The procedure of artscience collaboration has to be incorporated and adapted for the organization and the collaborating partners' needs. Some of these issues are straightforward and others involve interdisciplinary

competencies and knowledge of the organizational environment. For example, artists who get invited to residencies in scientific organizations like universities, scientific facilities, or R&D departments need to find points of contact in these new organizations and learn about routines and collaborating partners; scientists need to get in touch with art and the artist's ideas; and the organization itself needs to learn how to deal with this situation. Social skills are needed as soon as individuals from different cultural (art vs. science) or disciplinary backgrounds meet. Enough time to engage in exchange is one factor for a successful exchange; sometimes a mediator is needed. Already, early projects like E.A.T. and the APG experienced that certain steps are necessary in order to make collaboration effective: Billy Klüver wrote a manual for fellow engineers for collaboration with the different artists' characters, and there were difficulties for some artists in the APG to get certain freedom in the organizations in which they were placed or to reach out to employees and managers. So it is more than just invitations to artists and giving them space in the organization.

Before an interaction takes place and can be mediated, a framework within the organization needs to be built. It is important to have a designated person to do this, who has insights into the organization; knows about the structures, needs, and goals; and has the necessary social and interdisciplinary skills to make it happen. John Seely Brown, who supported the creation of PAIR at Xerox PARC from a top hierarchical position as director of PARC and chief scientist of Xerox Corporation, points to the social and managerial skills that are necessary, in an interview:

> It was Rich [Gold] who proposed building the formal program for the PARC Artists and Residence Program, PAIR. The challenge was how to build a new kind of institutional mechanism: How do you find the artists, how do you create a jury, how do you match up the artists' interests with the researchers' interests, how do you find the right pairing, how do you pair an artist with the right scientist so that it is a natural chemistry? If it isn't there, you don't do it at all. So there's a whole set of interesting institutional mechanisms that underlie making this work. He designed and drove the whole program for a three or four year period. (Naiman 2011)

Each organization has different needs, is embedded in a specific environment, and has a specific structure, culture, restrictions, and goals. Thus, there is not a single way that is correct to introduce artscience collaboration, as many actions and necessary steps are dependent on the organization and the goals of the project. The programs and projects presented above already show the variety of formats that are possible and work in their given environment. Nevertheless, there are questions to be asked that help managers to develop a solid framework, managerial steps to be taken to introduce artscience projects,

and social, interdisciplinary, and intercultural competencies required to create fruitful interaction.

The important questions to be asked right at the beginning are as follows:

- *What is the funding structure?*
 Let's be honest: you can only work with what you have and can't create time or materials out of thin air. Depending on the funding structure, artists and scientists can allow a certain amount of time to spend with the project, funds for experiments or time at scientific facilities, and funds for the creation of an artwork.
- *Is the project supported by the most important individuals and departments in the organization?*
 The reception of the project internally is important for programs and projects to be well-received and to create deep engagement. Sometimes awareness of the values-added has to be raised beforehand to create interest. Support and trust provided by the CEO or other major individuals in an organization, like the head of a research group, who hosts an artist, can be crucial for the success of a residency or artscience collaboration project and creates legitimization for something new and extraordinary like this.
- *How much time is available and how much time can employees or scientists spare to talk to the artists, have regular conversations, or engage in a collaborative project?*
 Aside from funding structures, it is necessary to have an understanding of the status of the artscience project within a team, group, or organization. How much time can employees or scientists spend to work with the artists without neglecting other projects? Are there routines where the artists can be integrated? And it is important to understand that moving the program or even a single project to pure spare-time activities can negatively impact the progress of the project and the status and reception of a program within an organization, degrading it to something unimportant, something that just takes up time that could be spent to relax at home.
- *How open is the process or are there specific organizational or individual goals?*
 There can be goals like free-floating exchange of ideas, engaging in personal development and new connections for the scientists/employees to acquire new perspectives, and communication goals, basically anything presented in the previous chapter or more specific goals related to the organization, a certain project, the artist, or the scientists.
- *Is there a focus on the process or is there a certain result that is required?*
 Some collaborations are open ended and focus on personal development and learning processes, others are output oriented, as the organization (or the collaborating partners) wants to have a result that can be presented

(this can also be a concept if there is not enough funding). Although funding bodies often require a certain outcome, a survey shows that most individuals engaging in artscience collaboration focus on the process and their personal development generated through the process (Sleigh and Craske 2017). Scientific or artistic progress comes afterward.

Answering these questions gives a first direction in framing an artscience project or residency program and helps to organize formal structures and managerial steps to take. The structure of an artscience program based on these influential factors is then formalized in the following dimensions:

- *Positioning of the artscience project in the organizational structure*
 Projects and residencies can be included in scientific groups or departments. Positioning within the organizational structure defines access, possible collaborating partners, interaction structures, and perceived value of the project or program for nonparticipating colleagues. These decisions often go along with formal positions of incoming artists as fellows, visiting "researchers" (because the title visiting artist is non existent in organizational structures or would give them less access), or other temporary positions. Titles like volunteers or internships are definitely not recommendable because this creates a low status in an organizational hierarchy and implies apprenticeship instead of expertise. Status differences can negatively influence collaboration or interaction processes.
- *Selection process*
 This often depends on the situation and funding scheme. There can be an open call for an artist-in-residence followed by a formal selection process, including an official jury meeting or a jury that is composed of internal personnel and external specialists. If there is no open call, but year-round application, then an internal board or application committee can be installed that involves different stakeholder groups in the organization in the selection. The selection process can be curated for specific opportunities. Not all artscience projects involve open calls; some curators invite artists for specific topics.
- *Design of the open call and application details*
 Essential information to be provided in the open call comprises main ideas of the program, goals, description of the format and facilities, application and selection process, timeline, funding situation, expectations, and responsibilities. The artist applying to the program or the organization has to articulate their intention; give their reason to match their art, processes, and perspectives to the organization or the goal of the program; sketch a project idea (do not forget, side projects and changes in the initial project idea are

often the most exciting!—but there has to be a starting point and clear intention); and show a portfolio of previous work and relate it to their letter of intention.
- *Payments and funding*
When artists join a scientific group or R&D department, they are specialists in what they do and are eager to work on ideas and projects. When they join, like visiting researchers or scientists, they can either be part of the team like a regular employee (specialist, co-worker in the project) or focus on their artistic work, which is often compensated by an adequate artist fee. Additionally, there are more pragmatic things to be aware of that have to be funded: travel and accommodation if the artist is coming from a greater distance, time and material for experiments and scientific engagement, and costs of artistic exploration and creation of an artwork (if the artwork is part of the project).
- *Allocation of resources*
Based on the funding structure, it is important to think of how much time employees can invest in collaboration (do they have a certain amount of time per month to invest in such experimental projects or does it need to be funded; what is the current workload in the department; is it possible to make time?), if requested facilities are available during the artscience collaboration period, and if there need be additional funds for production material and what material is available (this aspect exceeds the production of artworks and includes questions about ongoing projects as starting point for artscience collaboration).
- *Contractual arrangements and intellectual property (IP) rights*
Even individually initialized collaborations between artists and scientists can involve organizational restrictions, contractual agreements or a basic legal understanding of using materials, ideas that are part of a funded project, or nondisclosure agreements (NDAs) to be signed. It is necessary to have a clear understanding of how the outcome can be handled and communicated externally. This is an extremely sensitive topic and can vary from case to case. Contractual arrangements clarify aspects like duration, access to facilities, rights, responsibilities, presentation and evaluation, and payment agreements.
- *Duration of the project or residency*
Developing a project—an artistic or a scientific project—takes time. Projects and collaborations in artscience settings can take shape in about three months; six or nine months allow a more intense process. If the funding is not sufficient to cover such a long phase or if working processes of artists and scientists do not allow to focus on only one project for such a period, other options can be chosen that allow for intense shared working time

and phases of reflection at the respective lab or studio. These can be designed as shorter residency periods (e.g., a few weeks or one to two months) that take place in intervals over six months or the full duration of a scientific project. Short initiatives or short-term exchange, like inspiration visits, can be interesting and inspiring, but an ongoing exchange between the disciplines is more impactful.

- *Interaction structures*

 Placing a scientist and an artist in the same building does not necessarily lead to a collaboration process. There need to be structures that can be used for exchange and interaction, like the integration of the artist in weekly lab meetings, official presentations, or after-work mingling for artists and scientists to meet and talk about their work. Selection of offices for the artist on certain corridors, collaborative brainstorming meetings, or formal and informal possibilities to enable exchange (e.g., introduction to team, Pecha Kucha sessions, brown bag seminar, at the coffee table, or a weekly, sometimes daily, update meeting between artist and scientist) are essential to the process.

- *Internal communication*

 Mailing lists and internal communication opportunities should be used to announce the program or project and the incoming artists. Internal communication involves information about the project, the contributing individuals, values-added, and arguments supporting the project.

- *External communication*

 Even if outreach is not the issue of artscience collaboration, the projects are interesting for a wider public and stakeholders. Moreover, if an open call has to take place, outreach and external communication are essential to create a successful open call.

- *Presentation and evaluation*

 Although a focus on the process can create the most interesting outcomes, there are needs in the scientific and artistic community to present the work, experiences, and insights. Additionally, organizations love to have evaluations in order to make sense of what happened. Thus, whatever the outcome will be, presentation and (personal) evaluation strategies of the project should be invented. This can range from a reflective writing process in a blog to a presentation of the experience, the artistic and scientific contributions to the project. More institutionalized presentation like official talks, exhibitions, or papers published can help to raise awareness and show the impact.

It takes a huge amount of social, intercultural, and interdisciplinary skills to bring artscience collaborations in organizations to life. The organization and organizational members have to be made acquainted with new ideas and

processes and the ideas behind artscience collaboration. This involves social interaction, building up trust and relationships, as well as creating an understanding of different kinds of knowledge to create a feeling for the importance of artistic and scientific processes. Trust and willingness to experience artscience collaboration build a fertile environment for interaction. This exceeds the acceptance of different ideas and includes the willingness to experience new perspectives, as well as unknown and sometimes uncomfortable situations, and to relate them to the own thinking and working patterns. Introducing artscience collaboration to organizations requires conversations with directly involved individuals and managers and controlling bodies in the organization.

Social skills, like mediation skills, are necessary in the selection process of project proposals, in the establishment of a relationship between artists and scientists, and in the facilitation of the interaction. Some collaborations, especially of artists and scientists with little experience in this process, need more facilitation and mediation than others. Interdisciplinary and intercultural skills of facilitators of artscience collaboration also support the process between artists and scientists to translate jargon and ways of expression, to explain work processes and conventions within disciplines, and to contextualize artscience ideas within the realm of art and the scientific discipline.

11.4 Bridge-Builders

Important bridge-builders of artscience collaboration can be curators, facilitators, mediators, managers, and producers, and they are more than the middle-person who introduces the artist and the scientist. Creating the framework for residency programs or artscience collaboration projects within an organization comes with a lot of management responsibility. This management responsibility comprises determining goals, creating a structural framework within the organization, communicating internally within the organization as well as externally, taking all the management steps necessary to create a program, and bringing each project to life; it often includes funding responsibilities or at least the responsibility to state the value-added of such projects. But the responsibilities of the manager (or management team, depending on the size of the program) responsible for an artscience project or a residency program in an organization do not end there. To bring every single project on its way, the organization needs more than a project manager; it needs a person who has the social and interdisciplinary skills outlined above. Such persons in-between often have the abilities of a cultural producer, curator, mediator,

translator between the fields, and facilitator who guides the project and helps to communicate the project to the microcosmos of the organization in which it is embedded.

This bridge-builder is responsible for introducing the incoming artist to the common conversation at the organization: where is an intersection, what are possible starting points for the conversation? Thereby their curatorial and communication competences are important: to create and introduce the framework of the artscience collaboration and the fundamental goals of the artist-in-residence program within the organization; to support the selection process of the most suitable artist and communicate the reasons within the organization; to guide and—if necessary—curate the artscience collaboration process; to contextualize the outcome of the process; and to set up presentation opportunities as well as communicate the outcome internally and externally. This person has to be able to grasp the artistic and scientific value and impacts of the work, and to contextualize it within the organization and the disciplinary fields.

Especially in the initial phase of an artscience program in an organization or during the phase of establishing contacts between artists and scientists, social skills, in-depth knowledge of the organization, and relations with its employees are essential. This starts by creating insights about the value of artscience programs and then goes on to introducing the artist to the organization, establishing contacts between artists and scientists, creating platforms for exchange that fit in the organization's structure, mediating between disciplinary jargon and expressions, and making the incoming artist acquainted with structures, departments, contact persons, routines (even basic ones like lab meetings and email routines), ongoing projects, and goals. Some collaborations need more support in establishing communication than others, and the bridge-builder can direct the artist to interesting conversation partners due to their knowledge about the artist and the interests of the colleagues at the organization. Pre-established relationships and trust between the facilitator of the program and their colleagues (i.e., scientists, engineers) help to initiate exchange between the incoming artist and specialists within the organization. Bridge-builders are important because they do have connections and access to a range of organizations and a network of artists and other specialists who are open to participate in projects. Thus, collaboration within the organization and valuable exchange with external partners who contribute to the goal of the project can be facilitated.

After a certain experience, the artists and scientists develop an understanding of the different aspects that are special to artscience collaboration projects and get a feeling for organizational and managerial restrictions, and the different goals and ideas in the fields of art and science. Many artists grow with the experience of artscience collaboration and go on doing more projects in this intersection; some even create their own artscience laboratories or groups at

their home universities, as Oron Catts from SymbioticA reports. They start to take up the role of the facilitator and bridge-builder themselves, as, for example, Forest Stearns did at Planet Labs.

There is a learning process that experience of artscience projects bears for artists, scientists, managers, and organizations and that helps to increase the value of each following project and to better understand the process. But this does not make the role of such a bridge-builder obsolete. In my own experience with many different residencies, residency programs, and individual artscience projects, there are artists and scientists who are better at communicating on a meta-level about their work or understand how to communicate about their work to implement it within an organization or scientific group. The facilitator of the program creates legitimacy to decisions and can serve as an interface between the organizational necessities or managerial responsibilities and the actual communication about the specific project (and project idea) between artist and scientist. Moreover, for artists and scientists, taking over these responsibilities takes much time from their projects, as this uses up lots of their resources and energy, which they must redirect from their project to managerial and bridge-building activities.

But there is a second form of intermediary who is necessary and a growing part of the field of artscience collaboration. As director of a gallery who supports artists at the crossroads of art and science, giving them access to laboratories, and helping them to argue their ideas with scientists, Jurij Krpan (the director of Kapelica Gallery) sees a big opportunity in platforms and intermediaries who provide a space for collaboration or access to facilities in order to support artscience collaboration. These can be organizations that are in the position to mediate and facilitate between artists and scientific organizations or corporations and who can provide space, professional connections, and management support by experienced curators, producers, and managers in the context of artscience collaboration. They can provide artists with access to the scientific organizations they need and direct interested scientific and corporate organizations to artists who do work that is relevant for them. Ariane Koek, who guided and produced many projects during her time at Arts@CERN, similarly reports that this guidance and curation work is also extremely important for the artistic and scientific process as it creates space for these processes and can point out interesting new directions (Koek 2017). "This is like doing invisible weaving," she states in our interview.

What Jurij Krpan mentions as a professional platform in-between to provide managerial support for organizations that has access to different actors in the field of art and science has been studied by Ariane Berthoin Antal (2012) as "intermediary organizations." Her study is based on seven intermediary organizations in five European countries. The Swiss Artists-in-Labs program

and the Swedish consulting company TILLT are two examples of such intermediaries she investigated. TILLT in Skadebanan Västra Götaland is an organization that provides consulting for corporations and creates artist-in-residence projects and artistic interventions according to the required needs and challenging situations their client faces. The Swiss Artists-in-Labs is based at the Institute of Cultural Studies of the University of the Arts in Zurich and provides a program and a network for artscience projects. It collaborates with scientific organizations and scientific groups who are willing to host and collaborate with artists. It provides an interface to artists who apply for residencies and suggests collaborative artscience projects for the scientific opportunities that are offered (Scott 2006, 2010; Hediger and Scott 2016). The basic idea that led to the creation of the Ars Electronica Residency Network (2013–2016) was also based on this intermediary and network idea. Through the unique position within the art world and the broad network in the field of science and technology, interesting network opportunities could be developed into a range of residency programs, which are supported, co-curated, and facilitated in collaboration with respective institutions by experts in the fields of art, science, and technology.

Intermediaries can take other forms of platforms or centers that facilitate interdisciplinary exchange and artscience collaboration at an organization with internal and external partners, like SymbioticA at the University of Western Australia, or venues that do not necessarily include residency programs, like the Art|Sci Center at UCLA or each Science Gallery at its hosting university. They build up the competencies of the person of a bridge-builder in an organization, but through their structure as a center or department, they are able to provide space, can be a platform for exchange and workshops, and give additional support.

The roles that intermediary organizations and (full-time) managers of artscience programs—bridge-builders in organizations—take are as follows (e.g., Berthoin Antal 2012; Schnugg 2014):

– Seeking out artists and organizations, matching them, and making contractual arrangements
– Designing and executing open calls and jury meetings (if part of the project)
– Helping to specify the focus of the project or program
– Assisting in arguing the value-added and finding funding
– Connecting the focus of the program to the organization's vision and keeping it on track

- Providing a framework to structure the process, management, and facilitation
- Curating and guiding the project, and seeing opportunities and articulating them
- Providing mediation and translation between the fields, and finding a common language
- Keeping conversations going, as communication is key to a successful collaboration
- Guiding the progress
- Building up trust and relationships with and between core actors
- Addressing conflicts that may emerge before or during the collaboration process
- Dealing with concerns among artists, scientists, and employees, and providing introductory information
- Providing space for conversations, engagement, and exchange
- Communicating with authorities and the media locally and beyond
- Externally communicating the residencies and providing space for outreach about the project
- Evaluating results for communication or feedback to the management of the organization
- Stimulating cross-fertilization between projects and artscience projects and the organization
- Implementing results and guiding in integrating new knowledge and processes
- Setting up presentation moments, contextualizing, and staging the outcome

The professional experience such bridge-builders can provide to organizations that want to explore artscience projects for the first time or want to create artscience programs serves as guidance and helps to avoid pitfalls and to handle any outcome—implement positive results or deal with unforeseen situations.

References

Berthoin Antal, A. (2012). Artistic Intervention Residencies and Their Intermediaries: A Comparative Analysis. *Organizational Aesthetics, 1*(1), 44–67.

Hediger, I., & Scott, J. (2016). *Artists-in-Labs: Recomposing Art and Science*. Berlin: De Gruyter.

Koek, A. (2017). In/Visible: The Inside Story of the Making of Arts at CERN. *Interdisciplinary Science Reviews, 42*(4), 345–358.

Naiman, L. (2011). An Interview with John Seely Brown About Xerox PARC's Artist in Residency Program. *Creativity at Work.* Downloaded from https://www.creativityatwork.com/2011/01/10/xerox-parc-collaboration-at-the-intersection-of-art-and-science-an-interview-with-john-seely-brown/. 27 June 2018.

Schnugg, C. A. (2014). Curating and Facilitating Residencies for Artistic Production and Research: Colliding Art, Technology and Science in Residencies. In *Proceedings of the 7th Art of Management and Organization Conference 2014*, Copenhagen.

Scott, J. (2006). *Artists-in-Labs: Processes of Inquiry.* Vienna/New York: Springer.

Scott, J. (2010). *Artists-in-Labs: Networking in the Margins.* Vienna/New York: Springer.

Sleigh, C., & Craske, S. (2017). Art and Science in the UK: A Brief History and Critical Reflection. *Interdisciplinary Science Reviews, 42*(4), 313–330.

12

Things to Keep in Mind

Bringing artscience collaboration to life involves more than creating a program and facilitating it. With the right mindset, an interesting artscience program that is well-embedded in an organization, and motivated individuals, there are still additional conditions to think of that can lead to misunderstanding or possible pitfalls. Second, the exchange has been argued as valuable because of the interdisciplinary exchange and process between artists and scientists, and STEAM initiatives in education can help to foster this exchange and a basic understanding of its value. This implies an important role of the profession and comprehensive experiences outside the profession to refine understanding and practices, and learn from new perspectives. Everybody collaborating and putting work into this is bound to institutional mechanisms of their own fields. Arguing for the value-added of artscience projects in the own disciplinary realm can be difficult, as it involves outcomes that push the borders of a field and thus are difficult to evaluate in the organizational, scientific, and artistic realm. There is still potential to create additional and new ways of presentation and evaluation, but a first step is to recognize current frameworks and needs.

12.1 Important Conditions

Aspects that are engrained in organizational culture and the cultures of art, science, and economic environments and important conditions to enable open exchange right from the beginning and to avoid misunderstandings at a later point in the collaboration are presented here.

Ownership and Intellectual Property Rights Any collaborative project that is communicated and creates a certain outcome is confronted with this question: who owns the IP that comes out of such a process? Who is allowed to publish it, present it, put the name on it, and make money off it? Basic assumptions about answers to the questions are deeply rooted in usual procedures in a sector: organizations are used to employ people to produce outcome for them, artists are used to present their work and have to build their reputation and income on its presentation, and scientists are used to collaborate in a group and to put all the names, including that of their organization, on a paper. Acknowledging the whole process, the environment in which the artscience project emerged, enriches its reception. In most cases it is not problematic to add names as co-authors. Nevertheless, the fees and employment situation of an artist in the organization can introduce problematic situations: artists have to make a living off their art—which they also have to do with the art produced in an artscience collaboration—but scientific organizations can have a contractual limitation that does not allow their facilities to be used commercially. On the other hand, there are questions about what happens if the process triggers an invention that is essential for the organization or leads to a commercial spinoff by a scientist. Thus, referring to standard practices in art, science, or economic environments can be risky (Sleigh and Craske 2017; Gates-Stuart et al. 2016). Depending on the project structure (e.g., incoming artist who gets an artist fee, including allowance for using the artwork in the organization's communication while keeping the IP of the artwork with the artist; artist as short-term employee at the same level as the scientist or as contracted expert consultant), the contractual agreement can cover this issue for the specific situation. Decisions and mutual agreements are discussed based on the context of the artscience collaboration, its goals, and the situation of the individuals in the collaboration.

Funding Structure The funding structure partly defines relationships and contractual agreements: is the artist part of a team like a visiting scientist working on their own project? Is there a relationship that implies consulting work or the creation of an artwork as contribution to communication strategies? Responsibilities for materials and production cost of an artwork are often bound to these questions. The need to produce something specific can limit the process to this envisioned outcome.

Unfortunately, there is still a difficult situation to apply for funding for artscience collaboration within scientific projects outside the limited budget

of "communication and outreach" agendas or artistic funding that often focuses on the artistic process alone or the production of an artwork. Aside from corporate residencies, the FEAT Project funded by STARTS Horizon 2020 EC projects provides a first role model for such public funding schemes to promote the inclusion of artists as experts in research projects for a longer period.

The Importance of Time: Duration of the Residency or Interaction Process
Collaboration takes time. The process from getting in touch with new perspectives and knowledge to the inception of an idea to the execution of a project takes time. Mutual learning processes take time; even getting acquainted with a new setting and new people takes time. So residencies or artscience collaboration projects that are short term (less than two months) do not have the same effects or outcomes as projects that take longer and give every participant more time to digest. Even experienced artists and scientists who already know about artscience collaboration need time to adjust to new situations and new knowledge, and to develop new ideas. Very short-term visits (one to three weeks) can be inspiring, but miss the opportunity for in-depth interaction, reflection, and learning processes. Thus, short-term interactions are often not called residency or collaboration, but "interaction" or "visit."

Depending on the goal of the interaction both can make sense. Residencies at corporations can take different forms: some work best at a length of three or four months, as the artist comes in and starts to find their way around, connect to people, and develop a project. Others focus on a more intense process and span seven to ten months. A survey with artists in the Swiss Artists-in-Labs program showed that nine months can be short for the development of a big project, but most artists cannot afford to be away from their atelier for longer than nine months. A longer time span can be difficult. Some artists and scientists report that they love to focus on long-term connections that can include shorter periods at the laboratory and more loose connections like in ongoing research partnerships. This can develop a trustful working connection and support their artistic and scientific work over several years or even decades. Short interaction like visits for one week can only give a glimpse into the world of art or science, be informative, or rely on an insightful workshop. Shorter residencies can be inspiring opportunities for artists and scientists and affect the organizational culture, but more effective personal development and deeper insights are made in more intense interactions or ongoing exchange between the disciplines.

The process described by many facilitators of residencies and experienced artists is as follows: the first few weeks are the orientation phase; often the artist is in awe of science, in a honeymoon phase, as Sarah Craske described it in her residency process, and cannot understand the frustration or pragmatism of the scientists, who know the limitations of the processes, went through failing experiments, or are under high pressure to publish to get new funding. After the initial excitement, often a crisis in the project-finding process or even an existential crisis (ranging from "What to do with all this information?" to "Which way to go?" to "What am I doing with my life?") is reported around the end of the first month of a residency. After this phase, interesting questions are asked, in-depth conversations emerge, and first meaningful ideas are explored. Facilitators observe that this is the phase where artists start to vanish into specific research groups and dive into the subject. Based on this rich engagement, projects develop. Sometimes this takes a little longer; other processes have a more immediate outcome. Phases can range from three or four months up to nine months or longer depending on the project and the collaboration process.

In situations where artists cannot be away from their studio for a longer period or other factors limit the time at the scientific organization, the interaction phase can be prolonged by designing the residency in phases: for example, allowing an introductory week, then some time back at the studio for first preparation, a longer period on site again (two to three months), time for reflection back at the studio and email exchange with the scientist, and then the production phase (maybe back on site). Such phases give ideas more time to develop and for interaction competencies to grow over a longer period (e.g., a year).

Meet on a Level-Playing Field: Hierarchies, Power Relations, and Status A collaboration means exchange and spinning of ideas on a level playing field. It is not about artists coming into scientific contexts only to learn without having anything to give. And neither is it the other way around, artists coming to a scientific context to help scientists to make something more beautiful. Meeting at a level plane includes acknowledging that all partners in the collaboration (and the organization and the bridge-builder) are experts in their field of knowledge and craft, and thus contribute equally to the exchange. This should be the mindset when one enters into any artscience collaboration. Facilitators can help to introduce this mindset to the collaborating partners. Preparation by looking at the incoming artist's portfolio and reflecting on their project suggestions, as well as artists investigating the organization's and scientists' work (even having a look at their published papers), demonstrates interest

and is a helpful first step to create mutual interest. A structural action to create this level playground is to find the right job title for the artist-in-residence: a short-term position on an expert/consultant level, research fellow or visiting researcher on a level that is equal to others in the scientific group (it gives them access, responsibilities, and competencies), and introducing artist-in-residence as a position at this level in the organization are options. Low-level categorization of the position like "volunteer" or "intern" does not work and creates problematic hierarchical dependencies as well as an imbalance between the collaborating partners.

A facilitator's power to create this mindset from the organization's perspective (and that of its employees) is bound to formal structures and strategies of the organization's lead. Everybody understands that artscience collaboration needs time and engagement to work, but only with the right mindset in the organization are employees interested in engaging and can take time to collaborate with incoming artists. Support to the program from higher hierarchies and a willingness to invest time have to be noticeable throughout the organization.

Trust Mutual trust implies trust between artists and scientists, between employees in the organization and the facilitator as well as the incoming individuals. Establishing trust and validating it is essential to dive into unknown processes and situations. Contractual agreements, clear communication about ideas and needs, positive experiences, an open discussion culture, and building up relationships are preconditions. To a large degree a facilitator can help to build this fruitful environment.

Trust is important to take risks or go new ways that are off the beaten paths of routines or well-established scientific experiments. As the artist Sarah Craske points out, "[T]aking risks is important; there can be restrictions and hesitations to proposed ideas by the artist, but it is important to go the way instead of hesitating due to scientific rigor or deviations of scientific routine processes." Having trust and taking risks in projects that do not follow a beaten path or stick to conventions can create the most interesting outcome. The scientist James Gimzewski points out that exploring wild and deviant ideas and taking risks to grow create an impactful work because they lead to insights or even open up new fields. There can be mistakes and unforeseen events, but these are most important for a learning process. As Oron Catts adds, as facilitator of artscience collaborations, currently there is too little room for mistakes and failed projects in artscience collaboration because this

complicates the funding situation. Learning from mistakes is essential, though.

Openness of the Outcome Creating a program with an open outcome can be difficult for organizations. Nevertheless, many corporations that rely on their R&D departments have understood that this kind of space is necessary for their employees to flourish: they created the possibility to use up a percentage of the working hours for free exploration. There are always ideas and goals behind starting a project: the organization wants to influence work processes or support creativity; the scientist and the artist have their own reasons to enter a collaboration. Finding a way to meet the expectations and grow from the process develops in a dialogue where goals and ideas meet between artists and scientists. "First sit down, have a dialogue and listen, don't go in and work!" says Danielle Siembieda from Leonardo. Open-endedness is important to enable the project to go a completely different way than anticipated, to allow failure and mistakes, and to create disruption and deviations of routine processes.

As famous art and technology collaborations in the 1960s at Bell Labs already experienced, the outcome of experimental settings, upcoming ideas in the collision of an artistic and a scientific or technological mindset, and reactions of the material in these unusual projects cannot be foreseen. Many important twists in the process just happen (Patterson 2015; Taylor 2014). Even if projects take a different direction than expected, it is interesting to look at by-products that can be exhibited and presented. They can be made use of in personal reflection and evaluation within the artistic or scientific field, but they are not the main goal.

Possible Disruptions: There Can Be a Mess Artscience collaborations can make any participating party in an organization feel uncomfortable: being introduced to a new environment can be as uncomfortable as inviting an unknown person with a different mindset in the own space. Collisions of ideas, diverging work processes, and the understanding of topics can be challenging, and experiments can be disruptive to routines. Above all, there can be unwanted outcomes or insights that fundamentally change values or beliefs of individuals or a group. All this bears potential to learn, to reflect, and to create, but finesse in dealing with these situations by the facilitator and an open culture to discuss and engage with uncomfortable situations and disruptive elements are essential to grow from this.

12.2 The Role of the Profession

The previous part of the book looked at aspects of the artscience collaboration process to understand changes and mechanisms that lead to reflection and learning that is relevant for the own practice—and impressive artscience projects. This is based on the meeting of different disciplines and the socialization and acquisition of competencies in different disciplines. When these disciplines meet, there are areas of surprise, conflict, and unforeseen perspectives. This exciting interdisciplinary exchange is fed by the rich differences of their environment, education, responsibilities, opportunities, and roles in society. These differences in the daily realities, routines, and organizations create a different understanding of what is "normal" for them, which shapes their understanding of what they do and how they approach their work and the specific projects they approach and the people they meet. But at the same time, openness, new experiences, and completely different views can trigger big leaps in projects and lead to breakthrough ideas or paradigm-shifting approaches.

Scientists and artists do have different skills and a different training, but often are interested in the same topics from a different perspective, reflect on nature and societal problems, or complex issues like climate change or dynamics of the universe. Expanding contact with people and ideas beyond relationships one encounters daily and getting access to new information raise the probability of creative ideas and collaborations that are otherwise outside of one's "radar." These issues are relevant for us as society and can only be addressed when people with specialized knowledge and skills complement each other and sometimes have confrontational discussions. Sometimes it is bluntly the deliberating effect of engaging in something completely weird and fun that can lead to the greatest outcomes. And what could create a more exciting new experience than a meeting of artists and scientists. So arguing for artscience collaboration, the integration of art and artistic practices in STEM education, or giving scientists the opportunity to explore art (and artists the opportunity to explore science in their education and professional life) does not imply blurring the boundaries of the profession. Nor does it imply neglecting responsibilities or the depth of knowledge that enables interesting projects in any professional discipline.

There is relevance in specialization for pushing the borders of the fields. Only with deep knowledge can artists and scientists ask important questions and tackle those uninvestigated blind spots that are lurking behind the seemingly vast knowledge humankind has already created. Artists and scientists

have different approaches to topics to make their work—which is an important aspect too. Their own strategies lead to a scientific outcome or a specific question or a new surprising or provocative artwork. These methods and crafts are developed in their respective field. Only with this fundament do they have the power to go deep enough to create something relevant.

Thus, although artscience collaboration is about mutual learning processes, openness, and collective effort to contribute to a common goal, it is not about artists becoming scientists or scientists becoming artists. Nevertheless, acquiring new perspectives or techniques, appreciating new methods, and maybe even incorporating some of them in one's own competencies do not imply changing the profession or creating generalists of any sort. It is more about personal development and feeding new opportunities and knowledge into the repertoire of doing, perceiving, and understanding that helps to grow.

Artists are freer in their ways of inventions than scientists are. Although scientists can envision future technologies or desired future outcome and knowledge, they are bound in the communication to basic scientific principles. Artists are much freer to invent and communicate this, and nobody has grounds for objection if it violates natural rules (Malina 1968). Scientists can take these ideas and bring them into the context of possibilities and create strategies to reach possible goals.

Oron Catts, co-founder of SymbioticA, takes this further—that disciplines and professions are respected, and the borders should not get blurred—by arguing for the importance of the "integrity of the profession." The roles of artists and scientists are not only defined by the search for meaning or knowledge and the creation of beautiful things or innovative work. They are also defined through their roles in society and the reception of this work by society. Although artwork can transfer meaning and communicate complex content in a different way than science communication or science journalists can, artwork is free to make changes, to create fictional stories, and invent the impossible. Art is not bound to communicating verifiable facts. Even an artwork that reflects on scientific ideas, reality, or problematic political situations—or invents futures by contextualizing recent technologies in fictional stories—is not purely educational or journalistic, or communicates pure scientific knowledge. This freedom of art is necessary to find new perspectives or make things more understandable—or experiential. The audience is free to search for their own approaches, interpretations, and ways of experiencing an artwork. Opening up this potential is most important to creating art.

On the other hand, scientists are bound to verifiable facts and to the quest for knowledge. Scientists set out to find answers for questions about humankind, nature, and the universe, and to solve difficult situations like antibiotic

resistance or climate change. In their quest, they set out to find truth and inform a broader public about their findings, or point in new directions that are relevant to explore or to new ways that must be taken in order to create a better situation for society and nature. What they communicate is what they found out. Both roles are relevant in society to investigate the universe and to open up minds, and it is important for artists to engage in scientific ideas, as it is for scientists to open their minds in engaging with art.

The roles of artists and scientists in society should be taken seriously. Especially within science communication, it can be dangerous to blur these lines. Already imprecise translation of scientific jargon in science communication or communication of new findings that contradict previous theories can become misinterpreted or lead to the audience's distrust in the scientific method. So art should be communicated as such—as opening up the minds based on scientific possibilities or reflecting on scientific knowledge, as science should be communicated as what it is—an ongoing quest to understand the universe. Therefore, the artist does not become a scientist by employing scientific methods or data, or a scientist does not become an artist by exploring artistic visions or ideas. "The context in which the work is being developed and the approach of the artist or scientist create its meaning. Based on the social contract, the understanding of what art and science is, the ways in which the work is being read are defined," as Oron Catts points out. If borders between fiction and reality get blurred, trust in scientific research can be negatively affected and the competencies of artists and scientists are questioned.

12.3 Evaluation in the Field and the Attributed Value of ArtScience Collaboration

Although there is shared interest in artscience projects, artists and scientists pursue their own careers and thus pursue their own goals. This enriches the project and creates the opportunity to embed the outcome in diverse contexts: within scientific research, artistic and aesthetic discourses, corporate goals, as well as societal developments and public interests. All this is most welcome, but within the fields of art, science, and technology, the outcome is often difficult to evaluate. Thus, there are still difficulties for scientists and engineers, in certain circumstances also for artists, to present this work and get it recognized as a valuable contribution in their own discipline. The process definitely contributes to their personal and professional development, but the integration of an artscience project in a certain phase of their disciplinary careers is still

difficult and should not be understood as a matter of course in every professional environment.

A first reason for this is that the hybrid outcome of artscience collaboration is neither strictly science nor technology (Shanken 2005), as shown in many examples that create exploratory work, and often the outcome is not art either. So the question is how to evaluate these collaborations by the knowledge and insights they produce. At times, they can probably be evaluated by future professional development of the artist, scientist, or engineer, and the projects and insights that follow in the field based on the learning process in the artscience collaboration. This still poses difficulties to evaluate the immediate process itself. Moreover, it is often not possible to categorize the hybrid outcome. From the early interactions between artists, scientists, and engineers, even new disciplines developed, in science and art, and milestones have been created that have grown to be a point of reference since then (Taylor 2014). Immediate evaluations are based on established categories, though. There is still a need to create opportunities for evaluation of the outcome—the artscience project and possible new disciplinary fields that can grow from it (as was the case with fields like computer graphics and new media art).

A second reason is that a certain stage in an academic, artistic, or engineering career, professional development and educational benefits are strongly connected to experience in the profession (e.g., academics spending their sabbatical at a renowned scientific institution in their field producing new scholarly collaborations and publications). Evaluation systems within a field are, to a great extent, still quite restrictive. Decision-making in the fields, such as in academic recruiting, is most certainly based on these factors, including previous research projects, funding raised, number of publications, and so on. In the interviews for this book, scientists have been saying, "[Y]es, it was amazing, but it cost me half a year or a year of my scientific work," meaning that they fell back in the competition with others for funds. There is still limited possibility to present and publish this kind of work to demonstrate the relevance. More experienced scientists are thus freer to engage in artscience collaboration than younger scientists or even PhD students. Artists, on the other hand, are bound to certain ways of the art market, critics, curation of presentation of their work, and art funding schemes work. Gatekeepers in the artistic realm must understand and see the value of their work to develop their careers. The interdisciplinary experience and the reflection and mutual learning processes enabled by artscience collaboration have to be understood as essential and valuable in each field to legitimize them within a career path. A first step is to understand the process better instead of evaluating the outcome alone. A detailed description and analysis of effects of the artscience

collaboration process and a description of the values-added are necessary to give space (and funding) to the field of artscience collaboration. Second, individuals who have already experienced the richness of artscience collaboration themselves see the value for themselves to develop long-term collaborations and to support younger artists, scientists, and engineers to engage in artscience collaboration. The more widespread this experience is, the more its contribution to professional development will be understood.

A third reason is that these disciplinary mechanisms that define career paths and evaluate outcomes based on established categories limit the possibilities for new disciplines (in art and in science) to be understood right at their beginning. Innovations and paradigm-shifting approaches are so difficult to grasp because they deviate from previous knowledge. Although innovation as such is valued highly, it always takes time to understand its implications and relation to other fields. A lot of contextualization work and analysis of the role of these interdisciplinary exchanges has to be done to understand the full impact of artscience collaboration on these developments. As Shanken (2005)—one of the main art historians in the field of art and technology—points out: without defined methods for the analysis of the role of science technology in the history of art to reveal the interconnectedness of the fields, the development of digital art will remain misunderstood and played down in the context of art history.

Organizations make an important contribution to this interdisciplinary development by creating space for these exchanges and their presentation. Corporations involved in early art and technology projects and cultural institutions presenting this work were essential to push the boundaries of the fields and create an initial understanding of what is going on in the field that could be seen by a broader audience (Taylor 2014). Organizations are bound to economic development, values, and goals in the sector they are operating in (science, industry, culture, service, art, art market, etc.), and cultural and political constraints. Thus, their opportunities can be limited to small gestures or single projects that support artscience collaboration and its outcomes without legitimation of their actions within their field. Improving the understanding of the contribution of artscience collaboration to professional development and to the creation of paradigm-shifting approaches will help them to do so. Of course, organizations won't stop to see additional value in investing in these interactions (e.g., economic growth, invention of innovative products, be the first to exhibit seminal work, be influential in the academic sector), but so do artists, scientists, and engineers from their personal and professional perspective. Understanding that individual goals and shared goals are both valid and can be pursued in this mutually supportive process allows the framing of

these goals according to realistic possibilities and will create added value for every participating party—and help the field of artscience collaboration to grow.

References

Gates-Stuart, E., Nguyen, C., Adcock, M., et al. (2016). Art and Science as Creative Catalysts. *Leonardo, 49*(5), 452–453.

Malina, F. (1968). Some Reflections on the Differences Between Science and Art. In A. Hill (Ed.), *DATA: Directions in Art Theory and Aesthetics* (pp. 134–149). London: Faber. https://www.olats.org/pionniers/malina/arts/differencesScienceArt_eng.php

Patterson, Z. (2015). *Peripheral Vision. Bell Labs, the S-C 4020, and the Origins of Computer Art.* Cambridge, MA: MIT Press.

Shanken, E. A. (2005). Artists in Industry and the Academy: Collaborative Research, Interdisciplinary Scholarship and the Creation and Interpretation of Hybrid Forms. *Leonardo, 38*(5), 415–418.

Sleigh, C., & Craske, S. (2017). Art and Science in the UK: A Brief History and Critical Reflection. *Interdisciplinary Science Reviews, 42*(4), 313–330.

Taylor, G. D. (2014). *When the Machine Made Art. The Troubled History of Computer Art.* New York: Bloomsbury.

13

Outlook

Artscience collaboration initiatives and centers that focus on interdisciplinary exchange between art and science are growing around the world. Hubs at universities like the MIT Media Lab, SymbioticA at the University of Western Australia, or the Art|Sci Center at UCLA became role models for newly established centers and departments at universities. The Leonardo group is growing, and Leonardo events and talk series spread after the 50th anniversary of Leonardo even further, and hubs for exchange and meeting like Le Laboratoire and The Laboratory at Harvard are founded around the world. Initiatives like a2ru (Alliance for the Arts Research Universities) in the US map and support such centers, funding opportunities, and educational programs that include art in scientific research and education. In Europe the European Commission supports artists in scientific projects through and investigation into the role of art in the context of science and society through, for example, the STARTS grant; in addition, many smaller individual grant opportunities are developing right now internationally, and artscience festivals, galleries, museums, and exhibitions are rapidly growing and spreading, like Ars Electronica and Science Gallery, two institutions that started such initiatives around the world. The opportunities in the artistic and scientific field are growing worldwide; it is barely possible to name them all. At the same time, after a long absence since the 1960s, since Xerox PARC created the artist-in-residence program PAIR in the 1990s, the number of corporations inviting artists and supporting artist-in-residence programs seems to be growing exponentially. And those experiencing these collaborations and programs—if done well—understand how important this process is for them and their organization. The interest is growing, and in recent months, initiatives (e.g., festivals, residency programs,

exchange programs, intermediary organizations, artscience centers, cultural hubs) have been started more and more frequently based on the positive experiences and high expectations in artscience collaboration.

On some level, experience in artscience collaboration projects is still limited. Like in this book, positive experience is reported with different art forms and scientific backgrounds, at diverse organizations (cultural, scientific, corporate), by younger and more experienced scientists, engineers, and artists, including female and male perspectives. Nevertheless, the cultural diversity is rather limited: Northern American perspectives, European perspectives, and Australian perspectives are currently dominating the field that meet a rather limited number of actors that do not share this cultural background. As small glimpses into intercultural meetings in artscience collaboration show, these can be extremely valuable and insightful. There is rising interest and a growing number of projects in engaging in artscience collaboration between cultures that have a longer tradition of experience with artscience collaboration and other cultures that have different cultural traditions, philosophical approaches, and individual understanding of art and science—and what they can do. Moreover, inspired by the trend of artscience collaboration and the seminal work stemming from these collaborations, a growing interest in artscience collaboration and a rising number of initiatives are currently found in Asian, African, Arabian, and South American contexts. The cultural and intercultural impact of artscience collaboration in these new contexts and valuable contributions to public engagement, education (ranging from raising interest in science for school students up to educational workshops for adults), and professional development, or even spanning cultural gaps, will be explored and reflected upon in the near future.

Given all these developments, the outlook for artscience collaboration looks full of opportunities. The growing number of initiatives creates possibilities of integration of art and science in research and is spreading artscience collaboration to different disciplines and throughout the world. Current conversations are sometimes still a little bit clumsy, putting economic, artistic, or scientific terminologies and goals into the foreground without trying to speak a shared language. This still creates insecurities and misunderstandings. Those misconceptions and issues arise in situations where art is instrumentalized for economic outcome, where science is a pure informant for a beautiful artwork and where the terms creativity and innovation are used only in entrepreneurial contexts and do not refer to scientific effort or as transferable from art to other fields. Artists active in the field are currently exploring opportunities and communication frameworks that allow artscience collaboration in organizational contexts without instrumentalizing art for other goals or to get exploited in these contexts for others' products (Catts and Zurr 2018).

This is also a central topic for policy-makers. The elaboration on the importance of the process and its manifold implications for personal and professional development aims to be a first step to create a shared understanding of artscience collaboration that respects the needs and responsibilities of all participating parties.

The most recent developments that support artscience collaboration include a growing awareness of its importance in education and discussion outlets for artists, scientists, creatives, engineers, managers, curators, producers, and facilitators. This helps in raising awareness of the importance of such interdisciplinary exchange and to provide all these actors with the necessary tools to enter rich artscience projects. Moreover, it is essential to reflect on evaluation systems, to understand how artscience collaboration can fit in funding frameworks and in career development. There is still a lot of work to do for policy-makers and advocates of artscience collaboration to find strategies that give the necessary space and support to artscience collaboration in the diverse cultural, political, and economic environments.

13.1 Education

The inclusion of art in STEM education is called the STEM to STEAM movement. Similarly, educators and academics in the field of organization and management studies point to the importance of art and humanities in business education and how such new curricula are beneficial for future managers and organizations. Both these educational concepts have several goals and arguments as to why arts in STEM and arts in business education contribute essential aspects of learning. These include aspects such as how artistic approaches and experimental learning can help to reach new levels of understanding of a topic—as presented in the course of this book—and how aesthetic experience, craft, and embodied knowledge affect learning. Aside from more comprehensive learning and acquirement of new kinds of knowledge and skills through integration of art in STEM and management education, arguments about the importance of these initiatives revolve around better contextualization of work in the environment, reflective practices, and understanding of interdisciplinary dependencies, as well as disciplinary dependent perspectives on issues (e.g., Wong 2007; Steyaert et al. 2017; de la Garza and Travis 2019).

Research into new kinds of educational programs shows that courses promoting an interdisciplinary understanding of a topic built through the sciences, arts, and humanities is more comprehensive than purely scientific and rational approaches (Jacobson et al. 2016), and that students of such courses

develop the ability to connect academic domains of knowledge and creatively address challenges (Clark and Button 2009). Similarly, a row of studies show how interdisciplinary education including art and craft skills enables individuals to improve their disciplinary skills, intellect, and working processes (Root-Bernstein et al. 2017). In education John Dewey pledged already in 1934 in his prominent essay *Art as Experience* (1934) for art as a valuable component in education and in widening perspectives and individual understanding. Lately, this idea has been widely supported in education by people who tried to make curricula more interdisciplinary and started integrating art courses and artistic approaches into STEM courses as well as into curricula. Taking a step away from STEM toward STEAM (now including the arts) is an upcoming trend that has been supported by psychological and pedagogical studies, for example, by the Art of Science Learning group led by Harvey Seifter and by Robert Root-Bernstein et al. (2017) in their "Review of Studies Demonstrating the Effectiveness of Integrating Arts, Music, Performing, Crafts and Design into Science, Technology, Engineering, Mathematics and Medical Education." Harvey Seifter's group's research in pushing arts-based learning in science points to important impacts of arts-based training in STEM education (Goldman et al. 2016). Its findings provide clear evidence of a strong causal relationship between arts-based learning and improved creativity skills and innovation outcomes in adolescents, and between arts-based learning and increased collaborative behavior in adults.

These STEM to STEAM initiatives or arts and humanities to business education can take many forms. Some create courses where arts and STEM students have to collaborate in teams, some include a range of obligatory arts or humanities courses for STEM students (or science courses for art and humanities students), and still others integrate artistic processes or art pedagogical methods into STEM courses, high-school teaching, or business education. The increasing effort of academics and practitioners to include humanities in business education aims at helping managers to understand and reflect the context of their organizations and integrate new methods like arts-based initiatives. This aims at supporting managers to act sustainably, and to reach their managerial goals by creating open and innovative systems in their companies and by enabling employees to develop their skills and push boundaries (Steyaert et al. 2017).

Creating interdisciplinary courses and bringing art into STEM and business education help individuals to grow and expand their professional skills. Additionally, a more comprehensive understanding of topics and the interconnectedness of disciplinary approaches in challenging situations or research questions can be experienced. This builds awareness of the importance of interdisciplinary collaboration and contributes to the development of competencies in interdisciplinary collaboration, which is necessary in many fields

and professions. Especially in artscience collaboration these competencies are important for artists, scientists, facilitators, and managers of any organization (cultural, scientific, corporate).

Since the beginning of the 2000s the initiatives at universities have grown to start graduate programs to support interdisciplinary collaboration between art, science, and technology (Shanken 2005). Another important development is the recent creation of academic courses and master's programs that focus on art and business. These courses and educational programs provide the opportunity to artists, scientists, curators, and managers to learn about the process of artscience collaboration (or its integration into organizations), to experience such a process themselves, and to explore their own interdisciplinary collaboration capacities. These include aspects like the design of artscience projects, reflections on where there are important connections to other disciplines, finding a common language to talk to professionals from other disciplines, and start one or the other process presented by the previous chapters in this book. Many of these newly developed programs are connected to art universities and business schools, but there is also a growing number of courses offering courses to students in STEM disciplines. Some of the initiatives like joint research centers or joint artscience master's programs bring arts and science faculties and their students together to collaboratively develop projects.

Other programs focus on introducing artists and scientists to interdisciplinary collaboration practices and developing a practice to create relevant artwork by exploration of scientific approaches and a reflective practice based on the artscience collaboration process. Examples of such initiatives at an academic level that are connected to cases presented in this book are the Convergence Initiative at Concordia University and the McGill University, Art|Sci Center + Lab at UCLA, and SymbioticA. The Convergence Initiative brings together graduate students from neuroscience and students in the final year of their Bachelor of Fine Arts. Through this course students learn to experience and explore such interdisciplinary collaboration and develop their own creative project that will be presented in an exhibition at the end of the semester. The Art|Sci Center at UCLA provides courses for art and science students to learn about the field of artscience collaboration and art and technology. Students from diverse backgrounds are encouraged to open their minds to new perspectives and relate their own work to other scientific or artistic approaches. Master's and PhD students are encouraged to create a collaborative project within the course framework. Next to the artists-in-residence program, SymbioticA provides interdisciplinary courses and events for students from different disciplinary backgrounds.

It is important to support these initiatives and those artists and scientists who are eager to expand their scope by crediting artscience exchanges and learning processes within their curricula. Such a step underlines the importance of this broader view on one's own work instead of restricting these exchanges to spare-time activities that are not recognized as an essential part of education. This will help artists and scientists to find better access to their own work and to interdisciplinary exchange in their future work. Managers and others confronted with such situations will have a better understanding of the effects on their teams and organizations, but at the same time they will grow the ability to integrate this thinking and provide space for these important processes.

13.2 Next Steps

The recent development fostering artscience collaboration and the inclusion of art and interdisciplinary projects in education is a pleasant one. The experience of art and science at any educational level and in the education for different professions will raise awareness of the potential of artscience and the competencies that are needed to realize artscience collaboration. This growing group who are able to incorporate the idea of artscience collaboration and have experienced the values-added has to be supported by advocates of artscience collaboration to reach out to policy-makers and spread the word within the existing system.

Based on a broader understanding of the artscience collaboration process and the rising awareness of its values-added, policy-makers can support the inclusion of art in education and create space for artscience collaboration by new funding schemes. Such official support and awareness-building help to raise the perceived value of artscience collaboration in the fields of corporate organizations, science, and art. Many restrictions artists, scientists, and organizations currently face are connected to difficulties in communicating the value of artscience collaboration, limited evaluation systems, and restrictions to formally integrate artscience collaboration in a professional career path. Currently even scientists working in interdisciplinary fields have difficulties developing a career and recognition of their work (Benson et al. 2015; Klein 2006, Klein and Falk-Krzesinski 2017). Artscience collaboration is even more difficult to evaluate, as it focuses on the process (mutual learning, experimentation, learning from mistakes) and there are still limited outlets to present artscience projects and discuss them. Ways to integrate artscience collaboration

in a professional career path—maybe even based on reflections on the artscience collaboration process or by reflecting approaches of art in professional education in career trajectories—could be a first step to facilitate this. The increasing number of exhibition spaces, journals, festivals, symposia, conferences, and centers will provide a stage and a platform for a growing conversation about artscience.

These platforms can support the discussion of best practices to integrate artscience collaboration in curricula and career paths and can help to reflect on its impact. By focusing on the process of artscience collaboration through the lens of organization studies and using a row of interviews and case studies to illustrate the effects of this process, this book can give a first overview and a glimpse of what the artscience collaboration process can be. In-depth studies will illuminate more details with a broader empirical base of what is shown now in single-case studies and reports gathered by qualitative interviews.

References

Benson, M. H., Lippitt, C. D., Morrison, R., et al. (2015). Five Ways to Support Interdisciplinary Work Before Tenure. *Journal of Environmental Studies and Sciences, 6*(2), 260–267.

Catts, O., & Zurr, I. (2018). Artists Working with Life (Sciences) in Contestable Settings. *Interdisciplinary Science Reviews, 43*(1), 40–53.

Clark, B., & Button, C. (2009). Sustainability Transdisciplinary Education Model: Interface of Arts, Science, and Community (STEM). *International Journal of Sustainability in Higher Education, 12*(1), 41–54.

de la Garza, A., & Travis, C. (Eds.). (2019). *The STEAM Revolution. Transdisciplinary Approaches to Science, Technology, Engineering, Arts, Humanities, and Mathematics.* Cham: Springer.

Dewey, J. (1934). *Art as Experience.* New York: Minton, Balch and Company.

Goldman, K. H., Yalowitz, S., & Wilcox, E. (2016). The Impact of Arts-Based Innovation Training on the Creative Thinking Skills, Collaborative Behaviors and Innovation Outcomes of Adolescents and Adults. Research Study Report *Art of Science Learning (Harvey Seifter, Principal Investigator).* http://www.artofsciencelearning.org/wp-content/uploads/2016/08/AoSL-Research-Report-The-Impact-of-Arts-Based-Innovation-Training-release-copy.pdf

Jacobson, S. K., Seavey, J. R., & Mueller, R. C. (2016). Integrated Science and Art Education for Creative Climate Change Communication. *Ecology and Society, 21*(3), 30.

Klein, J. T. (2006). Afterword: The Emergent Literature on Interdisciplinary and Transdisciplinary Research Evaluation. *English Faculty Research Publications.* Paper 4. http://digitalcommons.wayne.edu/englishfrp/4

Klein, J. T., & Falk-Krzesinski, H. (2017). Interdisciplinary and Collaborative Work: Framing Promotion and Tenure Practices and Policies. *Research Policy, 46,* 1055–1061.

Root-Bernstein, R., Pathak, A., & Root-Bernstein, M. (2017). Review of Studies Demonstrating the Effectiveness of Integrating Arts, Music, Performing, Crafts and Design into Science, Technology, Engineering, Mathematics and Medical Education. Part 1, Part 2, Part 3. *White Paper.*

Shanken, E. A. (2005). Artists in Industry and the Academy: Collaborative Research, Interdisciplinary Scholarship and the Creation and Interpretation of Hybrid Forms. *Leonardo, 38*(5), 415–418.

Steyaert, C., Beyes, T., & Parker, M. (2017). *The Routledge Companion to Reinventing Management Education.* Abingdon: Routledge.

Wong, D. (2007). Beyond Control and Rationality: Dewey, Aesthetics, Motivation, and Educational Experience. *Teachers College Record, 109*(1), 192–220.

Index[1]

A

A2ru, 235
Agapakis, Christina, 75, 158, 209
Agent Unicorn, 57–61, 68
Antibiotic resistance, 32, 50n8, 51, 78–80, 202, 230–231
Antibiotics, 26–30, 34, 79, 144, 146
Antimatter, 70, 83, 84
Appropriate Audiences, 105–108
Ars Electronica, 10, 57, 57n2, 59, 60, 85, 131, 134, 150, 208, 211, 235
Art and Technology Program, 8
Artificial life, 83
Artist Placement Group (APG), 9, 212
Arts@CERN, 83, 204, 209, 219
Art|Sci Center + Lab, 147, 210, 239
Arts & humanities to business education, 237, 238
Astronomy, 151, 154
Astrophysics, 124, 151
Atmosphere, 114, 118, 127, 128, 188, 199
Autodesk, 63–70, 87, 88, 105–111, 198, 201, 209

B

Bachmayer, Alex, 140, 141, 172
Bacteria, 26, 50, 51, 76, 79, 145, 146, 186, 202
Bell Telephone Laboratories, 8, 117
BioArt, 48, 49, 64, 202
Biofaction, 32, 35, 208, 210
Biology, vi, 33, 49, 76, 209
Birdsong Diamond, 85
Blue Morph, 123, 125–129
The Bridge residency, 142, 211
Brunelleschi, Filippo, 1–3
Buckminsterfullerenes, 102
Buntaine, Julia, 142, 211

C

CalTech, 8
Catts, Oron, 17–20, 37, 65, 158, 159, 208, 210, 219, 227, 230, 231, 236
Center for Advanced Visual Studies (CAVS), 7
CERN, 83, 84, 98, 204, 209

[1] Note: Page numbers followed by 'n' refer to notes.

Chemistry, 80
Chemistry of Biology, 36
Chicks on Speed, 63–67, 110
Chieza, Natsai Audrey, 28–29, 75–78, 209
Comerón, Fernando, ix, 151, 152
Complex systems, 83
Computer Enhanced Footwear, 63, 65, 66–68
Computer science, 8, 23, 24, 41, 80, 86, 87, 130, 133, 185
Concordia University, 140, 210, 239
Controlled Commodity, 50n8, 79
Convergence Initiative, 140–142, 172, 239
Cosmology, 99
Craske, Sarah, 7, 26–30, 32–37, 46, 69, 137, 202, 214, 224, 226, 227
Creatura Micro_Connectomica, 140–142, 172–173
CRISPR, 50, 50n7, 50n8, 78, 79
Culture, 1, 2, 7, 10, 35, 49, 55, 66, 67, 70, 77, 97, 103, 117, 138, 153, 164, 167, 177, 178, 183, 188, 196–199, 203–205, 212, 228, 236
Current LA: Water, 148, 149

D

Da Vinci, Leonardo, 1, 6
Dance, 128
Davis, Ian, 177–181, 198
Delta Sound Labs, 179–181
Device, vi, 20, 23, 57–61, 84
Djerassi residencies, 211
Doser, Michael, 83, 84
Dumitriu, Anna, 28–29, 35, 36, 49–51, 73, 78–81, 142–146, 158, 160, 177, 185–187, 202, 208, 210

E

Egypt, 49, 204
Emm, Pierre, 105
ESTEC, 43, 44, 46, 90
ETH Bioprocess Laboratory, 26–30, 32, 69
Ethics, 43, 48–51, 204
European Southern Observatory (ESO), 28, 150–156, 200, 208
European Space Agency (ESA), 43–48, 90–92, 201, 208
Evolutionary biology, 83, 157
Experiments in Art and Technology (E.A.T.), 8, 98, 117–121, 177–178, 198, 208, 212
Ex Voto, 144–146

F

Faber Futures, 76
Fashion-tech, vi, 57, 60
Fawcett, Nicola, 50, 78, 144–146, 158
FEAT, 177, 210, 225
Feynman, Richard, 8, 102
Fictional documentary, 38, 39
Flow, 81, 120, 127, 151, 167, 175, 178, 180, 198
Fraunhofer MEVIS, 130–134, 157, 211
Fuller, Buckminster, 6, 102, 102n1, 102n2, 125, 126

G

Gannon, Madeline, 86–89, 185
Gimzewski, James, 85, 125–128, 227
Ginkgo Bioworks, 75–81, 158
Graham, Ricky, 177–181
G.tec, 59–61

H

Haase, Sabrina, 131–133
Hernon, Domhnaill, 98, 117, 118, 178, 208

Hofmann, Bianka, 130–133, 211
Human-robot interaction, 43, 88, 118, 119

I

Industrial robot arm, 87, 88, 105–108
The Institute of Isolation, 38–40, 48, 159
Instituto de Astrofísica de Canarias, 99
Interactive, 22, 22n1, 37, 63, 85, 104, 127, 149, 156, 157, 180
In-vitro meat, vi, 18, 19

K

Karle, Amy, 40–42, 48
Kepes, György, 7
Kinetic, 6, 140
Klüver, Billy, 8, 212
Koek, Ariane, 98, 201, 204, 209, 219
Kroto, Harold, 102
Krpan, Jurij, 219

L

The Laboratory (Harvard), 235
Latour, Bruno, 114, 122
Le Laboratoire, 235
Leonardo (journal), 9, 10
Leonardo, new Leonardos, 2, 3, 201, 211, 228, 235
Logan, Melissa, 63–65
Lorusso, Mick, 148, 150
Los Angeles County Museum of Art, 8, 127

M

Make Do and Mend, 51, 78–81, 177
Malina, Frank J., 9, 230
Malina, Roger F., 9, 10, 75
Mampaso, Antonio, 123–125

MASSES, 150–156
McGill University, 140, 210, 239
McRae, Lucy, 21, 38–40, 48, 158, 159, 175
Media art, vi, 6, 9, 10, 86, 87, 125, 126, 130, 205, 232
Medicine, 33, 38, 41, 57, 131, 133
Mignone, Claudia, 46, 90
Mimus, 88
MIT Media Lab, 7, 235
Modernising Medical Microbiology, 50, 50n6, 78, 144, 186, 187
Morales, Sebastian, 105
Murray-Leslie, Alexandra, 63–70, 110, 111
Museum of Science and Cosmos in San Cristobal de La Laguna (Museo de La Ciencia y el Cosmos), 124, 156
Music, vi, 10, 21–24, 63, 64, 66, 99–102, 110, 111, 115, 126, 128–130, 138, 156, 178–180

N

NANO, 127
Narrate, 37, 143
Neely, Rob, 36, 78, 80, 142, 143, 185
Neuroscience, 210, 211, 239
Nokia Bell Labs, 98, 117–121, 178, 179, 198, 208
No Man's Sky, 45, 45n2
NoodleFeet, 43–48, 90–92

O

O'Flaherty, Karen, 46, 90, 201
O'Gorman, Larry, 119, 120
Omnia per Omnia, 117–121
Organizational culture, 4, 9, 91, 165, 174, 176–184, 197–199, 223, 225
Osborne, Olivia, 85, 147–150

P

Painting, vi, 1, 115, 119, 120, 130, 167, 183
PAIR, 10, 212, 235
Park, Ed, 177–181
Paul, John, 78, 186, 187, 202
Pellejero-Ibanez, Marcos, 99–102
Peña, Andrea, 140, 141, 172
Performance, 10, 29, 65, 92, 106, 119–122, 129, 132, 156, 163, 185
Petkus, Sarah, 43–48, 90–92, 185
Philosophy, 1, 9, 38, 113, 121
Physics, 9, 100
Planet, vi, 39, 43, 45n2, 48, 152, 153, 155
Planet Labs, 157, 180–184, 198, 202, 209, 219
Porter, Ben, 7

Q

Quadrature, 28, 150–156
Quipt, 87, 88

R

Redhead, Tracy, 22–25
Regenerative Reliquary, 40–42, 48
Reichardt, Jasia, 7
Robot, 43–45, 47, 48, 86–92, 105–107, 111, 119–121, 202
Robotics, 43, 57, 87, 105–108, 110
Rocket, 183
Root-Bernstein, Robert, 29, 102, 124, 129, 166, 171, 173, 238

S

Safety, 49, 88, 104–108, 174, 175
Salmon, Chris, 51, 140, 140n1, 141, 157, 172, 173
Satellite, 17, 182, 183
Schmidt, Markus, 32, 210
SciArt Center, 142, 211
Science Gallery, 11, 60, 157, 220, 235
Scott, Jill, 74, 142, 209, 220
Sculpture, vi, 22, 37, 41, 147, 156
Séguéla, Jade, 140, 141, 172
Semantic Player, 22–25
Shanken, Ed, 6, 232, 233, 239
Siembieda, Danielle, 201, 228
Sigurdson, Vanessa, 209
Silveira, Johan da, 105
Sleep research, 64
Sleep Symphony, 64, 65
Sonocytology, 126
Sougwen Chung, 117–121, 205
Sound, 21, 22, 64, 65, 84, 126–128, 130, 132, 133, 178–180
Sparks (Project), 38, 57–61, 68, 82, 143–146, 208
Sport science, 65
STARTS, 177, 210, 225, 235
STEAM, 5, 102, 211, 223, 237, 238
STEAM Imaging, 130–134, 157, 211
Stearns, Forest, 180–184, 198, 199, 202, 209, 219
STONES, 150–156
Storytelling, 24, 43, 143
Strati, Antonio, 114, 115, 122
Swiss Artists-in-Labs program, 11, 81, 98, 142, 209, 219, 225
SymbioticA, 11, 17–20, 63–70, 210, 219, 220, 230, 235, 239
Synthetic biology, 28, 32, 34, 41

T

tatoué., 104, 105, 107, 108
Tattoo, 105–108
Taylor, Charles, 83, 84, 157
Thalmann, Florian, 22–25
Theriak, 26–30, 34
Thomasson, David, 106, 111
The Tissue Culture and Art, 17–21
Tissue engineering, 17–19
Trust Me, I'm an Artist, 49
Tuchman, Maurice, 8
Turbulence, 178, 179

U

University of California, Los Angeles (UCLA), 11, 83, 85, 125, 126, 147, 149, 210, 220, 235, 239
University of Oxford, 50, 144, 186
University of Western Australia (UWA), 11, 17–20, 64, 65, 210, 220, 235
Urbanization of Ecological Networks, 148, 150

V

Vesna, Victoria, 83, 85, 125–128, 157, 210
Visualization, viii, 4n1, 6, 9, 21, 22, 105, 123, 124, 126, 130, 132, 147, 178, 179
Vorticity, 177–181

W

We Are Data Remix, 66, 67, 110, 111
Weinstein, Noah, ix, 109, 209
Where There Is dust There Is Danger, 187
Whose Scalpel, 131, 132
Wipprecht, Anouk, 57–61, 68

X

Xerox PARC, 10, 11, 212, 235

Y

Yen Tzu Chang, 130–134

Z

Zaelzer, Christian, 141, 210